SCHOOL OF GENIUS

A History of the Royal Academy of Arts

James Fenton

ROYAL ACADEMY OF ARTS

The Royal Academy of Arts would like to record its deep gratitude to John Madejski and to The Monument Trust for their generous donations towards the cost of producing this book

It gives me great pleasure to have been able to support this important new book on the history of the Royal Academy of Arts. James Fenton's *School of Genius* brings to the fore the rich cast of great, and sometimes eccentric, personalities who have shaped the history of an institution that has been at the forefront of the visual arts for over two centuries, and with which I have had an enjoyable relationship over many years.

JOHN MADEJSKI OBE DL

Text copyright © 2006 Salamander Press Ltd

The quotations on pages 252–54 from volume 4 of Virginia Woolf's *Collected Essays*, first published by The Hogarth Press, are reprinted by permission of The Random House Group Ltd. The quotations on pages 252–54 from volume 4 of Virginia Woolf's *Collected Essays* (US edition), copyright © 1950 by Harcourt, Inc., and renewed in 1967 by Leonard Woolf, are reprinted by permission of the publishers.

British Library Cataloguing-in-Publication Data
A catalogue record for this book is available from the British Library

ISBN 1-903973-20-1 (hardback)

Distributed outside the United States and Canada by Thames & Hudson Ltd, London

Distributed in the United States and Canada by Harry N. Abrams, Inc., New York

Royal Academy Publications
David Breuer
Harry Burden
Claire Callow
Carola Krueger
Peter Sawbridge
Nick Tite

Design: Philip Lewis
Picture research: Sara Ayad
Colour origination: DawkinsColour

Printed in Italy by Graphicom

Endpapers
Sydney Smirke RA (1798/99–1877), *Burlington House, Piccadilly: Elevation Showing Proposed Alteration of the South Front*, March 1867 (detail). Pencil and wash, 39 × 45.5 cm. Royal Academy of Arts, London. 05/2111

Pages 2–3
Doors spattered with paint in the Royal Academy Schools

Pages 6–7
Charles West Cope RA (1811–1890), *The Council of the Royal Academy Selecting Pictures for the Exhibition*, 1876 (detail). Oil on canvas, 145.2 × 220.1 cm. Royal Academy of Arts, London. 03/1288

Pages 8–9
John Constable RA (1776–1837), *The Leaping Horse*, 1825 (detail). Oil on canvas, 142 × 187.3 cm. Royal Academy of Arts, London. Given by Mrs Dawkins, 1889. 03/1391

Page 10
John William Waterhouse RA (1849–1917), *A Mermaid*, 1900 (detail). Oil on canvas, 96.5 × 66.6 cm. Royal Academy of Arts, London. Diploma Work, accepted in 1901. 03/805

Pages 12–13
The Cast Corridor in the Royal Academy Schools

Pages 14–15
Visitors to 'Sensation: Young British Artists from the Saatchi Collection' (1997) look at *Dead Dad* by **Ron Mueck** (b. 1958)

Contents

Acknowledgments

While writing this book I have had at my elbow William Sandby's two-volume history of the Royal Academy of 1862; the much abbreviated successor to that work by Sir Walter Lamb (first edition 1935, revised 1951); and Sidney Hutchison's more substantial volume of 1968 (second edition 1986). I can't pretend, however, that any of these official histories has much to attract the general reader.

There is however a wealth of literature I have been able to draw on, including classic works such as Benjamin Robert Haydon's *Autobiography* and J. T. Smith's *Nollekens and His Times*, William Hazlitt's *Conversations of James Northcote, Esq., RA*, Northcote's own life of Sir Joshua Reynolds, John Galt's life of Benjamin West and many more. Among twentieth-century historical works, I have often used the admirable volumes by William T. Whitley, in which the scholar collected anecdotes and information about the early decades of the Academy, passing his material on more or less without comment.

More recent research has however been important, and the reader will see that I am particularly indebted to works by the late Ilaria Bignamini and by Martin Postle on the forerunners of the Academy, and to Postle's works on the history of the artistic model. Dr Holger Hoock was kind enough to give me what he pretended was a spare copy of his outstanding 2000 doctoral thesis, 'The King's Artists'. This admirable work has been since been published. The exhibition 'Art on the Line', and its accompanying catalogue, edited by David Solkin, again focused on the early decades of the Academy, and enabled the public to see the old exhibition space at Somerset House fitted out as it was when the Academy's Exhibitions were held there. And I should like to mention Ian McIntyre's biography of Sir Joshua Reynolds, which came out in 2003. Sir Michael Levey's monograph on Sir Thomas Lawrence regrettably appeared only as this book was going to press.

I am grateful to Malcolm Baker, Lucy Capes, Hugo Chapman, Martin Clayton, Kelley Helmstuttler di Dio, Richard Dorment, David and Susan Ekserdjian, John Forster, Peter Fotheringham, Sir Christopher Frayling, Burton Fredericksen, Frederick Gore RA, Ketty Gottardo, Richard Hamilton, Sir Howard Hodgkin, David Jaffé, Martin Kemp, Fiona Maddocks, Penelope Marcus, Jonathan Nelson, Nicholas Penny, Tom Phillips RA, Elizabeth Robertson, Jaco Rutgers, Joseph Rykwert, Charles Saumarez Smith, David Scrase and Greg Sullivan, Jon and Linda Whiteley, Tim Wilson and many others in and around the Ashmolean and the National Gallery. The staff of the Western Art Library in Oxford have always been kind and helpful. This book was completed during a visiting professorship at the Warburg Institute in Hamburg. My thanks to everyone there, and especially to Marianne Pieper who took care of me, and to Henning Ritter who was behind my being invited to Hamburg.

My chief debt, however, is to the staff of the Royal Academy: to MaryAnne Stevens, Norman Rosenthal, to the patient luminaries of the Publications Department, but most of all to Nicholas Savage, Librarian, and to Mark Pomeroy, Archivist. The reader of these pages will soon realise what particular value I set upon their work in preserving the heritage of the Academy, which this book is designed to celebrate, and can easily imagine how much I relied on their help.

The Academicians themselves kept their part of the bargain, which was that I was to be allowed unrestricted access to their records, and that, though they would be given an opportunity to comment on my manuscript, I would be free to express my conclusions as seemed right to me. My thanks to two Presidents – Professor Phillip King and Sir Nicholas Grimshaw – for that forbearance and good faith.

Introduction

The purpose of this book is to provide the general reader, and the visitor to Burlington House, with a good idea of what the Royal Academy of Arts is, where it came from and how it has changed and developed over the years. It is not intended to serve as an official history. The Royal Academy commissioned the work from me because it wanted an outsider's unofficial view. It wanted in part to draw attention to its own remarkable collections – painting, sculptures and drawings, as well as the library and archive – and to the building which houses London's most elegant exhibition space.

One may visit this building for some immediate purpose – to see a Van Dyck show, or to experience African or Aztec art – and be too busy to be curious about the Academy itself. Alternatively, one may be puzzled or intrigued by the evidence that one is passing through what was once a fine aristocratic town house. There are paintings and sculptures on display from the Academy's collection, including the only Michelangelo marble in Britain. There are the annual Summer Exhibitions, which continue a tradition stretching back to the eighteenth century. Somewhere in the building there are the Royal Academy Schools, still training artists, as the founders intended, although not necessarily, of course, in the way that they envisaged.

The Royal Academy began its life in a former auction house, and it very nearly ended up, at one point in the last century, as a branch of Sotheby's, when a proposal was mooted to hand Burlington House over to the auction house, retaining it only for the purposes of the Summer Exhibitions. The Academy has been located successively in Pall Mall, in the old palace of Somerset House and in 'New' Somerset House, today the home of the Courtauld Institute of Art. For a while it shared premises with the National Gallery on the north side of Trafalgar Square. Finally – at least one hopes finally – it came to rest in another prime position, on the north side of Piccadilly.

Sometimes, when it has been passing through one of its periodic crises, stern voices have been raised to say that the time has come for the Academy to vacate its grand premises and head for the suburbs – or worse (for the institution has made its share of enemies), to take the proverbial long walk off a short cliff. One only has to read the files from the period in which the Academy made its regrettable move to sell the Leonardo Cartoon to see how widespread was the dislike of the Academicians, both among the politicians of the day and, unmistakably and much more worryingly, among artists and serious critics.

Here is a letter from Herbert Read, the poet, literary critic and writer on modern art, to the editor of *The Times* in June 1962:

Critical Mass by **Antony Gormley** RA (b. 1950) in the Annenberg Courtyard during the 1998 Summer Exhibition

Sir,
You today chide the people of this country for their sluggishness in responding to the appeal for £800,000 to save the Leonardo Cartoon, but you do not take account of the genuine dilemma that is perhaps mainly responsible for this state of affairs.

No one disputes the right of the owners, the Royal Academy, to sell what is their property, but £800,000 is a blackmail price, determined by extraneous circumstances (the willingness of rich American institutions to pay this price or even more for something they do not possess and cannot hope otherwise to possess). Many of us see this great sum being used to perpetuate an institution that over the past century has shown itself a re-actionary force in the arts – it is surely significant that none of our great contemporary artists such as Henry Moore, Barbara Hepworth, Ben Nicholson and Graham Sutherland belongs to it.

If the people of this country were to be asked to subscribe to a fund that would support the Leonardos of the future they might respond more generously. I should like to suggest that the sum of £800,000 be divided between the Royal Academy and certain other institutions that cater for the interests of the unacademic artist. Then I for one should subscribe.
Yours faithfully,
Herbert Read[1]

The cartoon was sold, the nation intervened (but only just in time) and the Leonardo made its way back down to Trafalgar Square to the National Gallery. At the time, the outraged line in the press was that the Academy was holding the nation to ransom, while an indignant Academy maintained that it was behaving entirely responsibly by providing for its independent future as a private institution.

Moving *Newton after Blake* by **Sir Eduardo Paolozzi RA** (1924–2005) for display in the 1995 Summer Exhibition

Michelangelo Buonarroti (1475–1564), *The Virgin and Child with the Infant St John*, the 'Taddei Tondo', *c.* 1504–05. Marble relief, diameter 106.8 cm. Royal Academy of Arts, London. Bequeathed by Sir George Beaumont, 1830. 03/1774

It was merely setting up an endowment fund. The cartoon had been offered to the nation first, at a knockdown price. And so on.

Behind these public and private arguments there was confusion and uncertainty about what the Academy actually was. On the whole, if words have any meaning at all, one would have thought it was true to say that the Royal Academy is one of our great national institutions, and one of the major public spaces devoted to the arts that London has to offer, along with the British Museum, the National Gallery, the Victoria and Albert Museum, and the assorted Tates. But at the time it sold the Leonardo,

the Academy was right to say that it was a self-financing organisation, run by and for its member artists, and offering free education in its Schools.[2]

Today that is no longer true. The sale of the Leonardo did not succeed in preserving the *status quo* for very long. In 1976, a decision was made to charge fees for students in receipt of a government grant, while reserving only six free places a year. The loan exhibitions, while they are funded from the Academy's own resources and must pay their way, are covered by the government's indemnity scheme. This means that, instead of having to insure the immensely valuable works of art loaned to these

shows, the Academy receives the benefit of a government guarantee that, were a masterpiece to be damaged or stolen, the Treasury would pay compensation to its owner. The upshot of this is that institutions covered by government indemnity enjoy free insurance for their exhibitions. Great national galleries, such as the Prado in Madrid, which receive other kinds of state benefits, and in generous measure, nevertheless cast longing eyes at the British system of government indemnity. No money changes hands, and millions of pounds are saved. Without the indemnity system, much of our cultural life would grind to a halt. Certainly the Royal Academy could not function in the way it does today. Nor could the National Gallery.

The irascible old men at Burlington House who felt so abused and misunderstood after they had sold the Leonardo made it a mark of honour to say that, nevertheless, if it came to the point when they had to sell the Michelangelo tondo, *in order to protect the independence of the Academy*, they would not hesitate to do so. But this talk about independence rang hollow at a time when the Academy was seen as a manifestation of the Establishment at its most absurd, and would have surprised the Academy's founders in 1768, who knew very well that to solicit royal patronage and to maintain independence were two very different things.

William Hogarth's academy, one of the forerunners of the Royal Academy, was indeed an independent body, financed and governed by its artist members and by them alone. And Hogarth looked with great disfavour on the idea of a formally established state academy along French lines; he would have been unlikely to join the founders of the Royal Academy, had he lived long enough.

What royal patronage meant, to the founders of the Royal Academy, was not only the tangible privilege of being the exclusive holders of the title (with all the advantages that held out, in terms of securing patronage), but also the financial assurance given by George III that, if the income from the exhibitions did not cover the expenses of the Schools, he himself would make good the difference. That financial undertaking in turn made the position of Treasurer of central importance within the Academy: the Treasurer was the representative of the King, and had the monarch's direct interests at heart.

William T. Whitley, writing in 1928, puts the matter rather forcefully:

> . . . to the King it was important that his representative should have power in the Academy, as he was providing from his private purse the money that founded, and for a time supported, the institution. This gave him control over its private affairs that has descended in turn to each of his successors and has never been relaxed. The position of the reigning sovereign in this connection is that of a man who holds the predominant interest in a firm founded by his ancestor in 1768. He is a sleeping partner in the Academy and one who draws no profits from it, but his power is none the less existent. Its most important business is submitted for approval to the sovereign, and it is notorious that in our own times the hanging of pictures in the summer exhibition has been affected by Royal commands.[3]

Whitley's expression 'a firm founded by his ancestor' reminds us that the founders of the Academy envisaged a commercially viable organisation that would serve the business interests of contemporary artists. This was long before the rise of the art-dealer, and the exhibitions gave the artists involved a unique opportunity to show their best work in public. Recently, when the Academy, to fill a gap in its exhibitions programme, invited the leading dealers of London to mount their own joint show in the Main Galleries, I was surprised to see one of the Academicians object that this constituted an improper commercialisation of the institution. It seemed to me, on the contrary, to be very much in the eighteenth-century spirit of the thing.

What could never have been expected to balance indefinitely was the eighteenth-century equation that the Schools should be funded by the holding of an annual exhibition, with a possible surplus for charitable purposes. What has survived remarkably well, though, is the spirit of that mix *as developed over the years*. The Academy remains an exhibiting society,

Agostino Carlini RA (*c.* 1718–1790), *Model for an Equestrian Statue of King George III*, 1769. Gilded plaster with metal and string bridle, 87.6 × 38.1 cm. Royal Academy of Arts, London. Given by the artist, 1781. 03/1684

The older the teaching aids, the greater the likelihood that they would have been used by some of the greatest artists who studied at the Academy. Blake tells us:

> I was once looking over the Prints from Rafael & Michelangelo in the Library of the Royal Academy. [The first Keeper, George] Moser came to me & said: 'You should not Study these old Hard, Stiff & Dry, Unfinish'd Works of Art – Stay a little & I will shew you what you should Study.' He then went & took down Le Brun's & Rubens's Galleries. How I did secretly Rage! . . . I said to Moser, 'These things that you call Finish'd are not Even Begun; how can they then be Finish'd? The Man that does not know The Beginning never can know the End of Art.'[6]

And here is Richard Wilson, the great landscape artist, who was the Academy's Librarian, trying to keep order, at a time when the students included Thomas Rowlandson, the future caricaturist:

> The Librarian's voice was no less gruff than his manner. Wilson, hobbling round the library table and suddenly stopping, 'What are you about, Sir? What are you doing?'
>
> 'I am sketching, Sir.' 'Sketching! Take your hands off the book, boy.' 'And what are you about?' (addressing another). 'Drawing from this print.' 'Drawing! Don't paw the leaves, Sirrah. You'll spoil the book. What – have you got eyes in your fingers, boy?'[7]

And it is still possible to detect, among the architectural books that the Academy library had acquired by 1802, with its 'eclectic range and strong theoretical slant', the 'strong, guiding critical spirit of discrimination' of Sir William Chambers.[8]

Eventually it was pointed out (by, among others, the architectural historian Joseph Rykwert) that if the best things in its library were sold off, the Academy would find it difficult, in the long run, to attract funding for whatever it had in mind for the library's improvement. If you dismantle a thing in order to defend it, in the end you will have nothing left to defend.

A copy of Raphael's *Peter and Barnabas at Lystra*, painted in *c.* 1729–31 by **Sir James Thornhill** (1675–1734), is unrolled in the Royal Academy Schools prior to conservation

I quote Rykwert's letter at length because it represents a fresh spirit in the argument, and to come upon such a document in the archives is to feel some renewed hope:

20 January 1977
'Libraries are the repository of collective inherited knowledge, history is contained in libraries; to destroy books or to tamper with libraries is to tamper with history, indeed to tamper with knowledge. . .'

This quotation came in a Cambridge student's thesis which I happen to be reading at the same time as the list of books which the RA library is offering for sale. Whatever reservations I might have about the thesis, this is an opinion which I endorse wholly. The library is – apart from its collection – the RA's most essential possession. In some cases (the collections of engravings) the two heritages overlap. Their dispersal would be a blow to the cause of the arts in this country generally, and to the Academy in particular. It would be . . . tragic at the very moment when the younger generation of artists and architects has a renewed, lively interest in history.

It has an attendant disadvantage, judged by the standards of pure expediency. Every sale reduces the appeal of the Academy to possible sponsors. Its library is unique in being a memento of the sort of books which artists collected and used over the last two centuries. It is, in spite of previous inroads, still an inestimable working collection. While a certain amount of sagacious culling is always possible and sometimes necessary, the RA library is not crowded with duplicate copies. I would therefore oppose the sale of any books except those where the duplication really is glaring. In any case, the library needs to acquire new books, and all its sales should be retained within its book budget.

I therefore suggest three classes:
A you might as well shut up shop
B not on any account
C if you have three or four copies, in the last resort.

Joseph Rykwert[9]

If the sellers-off failed to be converted overnight, they must nevertheless have begun to notice that there were people in the outside world who saw that there was a value in the ensemble, as it had survived; that the archives, the library and the collection of Diploma Works in painting and sculpture had a meaning when taken together that might prove, in the long run, more of an asset than Bond Street was offering for any individual pieces. But it seems to have been a damned close-run thing.

The turning point came, for the Academy as a whole as well as for its collections, some time around the presidencies of Sir Thomas Monnington (1966–76) and Sir Hugh Casson (1976–84). One begins to see clear signs in the correspondence that these presidents thought it a good idea to mend bridges rather than hurl insults from the bastions. A generation before, when the Academy had failed to ride to the aid of the sculptor Jacob Epstein, Walter Richard Sickert resigned in the following terms:

Sir Thomas Monnington PRA (1902–1976), President from 1966 to 1976

May 19. '35
My very dear Llewellyn
Ahimé!

You have seen my letter on Epstein in the D.T. [*Daily Telegraph*] and will understand that I have no choice but to hand in to you my resignation of membership of the R.A.

If the R.A. cannot throw its shield over a great sculptor, what is the Royal Academy for?

No one knows better than you the regret that I feel in differing from a body of lifelong and very dear friends.
Affectionately yours,
Richard Sickert[10]

Bitter feelings were long held about this row. Nevertheless, fifty years later, even the several letters that have been preserved from artists turning down the offer of membership, in their circumlocutions and their unwillingness to wound, show that, while the luminaries who had been approached still thought the Academy a lost cause, they did not want to make a song and dance about it.

Here are some examples:

20 Nov. 1984
Dear Roger de Grey,
I'm sorry to say I can't let you put my name forward, as you suggest. Thank you very much for asking me, all the same, and for the nice things you say in your letter: I appreciate, and shall not forget, your kindness.
Yours sincerely,
John Piper[11]

26/10/85
Dear Roger de Grey
Thank you very much for offering to make me an Academician but I am afraid I must *refuse*. I belong to nothing and feel I am too old to start now but thank you very much for the suggestion. With all very best wishes
Yours very sincerely
Francis Bacon[12]

10th June, 1986
Dear Roger,
Thank you for your letter of May 27th. When I was telephoned shortly after my return from

Letter of resignation from Walter Richard Sickert RA, 19 May 1935

Francis Bacon's letter refusing membership, 26 October 1985

New York and told that I had been elected a member of the Royal Academy, I was astonished.

When in the past I have been informally approached and asked the question, 'Would I like to become a member?', I have always said no. And after thinking about it again at length, I am afraid I must still say no.

Naturally I was pleased and touched to have been asked.

Yours,
Howard [Hodgkin][13]

And here is an extract from a letter of Richard Hamilton to Sir Hugh Casson, from the same period, 1985 (in which there seems to have been a recurrent problem over whether to approach artists for their consent before electing them):

I am embarrassed. It's a great shock and I suspect it is just a mistake on Kitaj's part, perhaps he was over-enthusiastic or maybe he just didn't know the form. It seems likely to me that the normal procedure would be to first ask another artist if he wished to be nominated . . . If [Kitaj] had I would have let him know that, now as always, I have no wish to become a member of the Royal Academy.

Of course I appreciate all the good things [done] by the Academy during your term. When I remember the abysmal state things were in when Munnings was President and I was a student there my flesh creeps. But even so I think back on the time I spent in the Schools with fond nostalgia. The perspective lectures given by the great Walter Bayes have lasted me a lifetime. Sir Walter Russell was a wonderful Keeper. Even the thought of those red fire buckets bearing the Royal crest, filled with mustard-coloured sand from which the odd du Maurier fag end protruded, brings a tear to my old eyes – come to think of it they are getting a bit rheumy. I have been to the odd special exhibition in the last decade and admired the shows. It's just that there doesn't appear to be any point in my joining the club, though there is good reason to continue to enjoy the comforting feeling of being outside it.

But I do miss you.
Love,
Richard[14]

Passing this on to Roger de Grey, Casson writes 'Ah well!', an expression they must both of them

Leonard Rosoman RA (b. 1913), *Sir Hugh Casson in the Print Room at Burlington House*, 1992.
Watercolour and pencil on paper, 80 × 112 cm. Royal Academy of Arts, London. 04/2397

often have used. For the fact remains that, although it did now begin to attract important figures to join, the Academy had alienated a whole generation of leading artists, and some of its insults were not easily forgiven or forgotten.

But the spirit began to change. Monnington had obviously wanted that. Asked in an interview why it was that several English artists from the representational tradition (Francis Bacon, Claude Rogers and Frank Auerbach are the names mentioned) were not members of the Academy and did not show at its exhibitions, Monnington says diplomatically:

> One reason why artists don't allow themselves to be put forward as members is that no painters want to commit themselves to any loss of independence or to feel in any way tied to what may appear a conventional attitude. The painters'

very function is to be free and you cannot escape the fact that belonging to any academy suggests a certain surrender of freedom. You will be aware that many of the artists you are thinking of choose not to belong to any society at all.[15]

That is indeed what artists were in the habit of saying. The irony of the situation was that the Academy was staunchly defending its independence – and so were the artists.

With Casson's correspondence, the embarrassment begins to wear off, and one sees an extraordinarily energetic figure at work. He was a born courtier, always dashing off little notes, embellished with endearing caricatures of himself, to members of the royal family, keeping them involved and amused. He illustrated a book for the Prince of Wales.[16] He was quintessentially one of the great and the good, serving on committees, espousing good causes,

Sir Hugh Casson PRA (1910–1999), 'Trailers' and 'The Mobile House' from *Homes by the Million: An Account of the Housing Methods of the USA, 1940–1945*, Penguin, London, 1946

turning up at events – *eventing*, one might say, like some energetic social pony.

I have sometimes thought, on reading through this part of the archive, that it was no coincidence that Casson was an architect, for architects are obliged to work with people, to get on with them, to get out and about in the world. But then, Richardson, too, had been an architect, and he believed in doing without electricity and living as if George III were still on the throne.

Casson was an architect, and he was also, or had been, a modernist. I have a booklet by him in front of me, dated 1946, called *Homes by the Million*, telling in relentlessly upbeat style, in the manner of wartime propaganda, how eight million Americans were re-housed within four years, using trailer parks, dormitories and 'demountables'. He had thought about this kind of cheap mass housing, and he had also designed comfortable interiors for the royal yacht *Britannia*: he had a certain range of interests, and I was not entirely surprised to learn from Joseph Rykwert that it was Casson who put him up to writing the letter quoted on page 25, in defence of the Academy's library.

The battle that the dimmer of the presidents had been fighting was against the avant-garde. But the art that was being exhibited at the Academy always stood in some relation of indebtedness to the avant-garde, although there might be something of a time lag. How many Academy careers were made on the basis of ideas originally put forward by Cézanne or Matisse?

Welcoming the election of Monnington, Robert Melville, the art critic of the *New Statesman* and devotee of the arch-recusant Henry Moore, wrote in 1967:

'The critics will slate it as usual,' said Mr Noakes, who went round the RA Summer Exhibition for *Town and Around*; but no one really wants to slate it any more. It's now paying too heavy a price for that seemingly inexhaustible succession of old men who year after year made their arrogant, stupid and dreary jokes about Picasso and modern art at the Annual Banquet. It has at last elected a President who doesn't make jokes about modern art, and one would like to think that it's a sign that the Academy is recovering some shreds of dignity. But the President paints pictures which disclose a very belated and very confused interest in the art of Mondrian. Their only virtue (shared by too few of the exhibits) is that they are neatly done. It's not pleasant to see the members of an institution with a great past reduced to scavenging. . .[17]

OVERLEAF
The installation of 'Sensation: Young British Artists from the Saatchi Collection' (1997)

The installation of 'A New Spirit in Painting' (1981)

Sir Charles Wheeler, the president who protested against the Arts Council mounting a Giacometti show, was not an academic sculptor in some eighteenth- or nineteenth-century sense. He was a floundering and timid *pasticheur* of strong and original artists such as Epstein and Eric Gill. His best work is decorative: the Zimbabwe bird that perches on the dome of Rhodes House in Oxford, or the gilded bronze springbok leaping from the corner of South Africa House in Trafalgar Square (for which he also made the fountains). But we do not turn to him, as we would turn to Gill, for great design. And there is nothing in his work that remotely constitutes a criticism, by counter-example, of Giacometti.

Such things are easier to say, unpleasant though they may be, at a cool distance, and they are easier to say when the relationship of the Academy to the avant-garde has long changed. Whatever the critics may have thought about such exhibitions as 'A New Spirit in Painting' (1981) or 'Sensation: Young British

Artists from the Saatchi Collection' (1997), the fact was that the controversy was being hosted by the Academy rather than held at arm's length.

How strange it is that the notorious exhibits from the latter show went for a while to a new private setting, the Saatchi Gallery, in a building that was purposely designed to house the local government of London, while the international collections of the Tate are in a power station, and the Courtauld collection (as mentioned already) occupies the rooms of the old Academy. Nothing in London's disposition of galleries, museums and collections makes sense when viewed as an overall design. Things only make sense – to the extent that they make sense at all – when viewed in historical terms, as the result of long and complex processes.

That is to say, London was not laid out in a single campaign by some planning genius of a monarch or dictator. If the oil paintings of the old masters are in the National Gallery, while the drawings are in the British Museum, and watercolours – and many

The installation of 'Van Dyck 1599–1641' (1999)

The installation of 'Aztecs' (2003)

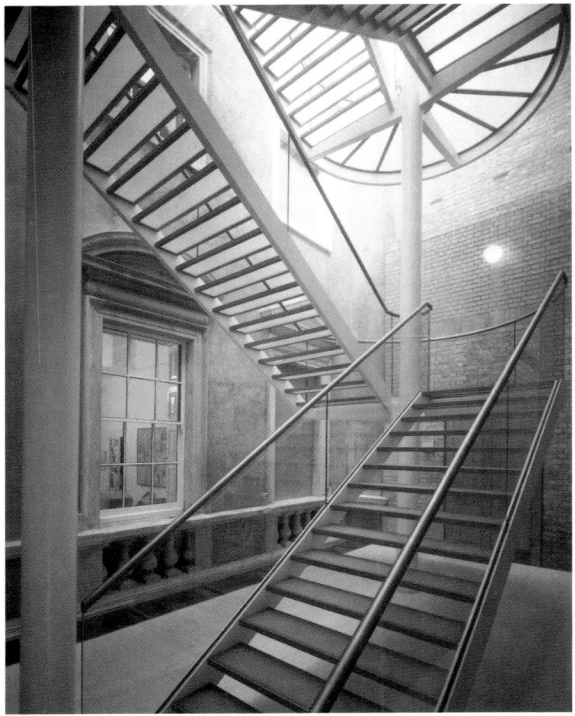

The glass staircase to the Sackler Wing

galleries are outstanding. It follows that one outstanding contribution the Academy can make to the cultural life of London is the mounting of remarkable exhibitions throughout the year.

As it happens, the Academy has also managed to create in its Jillian and Arthur M. Sackler Wing of Galleries a suite of rooms for smaller shows, and it has just taken over a large adjacent building, 6 Burlington Gardens, formerly occupied by the British Museum's ethnographic collection. In the nature of things, it was rather against the odds that an often cash-strapped institution should be able to acquire such important new premises in the heart of one of the most up-market commercial districts in the world. The Academy has been very lucky in this respect and it will be interesting to see how it builds on its good fortune.

The most important point is that the Academy has recovered a sense of the value of what it possesses, and that it can pursue those activities which it is uniquely fitted to pursue; that it should remain a society dedicated to the promotion of contemporary art, and of art in general. How it achieves this in the future is a matter for constant reinterpretation.

drawings, to be sure – are in the Victoria and Albert Museum, if one would do well to look for the French eighteenth century in the Wallace Collection, and the Impressionists in the Courtauld – if in short it takes some patience to work out where everything can be found, that is the sort of city London is. And the Royal Academy resembles London in that some of its assets, and some of its functions, have been acquired more by historical accident than by design.

The collections I have already referred to. The greatest functioning asset is the suite of top-lit galleries in which the main exhibitions are held. These were built and paid for by the Royal Academy when it moved to Burlington House in 1868. Nowhere else in London can match them for the accommodation of temporary exhibitions; whether for the display of old master paintings at their grandest, such as the Van Dyck show already mentioned, or for showing imposing Aztec sculpture, or indeed – for those who remember an experiment which in its day raised some eyebrows – for the pioneering laser exhibition 'Light Fantastic' (1976), the Academy's

The Jillian and Arthur M. Sackler Wing of Galleries, designed by Foster Associates, 1991

1 What Academies Did and Were

'The Academy, a little pingle or plot of ground, was the habitation of Plato,'[1] says an early source, and that is where the great, enduring idea of an academy begins: in a little pingle (a paddock or copse), a garden, a park, a scholar's villa or the private apartment of a prince, somewhere for like-minded persons to meet and debate. The name came from a district in the northwest of Athens, a garden where Plato taught, and the idea of an academy spread and fed off the philosopher's prestige. 'Navarre shall be the wonder of the world,' says the King in *Love's Labour's Lost*; 'Our court shall be a little academe, / Still and contemplative in living art.'[2]

And indeed there was a King of France, Henri III, predecessor of Henry of Navarre, who had his own palace academy, in a windowless room lit only by candles, to which he would retire every day after dinner, with poets and scholars and men and women of the court. The poets, Pierre de Ronsard among them, would make speeches in favour of the virtues, and it was up to the others to reply to what had been said. The king so loved this academy, this school of rhetoric, that he drove his mother, Marie de Médicis, to distress, and his critics accused him of practising grammatical exercises while the country fell into ruin and civil war.[3]

This sort of after-dinner debating group is familiar to readers of Castiglione's *The Book of the Courtier*, in which the court gathers around the Duchess of Urbino (the Duke being largely absent from the picture), and it is interesting that noblewomen as much as men might participate in a renaissance academy. Isabella d'Este had her own academy at Mantua, as did the Duchess of Correggio, Veronica Gambara.[4] Scholars or humanists who emulated Cicero in having a country cottage or villa where they retired to study might be in the habit of calling this refuge an academy, even if no formal debating activities took place there: the word in its early renaissance sense had associations of learned discussion and inquiry, as well as garden, park, cottage or study.

It seems that Leonardo da Vinci, when in Milan, had an academy in the first sense. On 9 February 1498 there took place, in Lodovico Sforza's castle, a 'laudabile e scientifico duello', a praiseworthy and learned debate, involving scholars, theologians, doctors, lawyers and Leonardo himself. The fact that several engravings from this period, mostly illustrating complicated decorative knots, have survived, bearing the inscription 'Academia Leonardi Vin' or some variant, suggests that Leonardo was the leading figure in this and any such debates. What it does not suggest is that Leonardo was running an art academy, eminently equipped though he would have been to do so.[5]

Artists of this period were advancing in education and status. Leonardo had an academy to his name.

Agostino Ciampelli (1578–1640), *Michelangelo's Funeral in San Lorenzo*, 1617 (detail)

An engraving with the inscription 'Academia Leonardi Vin', illustrated in the *Burlington Magazine*, vol. 12, 1907–08

Titian was a member of a Venetian group that included the writer Pietro Aretino and the sculptor Jacopo Sansovino and called itself an academy, apparently a private club. But it is Michelangelo who, at the beginning and end of his career, was most notably associated with artists' academies in something like the modern sense. For he worked as a young man in the sculpture garden of Lorenzo the Magnificent in Florence, under the sculptor Bertoldo di Giovanni; and on his death his funeral arrangements were put in the hands of the newly founded Florentine Academy of Design.

The sculpture garden, which has sometimes mistakenly been dismissed as mythical, was near the monastery of San Marco, and must have been founded some time in the early 1470s. It had a short avenue of cypresses, a loggia, some antique statuary, and various small buildings. It must have been a bit like a garden, a bit like a stonemason's yard and a bit like a school – but a school where members of the ruling élite dropped in to observe the pupils at their studies. Giorgio Vasari calls it an academy, although he does so several decades after Michelangelo worked there; but that does not mean that he is wrong. We

know the names of several artists, Leonardo among them, who spent time in Lorenzo's garden.[6]

Michelangelo's father considered the career of a sculptor no better than that of a stonemason. The artist himself was keen to emphasise the honour with which he had been treated in Lorenzo's household, and happy to edit out of his biography the details of his early apprenticeship as a painter to Domenico Ghirlandaio and, perhaps, to play down his indebtedness as a sculptor to Bertoldo di Giovanni.[7] He wanted to appear in the guise of untutored infant prodigy.

In Ascanio Condivi's *Life* we see the boy working away in the garden, studying ancient sculpture, showing his work daily to Lorenzo and taking advice on literary matters from the humanist Angelo Poliziano, who was tutor to Lorenzo's sons. Also from Condivi, who received his information directly from Michelangelo, we learn of the respect accorded to members of the Medici household in daily life. But we hear nothing of any tuition in art.

It is Vasari who tells us that the aged Bertoldo, once the star pupil of Donatello, was engaged by Lorenzo to create at the garden a school of painters and sculptors (just as it is Vasari who gives us the details of Michelangelo's earlier apprenticeship to Ghirlandaio). The picture that emerges is of a private academy, founded no doubt with some sense of the common civic good but entirely run from within the Medici family household. Young apprentice artists were recruited from the studios of Florence, and paid a varying stipend. The fact that Michelangelo left the garden on the death of Lorenzo in 1492 suggests that the institution (if that is the right word for it) was tied to one man's patronage and that no immediate provision had been made for its continuing after his death. The garden itself was sacked by the enraged Florentine populace after the flight of Piero de' Medici in 1494.

Seventy years later, in February 1564, Michelangelo died in Rome and his body, in accordance with his wishes, was sent to Florence for burial, the coffin enclosed in a specially made leather sleeve. Although the corpse arrived sooner than expected, plans were already in hand. The Florentine Academy of Design, which had been founded a year before, had unanimously elected Michelangelo 'capo, padre

Giovanni Battista Naldini (1537–1591), *Michelangelo in the Garden of San Marco*, undated. Pen and ink on paper, 18.7 × 33.6 cm. Galleria degli Uffizi, Florence, inv. 7286

e maestro di tutti', and the Academy would see to the provision of an imposing funeral service for its most distinguished member.

This was more or less the first big thing, apart from squabbling, that the Academy had done – certainly the first thing that earned it fame. Within two years, a letter of application was to arrive from Venice signed by Veronese, Titian, Tintoretto, Palladio, Giuseppe Salviati and Danese Cataneo. The organisation of Michelangelo's funeral was cited by these distinguished signatories as a reason for the esteem in which the Academy was held.[8]

This may seem surprising: surely the burial of its members is a minor part of an academy's work? The answer is that the new academy was not only conceived as an art school and a place for lectures and debates: it was also, in a revived form, a guild and confraternity. Already the association had a chapel, where they had reburied, with due honour, the painter Pontormo. And the significance of the present occasion can be seen from the Academy's decision that all its members should meet at sunset at the Compagnia dell'Assunta, where Michelangelo's coffin had been secretly brought, and that 'anyone

who failed to appear without valid excuse should be treated as if he had absented himself for six months from the meetings [a punishable offence]'.[9]

So it was that, on the given evening, all the painters, sculptors and architects of Florence assembled stealthily:

> They brought nothing with them except a large velvet drapery, bordered and embroidered with gold, which covered the coffin and the entire bier. A Cross was placed on the coffin. Then, about half an hour after nightfall, as all were crowding around the body, the oldest and most distinguished artists suddenly picked up torches, of which many had been brought, and all the young men took hold of the bier. Happy were those who could get near and shoulder it, thinking of how in times to come they could glory in having carried the remains of the greatest man that had ever existed in their profession.[10]

At once, the news spread that Michelangelo's body was to be carried to Santa Croce. The church filled in an instant, and our eyewitness account conveys the excitement:

As far as solemnity is concerned, it cannot be denied that it is a great sight to see at obsequies a lavish show of priests and candles and large numbers of black-dressed mourners. But I swear to you it was no meaner thing so unexpectedly to see those excellent men who are held in such esteem today and will be even more so in the future – some in the lowly task of holding torches around the body, others carrying it lovingly on their shoulders.[11]

The hands of these excellent men, these academicians, were engaged in a lowly task, paying homage to the genius of the painter, ceremonially conveying his body to the church where his family was buried. And our eyewitness cannot resist pointing out – in the midst of an exciting narrative – that Florence has always been a place where artists have been held in high esteem. Even though theirs might appear to be a manual occupation, 'intellect and talent play a major part in it'. Florence is the main abode of the arts, he says, just as Athens (the home of the original academy) was that of the sciences.

The Vice-President of the Academy, Vincenzo Borghini, represented its President, Cosimo I de'

Agostino Ciampelli (1578–1640), *Michelangelo's Funeral in San Lorenzo*, 1617. Oil on canvas, 152 × 138 cm. Casa Buonarroti, Florence

Medici, Duke of Florence. Partly out of consideration for the wishes of the crowd, and partly to satisfy his own curiosity, Borghini gave orders for the coffin to be opened. Although more than three weeks had passed since Michelangelo's death, there was no sign of putrefaction. Michelangelo was dressed in a black damask gown, boots with spurs and a silk hat trimmed with black velvet. 'When touching his head and his cheeks, which everyone did, they found them to be soft and life-like, as if he had died only a few hours before, and this filled everyone with amazement.'[12]

This was the first interment of Michelangelo. The spectacular obsequies, for which a great catafalque was constructed by young Florentine painters and sculptors, followed in July of the same year, in the Medici church of San Lorenzo. And it is notable that pride of place was given, on this catafalque, to a painting depicting Lorenzo the Magnificent receiving the boy Michelangelo in his sculpture garden. By this means the newly created Academy of Design paid tribute not only to the tradition of Medici patronage but also to its own informal predecessor, Lorenzo's garden 'academy'.

To be a member of the new institution was to be recognised as one of the Duke's men: the officers of the Academy wore special costumes, and, when they were buried, that costume – that evidence of rank – went with them to the grave, and their fellow artists would make great show of parading the Academy's bier around the streets, to impress the populace with the honour accruing to the dead artist. They honoured their own. They even honoured artists who had lived and died in other cities (as Francesco Salviati, Jacopo Sansovino and indeed Michelangelo had). This early academy, like so many it spawned, had a great interest in honour and status.

But it was also (and to a greater extent than has sometimes been allowed) concerned with the teaching of the rudiments and theory of art.[13] It had its own premises, initially in an unfinished building designed by Brunelleschi, later in Michelangelo's (also unfinished) New Sacristy, part of San Lorenzo and a site that was itself a source of education for artists of the time. A couple of drawings by Federico Zuccaro, now in the Louvre, give a very good idea of the kind of sketching session customary at the time.

Attributed to Zenobi Lastricati (1538–1633), *Design for the Catafalque of Michelangelo*, c. 1564.
Pen, bistre, white lead and black wash on prepared paper, 39.6 × 25.3 cm. Biblioteca Ambrosiana, Milan.
F261, inv. no. 67/2, p. 65

Federico Zuccaro (*c.* 1540–1609), *Artists Drawing after Michelangelo in the Medici Chapels*, sixteenth century. Red chalk and charcoal, 200 × 263 cm. Musée du Louvre, Paris, inv. 4554

The Academy taught geometry and mathematics both pure and applied (that is to say, as it related to such useful matters as the design of bridges and fortifications). It taught perspective and shadow-drawing, through whose study Galileo, a member, may have gained insights into the surface of the moon. It held anatomical demonstrations and carefully controlled life classes (the seriousness of such pursuits is underlined by rules that there should be no observers, only participants, at these sessions). It taught figure-drawing and drapery studies, and gave lectures on *Disegno*, the art and philosophy of drawing and design as applied to painting, sculpture and architecture.

Two kinds of artefact derive from this period, and would become familiar throughout the history of academies. One is the sculptural model of the

Federico Zuccaro (*c.* 1540–1609), *Artists Drawing in the New Sacristy of San Lorenzo*, sixteenth century. Red chalk and charcoal, 200 × 263 cm. Musée du Louvre, Paris, inv. 4555

flayed man, conceived in various expressive poses, seemingly oblivious to the fact that he has been skinned. Pietro Francavilla made such models around 1600, to be used in drawing classes. Their advantages over rotting corpses (which were known to have caused sickness and even madness among artists) are obvious. And it is interesting that these anatomical models, which were studied by artist and scientist alike ('natural philosophy', that is science, was part of the academic curriculum), continued for centuries to be studied, long after, in most other respects, the artist and the scientist had parted company.

The second typical product of the pioneering academies was, of course, the 'academy' itself. An academy is a type of drawing immediately recognisable for its concentration on the single nude figure (usually, at first, male) in an exemplary pose. No background is given, and the few props that are shown will be sketched in by the briefest of indications. Sometimes the figure holds a staff, in order to maintain the arm in a raised position, or clings to a strap, like a traveller in a crowded train. Sometimes we see the edge of the posing platform. There may be a headrest for a sleeper, a skimpy drapery serving as a *cache-sexe*, or the model may be shown with a posing pouch. But it often happens that the modesty of the artist, or the in-sistence of the teacher, has edited out the genitalia altogether, along with details of the individual's face. The Council minutes of the nineteenth-century Royal Academy include the following resolution:

> That as a general principle it is desirable that the model in the Life School should be undraped, and that any partial concealment for considerations of decency would rather tend to attract attention to what might otherwise pass unnoticed. It appears to the Council that the particular objection suggested by a needless fidelity sometimes observable in drawings, is a question rather of taste than of morals, and they are therefore of opinion that the objection should be met by recommending and requiring the Visitors to dissuade students from bestowing unnecessary attention on unimportant parts, especially when decency suggests their being passed over.[14]

Many academies must have had some such convention or rule.

The kind of nude study developed in Florence before the days of academies, beginning around 1440, has a quite different, characteristic feel. Sometimes it turns out that what looks like a life study is in fact a drawing from antique sculpture. At others, for instance with the numerous surviving drawings of an attractive minor figure such as Maso Finiguerra, it is hard to tell whether a given nude is a copy from a model book or an original study. But the picture overall is clear: artists drew figures from life, in their own workshops or on the street (the cobbler at his awl, for instance, or a litter-bearer).

Pietro Francavilla (1548–1615), *Arching Ecorché Flayed Male Figure*, *c.* 1580. Bronze, height 42 cm. Jagielonian Library, Krakow, inv. 3917

Maso Finiguerra (1426–1464), *Male Nude Holding a Mace and Shield*, *c.* 1460–70. Pen and brown ink, brown wash and numerous traces of black chalk on paper with holes and abrasions, 37.5 × 20.3 cm. Biblioteca Ambrosiana, Milan. F261, inv. no. 13/3, p. 10

Filippino Lippi (*c.* 1457–1504), *Standing Male Nude Facing Left and Leaning on a Staff*, *c.* 1475–85. Metalpoint heightened with white gouache on grey prepared paper, 27.2 × 8.4 cm. Kupferstich-Kabinett, Staatliche Kunstsammlungen Dresden, c. 21, verso

They posed their assistants, their *garzoni*, nude or clothed, in order to solve some figural problem in an eventual painting, but they did not, initially, study the nude as an end in itself, let alone expect their drawings to attract the attention of connoisseurs or collectors. Nor did they necessarily idealise their figures: some of the life studies of Filippino Lippi depict a perfectly credible, ungainly musculature, a protruding belly, knobbly knees and somewhat haphazard underwear.

Between such practical-minded life studies and the drawings known as academies (which begin

around 1600) lie the enduringly powerful examples of Leonardo, Raphael and Michelangelo. It is to them that we owe the development of the ideal body, the ideal anatomy, and it is to their ideals that the artists of the academies aspire. If we took a sheaf of such drawings, unlabelled and unsigned, all jumbled in period from between 1600 and 1900, and laid them out at random, they would look remarkably similar. In order to distinguish between periods we might consider the type and condition of the paper, the medium and technique of drawing. But the bodies themselves, and their poses, would not vary so

William Mulready RA (1786–1863), *Life Drawing of a Standing Male Nude*, 1863.
Black and white chalk on brown laid paper, 48 × 31.5 cm. Royal Academy of Arts, London.
Bequeathed by Gilbert Bakewell Stretton, 1949. 02/624 recto

greatly until, towards the end of the period, the artists' realism begins to undermine the idealism of the exercise. Once the models begin to come over as individuals, with knobbly knees again, and quirky physiques (as in the student drawings of a Degas or a Seurat), then the days of the academy – the idealist nude study – are numbered.

And around the same time it becomes obvious that there is a crisis in the academies themselves, the institutions. They had begun in city states where it might be natural to expect there to be one academy of art per city, that is one organisation to represent and further the interests of artists, as there had been one guild for cobblers or dyers. They went on to become typical monopolistic institutions under absolute power: the members aspired to monopolise, for instance, all state patronage, all royal commissions, all training of artists, all rewards, while the rulers were interested in monopolising the loyalty and attention of the artists.

But as cities expanded, as the middle class grew in power, as art itself changed, it became impossible to think of one academy representing the interests of all artists: there were too many different kinds of artist. The academies had wanted to be teacher, dealer, power-broker, freemasonry, club. Suddenly this was no longer possible. Other art schools grew up. Other kinds of gallery were opened, offering a different kind of dealership.

The academies declined in power, and their authority, such as it had ever been, to dictate terms, to set standards, to say 'Whatever is done must be done in such and such a way', evaporated. And eventually it became possible for a young artist in England to ask himself, to ask *herself*, whether, say, London was the best place to study, or whether Paris or Brussels might not be better suited to her needs. Simply to be able to ask this kind of question implies that one aspect of the old academies had gone, even if it happens still to be the case, as it was in London, that the Royal Academy was to all appearances an august and flourishing institution. In his history,

Sidney Hutchison, the Royal Academy's Librarian and later its Secretary, calls the period from 1878/9 to 1896, under Frederic Leighton's presidency, 'the palmy days'. But it was precisely in these years that the new institutions completed a development that made the Academy, in some senses, redundant. (Leighton himself had studied in many European cities, but not, as it happens, at the Royal Academy.)

There was nothing peculiar to London in this development. It affected every city that boasted an academy. It caused crises and ructions, secessions, rebellions, schisms and scandals wherever artists worked and met. It became manifest and blatant in the mid-twentieth century, and there were times when the Royal Academy seemed doomed to face closure.

And yet when, towards the end of that century, a conference was held in Madrid to compare the various surviving academies of art, and when each representative of these institutions stood up and gave an account of what his or her academy was (what it did, what it possessed, how it was constituted and so forth), it became clear – and it was a matter of wonderment to those present – that the Royal Academy retained more of its original characteristics than any comparable institution. That is, it remained a private organisation of artists under royal patronage; it was an exhibiting society, holding an annual summer show; it retained its schools, its teaching collections, its library, its premises.

It had done so by adding to the original remit and becoming not only an exhibiting society in the old sense but the pre-eminent venue for art exhibitions in general. Yet it is remarkable that, for instance, unlike the nearest comparable academy, that of Sweden, it has not lost its art school. Astonishingly, as we shall see, many of the original teaching aids have survived. Indeed, the most significant loss to the Academy's collections, the Leonardo Cartoon, remains nearby at the National Gallery, having been bought for the nation. The Academy has changed, to be sure. But the degree of its survival is in some ways as remarkable as its change.

Edgar Degas (1834–1917), *Study of a Standing Nude Young Girl, with a Separate Study of Her Head and Arm*, probably 1858 (retrospectively misdated 'Florence 1857' by the artist). Pencil on pale blue paper, 31.8 × 22 cm. Jean-Luc Baroni, London

2 England before the Royal Academy

Academies of art were a feature of late sixteenth- and seventeenth-century Europe – Florence in 1563, Rome in 1593, Milan in 1620 and Paris in 1648. One might expect that in Britain such an institution would have been founded, at the very least, at around the time of the Restoration, around the time of the Royal Society, when projects of this kind were so much in the air. The fact that we had to wait until 1768 for a fully established art academy is profoundly indicative of the state of development of the arts in this country. Our leading artists tended to be imported from Europe, and it is in their circles that one might look to find *cognoscenti*, *virtuosi*, *connoisseurs*, that is experts on art – the imported words suggestive of an imported phenomenon.

Anthony van Dyck arrived in England in the spring of 1632 and soon afterwards was knighted as 'principalle Paynter in ordinary to their Majesties'. His large riverside house in Blackfriars is said to have been hospitable to the 'Whitehall group' of *cognoscenti*. George Vertue, a source for much of the information about this period, tells us:

> 'Tis said Sr. Anthony Vandyk appointed one evening of the week in Winter Time for the Virtuosi of London in the several branches of Painting, Sculpture &c. & Lovers of Art to meet at his house. he entertaining them in Generous manner. Chiefly on the festival yearly of St Luke. till his death. [in 1641] put an end to it.[1]

William Hogarth (1697–1764), *A Midnight Modern Conversation*, c. 1732 (detail)

Ilaria Bignamini, who studied the forerunners of the Royal Academy, suggested that these annual meetings could hardly have constituted a real club with a real purpose, but were more likely a little court that formed around the great artist. The choice of St Luke's Day, 18 October, honours the patron saint of painters. After the Restoration, Sir Peter Lely, in imitation of Van Dyck, held similar meetings at his house, and it is this tradition that was formalised when, in 1689, the 'Virtuosi of St Luke'

Sir Anthony van Dyck (1599–1641), *Self-portrait*, c. 1630 (detail). Etching, 24.9 × 15.9 cm. British Museum, London. Bequeathed by Felix Slade. PD 1868-8-22-806

Gawen Hamilton (c. 1697–1737), *A Conversation of Virtuosis … at the King's Armes (A Club of Artists)*, 1735. Oil on canvas, 87.6 × 111.5 cm. National Portrait Gallery, London. NPG 1384

began their regular meetings. There were sixteen members at first, of whom about half were artists, the rest lovers of art.

They met in various London taverns, and a part of the intention of such meetings was simply to enjoy a feast. The cost of membership was high, however, and this might have been because the club purchased paintings, which were then raffled among the members. They ate Westphalian ham. They drank. They viewed works of art and discussed questions of connoisseurship and collecting. They seem to have liked architectural compositions, and wild landscapes by or in the manner of Salvator Rosa.

Some members of the club took the initiative of publishing a book, the first English edition of the treatise *De Arte Graphica* by Charles Alphonse Du Fresnoy, translated by John Dryden (1695). In doing so, it seems that the Virtuosi saw themselves as campaigning for an academy to be established, as a means of nurturing an English school in the arts. Around the same time (1697–98) Narcissus Luttrell recorded that William III was 'resolved to settle an academy to encourage the art of painting, where are to be 12 masters, and all persons that please may come and practise gratis'.[2]

This academy of painting, had it been founded, would very likely have been an attempt to introduce a classical taste into portraiture and other genres. But Bignamini suggests that this would have involved the setting up of a dictatorship of taste

William Hogarth (1697–1764), *A Midnight Modern Conversation, c.* 1732.
Engraving, 35 × 47 cm. Royal Academy of Arts, London

according to the ideas of the Earl of Shaftesbury, which would have been opposed by powerful artists such as Sir Godfrey Kneller, Principal Painter to the King. If the new academy had been set up along French lines, it probably would indeed have aspired to such a dictatorship, monopolising the teaching of artists, the life classes, and the royal commissions available. In the event neither William III nor Queen Anne took the necessary steps. Shaftesbury pointed out, in his *Letter Concerning the Art, or Science of Design*:

> As for other Academys, such as those for Painting, Sculpture, or Architecture, we have not so much heard of the Proposal; whilst the Prince of our rival Nation, raises Academys, breeds Youth, and sends rewards and pensions into foreign Countrys, to advantage the interest and credit of his own.[3]

None of these worthy activities were yet receiving royal patronage. Instead, at the private level, painters and connoisseurs were meeting for informal festivities, to examine drawings and engravings together, and to raffle paintings. One example of such a raffled work of art is Gawen Hamilton's *A Conversation of Virtuosis . . . at the King's Armes (A Club of Artists)* which was 'raffled for on 15 April. 1735, and won by Mr Goupee – 40. highest Number. Thrown'. Joseph Goupy, the winner, is among the artists depicted (sixth from the left). He was a miniature painter and copyist.

Another such association (this was an age of clubs, and artists were not unique in forming such groups) was the Rose and Crown Club, founded around 1704. It met routinely on Saturdays. Vertue notes a meeting in the 1720s:

At the Harpsichord Lubec a Playing a piece of musick of Mr. Trusty's composing & other proper ornaments about the room as the Prints the Pinecothoca, etc. Punch bowl on the table bottles of wine pipes glasses Tankard ect.[4]

The kit tells one everything: that there was music, smoking and above all drinking; that prints would have been handed round for examination; and that there was a *pinacoteca*, a special exhibition of paintings, mounted somewhere in the room. Various conversation pieces of the period have been associated with the Rosa Coronians, as the members of the club were known, and several of the club members painted each other, a fact which is taken as evidence for an increasing self-confidence and self-assertiveness among artists as a profession.

The conversation piece itself, the kind of painting in which 'small figures from the life in their habits and dress of the Times' are shown in 'gracefull and natural easy actions suteable to the characters of the persons and their portraitures'[5] is said by Bignamini to have its origin in this painterly milieu of the 1730s. English artists derived their version of this genre from Flemish and Dutch painting, and from no less a figure than Watteau, who visited London in 1719–20 (partly in order to consult the renowned physician Dr Richard Mead) and was a Rosa Coronian.

The other now celebrated member of the club was William Hogarth, whose *A Midnight Modern Conversation* gives a strong sense of the direction in which such sessions often headed. The punchbowl is prominent. Wigs are coming adrift, and the company is beginning to dissolve into a stupor of nicotine and alcohol. But before leglessness prevailed, there was no doubt much consequential discussion. The circulation of prints, for instance, was of interest to the artists of the period because prints offered a promising source of revenue, as Hogarth's career illustrates. Among the Rosa Coronians, in addition to painters such as Marcellus Laroon, John Smibert, Gawen Hamilton and Sir James Thornhill, there were architects (Thornhill himself, James Gibbs) and sculptors (John Rysbrack, Peter Scheemakers) and numerous engravers and printsellers, including George Vertue.

Many of the artists involved with both the Virtuosi of St Luke and the Rose and Crown Club specialised in portraits and conversation pieces, neither of which required (or at least received the benefit of) the kind of anatomical study and classical instruction that an academy would offer. Evidence of the latter kind of training in seventeenth-century England is patchy. It is not true, as some works have suggested, that John Evelyn produced a plan for an art academy in 1662. This is exactly the sort of scheme one might have expected from Evelyn, but the evidence is based on a misreading of sources, as Bignamini has shown.[6]

She herself gives the honours to Sir Peter Lely, who supervised drawing from the life around 1673 in an academy set up next to his studio in the northeast corner of Covent Garden piazza. Remaining work from this period shows that members of this academy had the opportunity to draw from the male and perhaps female model, as well as to copy from drawings or engravings.[7] Lely was a great collector of drawings, and would have been better equipped to run such a private institution than any other artist of his day.

Kneller succeeded Lely as pre-eminent artist, earning a 'princely income' and maintaining a townhouse first in Covent Garden, then in Great Queen Street, and a country seat in Hounslow, Middlesex. Liveried servants and his habit of travelling between town and country with a coach-and-six earned Kneller the attentions of highwaymen. When a formal academy was finally initiated, in 1711, premises were found near Kneller's home in Great Queen Street. (The street was to continue its association with artists when Thomas Hudson moved there in 1746; his apprentices included Joshua Reynolds and Joseph Wright of Derby.[8]) The Academy found its home at number 55 or 56. Vertue says:

The subscription was a guinea for each person, paid down; the place for drawing a large room, ground floor, in the great house in the middle of Great Queen Street, near Lincoln's Inn Fields, where formerly many great noblemen had lived, and once the land-bank was kept there, but gone to decay and uninhabited.

Sir Godfrey Kneller (1649?–1723), *Self-portrait*, 1685.
Oil on canvas, feigned oval, 62.9 × 56 cm. National Portrait Gallery, London. NPG 3794

Louis Chéron (1660–1725), *Male Nude Seated on a Rock*, c. 1676–77.
Red chalk heightened with white on paper, 56.5 × 42.9 cm. British
Museum, London. BM 1953-10-21-11 (96)

The evidence seems to indicate that Kneller was chosen by previous agreement as governor of the Academy, on the understanding that he would in due course hand over to the portrait painter Michael Dahl. However he did not wish to do so, the reason perhaps being that he did not want the Academy to turn into an institution under royal patronage. At all events, the Academy at Great Queen Street was never more (nor less) than a private school, at which the subscribing artists were able to draw from the male model. That there were some plaster casts available for study is also likely.

Kneller did some of the teaching, as did the Paris-born history painter Louis Chéron. Chéron represents a direct link between the French and English academic tradition, for he had studied at the Académie de Peinture et de Sculpture, had won the Grand Prix de Rome and had gone to Italy to study. In England, where he converted to Protestantism, he painted ceilings for the great country houses. An album in the British Museum contains numerous academy studies by Chéron, showing a definite,

descriptive and analytic approach to musculature and the expressive figure.[9] If one is put in mind, when looking at some of Chéron's bald nudes, of the naked figure of the rake in the foreground of the last scene of Hogarth's *The Rake's Progress*, that is no coincidence. For Hogarth studied in 1720 with Chéron, who, in addition to this exact and scientific approach to anatomy, had a great stock of copies he had made from the paintings he had studied in Rome.

Chéron had studied Annibale Carracci's nudes, and had made copies from Raphael. Another French artist, Sir Nicholas Dorigny, was engaged in the production of engravings after Raphael's Cartoons at Hampton Court. And then there was Jonathan Richardson the Elder, a founder director of the Great Queen Street Academy, portrait painter, art theorist and another of the key figures in the history of the collecting of old master drawings. Richardson's forceful study in black and white chalk, inscribed by his son with the title *Figg the Gladiator ad Vivum*, gives us an idea of the kind of life studies that might have been made at Great Queen Street. It is dated 1714. Traditionally, life classes have sought the services of soldiers and other strong men, in their pursuit of the ideal anatomy. James Figg was a pugilist who ran his own academy of arms, where he instructed men and women in the arts of swordplay, boxing and cudgelling. (He is supposed to have modelled for the prone drunken figure in Hogarth's *A Midnight Modern Conversation*.)

No women were among the artists studying at Great Queen Street, and there were no female models. The male model, when necessary, must have stood in for the female. Vertue tells a story of the artist Peter Angellis in Rome in the late 1720s:

> Mr Angelis painter when he was at Rome. studying there, he had a young man that he made use of for his model to draw after – dressing him in several habits – or cloaths suteable to his purpose for his paintings at some times it causd much sport and laughter to his companions Artists when Angelis usd to dress up this young man (who was not very handsom nor likely) into womens dresses or habits, he made such aukard – queere figures – that provokd them to laugh at

Figg the Gladiator ad Vivum.

Jonathan Richardson the Elder (1667–1745), *Figg the Gladiator ad Vivum*, 1714.
Black and white chalks on blue paper, 29 × 22.5 cm. Ashmolean Museum, University of Oxford

Sir James Thornhill (1675–1734), *Self-portrait with Parrot*, undated. Black and white crayon on paper, 41 × 25.2 cm. National Maritime Museum, London. PAH 3341

rather than admire, especially being a rustick ill shapd mortale and the cloaths quite as ridiculous.[10]

Kneller kept a close watch on the Great Queen Street Academy. A story related years later by William T. Whitley gives an idea of the importance traditionally assigned, both then and much later in the Royal Academy itself, to the setting of the model's pose:

> One evening when Sir Godfrey was visiting the Academy he noticed that the model was placed in a curious, crouching position, and demanded of the student nearest to him, who had set the figure in such a fashion. He was told that the pose had been given by Mr Gibson, and that artist coming in at the moment was asked by the

Governor why this uncommon attitude had been chosen. Gibson replied that he had received a letter from Mr Thornhill (this was before he had been knighted) who was then at work upon the ceiling of the Painted Hall at Greenwich Hospital. Thornhill explained in his letter that as he was too busy to come to town, he enclosed several small sketches of figures in order that Gibson, whom he knew to be a good draughtsman, would place models in similar positions and send his studies of them to Greenwich. The meaning of this was at once clear to Sir Godfrey. 'I see, I see!' he cried scornfully. 'Mr Dornhill is a wise man. But if I was Mr Dornhill I should let Mr Gibson draw *all* my figures for me.'[11]

The implication is that Thornhill was abusing the Academy's facilities. But the story shows the utility of the life class for the busy, professional painter.

It is this matter of utility that looms large in the early histories of the academies. The artists needed to draw from life, but where would they find a model? Where would they find a room? If the model were to pose nude, how would the room be heated? If, as was often convenient, the sessions were to be held in the evening, who would provide the lamp, and who would pay the ongoing expenses for light, heating, rent and the model's wages? If decorum was to be preserved in the presence of nude models of either sex, who would be permitted to visit the life class? Who would 'set' the model, that is, choose the pose for the day's session? What would the model pose on, and what would the artists sit on?

Mundane questions, most of them, requiring mundane solutions. Nevertheless, if you succeed in solving these questions, what you have is an academy. If you fail, what you have is a recipe for decades of bitterness.

The Academy at Great Queen Street was not a place at which, generally speaking, the apprentice artist seems to have received a full, rounded education. Rather, it supplemented and perfected the education available in working studios. But it is also possible to overlook, for lack of surviving evidence, the intellectual stimulus that would have provided much of the attraction for those involved. Sir Richard Steele, the pioneering journalist, was

a member. Vertue, whose notes on the history of painting and engraving in England[12] formed the basis for Horace Walpole's *Anecdotes*, began his records at this time, with a view to writing an account of the national school. Richardson's critical works were all written while he was a member.

In due course, in 1715, Thornhill supplanted Kneller as Governor. Three years later, he moved the Academy to a room attached to his own house in Covent Garden, where it lasted two years until Thornhill, according to Vertue, grew tired of it. Chéron and John Vanderbank undertook to keep the institution going, moving it to a large room in Peter's Court, St Martin's Lane (probably Russell's Meeting House, a disused Presbyterian chapel, later rented by Louis-François Roubiliac as a sculpture studio). This institution is now known as the First St Martin's Lane Academy of 1720–24.

At the time of its founding there was a potential rival scheme for an academy on the Italian model. This was the brainchild of the 3rd Earl of Burlington, who had returned from Italy in 1719 in the company of William Kent. The surprising feature of Burlington's scheme, in retrospect, is that, had it gone ahead, this academy would have had its home where the Royal Academy eventually ended up in 1868 – at Burlington House, Piccadilly. According to Sir John Summerson, Burlington

seems to have had in mind the formation of something in the nature of an Academy of Arts or least of a practising combination of architect, sculptor, and painter, based on Burlington House. An architect he already had in [Colen] Campbell; a sculptor he had found in the person of [Giovanni Battista] Guelfi, who lived for many

William Hogarth (1697–1764), *Masquerades and Operas*, 1724. Engraving, 12.7 × 17.8 cm. Royal Academy of Arts, London

The opening pages of *Osteographia, or The Anatomy of the Bones*, London, 1733, by **William Cheselden** (1688–1752). Royal Academy of Arts, London. Later editions identify the engraver as **Gerard Vandergucht** (1696–1776)

years in his house; while as for painter, there was in Rome a young Yorkshireman called William Kent, whom he had met on his first visit and whom he now proposed to invite to complete the decorative painting at Burlington House.[13]

In 1724 Hogarth published a print called *Masquerades and Operas*, satirising the bad taste of the town, chiefly in the form of the Haymarket Opera House and the theatre at Lincoln's Inn Fields. In the centre, in the background, is the Palladian gateway of Burlington House, designed by Colen Campbell. On the pediment above the closed gate, the figure of Kent (spelt KNT) is triumphantly placed, with Michelangelo and Raphael reclining on either side. Below them is the inscription 'Academy of Art'.

The promotion of Palladianism at the expense of the baroque, and of Kent (who was a feeble painter) at the expense of Hogarth's father-in-law Thornhill, are the objects of satire here. Burlington had brought back to England his astonishing collection of Palladio's architectural drawings, and it was under his influence that English Palladianism was promulgated. Had Burlington actually formalised an academy of art at Burlington House, it would have come into being alongside the Royal Academy of Music, which was founded in 1719 with Handel as director and Burlington one of the subscribers. This Royal Academy, set up as a joint stock company under the patronage of the King, put on Italian operas at the King's Theatre, Haymarket, and lasted until 1728.

Meanwhile the First St Martin's Lane Academy was in operation. Run by Chéron and Vanderbank, it attracted 35 subscribers at two guineas each. Chéron was 60, and had five years to live. He was noted as a draughtsman, a designer of book illustrations. His academies have already been mentioned. Bignamini concludes that he collaborated with the surgeon and anatomist William Cheselden on anatomical illustrations. Cheselden, who had trained with William Cowper, another anatomist and member of the Virtuosi of St Luke, wrote an *Anatomy of the Humane Body* (1713), which was to dominate most of the eighteenth century, running through thirteen editions. He became a member of the Academy, receiving instruction at St Martin's Lane, and also gave a series of lectures in Fleet Street, which it is believed would have been attended by artists. He is thus said to have been the first anatomist to lecture artists and art students in England.[14]

William Kent was another member, and could no doubt pull some rank, being the favourite of Burlington and his circle, and having experience of the world of the Italian academies. He had a prize from the academy in Rome, and was a member of the one in Florence, and had even decorated the ceiling of a Roman church, San Giuliano dei Fiamminghi. Some of the work he did at Burlington House has survived under layers of paint, and has been partially uncovered by recent restoration. Whether Walpole was right to remark that the ceilings were painted by Kent in his worst manner remains perhaps to be seen. At all events Kent had not yet been steered by Burlington in the direction of architecture, which, along with garden design, became his forte.

Hogarth joined the First St Martin's Lane Academy at the age of 23. The method of instruction of young artists was exceedingly pedantic. The student began by copying abstract shapes, before moving gradually from shapes to nature. Every stage of the process had to be completed in order – eyes, noses, mouths, hands, feet, and so forth. Every part had to be learnt separately before the student went on to copy the whole body.[15]

Hogarth had served a seven-year apprenticeship as an engraver of coats of arms on silver plate, and such a copying régime must have taxed his patience. He became both a subtle analyst and critic of the

shortcomings of the academic approach and, surprisingly enough, the founder of his own academy. Hogarth noted that, just as professional copyists might copy out a passage of writing and at the end have no idea what it was they had written down, because they had paid attention only to each part of the text, so it might be that a student making a copy at an academy might set down the parts without forming any idea of the whole. But with this difference, that the copyist of a text might well get the text down word for word, 'whereas what is copied for example at an academy is not the truth, perhaps far from it, yet the performer is apt to retain his perform'd Idea instead of the original'. So Hogarth asked himself 'why I should not continue copying objects but rather read the Language of them and if possible find a grammar to it and collect and retain a remembrance of what I saw by repeated observations only trying every now and then upon my canvas how far I was advanc'd by that means'.[16] In other words,

British School (Circle of Charles Phillips), *William Cheselden Giving an Anatomical Demonstration to Six Spectators*, 1730–40. Oil on canvas, 79.7 × 60.5 cm. Wellcome Library, London

Benedetto Luti (1666–1724), *William Kent*, 1718.
Oil on canvas, 48.9 × 44.5 cm. Trustees of the Chatsworth Settlement

the crucial thing was to understand the way the parts related to each other.

And here Hogarth speaks from long experience of academies:

There can be no reasons assign'd why men of sense and real genious with strong inclinations to attain to the art of Painting should so often miscarry as they do . . . but those gentilmen who have labour'd with the utmost assiduity abroad surrounded with the works of the great masters, and at home at academys for twenty years together without gaining the least ground, nay some have rather gon backwards in their study as their performance before they set out upon their travail and those done twenty years since will testifie. Whereas if I have acquired anything in my way it has been wholly obtain'd by Observation by which method be where I would with my Eyes open I could have been at my studys so that even my Pleasures became a part of them and sweetned the pursuit.

As this was the Doctrin I preach'd as well as practic'd an arch Brother of the pencil gave it this turn That the only way to learn to draw well was never to draw at all.[17]

The history of the early academies is intimately connected to that of Hogarth, for Thornhill was his father-in-law, and in 1734,

Sir James Thornhill dying, I became [recipient?] of his neglected apparatus and began by subscription that in the same place in St Martin's Lane, as it was founded upon a still more free footing, each subscriber having equal power, which regulation [it] has preserved to this day. As perfect an academy as any in Europe but and with good manage[ment] had a bank and their bank of about £30.[18]

This is Hogarth writing at an advanced age, in great bitterness, against the idea that was to come to fruition in the form of the Royal Academy. What he is saying essentially is that England already has as much of an academy as it needs, and that great hierarchical institutions founded on foreign models are superfluous.

Everything requisite to compleat the consummate painter or sculptor may be had with the utmost ease without going out of London at this time. Going to study abroad is an errant farce and more likely to confound a true genious than to improve him. Do skyes look more like skies, trees more like trees? Are not all living objects as visible as to light or shade or colour? Do mens bodys act and move as freely as in Rome? If so, all their limbs must be the same.[19]

And again:

We hear much of the academies of painting abroad, rooms where naked men stand in a certain posture to be drawn after. With[out] these places, many are made to believe, painting can never be attained to any degree of perfection. Lewis the 14 got more honour by establishing a pompous parading one at Paris than the academician advantage by their admission into it. Voltaire observes after that establishment no work of genious appeared, for says he they all became imitators and mannerists.[20]

Referring to himself in the third person, Hogarth explains how the Second St Martin's Lane Academy was founded in a room 'big enough for the naked figure to be drawn by thirty or forty people'.

William Hogarth (1697–1764), *Self-portrait, c.* 1757.
Oil on canvas, 45.1 × 42.5 cm. National Portrait Gallery, London. NPG 289

He [Hogarth] proposed a subscription for hire of one in St Martin's Lane and for the expenses attending in this was soon agreed to by sufficient number of artists. He presented them with a proper table for the figure to stand on, a large lamp, iron stove and benches in a circular form. He became an equal subscriber with the rest, signifying at the same time that superior and inferior among artists should be avoided, especially in this country, adding that the having directors with and imitation of the foolish parade of the French academy had two academies and in queen street and are in common garden [Covent Garden] already, which regulation hath been probably the cause of it being still, subsisting in the same place now about 30 years.[21]

Unknown artist, *A Life Class*, early nineteenth century. Oil on canvas, 98.7 × 134.7 cm. Royal Academy of Arts, London. Purchased from Messrs Hogarth in 1885. 03/973. This work was formerly known as *The St Martin's Lane Academy* and attributed to William Hogarth

In his garbled way – for he wrote these notes towards an *Apology for Painters* in a state of mind that bordered on the insane – Hogarth is saying that it was the pompous structure, and the tendency to schism, which proved the undoing of the earlier academies, while his own – with its democratic character, modest means and aspirations – had proved the more durable.

Naturally over the years there has been a great interest in discovering some images or records of Hogarth's academy. For much of the last century it was believed that a curious oil painting of a life class, purchased by the Royal Academy in 1885, gave such an image or record, and might even be by Hogarth himself. The painting shows a model posing on what looks like a kitchen table, by a fireplace, and the artists are seated at semicircular benches in much the manner one might expect from reading

Hogarth's text. However a crucial detail of the oil lamp has been misunderstood: it is shown hanging from the ceiling by a cord, and no provision is made for the flue which was necessary to extract the considerable amount of smoke and heat such a multi-burner lamp would have produced.

In 1991 Martin Postle was able to demonstrate that this painting was not contemporary (it dates perhaps from the early nineteenth century), but that another oil painting in the Royal Academy's collection did indeed depict the St Martin's Lane Academy around the year 1761.[22] This work, quite possibly by Johann Zoffany or by John Hamilton Mortimer, is just the kind of document one might hope to find, for it shows very clearly how the set-up worked, and it gives us a clear view of several faces. By a stroke of extraordinary good fortune, a key to this painting

Unknown artist, *A Life Class* (possibly in the St Martin's Lane Academy), *c.* 1761.
Oil on canvas, 50.5 × 66 cm. Royal Academy of Arts, London. Given by William Smith, 1871. 03/621

exists in the British Museum. From this we can identify the figure in the foreground gazing at the viewer as George Michael Moser, one of the Academy's directors and soon to be a co-founder of the Royal Academy itself. He had been a gold-chaser, a decorator of cane-heads and watchcases, then an enameller of necklaces and trinkets, before becoming an 'instructor in delineation' – in plain English, a drawing master.

The conceit of the painting is that Moser has been supervising the artistic efforts of John Taylor, then in his early twenties, who himself went on to become a drawing master and in old age, known as 'Old Taylor', a source for more than one historian of eighteenth-century art. Thanks to J. T. Smith, author of that vivid book *Nollekens and His Times*, we

know just how Taylor spoke. Here he is, arriving at Nollekens's house unannounced, while Smith, the narrator, is posing for the sculptor. (This passage is of interest as a rare account written by an artist's model.)

At this moment who should come in but John Taylor . . . 'Why don't you go to your dinner, my good friend?' said he; 'I am sure it must be ready, for I smell the gravy.' Nollekens, to whom he had spoken, desired him to keep his nonsense to himself. *Taylor.* 'Well, well, well, I own, I ought to have nothing to do with family affairs. I see your dog Daphne has the mange! You should put some brimstone in his water; it is a very fine purifier of the blood; indeed I take it myself

now and then; and I recollect my old friend Jonathan Tyers never suffered any of his dogs to be without it. Heighday!' looking behind the screen; 'why here's a boy naked! – What! Tom, is it you?' – 'Yes, Sir,' replied I. – *Taylor.* 'Why, what are you sitting for now? You were a Cupid the other day. Oh! A Mercury, I see; a pretty compliment, faith! Well, you must mind what you're about. However, Nollekens has made a god of you, you'll remember that. . .'[23]

And so on, unstoppably.

To return to the painting, something has caught Moser's attention and he turns to look at the artist, as does a figure on the left, who is a watercolourist called John Alexander Gress. The figure in profile to the left of him is John Hamilton Mortimer. Behind this group is a man in red, identified by Postle as John Malin, reaching into a cupboard containing drawing materials. The interesting thing about him is that he was the porter and sometimes the model at the St Martin's Lane Academy, and later the first porter at the Royal Academy Schools.

The Royal Academy owns a tremendous chalk drawing of Malin by Thomas Banks, which clearly shows the same brooding face. On the back is an inscription: 'this fine drawing . . . is a portrait of John Malin the first porter and model at the Royal Academy, which posts he had filled at the Academy in Peter House St Martin's Lane from which the Royal Academy emanated.' Evidently, says Postle in a note on this drawing, Malin 'was simply transferred, alongside the benches, casts and other paraphernalia, to the new Academy . . . He died early in 1769, whereupon the Academy agreed to pay funeral expenses of £6 2s 2d, owing to his "long and faithful services".'[24]

The model is placed in a standard reclining pose, no doubt on the 'proper table' Hogarth inherited from Thornhill. The benches appear to be in a

George Dance RA (1741–1825), *Portrait of Thomas Banks RA*, February 1793. Pencil and black chalk (?) on cream laid paper, 22.6 × 18.2 cm. Royal Academy of Arts, London. Purchased from the artist in 1813. 03/3259

roughly semicircular configuration. The lamp, with its hood and flue, is clearly shown. The cord above the model's head might well have served as a harness to support the model's arm for a pointing gesture. The row of busts, casting atmospheric shadows, is part of a typical drawing-school stock, and suggests that elsewhere in the room there might be other kinds of plaster cast. Each artist of course requires his own lamp to draw by. One receives a clear and immediate impression of the modest scale and furnishings of this informal academy. Hogarth would have deplored the attempt to make anything grander.

Thomas Banks RA (1735–1805), *John Malin*, c. 1768–69. Black and red chalk, heightened with white, on laid paper on canvas, 48.5 × 37 cm. Royal Academy of Arts, London. 04/3423

3 Meet the Artists

To move from the anonymous painting (possibly by Zoffany) discussed in the previous chapter, to the Royal Collection's celebrated group portrait of the Royal Academicians, which Zoffany certainly painted (presumably for George III), is to see the essential continuity that exists between the early academies and the Royal Academy itself. Here are, it would seem, some of the same props. The great lamp is now more legible, with its two layers of flares, and the white reflecting internal surface of its hood. Here is a section of the semicircular bench, with one of those individual lamps with its conical shade. The bust up on the shelf on the far left has made its way from St Martin's Lane. And now we see how the pose of the model was set, with the knotted cord brought to support the model's hand.

The elegant figure setting the pose, while looking across the room towards the group of Academicians (including the standing figure of Reynolds with his ear-trumpet), has the same face that stared out at us from the previous canvas: it is Moser, now Keeper of the Royal Academy Schools, who is shown in the act of setting the second model of the evening.

The first model, the young man in the foreground, is depicted putting his clothes back on. By looking the artist in the eye, he engages the viewer in the way Moser had done in the other painting. Nobody looks at the young man; he is a part of the

Charles Grignion (1754–1804), *Dr William Hunter*, c. 1780. Pencil on grey paper, 12.5 × 15 cm. Hunterian Museum and Art Gallery, University of Glasgow, inv. no. 42340

scene but not of it. Considered individually, he is very much like one of the informal Carracci studies of young models emanating from Bologna. His pose, pulling on a stocking, has reminded some of the Spinario, the classical statue of the boy pulling the thorn out of his foot. Comparison could also be made with the study by Michelangelo of a soldier pulling on a stocking, for *The Battle of Cascine*. Neither the young man's name nor that of the older model seems to have come down to us, but every other figure in the room has been identified.

Johann Zoffany RA (1733–1810), *The Academicians of the Royal Academy*, 1771–72 (detail)

Unknown artist (Royal Academy Lecture Drawing), *The Strand Façade of Old Somerset House*, c. 1817.
Pencil, pen, wash and body colour on paper, 44.2 × 68.4 cm. Sir John Soane's Museum, London. 27/6/10

The painter himself is on the far left, holding his charged palette ready. We read of him that

> his chief peculiarity was that he squinted horribly, so that one could never know what he was looking at; but this proved a great advantage to him in portrait painting, as it was said he could look at his Sitter with one eye, and go on with his picture with the other.[1]

Horace Walpole wrote in his catalogue of the 1772 Royal Academy exhibition that 'This excellent picture was done by candle light; [Zoffany] made no design for it, but clapped in the artists as they came to him, and yet all the attitudes are easy and natural, most of the likenesses strong.'[2] This must be a slightly abbreviated version of Zoffany's method, for he did indeed make a study of individual sitters, now in the collection of the Royal Academy. While he was working, Charles Grignion, a pupil of the Academy, sketched Dr William Hunter, the institution's first Professor of Anatomy, in the same pose that Zoffany was using, but from a different

angle. According to Martin Kemp, this study originally bore an inscription (lost during restoration), recording that it was made 'by Chas. Grignion at the Royal Academy whilst the Dr was standing for his portrait to Mr Zoffany'.[3] (This study is in Glasgow. Other Academicians' portraits by Grignion are in the National Portrait Gallery, London.)

The picture, then, unlike (one assumes) the study of the St Martin's Lane group, is a carefully re-composed and devised evocation of the kind of gathering that *might* have taken place in the early days of the new Royal Academy. The room shown is in Old Somerset House, in fact the second location of the Academy's Schools (the first having been briefly with the rest of the Academy in Pall Mall).

Old Somerset House (Somerset Palace), home not only to the Academy Schools but also to Moser's apartment, had been remodelled by Inigo Jones for Queen Henrietta Maria. Later, Catherine of Braganza had held court there but the building had been abandoned as a royal palace after the flight of James II. The earlier parts, originally the residence

of the Duke of Somerset, had simply been locked up. When Moser's nephew saw them, prior to their demolition by Sir William Chambers, they were covered in dust.

In these rooms, which had been adorned in a style of splendour and magnificence that was creditable to the taste of Edward the Sixth, part of the ancient furniture remained and indeed from the stability of its material and construction might have remained for centuries had proper attention been paid to its preservation. The audience chambers had been hung with silk, now in tatters, as were the curtains, gilt leather covers, and painted screens. There were in this, and in a much longer room, a number of articles which had been removed from other apartments, and the same confusion and neglect were evident. Some of the sconces, though reversed, were still against the hangings, and I remember that one of the brass gilt chandeliers still hung from the ceiling.

Passing through these rooms, which had once been the regions of splendour and festivity, of luxury and hospitality, we arrived at some doors that were opened with difficulty, but which gave access to a room the sight of which repaid the trouble incurred. This apartment was upon the first floor of a small pile that formed a kind of tower at the end of the old buildings, the internal part of which was unquestionably the work of Inigo Jones. It was known to have been used as a breakfast or dressing room by Catherine of Braganza, Queen of Charles the Second, who lived and kept her Court in this palace for many years. This apartment had more the appearance of a small temple than a room; it was of octagonal form and the ceiling rose in a dome from a beautiful cornice. There was such an elegant simplicity in the architecture that Sir William Chambers exceedingly regretted the necessity for its destruction.[4]

The house occupied a position, as now, between the Strand and the river, and Jones had created an impressive façade on the Strand frontage. On the south side, as was typical of the palaces along the Strand, a large garden gave down towards a watergate.

George Dance RA (1741–1825), *Portrait of Richard Cosway RA*, 6 April 1793. Pencil with black, pink and blue chalks on cream wove paper, 25.3 × 19 cm. Royal Academy of Arts, London. Purchased from the artist, 1813. 03/3260

It is extraordinary to think of this ancient half-empty palace, half occupied by art students, and to think that these were the Academy Schools known to the American artists Benjamin West and John Singleton Copley, who both saw the life class there.

The sculptures on display in Zoffany's painting show a greater variety of teaching aids than before. One, the female torso in the foreground, is part of a joke: Richard Cosway, 'the Maccaroni miniaturist', places the tip of his clouded cane just above the *mons veneris*. Resplendently dressed, he is the only one of the group apart from Reynolds to wear a sword.

Of Cosway we are told, rather surprisingly, that in person he was not only little (Tiny Cosmetic was another of his nicknames) but mean:

He assumed great airs, and his vanity tempted him to deck himself in portraits *ipse pinxit* [self-portraits], in the most ludicrously gorgeous

OVERLEAF

Johann Zoffany RA (1733–1810), *The Academicians of the Royal Academy*, 1771–72. Oil on canvas, 100.7 × 147.3 cm. The Royal Collection. RCIN 400747

John Sanders (1750–1825), after **Johann Zoffany** RA (1733–1810), Key to *The Academicians of the Royal Academy*, c. 1773. Pencil on paper, 19.1 × 27 cm. National Portrait Gallery, London. NPG 1437a

1 Sir Joshua Reynolds PRA (1723–1792), painter; first President, 1768–92

2 Sir William Chambers RA (1723–1796), architect; first Treasurer, 1768–96

3 George Michael Moser RA (1706–1783), painter; first Keeper, 1768–83

4 Francis Milner Newton RA (1720–1794), painter; first Secretary, 1768–88

5 Edward Penny RA (1714–1791), painter; first Professor of Painting, 1768–82

6 Thomas Sandby RA (1723?–1798), architect; first Professor of Architecture, 1768–98

7 Samuel Wale RA (1721–1786), painter; first Professor of Perspective, 1768–86

8 Dr William Hunter (1718–1783), anatomist; first Professor of Anatomy, 1768–83

9 Francis Hayman RA (1708–1776), painter; first Librarian, 1770–76

10 Tan Chitqua (d. 1796), a Chinese artist who came to England in 1769

11 George Barret RA (1728/32–1784), painter

12 Francesco Bartolozzi RA (1727–1815), engraver

13 Edward Burch RA (c. 1730–c. 1814), sculptor; Librarian, 1794–1814?

14 Agostino Carlini RA (c. 1718–1790), sculptor; Keeper, 1783–90

15 Charles Catton the Elder RA (1728–1798), painter

16 Mason Chamberlin RA (1727–1787), painter

17 Giovanni Battista Cipriani RA (1727–1785), painter

18 Richard Cosway RA (1742?–1821), painter

19 John Gwynn RA (1713–1786), architect

20 William Hoare RA (c. 1707–1792), painter

21 Nathaniel Hone RA (1718–1784), painter

22 Angelica Kauffman RA (1741–1807), painter

23 Jeremiah Meyer RA (1735–1789), painter

24 Mary Moser RA (1744–1819), painter; daughter of George Michael Moser RA

25 Joseph Nollekens RA (1737–1823), sculptor

26 John Inigo Richards RA (1731–1810), painter; Secretary, 1788–1810

27 Paul Sandby RA (1730?–1809), watercolour painter; brother of Thomas Sandby RA

28 Dominic Serres the Elder RA (1722–1793), painter; Librarian, 1792–93

29 Peter Toms RA (fl. 1748–1777), painter

30 William Tyler RA (fl. 1756–1801), sculptor and architect

31 Benjamin West PRA (1738–1820), painter; President, 1792–1805 and 1806–20

32 Richard Wilson RA (1713?–1782), painter; Librarian, 1776–82

33 Joseph Wilton RA (1722–1803), sculptor; Librarian, 1786–90; Keeper, 1790–1803

34 Richard Yeo RA (c. 1720–1779), medallist

35 Johann Zoffany RA (1733–1810), painter

36 Francesco Zuccarelli RA (1702–1788), painter

William Russell Birch (1755–1834), after **Richard Cosway** RA (1742?–1821), *A View from Mr Cosway's Breakfast-Room in Pall Mall, with a Portrait of Mrs Cosway*, published 1789. Stipple engraving, 15 × 17.6 cm. National Portrait Gallery, London. NPG D13728

Richard Cosway RA (1742?–1821), *The Artist and His Wife in a Garden with a Black Servant*, 1784. Etching, 20.9 × 24.8 cm. Whitworth Art Gallery, University of Manchester, inv. 20239

costume. Aiming also at a luxurious manner of life, his house, and especially his studio, was filled with costly works of art, jewels, china, silks, gems, and gew-gaws of every description, and was the resort of idle fashion and rank, including the Prince Regent himself, whose favourite beauties Cosway had painted and flattered, and of whose favour and intimacy he boasted.[5]

Early in his career he made, among other things, erotic miniatures for snuff-box tops. He collaborated with George Stubbs in painting 'loose and amorous' subjects in enamel, none of which have been identified.[6] He was known as a rake and a fop (the sword was an anachronism, and he once tripped over it in his eagerness to pay obeisance to royalty). A letter of his to the collector Charles Townley gives us the general idea: 'Italy for ever say I – if the Italian women fuck as well in Italy as they do here, you must be happy indeed – I am such a zealot for them, I'll be damned if I ever fuck an English woman again (if I can help it).'[7]

William Blake, in his generally incomprehensible *An Island in the Moon*, is said to be referring to Cosway in the following passage:

> And I hardly know what a coach is, except when I go to Mr Jacko's. He knows what riding is, & his wife is the most agreeable woman. You hardly know she has a tongue in her head, and he is the funniest fellow, & I do believe he'll go into partnership with his master, & they have black servants lodge at their house. I never saw such a place in my life. He says he has six & twenty rooms in his house, and I believe it, & he is not such a liar as Quid thinks he is.[8]

The passage is interesting because Cosway, Blake's friend and admirer, did indeed have a very distinguished black servant, the former slave Ottobah Cugoano, author of *Thoughts and Sentiments on the Evils of Slavery*. Among the subscribers to the 1791 edition of this book were Cosway, Nollekens and Reynolds.[9] Cugoano corresponded with Edmund Burke, from Cosway's home in Pall Mall, Schomberg House. And, in a fanciful etching, Cosway depicts himself and his wife, in seventeenth-century costume, in their garden, being served grapes by their black servant. In this context, Cugoano hardly looks like a radical emancipationist. But that is what he was (he published the 1787 version of his book from Cosway's Pall Mall address), and that is undoubtedly what Cosway encouraged.

The more one learns of Cosway, the more extraordinary his character appears. He was one of the great devisers of the romantic interior, after the manner and inspiration of Walpole's Strawberry Hill or like William Beckford – better than Beckford if Hazlitt is to be believed. Here is J. T. Smith, in a classic description of the romantic-antiquarian style:

Sir Joshua Reynolds PRA (1723–1792), *Portrait of Francis Hayman RA*, 1756. Oil on canvas, 76.2 × 63.5 cm. Royal Academy of Arts, London. Given by J. E. Taylor, 1837. O3/213

His new house [Cosway] fitted up in so picturesque, and, indeed, so princely a style, that I regret drawings were not made of the general appearance of each apartment; for, many of the rooms were more like scenes of enchantment, penciled by a poet's fancy, than any thing, perhaps, before displayed in a domestic habitation. His furniture consisted of ancient chairs, couches, and conversation-stools, elaborately carved and gilt, and covered with the most costly Genoa velvets; escritoires, of ebony, inlaid with mother-of-pearl; and rich caskets for antique gems, exquisitely enameled, and adorned with onyxes, opals, rubies, and emeralds. There were also cabinets of ivory, curiously wrought; mosaic-tables, set with jasper, blood-stone, and lapis-lazuli, having their feet carved into the claws of lions and eagles; screens of old raised oriental Japan; massive musical clocks, richly chased with or-molu and tortoiseshell; ottomans, superbly damasked; Persian and other carpets, with corresponding hearth-rugs, bordered with ancient family crests, and armorial designs at the center; and rich hangings of English tapestry.

And Smith has by no means finished, for he has still to enumerate objects of historical association, such as 'crystal cups adorned with the York and Lancaster roses, which might probably have graced the splendid banquets of the proud Wolsey' and a collection of armour which Smith says was not the equal of Dr Meyrick's (but that is only to compare it to the best).[10]

Hazlitt wrote of Cosway that

He was Fancy's child. All collectors are fools to him: they go about with painful anxiety to find out the realities: – he *said* he had them – and in a moment made them of the breath of his nostrils and the fumes of a lively imagination. His was the crucifix that Abelard prayed to – the original manuscript of the Rape of the Lock – the dagger with which Felton stabbed the Duke of Buckingham – the first finished sketch of the Jocunda – Titian's large colossal portrait of Peter Aretine – a mummy of an Egyptian king – an alligator stuffed. Were the articles authentic? – no matter – his faith in them was true. What a fairy palace was his of specimens of art, antiquarianism, and *virtù* jumbled all together in the richest disorder, dusty, shadowy, obscure, with much left to the imagination (how different from the finical, polished, petty, perfect, modernized air of Fonthill!) and the copies of old masters, cracked and damaged, which he touched and retouched with his own hand, and yet swore they were pure originals! He was gifted with *second-sight* in such matters: he believed whatever was incredible. Happy mortal! Fancy bore sway in him, and so vivid were his impressions that they included the reality in them. The agreeable and the true with him were one.[11]

This notion that Cosway's collection might have been very far from authentic is not, itself, to be taken uncritically. His contemporaries always wrote satirically about him, but were also from time to time obliged to acknowledge his skills as an artist and his connoisseurship. Here is a future President of the Royal Academy, Sir Thomas Lawrence, writing

to Joseph Farington in 1811. (Lawrence, it should be remembered, put together one of the greatest collections of drawings ever made.)

> . . . I have been out . . . to see Cosway's Drawings, and I am returned most heavily depressed in spirit from the strong impression of the past dreadful waste of time and improvidence of my Life and Talent . . . I have since been to Cosway's, and have seen an *Artist's House*, such a mass of *fit Materials* and so much Talent and Information in its Possessor (tho' not seeing him in Person), as to make me ashamed of the injustice, which prejudice, or say *just* opinion of his positive faults of character as a Man, have led me to commit against the general weight of his estimation as an Artist. – What are Mr Phillips, and Mr Owen, and Sir William Beechey, and Mr Shee's in mere colouring, when compar'd to the knowledge – the familiar acquaintance with, study; and often happy appropriation and even liberal imitation of the Old Masters, the fix'd Landmarks of Art, of this little Being which we have been accustom'd never to think of but with contempt?[12]

The striking figure seated opposite Cosway (with his hand on his knee in the manner of Ingres's *Monsieur Bertin*) is Francis Hayman 'who makes so important a figure in his coat, waistcoat and breeches of drab broadcloth and his Sunday wig. . . looking as large as life'. 'Another nightingale', this contemporary writer calls him, who 'kept his summer nights in the bowers of Vauxhall, and returned to his dormitory with the uprising of the lark'.[13] He was noted for his scene painting, and for his book illustrations.

Hayman, to some, looks here 'like an incarnation of British sturdiness and straightforward manhood'.[14] But a recent authority refers to this same image as of a 'corpulent, Falstaffian figure'[15] – Hayman was by this stage in his life a sufferer from gout. The writer in the *Literary Gazette* of 8 July 1826 (quoted in the previous paragraph) tells us that Hayman's portrait, though a strong likeness, was not entirely finished from life, 'for Master Frank was of too volatile a temper to afford even a brother Academician a fair number of sitting'.[16] Hayman

was celebrated for having fought a 'pugilistic set-to' with the Marquis of Granby.

Benjamin West told J. T. Smith the following anecdote, which he had from Hayman himself:

> Quin and Hayman were inseparable friends, and so convivial, that they seldom parted till daylight. One night, after 'beating the rounds', and making themselves gloriously drunk, they attempted, arm in arm, to cross a kennel, into which they both fell, and when they had remained there a minute or two, Hayman, sprawling out his shambling legs, kicked Quin. 'Hollo! What are you at now?' stuttered Quin. 'At? why endeavouring to get up, to be sure,' replied the Painter, 'for this don't suit my *palate*.' 'Poh!' replied Quin, 'remain where you are, the watchman will come by shortly, and he will *take us both up!*'[17]

Reynolds is shown listening through his ear trumpet to the conversation of Francis Milner Newton, the Secretary to the Academy, and Sir

William Daniell RA (1769–1837), after **George Dance** RA (1741–1825), *Portrait of Francis Milner Newton RA*, published 1 April 1803. Soft-ground etching, 27.1 × 19.7 cm. Royal Academy of Arts, London. Purchased from A. J. Stirling, 22 August 2000. 04/2314

William Chambers, the man credited with greatest influence in the founding of the Academy itself. Of Reynolds and Chambers I shall write in subsequent chapters. Newton was known as a poor artist, but a useful secretary to successive artists' organisations. Edward Edwards, who must have known him well, clearly disliked him. He says that 'liberality [we would say generosity], unhappily, formed no part of his character'.[18]

The American artist Benjamin West, who was to become the Royal Academy's second President, is shown in full figure just behind Zoffany. To the right of his wig is one of those characteristic and intriguing lone exotic figures that crop up in the London of the period. He is 'Mr Chitqua', or Tan Chitqua, or Chin Chin Chitqua, a Cantonese

Tan Chitqua (d. 1796), *Portrait of David Garrick, c.* 1770. Painted clay, with clothing and human hair, height 47 cm. Private collection

portrait-modeller whose speciality was small clay figures, which he coloured and sold for ten guineas for a bust, and fifteen for a full-length statuette.[19]

Chitqua's presence here stands as a reminder of the international character of the Royal Academy (such institutions, however nationalist their programme, characteristically prided themselves on their international connections): Chitqua and West – East meets West. Chitqua must have been a particular object of curiosity to Oliver Goldsmith, who became the Royal Academy's first Professor of History, since ten years earlier he had published a series of essays, collected as *The Citizen of the World*, which imagined England as seen through the eyes of a visiting Chinese philosopher. (Chambers was to borrow the name of 'Tan Chet-Qua' for the fictional author of his 1773 *Explanatory Discourse* on oriental gardening.)

Chitqua arrived in London in August 1769, 'a middle-aged man, of a proper stature; his face and hands of a copperish colour, is elegantly clothed in silk robes . . . and speaks the Lingua Franca mixt with broken English; is very sensible and a great observer. He is remarkably ingenious in forming small busts with a sort of China clay, many of which carry a striking likeness of the person they are designed to represent. He steals a likeness, and forms the busts from memory.'[20]

Chitqua spoke some English, and Whitley gives us what he says is an extract from a letter by him. He also describes the near disaster of Chitqua's attempt to return home to China on the East Indiaman *Greville*:

> He had made friends as well as money in England, and no doubt would have carried away nothing but pleasurable impressions of the country had it not been for the superstition and brutality of the crew of the ship in which he had taken his passage. When, in his Chinese attire, he went on board at Gravesend, he found that the sailors looked upon him as a passenger likely to bring ill luck to the ship, and their threats so terrified the artist that he begged the carpenter, in case he was killed, to make a coffin in order that his body could be taken ashore. In his country, he said, it was not lawful to be buried in water.

At length, the captain, seeing his distress and dreading also that his crew might mutiny if he remained on board, offered to set him on shore with the pilot, who would accompany him in the coach to London. (In another version of the story he fell overboard and floated half a mile, 'buoyed up by his loose habit'.) This offer Chitqua accepted gratefully, but in London fresh troubles awaited him. He wished to return to his old lodgings, but in his state of terror he had forgotten, or could not explain intelligibly, where they were situated. A mob soon gathered round the coach and began to abuse the pilot for having, as it was thought, kidnapped a foreigner, but at this moment a gentleman, passing by, recognised Chitqua and conducted him to the house in Arundel Street, Strand, for which he was seeking. He wisely adopted European clothing before seeking another ship.[21]

Chitqua exhibited a bust in the Academy exhibition of 1770. One of his models, depicting Anthony Askew, belongs to the Royal College of Physicians. Another, from a private collection, was exhibited recently in a show devoted to portraits of Garrick. In this case the clothes were made of fabric and the hair was real. The figure leans against a tree-stump executed in a Chinese style. The catalogue entry tells us that the King and Queen sat for Chitqua, as did the diarist William Hickey, who 'was careful to wear his most decorative suit of clothes, knowing that his outfit would be carefully reproduced'.[22] Chitqua's portrait by J. H. Mortimer, exhibited at the Society of Artists in 1771, has apparently been lost. In 1796 Chitqua took poison and died.

Dr William Hunter, the small thin man who strokes his chin with such evidence of judgment, was, as is noted above, the first Professor of Anatomy at the Academy; apart from the models he is the only non-artist in the group. In the middle of the eighteenth century he was known for his illustrated lectures, using dissections of hanged criminals from Tyburn. In order to illustrate the workings and structure of the muscles, such cadavers would routinely be flayed, and Hunter developed an interest in taking the freshly flayed corpse, before it was stiff, and setting it in a pose. From this, another

George Dance RA (1741–1825), *Portrait of Edward Burch RA*, 16 March 1793. Pencil with black and pink chalks on cream wove paper, 25 × 18.6 cm. Royal Academy of Arts, London. Purchased from the artist, 1813. 03/3262

of the artists in Zoffany's painting, Edward Burch, whose head and shoulders appear beneath the posing model's upheld arm, made a model in wax, which in turn was cast in bronze.

A letter of Northcote's dated 19 December 1771, after copying out Reynolds's Fourth Discourse, which had just been delivered, adds:

> I suppose you have seen the accounts upon the news-paper of the Jews which were hung for robbing a house and murdering a servant man in it. We had the body of one of them at the Academy for Dr Hunter to read his lecture on, and now I begin to know something of anatomy. We had but two lectures on it because they might have the body fresh to cast a plaster anatomical figure from it to be placed in the Academy to be drawn from.[23]

OVERLEAF
William Pink (nineteenth century), after **Agostino Carlini RA** (*c.* 1718–1790), *Smugglerius, c.* 1834 (original cast, 1775). Plaster cast, 68 × 148.6 cm. Royal Academy of Arts, London. 03/1436

Johann Zoffany RA (1733–1810), *Dr William Hunter Teaching Anatomy at the Royal Academy, c.* 1775. Oil on canvas, 77.5 × 103.5 cm. Royal College of Physicians, London. Reynolds can be seen in the audience with his ear trumpet

On another occasion, John Deare witnessed the process by which a famous figure was made which still survives in the Academy's collections:

> Deare, writing when he was only sixteen [1775], to his father in the country, says he has been to see two men hanged and afterwards witnessed the partial dissection of one of them at Surgeon's Hall. The muscular development of the second man was so remarkable that Hunter declined to dissect the body saying that it was worth preserving. It was therefore carried to the Academy schools, where Carlini the sculptor undertook to make a cast of it. The body, which was that of a smuggler, was placed in the attitude of the Dying Gladiator, and Carlini's cast, known always to the students as 'Smugglerius' remained in the Schools for many years afterwards.[24]

Agostino Carlini, the creator of Smugglerius, is also present in Zoffany's picture (he stands two to the right of Hunter). The version of such a figure which remains in the Royal Academy's collection may well be an aftercast from Carlini's model, for it is inscribed 'Moulder W. Pink British Museum', and probably dates from the 1830s.

Smith tell us that

> When Carlini was Keeper of the Royal Academy, he used to walk from his house to Somerset-place, with a broken tobacco-pipe in his mouth, and dressed in a deplorable great-coat; but when he has been going to the Academy-dinner, I have seen him getting into a chair, and fully-dressed in a purple silk coat, scarlet gold-laced waistcoat, point-lace ruffles, and a sword and bag.[25]

Within the depicted group of connoisseurs, there were not a few who would have been intimately

William Hunter (1718–1783), *Ecorché Figure*, 1770s. Plaster cast, height 171.5 cm. Royal Academy of Arts, London. 03/1435

several parts of the naked machine? and this sort of knowledge would be particularly useful when he wished to make designs of that machine in imaginary positions or attitudes, for the execution of which he could not have the advantage of copying the machine itself actually put into such attitudes before him.[26]

So to remove the skin from a human body is as natural as to remove a quilt from a machine.

The écorché figure in the background, the flayed man with the raised hand, had been a standard tool of academies for centuries, but such figures had only limited usefulness from Hunter's point of view, even though he seems to have been responsible for making several; Zoffany shows it again in a painting now in the collection of the Royal College of Physicians. The crucial point that he emphasised in his lectures to artists was the seeing of the body in action. 'There is certainly', he said,

> much elegance and beauty and grace and dignity in Nature; which should be introduced upon all fit occasion; but there is besides animation, Spirit, fire, force and violence, which make a considerable part of the most interesting scenes. Now it is this part which is generally more neglected, or worse executed by the Artist. You will commonly observe that the general attitude of a figure is well imagined, but the particular action so little defined that you cannot tell whether it is pulling for example or pushing, raising something, or putting it down; you shall see a hand *laid round* a spear, sword or dagger, but seldom *grasping* it. This defect renders the picture in my opinion lifeless and insipid. Why is it neglected? In reality I imagine because it is so difficult.[27]

aware not only of the structure of the skeleton, but also of the body with its skin removed. In his lectures on anatomy Hunter would ask the students to suppose

> that there is some mechanical machine to which we mean to compare the human body, made up of a number of pieces which move on one another so as to produce a great variety in the external figure and position of the machine; and let us further suppose that this machine is closely covered all over with a quilt; in the next place let us suppose that we wish to be able as artists to express all the variety of forms into which such a machine may be reduced. Is it not obvious to common sense that it would be of great advantage to the artist to have the covering removed, and thereby have the opportunity to study the form and motions of the

The body tires easily, and 'a living figure cannot continue one Action for any time'. The actions of the muscles are of infinite variety, but the muscles

> cannot act uniformly for any length of time. We see this evidently in every living naked figure which is endeavouring to preserve one uniform State. The muscles are all relieving one another; there is a constant play among them and thence a perpetual change of form. This is particularly so when the figure begins to be tired.[28]

Mary Moser RA (1744–1819), *Spring, c.* 1780. Oil on canvas,
63.5 × 53.3 cm. Royal Academy of Arts, London. 03/684

Hunter is describing the drawbacks involved with
the kind of life class that Zoffany depicts. Moser
arranges the hand of the model so that it will not
tire. The fingers are *laid round* the handle in order
to create the useful pose, but the better, the more
accurate, the sketch, the more it will reveal the
languid inactivity of the body. We may imagine
Hunter thinking such thoughts as he examines the
posed nude model. We may imagine Zoffany himself
thinking along much the same lines, since there
is a marked difference between the vividly caught
postures and actions of the other figures around
the room, including that of the young man in the
foreground, and the languid, generic character of
the posing model.

The two women depicted in unfinished portraits
on the wall are Academicians, unable, on grounds
of decency, to be present at the life-class in person.
The one on the right is Mary Moser, daughter of
the man setting the pose. She was a flower painter,
who was rumoured to have fallen in love with
Henry Fuseli, to whom she wrote some charming
letters that are preserved in *Nollekens and His Times*.[29]

A founder member, she remained active for many
years in the affairs of the Academy. She decorated
a room at Frogmore, near Windsor, which survives.

The portrait on the left is of Angelica Kauffman,
a more considerable artist, who is supposed to have
captured Reynolds's heart. It was said of her, and
the sculptor Nollekens believed this, that she had
'studied from the exposed male living model'.
Nollekens's biographer, J. T. Smith, decided to 'gain
the best information on the subject' and went to
a Mr Charles Cranmer who was one of the original
models of the Academy and was by then in his 82nd
year. Cranmer assured Smith that he had frequently
sat for Angelica Kauffman at her house on the south
side of Golden Square, but that he only exposed his
arms, shoulders and legs, and that her father was
always present.[30]

At all events, she studied from the living model,
a bold and unusual step for a woman, but necessary
if she was to develop as a history painter, which she
did. She also seems to have taken perspective lessons
from Giovanni Battista Piranesi, and from Charles-
Louis Clérisseau, who taught Robert Adam, for whom
Kauffman developed a decorative version of neo-
classical mural and ceiling design. When Chambers
rebuilt Somerset House, Kauffman supplied allegorical
paintings for the ceiling of the lecture hall, repre-
senting *Colour*, *Design*, *Composition* and *Genius*. These
are now in the Front Hall at Burlington House.

Kauffman, among her other achievements, is one

Attributed to Nathaniel Dance RA (1735–1811), *Sir Joshua Reynolds
and Angelica Kauffman, c.* 1766–67. Pencil on paper, 16.5 × 24.1 cm.
The Earl and Countess of Harewood

Angelica Kauffman RA (1741–1807), *Colour*, c. 1778–80. Oil on canvas,
130 × 150.3 cm. Royal Academy of Arts, London. 03/1130

of the few woman artists to have been given a state funeral. She died in Rome, where she had spent the last 25 years. No honour was spared. The funeral train included members of three academies – the Accademia di San Luca of Rome, the Academy of France in Rome and the Academy of Portugal – as well as members of other learned societies. A hundred ecclesiastics accompanied her and carried the bier. The pallbearers were four girls. The master of ceremonies was Antonio Canova. Two of Kauffman's own paintings, and Canova's marble rendition of her hand, were displayed in the procession, and in due course her bust was placed in the Pantheon.

Nollekens himself, who is shown in profile to the right of the model in the foreground, his head just visible behind Cosway's shoulder, had recently returned from Rome, bringing for the new academy a present of a cast of the Belvedere Torso. He was an accomplished smuggler of silk stockings, gloves and lace, Smith tells us:

His method was this: All his plaster busts being hollow, he stuffed them full of the above articles, and then spread outside a coating of plaster across the shoulder of each, so that the busts appeared like solid casts. I recall his pointing

to the bust of Sterne, and observing to the late Lord Mansfield: 'There, do you know, that busto, my Lord, held my lace ruffles that I went to Court in when I came from Rome?'[31]

Nollekens was mean – a painful subject to his biographer, who had been sorely disappointed by him in the matter of a legacy. Smith tells us:

> So determined was Nollekens upon all occasions to have a pennyworth for *his* penny, that he has frequently been noticed, when Visitor at the Royal Academy, to turn down the hourglass whenever Charles, the model, got up to rest himself; in order that the students might not be deprived of one moment of the time for which the model was paid. However, one evening, in doing this, he let the glass fall and broke it. This, he observed, he would replace by one which he would bring from his studio, muttering, 'They don't make things so strong as they did when I was a boy.'[32]

It is largely through J. T. Smith's biography that we know so much about the way Nollekens worked and talked, the way his household was run, the fact that he had a black maid nicknamed Bronze, and such details as the following:

> A modeller keeps his clay moist by spirting water over it; and this he does by standing at a little distance with his mouth filled with water, which he spirts upon it, so that the water is sent into all the recesses of his model before he covers it up: this, it is said, Nollekens did in the King's presence, without declaring what he was about to do.[33]

And here is the sculptor at work on his busto of George III:

> 'When I was modelling the King's busto,' observed Mr Nollekens, 'I was commanded to go to receive the King at Buckingham House, at seven o'clock in the morning, for that was the time his Majesty shaved. After he had shaved himself, and before he had put on his stock, I modelled my busto. I *sot* him down, to be even with myself, and the King seeing me go about him and about him, said to me: "What do you want?" – I said: "I want to measure your nose.

> The Queen tells me I have made my nose too broad." "Measure it then," said the King.'[34]

At which point, we are told, Nollekens pricked the King's nose with his calipers.

The disconsolate figure leaning at the side of the mantelpiece at the back of the room is the landscape painter Richard Wilson, Zoffany's former drinking companion, whose habits had recently deteriorated (in Zoffany's view). Instead of wine, he now drank stout and was devoted to tobacco. Originally, in order to satirise this descent, Zoffany painted a foaming tankard of stout and two crossed tobacco pipes on the mantelpiece. He then covered this part of the painting with 'goldbeater's skin', over which he painted a plaster-cast of a Gorgon's head, the idea being to remove this covering when the painting was exhibited at the Royal Academy. But he thought better of it, and later repainted the area.

Wilson's portrait was painted around the time that his career, in David Solkin's words, 'began to fall apart at the seams'. He had been recognised; as an Academician, he was busy and successful. Then

> relative prosperity gave way to abject poverty virtually overnight. Beginning in 1772, he started to change addresses with bewildering rapidity, each move taking him further and further away from the fashionable quarters of London. In 1776 the Royal Academy tacitly recognised his difficulties by appointing him its librarian – a sinecure reserved primarily for indigent artists . . . Despite the help offered him by artist-friends like Paul Sandby, and the annual salary of £50 provided by the Academy, by now Wilson probably could not even afford to purchase canvas. Eventually he had to be rescued by his relations, who took him home to North Wales in 1781. He died there the following year.[35]

Two Academicians are missing from the group. Nathaniel Dance, Hayman's pupil, who was a portraitist and history painter, spent years following Angelica Kauffman around Italy, in hopeless adoration. Some years later, he married a rich widow, took a new name, becoming in due course Sir Nathaniel Dance-Holland Bt. A founder member

John Francis Rigaud RA (1742–1810), *Joseph Nollekens with His Bust of Laurence Sterne*, 1772. Oil on canvas, 76.2 × 63.5 cm. Yale Center for British Art, New Haven. Paul Mellon Collection

Nathaniel Dance RA (1735–1811), *Self-portrait*, c. 1773. Oil on canvas, 73.7 × 61 cm. National Portrait Gallery, London. NPG 3626

of the Academy, he resigned in 1790, gave up on art and entered politics, becoming MP for East Grinstead.

The other absentee is Thomas Gainsborough, Reynolds's greatest rival in the group. At an Academy dinner Reynolds once gave a toast to 'the health of Mr Gainsborough, the greatest landscape painter of the day'. To this, Richard Wilson replied, 'Ay, and the greatest portrait painter too.' Gainsborough, who was anyway not a great mixer, would have been in Bath when Zoffany was mustering his sitters. Edward Edwards tells us that

> When the Royal Academy was founded, [Gainsborough] was chosen among its first members, but, being then resident in Bath, he was too far distant to be employed in the business of the institution[.] When he came to London, his conduct was not very respectful towards the members of that body, for he never attended to their invitations, whether official or convivial.[36]

No wonder he was dropped from the roster.

Of the 36 named figures in the group, two were women, one was Chinese, four (Francesco Bartolozzi, Agostino Carlini, Giovanni Battista Cipriani and Francesco Zuccarelli) were Italian. George Moser was Swiss, Zoffany was born in Ratisbon of Slovakian descent, Kauffman was from the Swiss Tyrol, Dominic Serres was a Gascon, and Nollekens's father was from Antwerp.

If these artists paid any credence, as some of them doubtless did, to the words of Dr Hunter in his lectures, they would have thought it possible that the works of English artists, in the course of a very few years, could rival, or even excel, 'the finest productions of Greece and Italy'. For, as Hunter so inspiringly put it,

> When we have already gone so far beyond the ancients, in science, in everything besides, are we never to excel, not even to equal them in works of imagination? Has Nature granted us with such compelling powers, powers in all other things and denied it in that? No: Shakespeare and Milton and Wren shew that Nature is not a partial step-mother, that genius is not confined to the latitudes of Athens and Rome. We are actually at this time making rapid progress, and Why should

Thomas Gainsborough R A (1727–1788), *Romantic Landscape, c.* 1783.
Oil on canvas, 153.7 × 186.7 cm. Royal Academy of Arts, London.
Given by Miss Margaret Gainsborough, 1799. 03/1396

not posterity be able to say that the later half of the 18th Century was the most distinguished period in the annals of human Genius? Why should they not be able to say that the brightest constellations of lights which ever appeared in the world rose in the days of George IIIrd. – that it was in its dawn when he ascended the throne, that [under] his auspicious influence, they may add *during a long and happy reign*, [it] rose to its full meridian glory: a demonstration, beyond all parallel, to what height humanity can rise when a virtuous and liberal prince governs a free people?

Let such a prospect be laid before us, rouze us to a contempt for trifling and temporary pleasures, and call our attention to objects of honourable fame. Let us feel with dilating hearts that the Olympic race is set up, – that the Prize is most certainly within reach – and that it is not less than Immortality![37]

Thomas Gainsborough R A (1727–1788), *Self-portrait, c.* 1787.
Oil on canvas, 77.3 × 64.5 cm. Royal Academy of Arts, London.
Given by Miss Margaret Gainsborough, 1808. 03/1395

LABOR ET INGENIVM

George R

GEORGE THE THIRD, BY THE GRACE OF GOD KING OF GREAT-BRITAIN, FRANCE, AND IRELAND, DEFENDER OF THE FAITH, &c. TO OVR TRVSTY AND WELL-BELOVED JOSEPH MALLORD WILLIAM TURNER, ESQVIRE, GREETING.

WHEREAS WE HAVE THOVGHT FIT TO ESTABLISH, IN THIS OVR CITY OF LONDON, A SOCIETY FOR THE PVRPOSES OF CVLTIVATING AND IMPROVING THE ARTS OF PAINTING, SCVLPTVRE, AND ARCHITECTVRE, VNDER THE NAME AND TITLE OF "THE ROYAL ACADEMY OF ARTS," AND VNDER OVR OWN IMMEDIATE PATRONAGE AND PROTECTION: AND WHEREAS WE HAVE RESOLVED TO ENTRVST THE SOLE MANAGEMENT AND DIRECTION OF THE SAID SOCIETY, VNDER VS, VNTO FORTY ACADEMICIANS, THE MOST ABLE AND RESPECTABLE ARTISTS RESIDENT IN GREAT-BRITAIN:

WE, THEREFORE, IN CONSIDERATION OF YOVR GREAT SKILL IN THE ART OF PAINTING, DO, BY THESE PRESENTS, CONSTITVTE AND APPOINT YOV TO BE ONE OF THE FORTY ACADEMICIANS OF OVR SAID ROYAL ACADEMY; HEREBY GRANTING VNTO YOV ALL THE HONORS, PRIVILEGES, AND EMOLVMENTS, THEREOF, ACCORDING TO THE TENOR OF THE INSTITVTION. GIVEN VNDER OVR ROYAL SIGN MANVAL, VPON THE TENTH DAY OF DECEMBER, ONE THOVSAND SEVEN HVNDRED AND SIXTY EIGHT, AND IN THE NINTH YEAR OF OVR REIGN.

AND WE ARE THE MORE READILY INDVCED TO CONFER VPON YOV THIS HONORABLE DISTINCTION AS WE ARE FIRMLY PERSVADED THAT YOV WILL, VPON EVERY OCCASION, EXERT YOVRSELF IN SVPPORT OF THE HONOR, INTEREST, AND DIGNITY, OF THE SAID ESTABLISHMENT; AND THAT YOV WILL FAITHFVLLY AND ASSIDVOVSLY DISCHARGE THE DVTIES OF THE SEVERAL OFFICES TO WHICH YOV SHALL BE NOMINATED.

IN CONSEQVENCE OF THIS OVR GRACIOVS RESOLVTION, IT IS OVR PLEASVRE THAT YOVR NAME BE FORTHWITH INSERTED IN THE ROLL OF THE ACADEMICIANS, AND THAT YOV DO SVBSCRIBE THE OBLIGATION IN THE FORM AND MANNER PRESCRIBED.

GIVEN AT OVR ROYAL PALACE OF SAINT IAMES'S, THE EIGHTH DAY OF APRIL IN THE FORTY SECOND YEAR OF OVR REIGN.

G. B. Cipriani inv.t et delt. F. Bartolozzi Engraver to his Majesty sculp.t

114,000 CEO's watch BBC World every week

4 The Founding of the Academy

Nobody believes that Sir Joshua Reynolds himself devised or created the Royal Academy of which he was to become such a distinguished first President. Reynolds was an operator, but not such a direct operator, to his own advantage. One might say that while the architect Sir William Chambers devised and created the Royal Academy, Reynolds's contribution was to bring about a situation whereby, somebody else having created a royal academy, he, Reynolds, would turn out to be its most suitable president.

On 28 November 1768, Chambers presented this petition to George III:

To the King's Most Excellent Majesty:
May it please your Majesty, We, your Majesty's most faithful subjects, Painters, Sculptors, and Architects of this metropolis, being desirous of establishing a Society for promoting the Arts of Design, and sensible how ineffectual every establishment of that nature must be without Royal influence, most humbly beg leave to solicit your Majesty's gracious assistance, patronage, and protection, in carrying this useful plan into execution.

It would be intruding too much upon your Majesty's time to offer a minute detail of our plan. We only beg leave to inform your Majesty, that the two principal objects we have in view are, the establishing a well-regulated School or Academy of Design, for the use of students in the Arts, and an Annual Exhibition, open to all artists of distinguished merit, where they may offer their performances to public inspection, and acquire that degree of reputation and encouragement which they shall be deemed to deserve.

We apprehend that the profits arising from the last of these institutions will fully answer all the expenses of the first; we even flatter ourselves that there will be more than necessary for that purpose, and that we shall be enabled annually to distribute somewhat in useful charities.

Your Majesty's avowed patronage and protection, is, therefore, all that we at present humbly sue for; but should we be disappointed in our expectations, and find that the profits of the Society are insufficient to defray its expenses, we humbly hope that your Majesty will not deem that expense ill-applied which may be found necessary to support so useful an institution. We are, with the warmest sentiments of duty and respect,
Your Majesty's
Most dutiful subjects and servants,

Benjamin West	Richard Yeo
Francesco Zuccharelli	Mary Moser
Nathaniel Dance	Augostino Carlini

J. M. W. Turner's Royal Academician's Diploma (8 April 1802), engraved by **Francesco Bartolozzi RA** (1727–1815), after **Giovanni Battista Cipriani RA** (1727–1785). 70.8 × 55 cm. Royal Academy of Arts, London. 03/173

Richard Wilson
George Michael Moser
Samuel Wale
G. Baptis. Cipriani
Jeremiah Meyer
Angelica Kauffman
Charles Catton
Francesco Bartolozzi

Francis Cotes
William Chambers
Edward Penny
Joseph Wilton
George Barret
Fra. Milner Newton
Paul Sandby
Francis Hayman[1]

There were, then, two parts to the plan. There was
to be a well-regulated school, of the kind whose
history has been traced in previous chapters, and
an annual exhibition of artists' work, whose
income, it was supposed, correctly, would finance
the school.

The holding of art exhibitions of any kind was a
novelty in the England of the time. There had been as
yet no hint of a move to exhibit old master paintings
to the public, and if there had been, one may be sure
that an artist such as Hogarth, with his dim view of
the cult of foreign masters, would have been the first
to attack it. Yet it was Hogarth, as Whitley informs us,
who 'unintentionally sowed the seed which originated
our modern system of exhibitions of pictures'.[2]

In 1740 Hogarth donated a portrait of Captain Coram to the Foundling Hospital, the charitable institution the captain had founded the year before. Other artists began to contribute their own work, and in due course the Hospital acquired a collection of contemporary paintings, which visitors were able to view throughout the year. The novelty was a great success. An annual dinner was established, at which further embellishments of the Hospital might be considered. On 5 November 1757, at one such dinner, attended by 154 supporters, including Hogarth, Reynolds and Allan Ramsay, an ode was sung, with words by Samuel Boyce, set to the music of Thomas Arne's 'When All the Attic Fire Was Fled'.

In this, Britannia contrasts the greatness, power and freedom of her country with the fact that 'The Arts, the Heaven-directed Arts, / Are here, alas! Unknown'. God grants Britannia's prayer and

> Again Corregio's genius liv'd,
> The warmth of Claude Lorrain reviv'd,
> And Titian's own'd the God.
> Diffuse, he cried, o'er Britain's Isle,
> Let there the Soul of Painting smile
> Transcendent, all refin'd:
> A noble portion HAYMAN caught,
> Soon Picture started from his thought,
> And History won his mind.
> The spirit glow'd in HOGARTH's heart,
> He rose Cervantes of the art,
> And boasts unrival'd praise.
> The impulse flame a LAMBERT warm'd;
> With Nature's rural beauties charm'd;
> He wears eternal bays.
> A SCOTT confess'd th'inspiring ray,
> The rolling bark, the wat'ry way,
> Assert the Master's hand;
> And REYNOLDS felt the sacred beam,
> Lo, Portrait more than Picture seem,
> It breathes at his command.[3]

This vision of the pictorial arts burgeoning in Britain culminated in an injunction 'Nobly to think on Hayman's thought' and to found 'A great Museum all our own', which a contemporary source explains as 'a scheme of Mr Hayman's . . . for a public receptacle to contain the works of artists for the general advantage and glory of the Nation and satisfaction of foreigners'.[4]

Two years later a notice was placed in the *Public Advertiser*:

> Foundling Hospital, November 5, 1759.
> At a Meeting of the ARTISTS.
> Resolved, That a General Meeting of all Artists in the several Branches of Painting, Sculpture, Architecture, Engraving, Chasing, Seal-cutting, and Medalling, be held at the Turks Head Tavern in Gerrard-Street, Soho, on Monday the 12th instant, at Six in the evening, to consider of a Proposal for the Honour and Advancement of the Arts, and that it be advertised in the Public and Daily Advertisers.
> JOHN WILKES, President
> FRA. MILNER NEWTON, Sec.[5]

Wilkes, an old friend of Reynolds and an enemy of Hogarth, was acting here in his capacity as treasurer of the Foundling Hospital. It may be that in supporting this initiative he was representing the interests of Reynolds. At all events, it is from this meeting at the Turk's Head that the move to found a Royal Academy in Britain can be dated.

The artists sought a large room in which to hold an exhibition, and found one at the Society for the Encouragement of Arts, Manufactures and Commerce in the Strand. Not allowed to charge for admission, they printed catalogues of the show, for which they charged sixpence apiece. The exhibition lasted from 21 April to 8 May 1760, and 6,582 catalogues were sold. It was, as Paulson says, the first specially organised art exhibition in England. Reynolds showed four paintings, Hogarth none. In the upshot the show proved too much of a success with the wrong kind of clientele, so the organisers, who called themselves the Society of Artists of Great Britain, availed themselves of the services of Dr Johnson in writing to arrange to hire the room again. 'The Exhibition of last year', Johnson wrote,

> was crowded and incommoded by the intrusion of great Numbers whose stations and education made them no proper judges of Statuary or Painting, and who were made idle and tumultuous by the opportunity of a shew.
> It is now therefore intended that the Catalogues shall be sold for a shilling each,

and none allowed to enter without a Catalogue which may serve as a ticket for admission.[6]

Thus Samuel Johnson stakes a claim to be the original theorist of the admission charge. He was not personally a great advocate of exhibitions, writing in 1761:

> The Artists have instituted a yearly exhibition of pictures and statues, in imitation, as I am told, for foreign Academies. This year was the second exhibition. They please themselves much with the multitude of spectators, and imagine that the English school will rise in reputation. Reynolds is without a rival, and continues to add thousands to thousands, which he deserves, among other excellencies, by retaining his kindness for Baretti. This exhibition has filled the heads of the Artists and lovers of art. Surely life, if it be not long, is tedious, since we are forced to call in the assistance of so many trifles to rid us of our time, of that time which can never return.[7]

By the next year, Johnson was composing the 'Apology' for the third exhibition, in which the catalogue was free but admission was set at one shilling:

> Of the price set upon this exhibition some account may be demanded. Whoever sets his works to be shown naturally desires a multitude of spectators; but his desire defeats his own end when spectators assemble in such numbers as to obstruct one another. Though we are far from wishing to diminish the pleasures or depreciate the sentiments of any part of the community, – we know, however, what every one knows, that all cannot be judges or purchasers of works of art, – yet we have found by experience that all are fond of seeing an exhibition. When the price was low our room was thronged with such multitudes as made access dangerous, and frightened away those whose approbation was most desired.[8]

The admission charge, upon which the fortunes of the Royal Academy were to be founded during the next decades, was from the start the key element in planning the finances of the proposed institution,

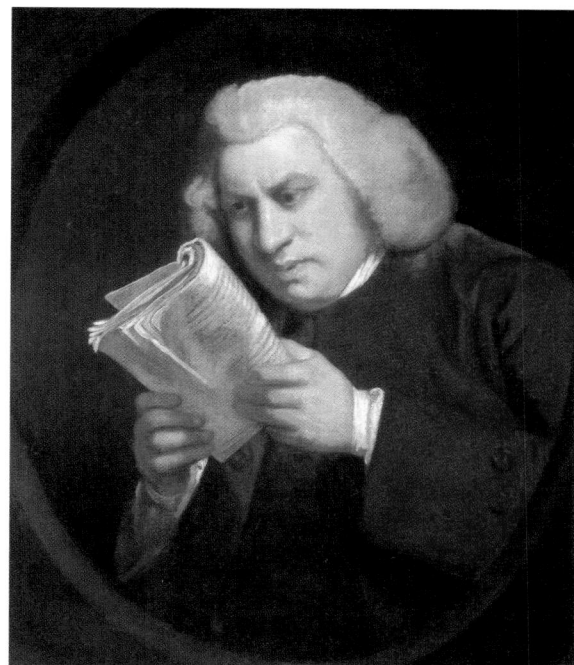

Sir Joshua Reynolds PRA (1723–1792), *Portrait of Dr Samuel Johnson*, 1775. Oil on canvas, 76.2 × 63.2 cm. Private collection

but it was also – to a conscious extent to which, very probably, little scandal attached – a device for keeping out the lower orders.

Between the first exhibition and the founding of the Royal Academy, the artists showed themselves to be fractious and apparently unable to unite around a single organisation. That would have been one good reason why Reynolds held himself carefully aloof from their squabbles. Another might be that, were a Royal Academy ever to be formed, Reynolds had no obvious rival as president. Hogarth died in 1764, and was in any case liable to be precluded by his advanced years and his personal opposition to such a scheme. Reynolds was the natural choice, if one thinks back to the tradition, which would have been current in artists' minds, that the proto-academies had formed around the leading *painter* of the day: Van Dyck, Lely, Kneller, Thornhill, Hogarth ... However much Chambers may have wished for the presidency, his being an architect would have told against him. Besides, he had worked out perhaps that there were consolations in the treasurership by the time the King, George III,

The Secret Councel of the Heads, November 1768: a satire on the plotting that preceded
the foundation of the Royal Academy. Etching after a pen-and-ink drawing by the Marquis
Townshend, 36.5 × 22.5 cm. British Museum, London

began making discreet noises to the effect that he
might well look with favour on the founding of
an Academy.

The story related in John Galt's life of Benjamin
West as to how the news was broken is so circum-
stantial as to sound plausible. The leading group
was by now known as the Incorporated Society of
Artists, and in 1768 Joshua Kirby was its recently
elected president. He was a Royal Clerk of Works,
Whitley tells us, 'a worthy man of excellent character,
but his artistic pretensions were of the slenderest and
he was wholly unfitted to act as President of a Society
that at the time included among its members, Joshua
Reynolds, Thomas Gainsborough, Richard Wilson,
John Zoffany, Francis Cotes and George Stubbs'.[9]
But Kirby, who had taught the King perspective and
had free access to his presence, was sure that the
rumoured Academy would not materialise. He told
his members as much. However, West, a young
American painter not long in Britain, had been
assured by King George himself of his interest in the

project, and it was West (in this version, which of
course comes from West) who first communicated
this intelligence to Chambers.

West was at Buckingham House one day, showing
the King a work he had painted for him, *The Departure
of Regulus*:

. . . His Majesty, after looking at it some time,
went and brought in the Queen by the hand, and
seated her in a chair, which Mr West placed in
the best situation for seeing the picture to advan-
tage. While they were conversing on the subject,
one of the pages announced Mr Kirby; and the
King consulted Her Majesty in German about
the propriety of admitting him at that moment.
Mr West, by his residence among the German
inhabitants of Lancaster in America, knew
enough of the language to understand what they
said, and the opinion of the Queen was that Kirby
might certainly be admitted, but for His Majesty
to take his own pleasure . . .

When Kirby looked at the picture he expressed himself with great warmth in its praise, enquiring by whom it had been painted; upon which the King introduced Mr West to him. It would perhaps be doing injustice to say that the surprise with which he appeared to be affected on finding it the production of so young a man, had in it any mixture of sinister feeling; but it nevertheless betrayed him into a fatal indiscretion. As a preceptor to the King, he had been accustomed to take liberties which ought to have terminated with the duties of that office; he, however, inadvertently said, 'Your Majesty never mentioned any thing of this work to me.' The tone in which this was uttered evidently displeased the King, but the discretion of the unfortunate man was gone, and he enquired in a still more disagreeable manner, 'Who made this frame?' Mr West, anxious to turn the conversation, mentioned the maker's name; but this only served to precipitate Mr Kirby into still greater imprudence, and he answered somewhat sharply, 'The person is not Your Majesty's workman;' and naming the King's carver and gilder said, 'It ought to have been made by him.' The King appeared a good deal surprised at all this, but replied in an easy good-humoured way, 'Kirby, whenever you are able to paint me a picture like this, your friend shall make the frame.' The unhappy man, however, could not be restrained, and he turned round to Mr West, and in a tone which greatly lessened the compliment the words would otherwise have conveyed, said, 'I hope you intend to exhibit this picture.' The Artist answered, that as it was painted for His Majesty, the exhibition must depend on his pleasure; but that, before retiring, it was his intention to ask permission for that purpose. The King immediately said, 'Assuredly I shall be very happy to let the work be shown to the public.' – 'Then, Mr West,' added Kirby, 'you will send it to my exhibition,' (meaning to the exhibition of the Incorporated Artists). 'No,' interposed the King, firmly, 'it must go to my exhibition, – to the Royal Academy.' Poor Kirby was thunderstruck; but only two nights before, in the confidence of his intercourse with the King, he had declared that even the design of forming such

an institution was not contemplated. His colour forsook him, and his countenance became yellow with mortification. He bowed with profound humility, and instantly retired, nor did he long survive the shock.[10]

Only the last detail of this vivid picture of an artist-courtier at the moment of realising that he had fallen from grace is known to be exaggerated. Kirby survived another five years, but he at once saw the leading figures in his Society abandon him.

How the presidency of the Royal Academy was eventually decided was related much later by Farington in his diary:

> West told Smirke and me that at a meeting at Wiltons where the subject of planning & forming the Royal Academy was discussed, Sir Wm. Chambers seemd. Inclined to be the *President*, but Penny [himself to be the Academy's first Professor of Painting] was decided, That a *painter* ought to be the *President*. It was then offered to Mr Reynolds, afterwards Sir Joshua, though he had not attended any of those meetings which were held at Mr Wiltons. – Mr West was the person appointed to call on Sir Joshua, to bring him to a meeting at Mr Wiltons, where an offer of the Presidency was made to him, to which Mr Reynolds replied that He desired to consult His friends Dr Johnson and Mr Burke upon it. This hesitation was mentioned by Sir Wm. Chambers to the King, who from that time entertained a prejudice against Reynolds, for both Johnson and Burke were then disliked by the King, the latter particularly upon political accounts.[11]

This accusation of back-stabbing seems perfectly plausible. Chambers comes across as a gifted conspirator and peddler of influence; he was not slow, when the redevelopment of Somerset House was in prospect, to put his own name forward in preference to William Robinson, the architect who had been chosen.[12] Chambers is also credited with having kept Robert Adam out of the Royal Academy for the whole of his career.[13] Adam never even submitted his designs for exhibition at Somerset House. It is worth remembering, however, that this is the eighteenth century. Adam himself, long before he set up practice in

London, knew that if he was to succeed there he had to supplant Chambers, and his letters are full of his obsessive plans to do so.[14] Chambers in a sense was only returning the compliment.

Reynolds consulted with his friends, and decided to accept. After the first memorial had been submitted, King George had asked for clarification as to the details of the scheme. This was swiftly provided by Chambers on 7 December 1768, and on 10 December, rewritten in proper form, it was signed by the King. This document is the Instrument of Foundation of the Royal Academy, and the only individual mentioned in it in connection with a particular office is Chambers, who is designated Treasurer, a post he is to hold, 'together with the emoluments thereof . . . during His Majesty's pleasure'. His salary was fixed at sixty pounds a year.

Allowance was made for forty Members of the Academy, but only 36 are inserted on the document (Reynolds being the first named), and not all of these were originally on the list, or indeed at the first meeting, which took place on 14 December. Then the General Assembly, with 28 members present, signed an Obligation to 'promote the Honour and Interest of the Establishment, so long as we shall continue Members thereof'. It was at this meeting that Reynolds was formally elected President with Moser as Keeper and Francis Milner Newton as Secretary. At this meeting too the Council and the Visitors were elected. The Council was to direct and

Richard Earlom (1743–1822), after **Michel Vincent 'Charles' Brandoin** (1733–1807), *The Exhibition at the Royal Academy in Pall Mall in 1771*, 1772. Mezzotint, 47.2 × 56.6 cm. Royal Academy of Arts, London. 03/4350

manage the business; the Visitors were to work in rotation, running the Schools, 'to set the figures, to examine the performances of the Students, to advise and instruct them, to endeavour to form their taste'.

The first home of the Academy was in Pall Mall, on the south side to the east of the site now occupied by the Institute of Directors, opposite the former Market Lane (now the Royal Opera Arcade). The building had been constructed to house Lambe's auction rooms, later Dalton's print warehouse. It possessed a top-lit gallery which can be seen in a mezzotint by Richard Earlom, after Michel Vincent 'Charles' Brandoin, showing the Academy's exhibition of the year 1771 (that is, the third of their exhibitions). But this room was only 30 feet long. The building had to house an antique academy (for studying from casts, under the supervision of Moser), a life class, and the lectures of the professors.

According to the rules, the plaster figures were to be set out afresh once a week in the Great Room, where they remained in position for seven days. A painting by the Stockholm-born Elias Martin, now itself in Stockholm, gives us an idea of how small the premises must have been, and how restricted the space for the students. In the light of a single lamp we can see casts of Sansovino's *Bacchus*, a group known as *The Cannibal*, the Uffizi *Mercury*, the *Callipygian Venus* and the Vatican group of Meleager with his dog. Since Martin's painting was exhibited at the Academy in 1770, it seems likely that all these casts came to the Academy in the first year of its existence. They may have come from the Duke of Richmond's gallery at Richmond House in Whitehall, where there had been a drawing school in 1758. Or they may have been among the effects of the Second St Martin's Lane Academy which Moser, high-handedly in the view of some of his contemporaries, commandeered for the new Royal Academy. For it must have been early in 1769 that the old casts and anatomical figures, the lamps and benches and easels made their way to Pall Mall, along with Malin the porter.

The choice of classical figures is not surprising – those in Martin's painting were among the most admired statues in the Italy of the time. Nor is it surprising to find the cast of the Sansovino *Bacchus*. What is most striking about the plaster casts available

Elias Martin ARA (1739–1818), *The Cast Room at the Royal Academy*, 1770. Oil on canvas, 122 × 98 cm. Royal Academy of Fine Arts, Stockholm

in the early days is that they included Ghiberti's gates for the Baptistery at Florence, the 'Gates of Paradise', which a council minute of 22 October 1773 orders to be placed at the end of the lecture room. This is very early for the appreciation of Ghiberti.

The plaster casts from the 'Gates of Paradise' are still in the collection at Burlington House, and their source is something of a mystery. However, in the Academy library there is a book by Thomas Patch containing a full set of engravings of one half of the Gates. These engravings were made, the text informs us, from casts. Patch, an English painter and caricaturist who settled in Florence after being expelled from Rome under unclear scandalous circumstances, had been a friend of Reynolds during the latter's Italian journey, and it may well be that Patch provided the Academy, directly or indirectly, with the casts. Whitley quotes a notice in the *Public Advertiser*:

A gentleman who has just arrived from Italy has made the Royal Academy a present of a mould of the gates of a church in Florence. These

Thomas Patch (1725–1782), 'The Creation', after **Lorenzo Ghiberti** (1378–1455), from *Libro della Seconda e Terza Porta di Bronzo della Chiesa di San Giovanni Battista di Firenze, 1403*, Florence, 1772. Royal Academy of Arts, London

gates have long been objects of curiosity among the virtuosi of Europe, insomuch so that the great Michael Angelo looking at them one day very attentively exclaimed 'these gates are fit for nothing but the gates of paradise'.[15]

Conceivably some of the scandal attendant on Patch's name led to reticence about the source of the gift.

No such explanation, however, covers the larger mystery of the source of the Leonardo Cartoon,

The Virgin and Child with St Anne and St John the Baptist (now in the National Gallery, London). The earliest visual evidence of the existence of this now-famous work anywhere in the world is in a drawing of 1779 by Edward Francis Burney entitled *The Antique School at Somerset House*, in which the cartoon hangs in the corner to the left of the door, over some plaster casts of body parts – an insignificant part of the composition, but giving us a very good notion of the way such large-scale drawings (naturally vulnerable

and liable to be cut up or destroyed) managed to survive in studios and academies.

The first written record of the work at the Royal Academy dates from 23 March 1790:

> The Cartoon by Leonardo da Vinci, in the Royal Academy, being in a perishable state, having been neglected many years.
>
> Resolved that it have all the possible repairs, and be secured in a frame and glasses – which the Secretary is requested to take charge of.[16]

The earlier history of the cartoon can only be reconstructed in part. The supposition is that it formed part of the estate of the artist himself, and would thus have been inherited by his pupil Francesco Melzi. From Melzi it seems to have passed into the possession of Bernardino Luini, who painted a version of the Holy Family deriving from the design. At Luini's death in 1535, it would have passed to his son Aurelio, who showed it to G. P. Lomazzo, who provides the first description of it. Lomazzo says that Leonardo

> expressed in the Virgin Mary the joyfulness and happiness she was feeling because of the beautiful child, Christ, she had given birth to, and because she was considered worthy of being His mother. And so with St Anne, who was showing great joy and satisfaction in looking at her daughter, Mother of God, and knowing herself to be beatified.

From the Luini household it seems to have passed into the possession of Leone Leoni, whose grand Milanese establishment, the Casa degli Omenoni, still exists, an example of the wealth and status that could accrue to the artists of the period. Leone Leoni and his son Pompeo Leoni were sculptors who built up an art collection, including two cartoons said to be by Leonardo. One was the now lost design for *Leda and the Swan*. The other was this Holy Family. Both works are mentioned in two inventories dated 1609 and 1615. Around this time the Grand Duke of Tuscany corresponded with his ambassador in Milan, with a view to making purchases from the Leoni collection, but the expert he sent to look at the cartoons told him they were not worthy of him.

Shortly afterwards, Count Galeazzo Arconati acquired the Leoni collection, and the two cartoons remained in his collection until around 1720, when they passed to the Casenedi family, also in Milan. It is here that the English grand tourist Edward Wright saw them in 1720–21, in a room devoted to the display of drawings and cartoons, which he describes in detail:

> The Marquis of *Casenedi*, the Son, has a Room entirely furnish'd with Drawings; many very good; some of *Raphael*, the *Caracci*, *And. Del Sarta*, *Pietro da Cortona*, &c. also of the *Procaccini Camillo*, *Jul. Caesar*, and *Hercules*, with several others of the *Milanese* School. But those which are most admirable in this Collection, are the Cartones of *Leonardo da Vinci*, done in Chalks, but rais'd a little higher with other Crayons: They are so excellent, that *Raphael*, as they affirm there, copied them all. He has certainly taken the Countenance of one of them in his *Transfiguration*-Piece; it is the figure below the Mount, which holds the possess'd Boy; at least the one puts me very much in mind of the other. Eleven of them are Designs of all the Heads, and some of the Hands, which Leonardo put into his celebrated Piece of the *Last Supper* painted by him in Fresco in the Refectory of the *Gratie*, which is now in a manner spoiled. Two of these Cartones contain two Heads apiece; so that in the eleven Cartones are drawings of thirteen Heads. The rest of them are as follows,
>
> A Ritratt of a Dutchess of *Milan* [Sforza]. Another Ritratt Profile, without Hands. An old Man resting his Cheek on his left Hand. A *Holy Family*, the same which is painted in Oil in the Sacristy of S. *Celsus*. A *Leda*, standing naked, with Cupids in one of the corners at the bottom. All of these are by *Leonardo da Vinci*, and are as big as the Life. There is likewise in the same Room, a Drawing said to be of *Raphael*, and another of Andrea del Sarta. These drawings of *Leonardo da Vinci*, and the two last mention'd, were purchas'd for about three hundred Pistoles, a Year before we saw them, or thereabouts, of Count Arconati, Descendant of him that gave the Volumes to the Ambrosian Library.[17]

Here we see the kind of tempting display of art which brought English collectors to Italy in large numbers. We should not assume, however, that all these attributions would hold good today. Nevertheless it is clear that the two cartoons, the Leda and the Holy Family, were still together around 1720. If, however, the Burlington House cartoon went, as scholars have asserted, to the Sagredo collection in Venice, then it must have been sold relatively soon afterwards, since Zaccaria Sagredo, who formed the collection, died in 1729.

It is frustrating that over the next decades the history of the cartoon becomes obscure. The Sagredo collection was broken up. Two British consuls in Venice, Joseph Smith and John Udney, acquired works from it. It is thought that John Udney perhaps bought the cartoon on behalf of his brother Robert, a wealthy West India merchant with homes in Mayfair and Teddington, and a gallery in the latter. Robert Udney had a connection with the Royal Academy through his patronage of Edward Edwards, who was an Associate and a teacher of perspective there from 1788 to 1806. But the Council note of 1790 seems to imply that the cartoon has been hanging around *at the Academy*, neglected, for many years.

Nor was it yet held to be an object of extraordinary value, for in 1798 the Council saw no problem in allowing Anker Smith to borrow it, in order to make an engraving. Between February and December of that year, Smith kept it at his home, while he made the first reproduction of what was to become one of the National Gallery's most famous masterpieces, after the Academicians had sold it off.

Edward Francis Burney (1760–1848), *The Antique School at Old Somerset House*, 1779. Pen and ink with watercolour wash on laid paper, 33.5 × 48.5 cm. Royal Academy of Arts, London. Purchased from Colnaghi, 5 July 1960. 03/7485

5 'This Man was Hired to Depress Art': Reynolds versus Blake

Reynolds's later Discourses were delivered to the students of the new Academy at the time of the distribution of prizes, but the first Discourse was naturally to Academicians only, since as yet there were no students. The date was 2 January 1769. No great ceremony seems to have been involved, and no members of the royal family attended.

Reynolds's speech has been criticised, even mocked, for his observation, which he later removed from the published text, that

> the Arts have ever been disposed to travel westward. *Greece* is thought to have received them from her more eastern neighbours. From the *Greeks* they migrated into *Italy*; from thence they visited *France*, *Flanders* and *Holland*, enlightening, for a time, those countries, though with diminished lustre; but, as if the ocean had stopped their progress, they have for near an age stood still, and grown weak and torpid for want of motion. Let us for a moment flatter ourselves that they are still in being, and have at last arrived at this island. Our Monarch seems willing to think so, having provided such an Asylum for their reception, as may induce them to stay where they are so much honoured.[1]

This idea of the westward progression of the arts is one of those poetic notions which, if anyone were to

choose to examine it, would not last long, however well it may have done on the day. Yet Reynolds picks up again this theme of a country at the beginning of its artistic career when he says:

> One advantage, I will venture to affirm, we shall have in our Academy, which no other nation can boast. We shall have nothing to unlearn. To this praise the present race of Artists have a just claim. As far as they have yet proceeded, they are right. With us the exertions of genius will henceforward be directed to their proper objects. It will not be as it has been in other schools, where he that travelled fastest, only wandered farthest from the right way.[2]

This dismissal of the English School, as it had been hitherto, this announcement of zero hour for a nation's art, may take our breath away. But it may well accurately reflect what some of the Academy's founders felt.

Reynolds makes a suggestion that afterwards hovered around the Academy for years, but never prospered. Almost at once he was proposing a permanent collection of the works of the old masters. There was at the time in London no equivalent of the National Gallery. Reynolds argued that

> The principal advantage of an Academy is, that, beside furnishing able men to direct the Student, it will be a repository for the great examples of the Art. These are the materials on which Genius is to work, and without which the strongest intellect may be fruitlessly or deviously employed. By studying these authentick models, that idea of excellence which is the result of the accumulated experience of past ages, may at once be acquired; and the tardy and obstructed progress of our predecessors may teach us a shorter and easier way. The Student receives, at one glance, the principles which many Artists have spent their whole lives in ascertaining; and, satisfied with their effect, is spared the painful investigation by which they came to be known and fixed.[3]

Reynolds was a great collector, and as soon as he had money he was spending it in the auction rooms.

Eventually around 1791, just before his death, he offered his collection to the Royal Academy at what Northcote says was a low price, but it was turned down.

Reynolds's idea was to acquire the Lyceum in the Strand, as an annexe to the Academy. Here would be shown the Laocoön and other large casts for which the Academy had only restricted space, and there might be a studio to put at the disposal of the Keeper. This was rejected on grounds of expense. Reynolds was disappointed. He decided to exhibit his collection anyway, and took two large rooms in the Haymarket, where he showed 176 paintings, three drawings and the Bernini *Neptune*, now at the Victoria and Albert Museum. The proceeds of the admission charge went to his long-time servant Ralph Kirkley, and the catalogue was entitled *Ralph's Exhibition*. McIntyre quotes a note at Yale: 'This was never intended as a scheme for getting mony, but mony at any rate must be taken for the same reason it is taken at the Exhibition even of a R.A. as no other means can be suggested to keep out the Mob.'[4]

William Pressly reminds us that James Barry, the Academy's ill-fated second Professor of Painting, cherished the same idea of a permanent collection, and wanted to use some funds that had been set aside for pensions for this purpose:

> He wanted to extend the exhibition space for sculpture and to buy and house masterpieces for the edification of the students and the public, an action, it was to be hoped, which would eventually lead to the formation of a national gallery. Barry knew that this proposal and similar ones were doomed to failure because he felt the Academy's majority desired to suppress great art that would expose their own inferior perform-ances. He did not pull his punches, once even referring to the group as 'this most odious of all jacobinical conspiracies, where mere scum and offal direct and govern'.[5]

However, Reynolds, in his opening speech, had no sooner urged the necessity of a study collection than he had to concede a counter-argument, and he does so in beautiful language:

Raffaelle, it is true, had not the advantage of studying in an Academy; but all Rome, and the works of Michael Angelo in particular, were to him an Academy. On the sight of the Capella Sistina, he immediately from a dry, Gothick, and even insipid manner, which attends to the minute accidental discriminations of particular and individual objects, assumed that grand style of painting, which improves partial representation by the general and invariable ideas of nature.[6]

And next comes the lovely sentence in which he tells us that 'Every seminary of learning may be said to be surrounded with an atmosphere of floating knowledge...' with its twin thought that 'a youth more easily receives instruction from the companions of his studies, whose minds are nearly on a level with his own, than from those who are much his superiors; and it is from his equals only that he catches the fire of emulation'. In other words, we learn from our peer group rather than from our superiors – a surprising thought for such an occasion, but one surely that will strike a chord with any former student.

Reynolds's fifteen Discourses, delivered between 1769 and 1790, just over a year before his death, are among the great monuments bequeathed by the Academy, and they achieved a reputation throughout Europe. Even in the short extracts already given we have seen a clear expression of the kind of classic distinction they make, between the 'dry, Gothick' manner attributed to the early Raphael, with its 'minute accidental discriminations of particular and individual objects' and the grand style, with its attention to the 'general and invariable ideas of nature'.

And the modern reader may immediately feel that he would prefer the Gothick, on this account,

Thomas Rowlandson (1756–1827), *The Historian Animating the Mind of a Young Painter*, 1784. Etching, 18.8 × 26.1 cm. Royal Academy of Arts, London

if the Gothick is the spirit in art that makes these minute accidental discriminations, while the grand style deals in the immutable, the ideal. But the theory Reynolds expresses is ancient in origin and was both widespread and dominant in the Europe and indeed in the America of the day, and to regret it is like regretting history itself.

William Blake more than regretted, he detested Reynolds, and his annotations to his copy of the *Discourses* (now in the British Library) provide one of the most withering assessments of one man by another: Blake says of Reynolds that 'This Man was Hired to Depress Art.' He goes on defiantly, 'This is the Opinion of Will Blake: my Proofs of this Opinion are given in the following Notes.'[7] Those notes filled Alexander Gilchrist, Blake's biographer, with dismay: 'Angels of light make sorry wits – handle mere terrestrial weapons of sarcasm and humorous assault in a clumsy, ineffectual manner.'[8] But the annotations are another distinctive product of the Academy, and, if laying one's cards on the table counts for virtue in an author, these annotations are virtuous:

> Having spent the Vigour of my Youth & Genius under the Opression of Sr Joshua & his Gang of Cunning Hired Knaves Without Employment & as much as could possibly be Without Bread, The Reader must Expect to Read in all my Remarks on these Books Nothing but Indignation & Resentment. While Sr Joshua was rolling in Riches, Barry was Poor & Unemploy'd except by his own Energy; Mortimer was call'd a Madman, & only Portrait Painting applauded and rewarded by the Rich & Great. Reynolds & Gainsborough Blotted & Blurred one against the other & Divided all the English World between them. Fuseli, Indignant, almost hid himself. I am hid.

That sense of abiding injury at the hands of the artistic establishment is hard to square with the surviving evidence that Blake spent a brief time as a student of the Academy, where he was probably as irreverent as anyone else,

William Blake's indignantly annotated copy of *The Works of Sir Joshua Reynolds ... Second edition, corrected*, London, 1798. British Library, London

Sir Joshua Reynolds pinx.

SIR JOSHUA R

Tum demum sana mentis

incipit, ubi corporis oculus in

Publish'd according to Act of Parliament Ma

Caroline Watson Engraver
to her Majesty sculpsit.

YNOLDS.

ulus acute cernere

it hebescere.

Seneca.

1789 by T Cadell, Strand.

This Man was Hired to Depress Art

THE

WORKS

This in the Opinion of Will Blake

OF

SIR JOSHUA REYNOLDS, KNIGHT;

LATE PRESIDENT OF THE ROYAL ACADEMY:

my Proofs

CONTAINING

HIS DISCOURSES, IDLERS,

of this Opinion

A JOURNEY TO FLANDERS AND HOLLAND,

are given in the

AND HIS COMMENTARY ON DU FRESNOY'S ART OF

PAINTING;

following Notes

PRINTED FROM HIS REVISED COPIES,

(WITH HIS LAST CORRECTIONS AND ADDITIONS,)

IN THREE VOLUMES.

TO WHICH IS PREFIXED

AN ACCOUNT OF THE LIFE AND WRITINGS OF THE
AUTHOR,

By EDMOND MALONE, ESQ.

ONE OF HIS EXECUTORS.

THE SECOND EDITION CORRECTED.

QUASI NON EA PRÆCIPIAM ALIIS, QUÆ MIHI IPSI DESUNT. CICERO.

VOLUME THE FIRST.

LONDON;

PRINTED FOR T. CADELL, JUN. AND W. DAVIES, IN THE STRAND.

1798.

Advice of the Popes who succeeded the Age of Rafael
Degrade first the Arts if you'd Mankind Degrade.
Hire Idiots to Paint with cold light & hot shade:
Give high Price for the worst. leave the best in disgrace,
And with Labours of Ignorance fill every place.

playing at leap frog, knocking the hand off Michelangiolo's beautiful Fawn, spouting water, breaking the fingers of the Apollo, pelting one another with modeller's clay and crusts of bread, roasting potatoes in the stove, teizing the Keeper by imitating cats. . .[9]

The story of Blake's argument with Moser, cited in the Introduction, is another example of a sort of 'teizing the Keeper'. Blake himself used to tell the story of an exchange with Reynolds, in which the President appeared, in Gilchrist's words, 'very pleasant personally':

'Well, Mr Blake,' blandly remarked the President, who doubtless, had heard strange accounts of his interlocutor's sayings and doings, 'I hear you despise our art of oil-painting.' 'No, Sir Joshua, I don't despise it; but I like fresco better.'[10]

But on another occasion Gilchrist tells us that Blake's experiences 'were not wholly of Sir Joshua's "blandness"':

'I once remember his talking to me of Reynolds,' writes a surviving friend: 'he became furious at what the latter had dared to say of his early works. When a very young man he had called on Reynolds to show him some designs, and had been recommended to work with less extravagance and more simplicity, and to correct his drawing. This Blake seemed to regard as an affront never to be forgotten. He was very indignant when he spoke of it.'[11]

One has to remember that Blake (born in 1757) applied to join the Academy in 1779, when he was already quite capable of producing the work for which he remains famous. Drawings for *Glad Day* were executed around 1780. The nude study of the side view of a young man, in the British Museum, is also traditionally dated to this period. Clearly it is a version of an academy, but it is a version that immediately declares its independence from the academic context in which it was executed. David

Bindman suggests, convincingly, that the work is a self-portrait, and this accounts for the intensity with which the model engages the viewer. Deference would not have come easily to the young artist capable of such a work.

We are told that Blake

began a course of study at the Royal Academy, under the eye of Mr Moser. Here he drew with great care, perhaps all, or certainly nearly all the noble antique figures in various views. But now his peculiar notions began to intercept him in his career. He professes drawing from life always to have been hateful to him; and speaks of it as looking more like death, of smelling of mortality. Yet he still drew a good deal from life, both at the academy and at home.[12]

The British Museum drawing would fit neatly into the category of a life drawing done from home.

The bitterness with which Blake wrote his annotations to Reynolds, around 1820, is that of one who has suffered his own struggles and seen the talent of those artists he admired, such as Barry, face disappointment. But it is also the expression of a powerful artistic antitype, the radical opponent of what Reynolds stood for. To take an example already quoted, Reynolds contrasts the 'dry, Gothick' manner of the early Raphael with his grand manner after seeing the Sistine Chapel. The first manner 'attends to the minute accidental discriminations of particular and individual objects', while the second is concerned with the 'general and invariable'. Blake will have none of this. 'Minute Discrimination is Not Accidental. All Sublimity is founded on Minute Discrimination.' Sublimity in art, by implication, is nothing to do with the fuzziness of grandiose suggestion. It is to do with accuracy. Blake goes on:

I do not believe that Rafael taught Mich. Angelo, or that Mich. Angelo taught Rafael, any more than I believe that the Rose teaches the Lilly how to grow, or the Apple tree teaches the Pear tree how to bear Fruit. I do not believe the tales of Anecdote writers when they militate against Individual Character.

William Blake (1757–1827), *Academy Study: Standing Male Nude Seen from Behind, c.* 1779–80. Pencil on paper, 34.9 × 22.5 cm. British Museum, London. BM 1874-12-12-110

It is vain to object here that Reynolds had studied Raphael and Michelangelo in the Vatican, whereas Blake in his whole life never strayed more than fifty miles from London, and had most of his knowledge of their work through engravings. Blake has somehow raised the level of debate, and at this level Reynolds is no match for him. Reynolds may have thought he was on safe ground to say that

> Albert Durer, as Vasari has justly remarked, would, probably, have been one of the first painters of his age . . . had he been initiated into those great principles of the art, which were so well understood and practised by his contemporaries in Italy.[13]

Blake pounces on this:

> What does this mean, *'Would have been' one of the first Painters of his Age?* Albert Durer *Is,* Not would have been. Besides, let them look at Gothic Figures & Gothic Buildings & not talk of Dark Ages or of any Age. Ages are all Equal. But Genius is Always Above The Age.

Here is Reynolds on nature:

> All the objects which are exhibited to our view by nature, upon close examination will be found to have their blemishes and defects. The most beautiful forms have something about them like weakness, minuteness, or imperfection.[14]

And here Blake:

> Minuteness is their whole Beauty.

To prove that Blake, who by the time he came to the Academy had already served a seven-year apprenticeship as an engraver, had no objection to the curriculum on principle, here is Reynolds on copying:

> How incapable those are of producing any thing of their own, who have spent much of their time in making finished copies, is well known to all who are conversant with our art.

And here Blake:

> This is most False, for no one can ever Design till he has learn'd the Language of Art by making many Finish'd Copies both of Nature & Art & of whatever comes in his way from Earliest Childhood. The difference between a bad Artist & a Good One Is: the Bad Artist Seems to Copy a Great deal. The Good one Really Does Copy a Great deal.

At the very least, Blake's is the superior wit, and the greater gift for the memorable phrase. And he is implacable:

> When Sr Joshua Reynolds died
> All Nature was degraded;
> The King drop'd a tear into the Queen's Ear,
> And all his Pictures Faded.

The last remark sounds absurd but is substantially true.

William Blake (1757–1827), *A Naked Youth Seen from the Side, perhaps Robert Blake, c.* 1779–80. Black chalk on paper, 47.9 × 37 cm. British Museum, London. BM 1878-4-13-34

6 Somerset House: Reynolds versus Chambers

The Academy, so the paradox runs, was concerned with the founding of a national school of art, yet the impulse to create it came from an internationally minded group of artists. Many were of foreign origin. Several had studied abroad and some were members of European academies. And occupying the important post of Treasurer, was an architect of Anglo-Swedish origin, whose first job had been with the Swedish East India Company and who had received his architectural training in Paris and Rome.

This was Sir William Chambers, the man we encountered earlier walking through the deserted apartment of Catherine of Braganza in Old Somerset House, marvelling at the 'elegant simplicity in the architecture' and regretting 'the necessity for its destruction'.[1] He not only regretted it. He had complained, when the commission for New Somerset House went to an inferior architect, William Robinson, that Robinson's designs showed 'no mercy for poor Inigo Jones's fine front . . . nor for a great part of that extensive palace almost new, having only been built about thirty years'. He is referring to alterations made by William Kent in the 1740s. 'I could easily save both,' says Chambers, 'and many thousands of pounds, but neither I, nor any of the Board officers are consulted, even in this vast work, which is to contain at least a dozen offices, and which the ground alone is to cost the nation seventy-eight thousand pounds.'[2]

Chambers went on to campaign against Robinson, and got Edmund Burke on his side. Burke and his fellow men of taste took the view that the new offices should be 'an object of national splendour as well as convenience' and 'a monument to the taste and elegance of His Majesty's reign'.[3] At this point, the unfortunate Robinson, no doubt seeing the odds stacking up against him, did the sensible

George Dance RA (1741–1825), *Portrait of Sir William Chambers RA*, 17 March 1793. Pencil with black and pink chalks on cream wove paper, 24.9 × 18.8 cm. Royal Academy of Arts, London. Purchased from the artist, 1813. 03/3263

Pietro Antonio Martini (1738–1797), after Johann Heinrich Ramberg (1763–1840), *The Exhibition of the Royal Academy, 1787*, 1787 (detail). Etching, 31.6 × 48.9 cm. Royal Academy of Arts, London. 03/332

Louis-Jean Desprez (1743–1804), *View of the Quadrangle, Somerset House, Strand*, undated. Pencil, pen and brown and grey wash on paper, 70.7 × 128.6 cm. Sir John Soane's Museum, London. SM 17/8/1

thing: he died. The project went to Chambers. And then the logic of Burke's grand plan kicked in, and instead of saving any of Jones's or Kent's work, Chambers, no doubt with a heavy heart, destroyed the lot.

What he put up in its place was unparalleled in London at the time, but reflected a careful observation of public buildings in Paris, such as the Louvre and the Mint, the Hôtel des Monnaies. New Somerset House was a huge project, only a small part of which had anything to do with the Academy. It was to house a set of offices serving the functions of the Navy, and the symbolism of the façade on the north side, the Strand frontage, was to do with Ocean, the rivers, empire, virtue and fame. On the south side, the waters of the Thames lapped the basements of the building.

The connection between the Academy and the Navy was accidental – the Academy happened to be using Old Somerset House and would therefore need replacement rooms when that building was pulled down. The connection on the other hand between the Academy and royalty was not at all accidental, least of all in Chambers's mind. The artists had

acquired their institution through the sanction of the King, and that came at a price, as Nicholas Savage argues:

> The price exacted for such sanction was complete unanimity among the artists on one crucial point, namely, that the success of the new institution must henceforth utterly depend on submission to the approval of the King, not only for the details of its constitution but also for the selection of its membership. None of the functions of the new Academy were new – the vital difference was in how these functions were to be validated. The forty Royal Academicians were now in effect charged, by virtue of their selection, with the task of carrying out the royal wish to protect and foster the arts. As quasi-servants of the crown they occupied positions analogous to Chambers's own existing office as Architect to the King.[4]

It is in this sense that the move to New Somerset House would have been symbolic. The Royal Academy had begun by meeting in a set of auction rooms, which it hired, season by season. Now it

had an official residence, alongside the Royal Society and the Society of Antiquaries, but in the much larger context of Navy and Empire. It was as if the arts had been elevated to governmental level.

The Strand façade, designed in the Palladian tradition, is considered a tribute by Chambers to Inigo Jones, the architect whose work he had had to destroy. It was

> an attempt to unite the chastity and order of the Venetian Masters with the majestick grandeur of the Roman. The great proportions are such, as have been observed by Palladio in the Tieni, Porti and other of his Palaces in and about Vicenza; and with regard to form, disposition, and measure, chiefly collected from the same Palladio, from Vignola, from Raphael, from Baldassar Peruzzi.[5]

The Strand façade is the smallest of the main elements in the overall design, and the first part to be built. But it is large enough to include features of great grandeur, such as the vaulted brick basements now used by the library of the Courtauld Institute. The colonnaded vestibule, with its view onto the great square, is reminiscent of one of the entries to the Louvre courtyard.

Turning right into the Royal Academy's premises, one was immediately confronted by Joseph Wilton's busts of Michelangelo and Newton (the latter, one

John Constable RA (1776–1837), *Somerset House*, c. 1819.
Oil on paper laid on canvas, 20.3 × 25.4 cm. Royal Academy of Arts, London. 03/1389

Thomas Rowlandson (1756–1827), *The Exhibition 'Stare-Case',*
Somerset House, c. 1800. Watercolour with grey and brown
wash on paper, 44.7 × 29.8 cm. Yale Center for British Art,
New Haven. Paul Mellon Collection

of Blake's greatest bugbears), and a room furnished
with plaster casts of various canonical classical
sculptures, including the Furietti Centaurs, still in
place today. To the right lay the Porter's Lodge and
the Life School, which, by the time Rowlandson
drew it in 1808, was thickly furnished with busts
and other works of art, as well as the traditional
semicircular benches and the lamp (or one like it)
whose career we have traced across town.

Ahead, if one passed the centaurs and their
Doric screen, rose the famous staircase – Chambers
was an inspired designer of stairs – once again the
subject of Rowlandson's pen: *The Exhibition 'Stare-Case',*
Somerset House, the ascent so steep it aroused in men
the desire to look up women's skirts. It is depicted,
less satirically and yet in a not dissimilar spirit,
in the background of a beautiful pastel portrait
of a porter at the Royal Academy in 1792 by the
Academician John Russell, acquired not long ago

George Johann Scharf (1788–1860), *The Entrance Hall of the Royal Academy, Somerset House*, 1836. Watercolour, strengthened with gum, on paper, 45.7 × 68.6 cm. British Museum, London. PDB 2586

Attributed to Johann Zoffany RA (1733–1810), *The Antique School at the Royal Academy*, c. 1780–83.
Oil on canvas, 110.4 × 164 cm. Royal Academy of Arts, London. Purchased from James Stewart in 1878. 03/846.
The professor in the room has been identified as George Michael Moser RA, the Academy's first Keeper

John Russell RA (1745–1806), *A Porter of the Royal Academy*, 1792. Pastel on paper, 77 × 64 cm. Courtauld Institute of Art Gallery, London

by the Courtauld Institute of Art Gallery.[6] An impression is given of a completely packed space.

Hutchison points out the sobering thought that

all works submitted for the exhibitions between 1780 and 1836 must have been either carried up this steep, winding ascent, from the entrance hall to the exhibition rooms, or else hauled up the well by ropes. Great full-lengths by Reynolds, Gainsborough, Raeburn and Lawrence, etc., which are now precious treasures, were subjected to this peril. There is proof that the climb was arduous in that a chair used to be placed on each landing when Queen Charlotte visited the exhibitions, in order that she might rest. . .[7]

Samuel Johnson, at the age of 75, in the last year of his life and when he had difficulty in walking to church, could nevertheless cheerfully report: 'I am favoured with a degree of ease that very much delights me, and do not despair of another race upon the stairs of the Academy.'[8]

On the first, the principal, floor of the new building were two rooms given over to the Academy of Antiques. Two early depictions of this, one attributed

to Zoffany, the other by Edward Burney (pages 100–01), show students drawing from the antique respectively by night and by day. On this floor were also the Library, and the Assembly or Lecture Room, shown in a painting of 1795 by Henry Singleton; all the works on the walls are known to have been exhibited in these positions and are still in the possession of the Royal Academy.[9] This room, also known as the Council Room, was the scene of Academy dinners, such as the one in 1813 of which Constable records:

> I dined with the Royal Academy last Monday in the council room. It was entirely a meeting of artists (none but the members and exhibitors could be admitted), and the day passed off very well. I sat next to Turner, and opposite Mr West and Lawrence. I was a good deal entertained with Turner. I always expected to find him what I did. He has a wonderful range of mind. . .[10]

One floor further up, the visitor reached an ante-room decorated with antique busts in niches, and an inscription: ΟΥΔΕΙΣ ΑΜΟΥΣΟΣ ΕΙΣΙΤΩ, let no one enter who is without the Muse. And at that point you were supposed to remember the original Academy of Plato, since the inscription was traditionally derived from his study. The ante-room led, and still leads, into the Great Room, the top-lit gallery where the annual exhibitions were held. In 2001, in a remarkably successful experiment,[11] this room was hung again as it would have been for one of those shows, which are well recorded in numerous paintings and drawings. The first thing the modern

Henry Singleton (1766–1839), *The Royal Academicians in General Assembly*, 1795.
Oil on canvas, 198.1 × 259 cm. Royal Academy of Arts, London. Given by Philip Hardwick RA, 1861. 03/1310

Thomas Sandby RA (1723?–1798), *The Royal Academy Exhibition of 1792: The Great Room, East Wall*, c. 1792. Pen and wash, 18.9 × 31.1 cm. Royal Academy of Arts, London

visitor realised was how small the room is, in comparison to the impression given by such images. And the second, immediate impression was how well the unfamiliar system of hanging worked, and how easy the paintings were to view, cantilevered forward from the walls.

The room looks smaller than it does in the drawings because the artists have opened up the perspective in order to increase the visibility of the contents. The method of hanging, which involved tilting the paintings forwards at 17 degrees to the perpendicular, was successful because it facilitated the viewing of paintings hung high: the tilt eliminates reflections and shadows, but it also enormously increases the sense that the painting is there to be viewed, and has not been simply 'skyed' (hung high in order to get it out of the way).

In the twentieth century, a convention grew up that any serious museum or gallery hang would consist of a single line of paintings displayed at head height. But this museum practice had never applied

in the great private collections, or in the palaces and stately homes of previous centuries. Nor is it likely that artists expected their works to be part of a single hang. What they wanted – and this is quite a different ambition – was pride of place. The witty expression of a later age – it is not enough to succeed; others must be seen to fail – could apply very well to what the artists wanted out of these Royal Academy exhibitions.

The drawings by Thomas Sandby showing the walls of the Great Room in the exhibition of 1792 give a good idea of the mechanics of such a hang. At a height of eight feet from the floor ran the all-important 'line', which was like a thick picture-rail. Below it hung the smaller paintings, for if these were not immediately below the line they would be hard to see in a great crush. Above the line hung the larger paintings, and they were attached to a specially constructed armature that held them at the required 17-degree angle. Before each exhibition, carpenters would arrive and fix up this armature, which was in turn covered in green baize.

When the large paintings were hung, the most visible place would be immediately above the line, which would keep the painting above the heads of the crowd, but close enough for ease of viewing. The system was apparently Chambers's invention. It was bound to cause dissent and acrimony. Gainsborough sent two letters in April 1783:

> To The Committee of Gentlemen
> appointed to hang the Pictures
> at the Royal Exhibition
>
> Mr Gainsborough presents his Compliments to The Gentlemen appointed to hang the Pictures at the Royal Academy; and begs leave to *hint* to Them, that if The Royal Family, which he has sent for this Exhibition (*being smaller than three quarters*) are hung above the line along with full lengths, he never more, whilst he breaths, will send another Picture to the Exhibition – This he swears by God.
> Saturday morn.[12]
>
> To F. M: Newton Esq.re [Secretary of the Royal Academy]
>
> Dear Newton
> I wd. beg to have them hung with the Frames touching each other, in this order, the Names are written behind each Picture –
> God bless you. hang my Dogs & my Landskips in the great Room. The sea Piece you may fill the small Room with –
> Yors. sincerely in haste
> T. Gainsborough[13]

The committee on this occasion did as he asked, following the appended sketch.

The next year he was back again:

> Mr Gainsborough's Compts to the Gentn of the Committee, & begs pardon for giving them so much trouble; but as he has painted the Picture of the Princesses in so tender a light, that notwithstanding he approves very much of the established Line for Strong Effects, he cannot possibly consent to have it placed higher than five feet & a half, because the likeness & Work of the Picture will not be seen any higher;

therefore at a Word, he will not trouble the Gentlemen against their Inclination, but will beg the rest of his Pictures back again – Saturday Evening[14]

The reply was business-like:

> Sir,
> In compliance with your request the Council have ordered your Pictures to be taken down & to be delivered to your order, when ever Send for them.
> I am and &c
> Saturday evening 9 o/clo: FM. Newton Secy

For the last five years of his life Gainsborough mounted exhibitions of his own work at his home, Schomberg House, Pall Mall. He did not submit to the Academy again. But in 1788 he wrote to Reynolds from his deathbed:

> Dear Sir Joshua,
> I am Just to write what I fear you will not read, after lying in a dying state for 6 month The extreem affection which I am informed of by a Friend which Sir Joshua has expresd induces me to beg a last favor, which is to come once under my Roof and look at my things, my Woodman you never saw, if what I ask more is not disagreable to your feeling that I may have the honor to speak to you. I can from a sincere Heart say that I always admired and sincerely loved Sir Joshua Reynolds.
> Tho Gainsborough[15]

Reynolds went, and shortly afterwards was one of the pall-bearers at Gainsborough's funeral.

No final reconciliation of this kind appears to have been achieved between Reynolds and his institutional rival, Chambers. However much Chambers may have craved the presidency, he undoubtedly designed for himself the next best outcome in the founding of the Academy: as we saw in Chapter Four, he had himself expressly appointed, by name, by the King, to the post of Treasurer – he was to be the conduit of the King's interest in Academy affairs. His autocratic tendencies are well documented, and are seen most vividly, towards the end of his life, in his conduct towards Reynolds on two notorious occasions.

Dear Newton, I wd beg to have them hung with the Frames touching each other, in this order, the Names are written behind each Picture —

God bless you. hang my Dogs & my Landskip in the great Room. — The sea Piece you may fill the small Room with — Yrs sincerely in haste

T. Gainsborough

Thomas Gainsborough RA (1727–1788), Letter to the Secretary of the Royal Academy, Francis Milner Newton RA, with appended sketch indicating his preferred hang for his entries to the annual Exhibition in 1783

Sir Joshua Reynolds PRA
(1723–1792), *Portrait of James Boswell*, 1785. Oil on canvas, 76.2 × 63.5 cm. National Portrait Gallery, London. NPG 4452

In the first affair, Reynolds was widely held by his contemporaries to have been at fault, and Boswell later said that it was one reason why he had rejected the idea of writing Reynolds's biography. To us, the motivations of the participants may seem petty and obscure, but the passions aroused come across vividly in a document still in the Academy's possession. This is the 'Apologia' Reynolds began to write in his fury, after resigning the presidency in 1790. He was so angry at the way he had been treated in the choice of a new Professor of Perspective that he was prepared to risk ridicule by publishing his version of events, and the Academy's furious manuscript is this version as far as it went, before Reynolds was mollified and his resignation withdrawn.

The Professorship of Perspective had fallen vacant in 1786, on the death of Samuel Wale. There seeming to be no appropriate successor within the ranks of the Academicians, Chambers proposed that someone should be elected to the Academy expressly for the purpose of taking up the Chair. Reynolds had his candidate in the person of Giuseppe, or Joseph, Bonomi, a former architectural draughtsman for the Adam brothers. Obviously well qualified for the job, he had been exhibiting at the Academy for the last few years, while his architectural practice in England had grown, and in 1789 he was elected Associate of the Royal Academy, but only on the casting vote of Reynolds.

The post of Professor of Perspective does not seem to have been much coveted. There was only one rival

candidate in the person of Edward Edwards, a figure only remembered now for his posthumous *Anecdotes of Painters* (a sequel to Horace Walpole's volumes of similar title). Edwards was also an Associate of the Academy, and indeed taught perspective there, although not as a professor. When asked to supply specimen drawings for the Council to consider, however, Edwards replied that he was 'past being a boy' and would produce none.[16] Bonomi on the other hand sent two. He himself does not appear to have eagerly sought the professorship (or indeed membership of the Academy; one remembers that his former employers, the Adam brothers, were never members or exhibitors there), but rather to have been caught up in a dispute not of his making.[17]

In principle, one would have expected Chambers to have been prepared to support Bonomi as being the more distinguished candidate. Reynolds argued against the view that great abilities, or the ability to produce splendid drawings, were not required from the new professor, that 'moderate abilities were sufficient'. Such sentiments might be excused, he said, if one were electing a perspective teacher 'for one of those boarding schools about London which are dignified with the name of Academys'. Reynolds then no doubt lifted his eyes as he made the next point, for he went on that 'the highly ornamented ceiling of the room in which we were then assembled, sufficiently shews that Sir Wm. Chambers thought, and he thought justly that something more than what was merely necessary was required to a Royal Academy'.

One source of Chambers's reluctance to accept Bonomi was, at least according to Reynolds, that he was a foreigner. Chambers had asked the President 'in a peevish tone why he would persevere in favour of this Foreigner but recollecting that a Foreigner Mr Rigaud was present he added, not that I have any objection to Foreigners, but that it will appear to the world as if no Englishman could be found capable of filling a Professors Chair'. A sense that such a prejudice against foreigners was at work provoked an inspiring statement of principles by Reynolds:

That our Royal Academy, with great propriety made no distinction between Natives &

Foreigners. that it was not our business to examine where [a] Genius was born before he was admitted in to our society, it was sufficient that the Candidate had merit & that the Candidate set up his Staff amongst us. As in the present Case of Mr Bonomi who has resided here upwards of more than 25 years . . . I might have added that he probably has been in England as many years as Sir Wm. Chambers himself before he was an Academician how many years Sir Wm. has been in England I was never informed.[18]

The 'intent' of the Academy had been to raise a school of arts, and if they could accelerate the growth of the arts by 'foreign manure' it was the duty of the Academicians to use it. If anything, he added, the French behaved with more 'liberality' in this matter than the English, and he recalled how when he had visited Paris twenty years before he had found that the director of the Gobelins tapestry works was a Scotsman. (Reynolds was slightly exaggerating here: the man in question, James Neilson, was only one of the 'entrepreneurs' of the establishment.)

Whether the opposition was to a foreigner, or to someone perceived to enjoy the benefit of patronage and the improper influence of the President, tempers were aroused. Although Reynolds anticipated that he would be able to deal with them, when the day for the vote came, on 10 February 1790, he realised as soon as he entered the Academy that his confidence had been misplaced.

The 'Apologia' is at its most vivid in describing how Reynolds, as he came up the stairs, saw that a greater number of the members than usual had turned up, and that 'Instead of the members as usual straggling about the room, they were allready seated in perfect order and with the most profound silence'. He went to the Chair and looked around for the candidates' drawings. Edwards, as forewarned, had not submitted any. Those of Bonomi he found 'thrust in the darkest corner at the farthest end of the room'.

Reynolds asked the Secretary, John Richards, to place the drawings on the side tables, where they might be seen. At this point something extraordinary happened, especially considering that Reynolds was 67 and partially blind, and that Richards was

George Dance RA (1741–1825), *Portrait of John Francis Rigaud RA*,
1 April 1793. Pencil with black, pink and brown chalks on cream wove
paper, 24.8 × 18.7 cm. Royal Academy of Arts, London. Purchased
from the artist, 1813. 03/3269

George Dance RA (1741–1825), *Portrait of John Richards RA*,
11 March 1793. Pencil with black and pink chalks on cream wove paper,
25.3 × 18.6 cm. Royal Academy of Arts, London. Purchased from
the artist, 1813. 03/3267

relatively new to his post (having succeeded Newton
in 1788). Richards, says Reynolds,

> at first appeard not to hear me. I repeated my
> request. He then rose and in a sluggish manner
> walked to the other end of the room (passing the
> drawings) rung the bell and then stood with his
> folded arms in the middle of the room.[19]

Such insulting behaviour was more than enough to
tell Reynolds that Richards had joined the rebellion.
He was ringing the bell in order to summon the
servant upstairs to move two drawings from one side
of the room to the other. Now Reynolds himself took
one drawing, and the servant took the other, and
put them on display. But of all the Academicians
present only Thomas Sandby deigned to go over to
look at them. Reynolds now opened the business of
the meeting, which was to elect a new Academician
in place of Jeremiah Meyer. The recommendation
was to elect someone qualified and willing to accept
the office of Professor of Perspective. Edwards, by
not submitting a drawing, had disqualified himself.
Reynolds was therefore hoping for unanimous
support for Bonomi.

Instead what he received was a direct challenge
to his integrity, for William Tyler, a sculptor and
architect generally agreed to have been of no distinc-
tion at all, demanded to know who had ordered the
drawings to be sent to the Academy. Reynolds said
it was by his order. Tyler repeated the question
'in a still more peremptory tone'. Again Reynolds
acknowledged that he had given the order. Now
Tyler moved that the offending drawings 'be sent
out or turned out of the room'.

Tyler was the kind of architect to whom you
might apply when you wanted an additional wing
for a county jail, or a pub for freemasons (the
Freemasons' Tavern in Great Queen Street, since
demolished, was his). Reynolds in his fury later
wrote that 'Men who have been accustomed to lay
down the law in Alehouses to Masons & Bricklayers
presume to interfere in a higher station where he
has crept in by mere accident'. And years later
George III was trying to remember who it was who
had done something to cause Sir Joshua to quit
the chair of the Academy. Was it not Farington?,
he asked Benjamin West. 'No, Sir,' replied West,

George Dance RA (1741–1825), *Portrait of Joseph Bonomi* RA, 4 August 1793.
Pencil with black and pink chalks and blue wash on cream wove paper, 24.3 × 18.8 cm.
Royal Academy of Arts, London. Purchased from the artist, 1813. 03/3258

George Dance RA (1741–1825), *Portrait of William Tyler* RA, 17 October 1796. Pencil with pink chalk on cream wove paper, 24.9 × 18.6 cm. Royal Academy of Arts, London. Purchased from the artist, 1813. 03/3273

'it is a misrepresentation, it was *Tyler*, I was present.' The King then said: 'Tyler was an odd man. How came He to be an Academician?' West replied: 'When the Royal Academy was formed there was not a choice of Artists as at present & some indifferent artists were admitted.'[20]

Nonentity though he might have been, Tyler had the support of the meeting. The drawings were removed and Fuseli was elected instead of Bonomi. Reynolds resigned both his presidency and his membership of the Academy, and it was several days before, at the urging of the King, he could be persuaded to receive a delegation at his house, conceding that there had been a misunderstanding over the drawings, and asking him to resume his post.

Reynolds died two years later, and the Academy met to discuss his funeral arrangements. It was proposed that he should lie in state at Somerset House, but Chambers tried to veto this, on the grounds that, as Farington later put it, 'He had from the Treasury the care of the Academy, which could not be used but for fixed and certain Academical

purposes' – that is, exhibitions or study. Nowhere was it stated that the building could be used for a lying-in-state.

Chambers knew very well that he was attempting by this perverse legalism to curtail the honours given by the Academy. He knew all about academies and their practices, and that the organisation of funerals was a traditional part of them (as we saw in Chapter One). Although Chambers had successfully opposed him, Reynolds himself had wanted the Academicians to have their own gowns to wear on such occasions, as the Florentines did; he would obviously have envisaged that he would be given full honours, as first president. The precedent of Michelangelo was always hovering around him.

Chambers was in a minority of one. The King was tactfully approached by Benjamin West and, once again, intervened, making clear 'His Royal Will that that mark of respect should be shown'. The night before the funeral, the coffin was brought from Leicester-Fields (Leicester Square) to Somerset House, where it lay in state in the Model Room of the Academy, which had been hung with black cloth and lit with chandeliers.

On Saturday 3 March 1792, 'peace officers' were stationed along the route to St Paul's Cathedral, to prevent any other traffic than the funeral procession. We are told by Northcote that the streets were lined by 'people innumerable of all ranks'. The Academicians wore black cloaks, and processed in pairs behind the pall-bearers, the chief mourners, the executors (including Burke) and the officers of the Academy (including Boswell, the honorary Secretary for Foreign Correspondence). It took two hours for the whole procession to move from Somerset House to St Paul's, and the City Marshals, at the head, arrived at the cathedral just as the last carriage left Somerset House. Northcote recalled that there were present 'three Knights of the Garter, two of St Patrick, and one of the Thistle, three Dukes, and four noblemen who had held the high office of Viceroy of Ireland'. If the foundation of the Academy had been in part motivated by the desire to secure high status for the artist, the funeral of its first president marked the fulfilment of that hope. Burke wept openly. Chambers no doubt gnashed his teeth a little.

91

~~every perso~~ and now ~~He~~ appears indifferent
to whom he should give ~~his~~ Vote.
with the on only of
excepting Mr Bonomi – and to do him justice
his opposition to him
he was allways steady in that opinion ✗

when the 10th of Feb arrived, I went to
by Sir Wm Letter 90
the Academy prepared to meet with a
that employed some of my kind &c ~~not~~ which I ~~
formidable opposition ∧now composed~~
~~despicable~~ know Sir Wm Chambers had thought
meerly of the idle and insignificant
proper to give them his Countenance he was himself a
hope however of flattered ∧ of the Academy. I flatterd myself
that I should be able to persuade the
a the business which
majority not to relinquish ~~this~~ in
~~that~~ ~~sitting after~~ ~~it was~~ ~~so~~
far advanced — when I enterd the Academy
✗ I begun to change my opinion confidence, a greater number than expected
I suspected that this number was not wrong ∧
~~the~~ whole appearance was new to me
Instead of the members as usual stragling about
the room, they were already seated in perfect
with
order and ~~in~~ the most profound silence, I went
directly to the Chair and looking round
for the Candidates drawings, I at last
most ∧ Mr Bonomi ∧ corner
I spyed them in a darkest ∧ part of
of the room
the room at the farthest end, I then
desired the Secretary to place them
on the side tables where they might
be seen, He at at first appeard not
to hear me, ~~and~~ I repeated my
request, He then rose and in a
sluggish manner walked to the

7 Meet the Models: An Anthology

My old man is a very clever chap –
He's an artist in the Royal Academy.
He paints pictures from morning until night –
Paints them with his left hand,
Paints them with his right.
All his subjects (take the tip from me)
Are very, very Eve-and-Adamy
And I'm the model that has to pose
For his pictures every day.

Oh it's alright in the summertime.
In the summertime it's lovely
While my old man's painting hard
I'm posing in the old back yard.
Oh! In the wintertime –
That's another thing you know,
With a little red nose
And very little clothes
And the stormy wynds do blow.

'It's Alright in the Summertime', a music-hall song
by George Everard (1873–1907)[1]

Although sitting as an artist's model was often a form of casual employment for men, and for women something they would prefer to do anonymously (being akin to prostitution in some cases), it is nevertheless possible to know a remarkable amount about some individuals (their domestic circumstances, how they talked, how they were treated by their employers), and even to match the names of models to certain drawings and paintings. It is striking that when the Academy first opened, female models were paid half a guinea a night – that is, ten shillings and sixpence. The men were given three shillings. In 1811, the women's rate was raised to twelve shillings, and the men's to five. In 1821, the women were raised again to one guinea (twenty-one shillings) and the men to half a guinea.[2]

1 The Men

Reynolds's Black Servant

Sir Joshua, as his usual custom, looked over the daily morning paper at breakfast time; and on one of these perusals, whilst reading an account of the Old Bailey sessions, to his great astonishment saw that a prisoner had been tried and condemned to death for a robbery committed on the person of one of his own servants, a Negro who had been with him for some time. He immediately rung the bell for the servants, in order to make his inquiries, and was soon convinced of

Sir Joshua Reynolds PRA (1723–1792), *John Manners, Marquis of Granby*, 1763–65.
Oil on canvas, 246.4 × 209.5 cm. The Collection of the John and Mable Ringling Museum of Art, Sarasota,
the State Art Museum of Florida. Bequest of John Ringling

the truth of the matter related in the newspaper. This black man had lived in his service as footman for several years, and has been pourtrayed in several pictures, particularly in one of the Marquis of Granby, where he holds the horse of that General. Sir Joshua reprimanded this black servant for his conduct, and especially for not having informed him of this serious adventure; when the black man said he had concealed it only to avoid the blame he should have occurred had

he told it: he then related the following circumstances of the business, saying, that Mrs Anna Williams (the old blind lady who lived at the house of Dr Johnson) had, some time previous, dined at Sir Joshua's with Miss Reynolds; that in the evening she went home to Bolt-court, Fleet-street, in a hackney-coach, and that he had been sent to attend her to her house. On his return he had met with companions who had detained him till so late an hour, that when he came to

Sir Joshua's house, he found the doors were shut and all the servants gone to rest. In this dilemma he wandered in the street till he came to a watch-house, in which he took shelter for the remainder of the night, among the variety of miserable companions to be found in such places; and amidst this assembly of the wretched, the black man fell sound asleep, when a poor thief, who had been taken into custody by the constable of the night, perceiving, as the man slept, that he had a watch and money in his pocket (which was seen on his thigh), he seized an opportunity and stole the watch, and with a penknife cut through the pocket, and so possessed himself of the money. When the Black awaked from his nap, he soon discovered what had been done to his cost, and immediately gave the alarm, and a strict search was made through the company; when the various articles which the Black had lost were found in the possession of the unfortunate wretch who had stolen them. He was accordingly secured, and next morning carried before the Justice, and committed to take his trial at the Old Bailey, (the Black having been bound over to prosecute), and, as we have seen, was at his trial cast and condemned to death. Sir Joshua, much affected by this recital, immediately sent his principal servant, Ralph Kirkly, to make all inquiries into the state of the criminal, and, if necessary, to relieve his wants in any way whatever could be done. When Kirkly came to the prison, he was soon admitted to the cell of the prisoner, where he beheld the most wretched spectacle that imagination can conceive – a poor forlorn criminal, without a friend on earth who could relieve or assist him, and reduced almost to a skeleton by famine and by filth, waiting till the dreadful morning should arrive when he was to be rendered a terrible example by a violent death. Sir Joshua now ordered fresh cloathing to be sent to him, and also that the black servant as a penance, as well as an act of charity should carry to him every day a sufficient supply of food from his own table; and at that time Mr E. Burke being very luckily in office he applied to him, and by their joint interest they got his sentence changed to transportation; when, after being

Sir Joshua Reynolds PRA (1723–1792), *A Man's Head, c.* 1771–73. Oil on canvas, 58.4 × 45.7 cm. Tate Britain, London. N00106. Presented by Sir George Beaumont Bt, 1826

furnished with all necessaries, he was sent out of the kingdom.

JAMES NORTHCOTE[3]

George White the Paviour

Walpole in his catalogue notes refers several times to this favourite model of Sir Joshua's, and speaks of him always as 'a beggarman'. But Henry Moser, who was acquainted with 'Old George', by which name White was commonly known among artists, says that when discovered by Sir Joshua he was not begging but practising his trade, 'exerting himself in the laborious occupation of thumping down stones in the street'. Sir Joshua, observing his majestic head and the muscular dignity of his figure, took him from this occupation and engaged him to pose, at first in the studio at Leicester Fields and afterwards in the Royal Academy Schools.

John Dean (*c.* 1759–1805), after **Sir Joshua Reynolds** PRA (1723–1792), *A Captain of Banditti*, 1772. Mezzotint. British Museum, London. BM CS1, 168

Sir Joshua Reynolds PRA (1723–1792), *Count Ugolino and His Children Dying in Prison*, 1773. Oil on canvas, 125.7 × 176.5 cm. The National Trust, Knole, Sevenoaks

'In this situation,' says Moser, 'George attracted the attention of several painters and sculptors, who copied his head and ideal figure in a variety of forms. Dr Hunter, also, who never suffered an opportunity to escape him for the improvement of the anatomical science to which he was so enthusiastically devoted, thought Old George the finest muscular subject he had ever seen, and in consequence had him at his lectures, in order, by comparison, to elucidate the superficial anatomy of the human system. The benevolence of the Doctor induced him to do more, for they took him into his house where he resided some time; but I have understood that the irregularity of Old George, who had been used to a dissolute course of life, induced his patron at last to part with him; though I think he received an allowance, from him, Sir Joshua, and others, that rendered his old age comfortable.

'Posterity, contemplating the busts, pictures, etc., of the last quarter of the Eighteenth century, will wonder to see the same figure and countenance exhibited in so many of them; it may therefore be curious to learn whence the formality has arisen.'

Sir Joshua's first exhibited study of White, described in the catalogue as *An Old Man, half-length*, was at the Academy in 1771, and in that and the three or four years following the paviour sat to numbers of artists, including Romney, West, H. D. Hamilton, and Nixon the miniaturist. Walpole says that when Sir Joshua showed his painting of White as *A Captain of Banditti*, in 1772, there were at least six other pictures of him at the Academy; and there were several besides at the Society of Artists. In the same year White sat for the figure of Count Ugolino, in *Count Ugolino and His Children Dying in Prison*, as we know from Daniel Wray, who, calling at the President's house in September, 1772, saw both the picture and the model. . .

White was a Yorkshireman, and it is said that, despite his age, he walked annually from York to London in the spring during the period that he posed as a model. 'Why don't you winter in London?' West asked him one day. 'Why, Sir?' replied the ancient, 'because coals be cheap in the North and warmth be the life of an old man.'
WILLIAM T. WHITLEY[4]

Curiously enough, White also sat as model for Nathaniel Hone's *The Conjuror*, a painting that was regarded by some as a libel on Reynolds for its lampooning of his dependence on old master sources.

the heel and ball of the toe like the human being, and in one instant of inspired perception saw the whole system. I found the lioness's feet flat – her chest narrow – her brain small – her forearm long – her body long. I found that she was totally incapable of standing on her feet when resting on the same bones as the human being. I compared the two in muscle and construction: the points where they differed, I put down as marks of brutality on the lion's part, as indications of humanity on that of man, and concluded that in building a superior form the human peculiarities are to be dwelt on, while for an inferior form those which belong to the brute are to be approached.

Eastlake was deeply interested in these details and assented to the soundness of the principles. By reference to the works of Phidias every conclusion was confirmed, so that I am convinced it was the system he acted on, and that it was acted on generally in Greek sculpture.

The drawings I made from this dissection impressed Wilkie very much; I lent them to him and he copied them. The principle in the construction of the lion seemed to be to pack the greatest possible strength in the smallest possible space, and I found that to increase the power of the brute many muscles acted from both origin and insertion, thus moving two ways when convenient for the animal.

About the end of this year the artists met with a black, a native of Boston, a perfect antique figure alive. On my getting a sight of him, I engaged him for a month, and proceeded to draw and cast him without a moment's loss of time in all the attitudes wanted for my picture. The most extraordinary thing was, that I found in this Negro all the positive marks characteristic of brutality. Beautiful as his form was, his calf was high and feeble, his feet flat, and heel projecting, his fore-arm as long as his arm-bone, his deltoid short, his jaw protrusive, and his forehead receding. What was excellent was the great flexibility and vigour of his movements in spite of his inherent defects. The moment he moved his intentions were evident. The great principle that the form of a part depends on its action was here confirmed. His joints were exquisitely clean. His body bent

at the loins like whalebone. He sat upon his heel and put his foot behind his neck. The bony flatness of his articulations and fleshy fullness of his muscles produced that undulating variety of line so seldom seen in the living figure. Pushed to enthusiasm by this man's form, I cast him, drew him and painted him till I had mastered every part. I had all his joints moulded at every stage, from their greatest possible flexion to their greatest possible extension. The man himself and the moulders took fire at my eagerness, and after having two whole figures moulded, he said he thought he could bear another to be done if I wished it; of course I wished it, so we set to again. In moulding from nature great care is required, because the various little movements of the skin produce perpetual cracks, and if the man's back is moulded first, by the time you come to his chest he labour to breathe greatly, so that you must then have the plaster rubbed up and down with great rapidity till it sets. We had been repeatedly baffled in our attempt at this stage, and I therefore thought of a plan to prevent the difficulty, by building up a wall round him, so that plaster might be poured in and set all around him equally and at once. This was agreed upon. The man was put into position, extremely happy at the promise of success, as he was very proud of his figure. Seven bushels of plaster were mixed up at once and poured in till it floated him up to the neck. The moment it set it pressed so equally upon him that his ribs had no room to expand for his lungs to play and he gasped out, 'I – I – I die.' Terrified at his appearance, for he had actually dropped his head, I seized with the workmen the front part of the mould and by one supernatural effort split it in three large pieces and pulled the man out, who, almost gone, lay on the ground senseless and streaming with perspiration. By degrees we recovered him, and then looking at the hinder part of the mould which had not been injured I saw the most beautiful sight on earth. It had taken the impression of his figure with all the purity of a shell, and when it was joined to the three front pieces there appeared the most beautiful cast ever taken from nature, one which I will defy any one in the

Benjamin Robert Haydon (1786–1846), *Anatomical Drawings of the Bones, Muscles and Tendons of the Arm and Hands*, c. 1805. Red and black ink with grey and red washes on off-white laid paper, 32.4 × 47.3 cm. Royal Academy of Arts, London. Bequeathed by Gilbert Bakewell Stretton, 1949. 02/317 recto

world to equal unless he will risk as I unthinkingly did the killing of the man he is moulding. I was so alarmed when I reflected on what I had nearly done that I moulded no more whole figures. The fellow himself was quite as eager as ever though very weak for a day or two. The surgeons said he would have died in a second or two longer. I rewarded the man well for his sufferings, and before three days he came, after having been up all night drinking, quite tipsy, and begged to know with his eyes fixed if I should want to kill him any more, for he was quite ready, and he found it 'a d——d good concern'. However I had done with him, and would not venture, as I had mastered his form, to run any more such risks.

I now returned to Macbeth with my principles of form quite settled. I finished the king, whom everybody liked, and was soon buried in application. I used to go down in the evenings with a little portfolio, and bribe the porter at Burlington House, to which the Elgin Marbles were now removed, to lend me a lantern, and then locking myself in, take a candle out and make different sketches, till the cold damp would almost put the candle out. As the light streamed across the room and died away into obscurity, there was something solemn and awful in the grand forms and heads and trunks and fragments of mighty temples and columns that lay scattered about

Benjamin Robert Haydon (1786–1846), *Anatomical Drawing of the Lower Back, Pelvis and Thighs*, 28 June 1805 (detail). Red and black ink with grey, brown and red washes on off-white laid paper, 46.7 × 32.5 cm. Royal Academy of Arts, London. Bequeathed by Gilbert Bakewell Stretton, 1949. 02/277

Henry Fuseli RA (1741–1825), *Self-portrait Between Forty and Fifty Years Old*, undated. Black and white chalk on paper, 27 × 20 cm. Victoria and Albert Museum, London. E1028-1918

in sublime insensibility, – the remains, the only actual remains, of a mighty people. The grand back of Theseus would come towering close to my eye and his broad shadow spread over the place a depth of mystery and awe. Why were such beautiful productions ever suffered to be destroyed? . . .

The study of this finely formed Negro directly after the dissection of the lion was of infinite advantage to my knowledge of the figure. I found the Negro in his form approach the radical deficiencies of the lion's construction, and in building up my heroic standard of form, I made the basis of it to be the reverse of all the deficiencies of the lion and the approaches to deficiency in the Negro. On these eternal principles I reared the figure of Macbeth.

BENJAMIN ROBERT HAYDON[6]

Samuel Strowger

Those of my brother artists who remember the Academy twenty years ago will not have forgotten Samuel Strowger, the most symmetrical of models in the Life School, and the best of servants to the Institution. He was a Suffolk man, and had worked on a farm in Constable's neighbourhood, where he was distinguished in the country phrase as 'a beautiful ploughman', until he enlisted in the Life Guards, when his strict attention to his duties soon acquired for him the character of the best man in his regiment. The models of the Academy are generally selected from these fine troops; Sam was chosen, and the grace of his attitudes, his intelligence and steadiness, induced the Academy to procure his discharge, and to place him in the Institution as head porter and occasional model. Sam and Constable, who had known each other in Suffolk, were thus brought together again in London; and Strowger showed his readiness to patronise his old acquaintance, as far as lay in his power, by interceding, when he could venture to do so, during the arrangements of the exhibitions, in behalf of his works. As they were generally views in Suffolk, they had peculiar charms in Sam's eyes, and he could vouch for the accuracy with which they represented all the operations of farming. He was captivated by one of them, a 'Corn Field with reapers at work', and pointed out to the arranging committee its correctness, 'the *lord*', as the leading man among reapers and mowers is called in Suffolk, being in due advance of the rest. But with all his endeavours to serve his friend the picture was either rejected or not so well placed as he wished, and he consoled Constable, and at the same time apologised for the members of the Committee, by saying, 'Our gentlemen are all great artists, sir, but they none of them know anything about the *lord*.'

I cannot take leave of my old friend Strowger without mentioning that towards the close of his life, the students of the Academy presented him with a silver snuffbox of huge dimensions; and that a very exact portrait of him in his best days was painted by Wilkie. It is the head of the

intelligent farmer in the 'Rent Day', who, seated at the table with his finger raised, appears to be recalling some circumstance to the recollection of the steward.

C. R. LESLIE[7]

. . . Constable and Strowger were great friends all their lives.

My father [C. R. Leslie] possessed two beautiful little life studies, by Wilkie, which he said must most certainly have been drawn from Strowger, as they showed unmistakably Sam's easy and graceful figure. My father related that a Visitor on one occasion, finding great difficulty in getting a stiff drilled life guards man to take the pose, sent for Strowger to assist him. Sam instantly placed himself into the required attitude; even after that and after both Sam and the Visitor had shoved and bent the life guardsman about he still looked as stiff and awkward as ever, Sam remarking, 'He does not feel it, sir.'

Besides serving as an occasional model Sam, according to my father, frequently acted as Fuseli's valet. On such occasions Fuseli would sometimes take counsel with Sam – 'I have been asked out to dinner, Sam; shall I go?' 'That's according to where it is, sir,' replied Sam. 'At Mr Smirke's, Sam.' 'Mr Smirke is a very nice gentleman, sir; I only wish I were qualified to go with you, sir.' 'I wish you were, Sam,' said the Keeper.

The students during Fuseli's Keepership got up a testimonial to Sam Strowger which took the form of a huge silver snuffbox. My father said it so highly gratified Sam that in return he invited a certain number of the students concerned in the affair to supper at his own house. Mrs Strowger and her daughters sat at the table with the students, but nothing could persuade Sam to do so, and he persisted in waiting on his guests all the evening. Amongst the good things provided for the repast was a pair of roast fowls which Sam had reared himself in his back yard, and which were, he said, fed entirely from the bits of bread left by the students in the Schools, remains of the bread used by them in rubbing out errors in their drawings.

Bread was still used largely when I was a student, but I believe it has now gone out of fashion, a sort of plumbed indiarubber being at present in favour with the students.

G. D. LESLIE[8]

Miss Patrickson is probably the only artist of her sex who worked in the Academy schools, though not among the Academy students, while the classes were conducted at Somerset House. How this was managed she explained in some recollections of Fuseli she sent to Allan Cunningham when he was writing his sketch of that artist's life. Cunningham was unable to use her notes, which were published after her death, in *The Builder*. Miss Patrickson was the pupil in her teens of John Young the engraver and the elder Hayter. At twenty she made the acquaintance of Mrs Fuseli, who invited her to come to Somerset House, where she was introduced to the Keeper and showed him some of her work. Fuseli lent her a book with anatomical plates, of which she

George Dance RA (1741–1825), *Portrait of Henry Fuseli* RA, 2 June 1793. Pencil with pink chalk on cream wove paper, 25.2 × 19 cm. Royal Academy of Arts, London. Purchased from the artist, 1813. 03/3271

Henry Fuseli **RA** (1741–1825), *Portrait of Mrs Fuseli*, c. 1798.
Watercolour and pencil on paper, 33.4 × 21.9 cm. Ashmolean
Museum, Oxford

was to take the greatest care, as he believed it
to be the only copy in England. 'If you lose it or
injure it,' he said, 'never venture to come near
me again, for I will hang you with my own
hands.'

The threat was characteristically ferocious,
but he was a good friend to the young artist and
allowed her to work in the Council Room of the
Academy, which adjoined his own apartments;
and, during the vacations, permitted her to draw
from the casts in the Antique School, where no
woman had ever drawn before. This, a great con-
cession, was obtained through Mrs Fuseli, whose
influence over her husband was considerable.

'You want to draw in the Antique School?'
said the Keeper. 'Yes.' 'Very well, you shall, but
you'll find it very cold, for I have no right to ask
the porter to light a fire in the absence of the
students.' The porter mentioned was Sam

Strowger, in whom Miss Patrickson was to find
a critic of her drawing, and a friend who was
less scrupulous than the Keeper about burning
Academy coals. She began to work in the
Christmas vacation, in a hard frost, and her
hands were so cold that until she had stitched a
piece of velvet round her porte-crayon she could
not hold it. She says: 'Mr Fuseli paid me two or
three visits every day to inspect my progress and
invited me to warm myself at his fire. But Sam
soon made the latter unnecessary; he seemed to
find a great pride in my devotion to the fine arts,
regularly made me a good fire, and inspected my
studies himself. He liked to come when Mr Fuseli
was away, to give me his opinion, which I was
quite ready to hear. For Sam rarely said, "Now
Miss, if you'll just imagine a straight line
dropped from such a place, I think you'll find the
right foot too backward", that I did not find that
he was right. One day he had been giving me
advice in the Council Room, when, as he went
out, he cast his eye upon the Hercules, and said:
"Mr Fuseli have'nt altered that leg yet, I see, as
I told him yesterday was wrong."'

His reference was not to the cast of Hercules
but to a picture upon which Fuseli was then
engaged, *Hercules Assailing Pluto*, for which Sam
had been sitting. Miss Patrickson continues:
'I liked Sam excessively, he was so identified
with the Academy by himself and everyone else,
and there was so much composure in his self-
complacency that I admired him greatly. He
liked my admiration of Mr Fuseli and was fond
of increasing it. He was goodnaturedly anxious
that I should become a regular student in the
antique, and I daresay if he had been satisfied
with my progress would have thought me worthy
of being admitted to the life-class. "Lord, Miss!"
he would say, "you'll never improve, drawing this
way by yourself. You've no idea what a difference
you would find if you were here with the young
gentlemen, and if you asked Mr Fuseli he'd
give you leave directly, I'm sure he would."'

Henry Fuseli **RA** (1741–1825), *Thor Battering the Midgard Serpent*,
1790. Oil on canvas, 133 × 94.6 cm. Royal Academy of Arts, London.
Diploma Work, accepted in 1790. 03/995

This, however, was impossible at the time, as Miss Patrickson was aware. Her friend the Keeper would have been powerless in the matter, and more than half a century was to elapse before the barrier that kept women out of the Academy schools was broken down by Miss Laura Herford, the aunt of Mrs Allingham.

Samuel Strowger, who dared to suggest that Miss Patrickson should work at the Academy with the young men, was probably the most popular, and is currently the best remembered, of all the porters of that institution. A Suffolk ploughman, he enlisted when young and served for some time in the Life Guards. He sat as a model in the Academy schools while in the army, and made so many friends at Somerset House that when in 1802 the post of porter fell vacant it was offered to and accepted by him. Through Earl Cathcart the Academicians obtained his release from the army, and he served them for many years as a porter and as an occasional model in the life school.

WILLIAM T. WHITLEY[9]

Whitley also tells us that there was a tradition that Strowger quarrelled with the Academy students, and that 'as their representative, Mulready – famous as a boxer – proposed to fight him'.

OCTOBER 15TH, 1808
Wilkie and I breakfasted with Wilson; our church is under repair and *of course* we could not go to another; dined early and went to drink tea with one of the porters, a model, formerly in the Life Guards; he is the Academy model, and has sat to me without pay for many days because I had nothing to pay him with. This tea I shall never forget. All his little family were dressed out in their best, and a fire in the parlour, but Sam and his wife had not returned from church. We were shown in by the eldest girl, all smiles and curtesies, evidently the result of instructions should we arrive before the parents returned. At last a rap was heard and away squeezed all the children to let in father; Sam shook hands with us and welcomed us to his castle, which was a perfect model of neatness and order; his wife seemed a bustling woman, and soon had tea ready, and

Sam amused us all evening with capital stories about the old days at the Academy.

I don't know when I have spent a more innocent amusing evening than this: everybody seemed to anticipate our wishes, and of course we could not go without tasting their home-brewed beer.

As far as I have gone in this world, I have certainly observed that in most cases, prudence and piety are rewarded by tranquillity and independence, and vice and dissoluteness by misery and want – of course I mean in a certain class; and there cannot be a stronger instance in my favour than the cases of the two porters at the Academy. They have both the same wages and advantages. And on the one hand one sees how much £50 a year can do when managed with care, and on the other how little it can do when wasted in debauchery. The one porter has a comfortable little house, an active affectionate wife, and a family of dear virtuous children, all of whom he keeps respectably and happily by his diligence and sobriety. The other squanders his money in an ale-house, leaving his wife and family in want and misery, without a rag to their backs, without a house, and sometimes without a bed to lie upon. Will not vice bring its own punishment? This man, in all probability, will soon lose his place and die in a jail or upon a dunghill, without a being to lament or a wife to attend him. Surely sometimes the punishment of vice is as certain as the reward of virtue, and who can tell that he is not to be the example? Came home, read my Bible and studied Greek.

BENJAMIN ROBERT HAYDON[10]

Old Christie

I remember that while Mr Dyce was Visitor for the month during which we were making our drawings in competition for the silver medal, the model, old Christie, failed one evening to make his appearance. Mr Dyce waited for nearly half an hour, at the end of which Christie at last came, but so totally drunk that he had to be turned away. Mr Dyce told us that we might stay on,

and work at our drawings if we liked, though he did not recommend us to do so, and then took his departure. In a very few moments pandemonium not unnaturally set in; the students began by pelting one another with pellets of modelling clay, which rendered work absolutely impossible. From this they proceeded to a game of cricket. There was an old bat among the properties, which had been used by some visitor for a pose; a ball was made by rolling up a lump of modelling clay, and a wicket was put up on the throne. No fielding was required as the ball, when hit, invariably stuck to the bat from which it was picked off, rolled up, and returned to the bowler.

The fun became fast and furious, ending in a sort of dramatic performance, the students dressing up in any odd and ends they could find in the property box. I remember in particular one student, who dressed himself up as a housemaid, with a broom, a dust pan, and a pail of water; the water was spilt all about the throne, the chalk marks, on which Christie's feet ought to have been, were entirely obliterated. When the performance was in full swing, little Bob the porter suddenly entered and proceeded at once to take our names down, whereupon one of the students promptly turned out the gas and we, scrambling over the porter and one another, made our escape.

G. D. LESLIE[11]

Sammons, Shaw, Dakin, Hodgson: Waterloo and the Models

Sammons was a favourite model; – a living Ilissus; – a good soldier; – had been through the war in Spain, and was very angry he had not been at Waterloo.

Whilst the wounded were describing the battle, Sammons explained what was military, and thereby kept up his command, he being a corporal and they being privates. Wilkie was always amused with my corporal, and Hazlitt held regular discussions with him about Spain and Napoleon, but Sammons was proof, and always maintained the Duke was the better man.

Sammons was a soldier in every sense of the word. He would have brought a million safe and sound from Portsmouth to the King's Mint, but he popped his hand into King Joseph's coaches at Vittoria and brought away a silver pepper-box. He was an old satyr, very like Socrates in face, faithful to me, his colonel, and his King; but let a pretty girl come in the way and the Lord have mercy on her!

The description of the men was simple, characteristic, and poetical. They said when the Life Guards and Cuirassiers met, it was like the ringing of ten thousand blacksmiths' anvils. One of them knew my models, Shaw and Dakin. He saw Dakin, while fighting on foot with two Cuirassiers, also on foot, divide both their heads with cuts five and six. He said Dakin rode out foaming at the mouth, and cheered on his troop. In the evening he saw Dakin lying dead, cut in pieces. Dakin sat to me for the sleeping groom on his knees in Macbeth.

Another saw Shaw fighting with two Cuirassiers at a time. Shaw, he said, always cleared his passage. He saw him take an eagle, but lose it afterwards, as when any man got an eagle, all the troops near him, on both sides, left off fighting and set on him who had the eagle. He went on himself very well, but riding too far, was speared by a Lancer and fainted away. Recovering, he sat upright, when three or four Lancers saw him, rode at him, and speared him till they thought him dead. He remembered nothing till revived by the shaking as they carried him to the yard at La Haye Sainte. There he heard someone groaning and, turning round, saw Shaw, who said: 'I am dying; my side is torn off by a shell.' His comrade told us how he had swooned away, and being revived by their taking him up to be carried to Brussels at daybreak, he saw poor Shaw dead, with his cheek in his hand.

Corporal Webster of the 2nd Life Guards saw Shaw give his first cut. As he was getting down the rising ground into the hollow road, a Cuirassier waited and gave point at his belly. Shaw parried the thrust, and before the Frenchman recovered, cut him right through his brass helmet to the chin, and 'his face fell off him like a bit of apple'.

Another, Hodgson (a model, and the finest of all, standing six feet four inches, a perfect Achilles), charged up to the French baggage. He saw artillery driver-boys of sixteen crying on their horses. In coming back a whole French regiment opened and let him pass at full gallop, then closed and gave him a volley, but never hit him or horse.

The first man who stopped him was an Irishman, in the French service. He dashed at him and said: 'D—n you, I'll stop your crowing.' Hodgson said he was frightened as he had never fought anybody with swords. Watching the Cuirassier, however, he found he could not move his horse so quickly as he could; so letting go the reins and guiding his horse with his knees, as the Cuirassier gave point at his throat, Hodgson cut his sword-hand off and dashed his sabre down through his throat, turning it round and round. The first cut he gave him was on his cuirass, which he thought was silver lace. The shock nearly broke his own arm. 'D—n me, sir,' he added, 'now I had found out the way, I soon gave it them.' As Hodgson rode back after being fired at, an officer encountered him. Hodgson cut his horse at the nape, and as it dropped dead the officer's helmet rolled off, and Hodgson saw a bald head and white hairs. The officer begged for mercy, but at that instant a troop of Lancers was approaching at the gallop, so Hodgson clove his head in two at a blow and escaped. The recollection of the white hairs, he told us, pained him often. Before he got back to the British lines a Lancer officer charged him, and missing his thrust, came right on Hodgson and his horse. Hodgson got clear and cut his head off at the neck, at one blow, and the head bobbed on his haversack, where he kept the bloody stain.

Wilkie, I, and Scott kept the poor fellows long and late, rewarded them well, and sent them home in charge of Corporal Sammons, as proud as the Duke, for they were under his command for the evening. Sammons always seemed astounded that the battle of Waterloo had been gained and he not present.

BENJAMIN ROBERT HAYDON[12]

2 The Women

Bet Belmanno

One morning during Mrs Nollekens's absence from town, Mrs Lobb, an elderly lady, in a green calash, from the sign of the 'Fan,' in Dyot-street, St Giles, was announced by Kit Finney, the mason's son, as wishing to see Mr Nollekens. 'Tell her to come in,' said Nollekens, concluding that she had just brought him a fresh subject for a model, just arrived from the country; but upon that lady's entering the studio, she vociferated before all his people, 'I am determined to expose you! I am, you little grub!' – 'Kit!' cried Nollekens, 'call the yard-bitch;' adding, with a clenched and extended fist, that 'if she kicked up any bobbery there, he would send Lloyd for Lefuse, the constable.' – 'Ay, ay, honey!' exclaimed the dame, 'that won't do. It's all mighty fine talking in your own shop. I'll tell his worship Collins, in another place, what a scurvy way you behaved to young Bet Belmanno yesterday! Why the girl is hardly able to move a limb today. To think of keeping a young creature eight hours in that room, without a thread upon her, or a morsel of anything to eat or a drop to drink, and then to give her only two shillings to bring home! Neither Mr Fuseli nor Mr Tresham would have served me so. How do you think I can live and pay the income-tax? Never let me catch you or your dog beating the rounds again; if you do, I'll have you both skinned and hung up in Rats' Castle. – Who do you laugh at?' she continued, at the same time advancing toward him; 'I have a great mind to break all your gashly images about the head of your fine Miss, in her silks and satins;' – mistaking his lay-figure for a living model of the highest sort. – 'I suppose, you pay my lady well enough, and pamper her besides?'

Nollekens perceiving Mrs Lobb's rage to increase, for the first time, perhaps, drew his purse-strings willingly; and putting shilling after shilling into her hand, counted four and then stopped. 'No, no,' said she, 'if you don't give me t'other shilling, believe me, I don't budge an inch!' This he did; and Kit, after closing the

gates, received peremptory orders from his master to keep them locked for three or four days, at least, for fear of a second attack.

J. T. SMITH[13]

Mrs Lobb had succeeded 'the notorious Dame Phillips' as brothel-madam at the sign of the Fan, in Orange-court. The Rats' Castle was a 'shattered house' nearby, 'so called from the rat-catchers and canine snackers who inhabited it, and where they cleaned the skins of those unfortunate stray dogs who had suffered death the previous night'. Mrs Lobb's reference to Fuseli as a better client indicates that, as Keeper, he may well have sought models for the Academy at the sign of the Fan. Henry Tresham, the other client referred to, was briefly Professor of Painting, before Fuseli, at the Academy (1807–09).

The sense of the following passage from Hazlitt only becomes clear as it is understood that the living models being discussed were female, and were prostitutes.

'Custom', said N[orthcote], 'makes a wonderful difference in taking off the sharpness of the first inflammable impression. People for instance were mightily shocked when they first heard that the boys at the Academy drew from a living model. But the effect almost immediately wears off with them. It is exactly like copying from a statue. The stillness, the artificial light, the attention to what they are about, the publicity even, draws off any idle thoughts, and they regard the figure and point out its defects or beauties, precisely as if it were of clay or marble.' I said I had perceived this effect myself, that the anxiety to copy the object before one deadened every other feeling; but as this drew to a close, the figure seemed almost like something coming to life again, and that this was a very critical minute. He said, he found the students some-times watched the women out, though they were not of very attractive appearance, as none but those who were past their prime would sit in this way: they looked upon it as an additional disgrace to what their profession imposed upon them, and as something unnatural. One in particular (he remembered) always came in a mask. Several

of the young men in his time had however been lured into a course of dissolution and ruined by such connexions; one in particular, a young fellow of great promise but affected, and who thought that profligacy was a part of genius. I said, It was the easiest part. This was an advantage foreign art had over ours. A battered courtesan sat for Sir Joshua's Iphigene; innocent girls sat for Canova's Graces, as I had been informed.

WILLIAM HAZLITT[14]

3 Children

Reynolds used many children as models, including poor children he must have encountered on the streets. Northcote, in conversation with James Ward, said:

Good G–d! how he used to fill his painting room with such malkins; you would have been afraid

George Dance RA (1741–1825), *Portrait of James Northcote* RA, 2 March 1793. Pencil with black and pink chalks on cream wove paper, 25 × 18.5 cm. Royal Academy of Arts, London. Purchased from the artist, 1813. 03/3268

to come near them, and yet from these people he produced his celebrated pictures. When any of the great people came, Sir Joshua used to flounce them into another room until he wanted them again.

JAMES NORTHCOTE[15]

George Ennis

In 1838, W. P. Frith, seeking a bearded model at a time when these were hard to come by, found an octogenarian apple-vendor being persecuted by street children, and persuaded him to visit his studio.

After buying apples enough to satisfy him, I tried to interest him in the bric-à-brac common to an artist's studio.

'What's that thing?'

'That', said I, 'is called a fez. It's what people wear in the East instead of a hat.'

'How rum!'

'It's very comfortable, mind you,' said I. 'Just you put it on.'

No sooner said than done, and the old man took an admiring look at himself in my cheval glass. I fully shared his admiration, for the dull red of the cap, the furrowed face, and the silvery beard, made a study that Rembrandt would have relished, and to which none but genius could do full justice. The sale of his stock had put my man into a good humour, and I ventured to ask him how old he was.

'How old? I don't know.'

'When is your birthday – I suppose you have one?'

'No, I ain't.'

'Were you born in Ireland?'

'No – Kent – 'opping time; that's all I know about it. My father and mother was Irish; come over 'opping.'

'Did you ever have your likeness taken?'

'Yes, once, when I was a boy. A deaf gent done it; leastways he had a trumpet, and I shouted at 'im.'

'A deaf man?' (Gracious goodness, could it be Reynolds!) 'What kind of man was he – where did he live?'

'What kind of man? Ah! It's a vast of years ago, you see, and I didn't take particular notice. Civil spoken he was, and gave me a kind of crook to hold.'[16]

In due course, Frith offers Ennis five shillings for three hours of sitting.

This demand plunged my friend into deep contemplation. He seemed to be trying to remember something.

'No,' he said after a pause, 'I couldn't take it off; I should get cold. No more I couldn't none of my clothes.'

'Take what off?' said I.

'This 'ere beard,' he said, handling it. 'You see, my hand got a bit shaky, and I was always a-cutting of myself. One morning my grand-daughter screeched that I had cut my throat.'

'Goodness, no!' I interrupted; it's your *beard* I want beyond everything.'

'Oh, all right then! You'll want my coat and waistcoat and shirt off, as the deaf gent did, and you see I was young then and didn't mind it; but I should get the rheumatics or something. No, I couldn't do it.'

'Bless the man! I don't want you to take off any of your clothes. I only want just to take your likeness – that is, the likeness of your face.'

'Oh, is that all? Then why did the old gent make me take off all but my trousers and give me a crook to hold? There was a lamb in the picture as the old gent done. . .'[17]

The last detail, together with the crook and perhaps the memory of shouting at the deaf man, suggest that Ennis had sat for Reynolds's *St John the Baptist in the Wilderness*. The portrait study Frith made was called *Ennis Effendi*. Frith tells us that it became 'an heirloom in a fine mansion near Grosvenor Square'. Ennis sat for other painters, but never became a regular model. Frith painted him again as Scott's *Last Minstrel*.

Sir Joshua Reynolds PRA (1723–1792), *St John the Baptist in the Wilderness*, c. 1776. Oil on canvas, 132 × 102.2 cm. The Wallace Collection, London

8 The Academy of Benjamin West

It is striking that, in electing a successor to Reynolds, the Academicians should have chosen an American. Benjamin West was voted in on 17 March 1792 by 29 votes to one. West's was a remarkable success story, and his habit of mind was to meditate upon that success and on the key moments in his career, until he had the story beautifully shaped. In later life, in August 1813, he told an American friend:

> Yesterday was fifty years since I first came to London. I remember travelling on the top of the Canterbury coach, and stopping about two miles from London at a mean tavern, and taking a dinner before entering the metropolis to seek my fortune; and I could not avoid yesterday going to the same tavern, calling for a dinner alone in the same room, and looking back on the fifty years I had spent, the progress I had made in my profession, the friends I possessed, and the adventures I had met with.[1]

This touching picture of the artist sitting alone in the mean tavern must be modified, for Farington tells us in his diary how he, Thomas Lawrence, the painter Robert Smirke and his architect son, together with West's son Ralph [Raphael], accompanied the aged painter to the inn at Shooter's Hill on 20 August, to commemorate 'Mr West's first dinner in England'. Typically for him, Farington records the *placement*, the topics of conversation, and the bill. 'We had conversation,' he tells us,

upon the state of Artists in this country, compared with what it was when Mr West arrived in England, in respect to their personal manners and the degree of estimation in which they were and are held. Mr West said that in 50 years they had become a different description of men, so much more decorous in their deportment and in their reception in Society. He observed that the establishment of the Royal Academy had done much in giving dignity to the Arts, and that too much could not be done to preserve its importance. Sir Joshua Reynolds was spoken of, and Lawrence said that He could justly assert that Mr West had maintained more personal dignity in Society than Sir Joshua had done: Smirke declared himself to be of the same opinion. Lawrence thought Sir Joshua a very worldly man.

The company stayed till eleven. The bill came to six pounds eighteen shillings, with five shillings extra for the waiter, and Farington tells us that 'Mr West desired it might be considered to be *His dinner*, which domestic circumstances prevented his giving at his own house, and He paid the Bill'.[2]

As his death approached (he died in 1820), West related his life story to the writer John Galt, and employed his last energies in the revising of the proofs. The resulting biography, based largely on material supplied by the artist (much like Condivi's

Benjamin West PRA (1738–1820), Study for *Death on a Pale Horse*, 1783, retouched 1803 (detail)

Benjamin West PRA (1738–1820), *Self-portrait*, 1793. Oil on panel, 101.5 × 132 cm. Royal Academy of Arts, London. Given by Joseph Neeld MP, 1830. 03/285. West served as President twice, from 1792 to 1805 and from 1806 to 1820

life of Michelangelo), was mocked at first for its exalted view of its subject, and for its perceived improbability. And it is true that it is furnished with portents and prophecies, and with speeches and thoughts remembered long after the event, and true as well that it ends with an ill-advised eulogy to the American painter (which considers comparing him to Michelangelo and Raphael, but settles for Shakespeare instead). Haydon, by contrast, was clear in his mind that West was not a great artist: 'He is refined in nothing – he paints expeditiously, he composes rapidly, he draws well, and colours without much trouble; I do not suppose a picture ever cost him trouble – from his infancy – he is a Lopez de Vega in Painting.'[3]

The first defence of Galt was provided by historians who, checking names and places in his account of

West's early life, found that they were often accurate: the hagiography, if that was what it was, was well founded in time and place. Galt (or West, speaking through Galt) always points us in the direction of a kernel of fact, even if the fact has then been lavishly interpreted. It is also the case that the facts are often more extraordinary than the embellishments.

West was born in 1738 in colonial Pennsylvania, and grew up in a world in which high art was unknown. The first American artist to travel to Europe for his education, he met with success in Rome, came to England and became History Painter and friend to the King. He helped to found the Royal Academy and was elected its second president. He is also considered the founder of the American school of painting, the teacher and nurturer of the first generations of American artists. Yet all of this was

achieved from London, and he never returned to post-revolutionary America.

It is hardly surprising that when he looked back on his childhood he should search for portents, or that, aware that he had enjoyed an extraordinary career, he should have encouraged his biographer to treat him not as a saint, but as an extraordinary man, after the manner of Plutarch, say, or Vasari. So it is that we learn from Galt that West's mother (whom another source claims was banished from the place of worship on grounds of fornication) went into labour in her agitation at the oratory of a Quaker preacher, Edmund Peckover, who was inveighing against the corruption and materialism of France and England:

> But from the woes and crimes of Europe let us turn our aside our eyes; let us turn from the worshippers of Commerce, clinging round their idols of gold and silver, and, amidst the wrath, the storm, and the thunder, endeavouring to hold them up; let us not look at the land of blasphemies; for in the crashing of engines, the gushing of blood, and the shrieking of witnesses more to be pitied than the victims, the activity of God's purifying displeasure will be heard; while turning our eyes towards the mountains of this New World, the forests shall be seen fading away, cities rising along the shores, and the terrified nations of Europe flying out of the smoke and the burning to find refuge here.[4]

It was at this point in the sermon, we are led to believe, that Mrs West's birth-pains began. 'The meeting was broken up; the women made a circle round her as they carried her home, and such was the agitation into which she was thrown, that the consequences had nearly proved fatal both to the mother and the infant, of which she was prematurely delivered.' Both the father and the preacher felt that a child born under such circumstances was destined for something extraordinary.

By means of the sermon, Galt has introduced the great theme of the biography: the contrast between the old world and the new, the corruption of Europe and the innocence of Pennsylvania in the days of George II – a world in which settler and Indian lived in harmony, the latter having been conquered not by the sword but 'by the force of Christian benevolence'. It is a world without art, in which the child is obliged to learn everything for himself from first principles.

The Indians teach him to prepare yellow and red pigments, according to their traditional ways, and his mother gives him a piece of indigo, thereby completing the primary colours. Learning that 'pencils' (paintbrushes) are made from camel hairs stuck in a quill, and there being no camels in America, the child improvises, using the hairs of the cat. He is eight before he is given his first paintbox, and sees his first engravings.

In one of those set pieces he delighted in, West told Galt how, before arriving in Rome, he had stopped at a milestone with a commanding view of the city (just as he was later to do at Shooter's Hill), and contemplated the progress of history. He had thought of the site of Rome as it had been in remote antiquity, covered with unexplored forests. Then he had passed rapidly over her history, until he was touched with sorrow at the solitude of Rome's decay, only to be cheered by the recollection of the greatness that seemed to be on offer for America. The arts had progressed from East to West, he reflected (in an echo of Reynolds's first Discourse), improving as they went. Their greatness in Europe seemed like an omen of their forthcoming glory in America.

> While he was rapt in these reflections, he heard the drowsy tinkle of a pastoral bell behind him, and on turning round, he saw a peasant dressed in shaggy skins, driving a few goats from the ruins. The appearance and physiognomy of this peasant struck him as something more wild and ferocious than anything about the Indians; and, perhaps, the observation was correctly philosophical. In the Indian, Nature is seen in that primitive vigour and simplicity, in which the actions are regulated by those feelings that are the elements of the virtues; but in the Italian bandit, for such he had reason afterwards to think was the real character of the goat-herd, he saw man in that second state of barbarity, in which his actions are instigated by wants that have often a vicious origin.[5]

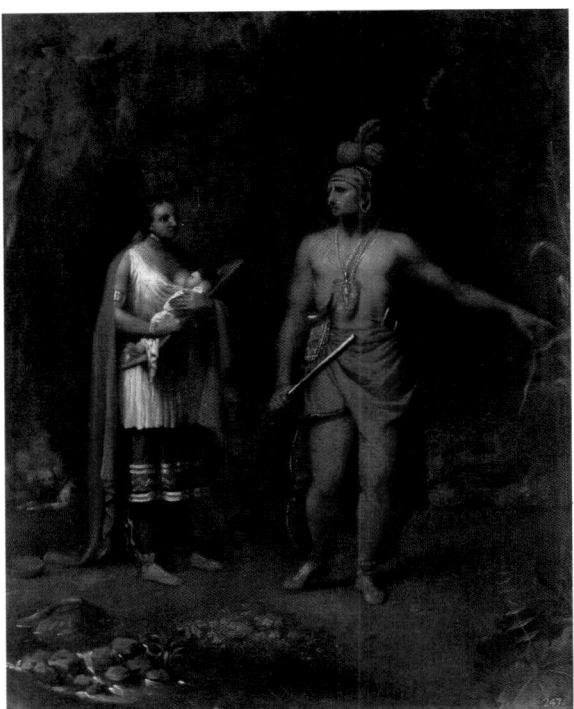

Attributed to Benjamin West PRA (1738–1820), *A Savage Warrior Taking Leave of His Family (American Indian and Family)*, 1761. Oil on canvas, 60 × 45.7 cm. Hunterian Museum at the Royal College of Surgeons, London. The chieftain's pose echoes that of the Belvedere Apollo, of which the Academy possessed a cast (see *The Antique School at the Royal Academy*, page 118)

The sense, apparent in such passages, is that West occupied a unique position as an artist, being from the world of the Noble Savage and partaking of, or benefiting by association with, some of that primitive nobility.

In Rome, he was a novelty – an American and a Quaker to boot – and there was some idea that he must also be an Indian. The blind Cardinal Albani's first question, when West was presented to him, was 'Is he black or white?' On being told that he was very fair, the Cardinal exclaimed, 'What, as fair as I am?' – a remark which caused some amusement, since Albani's complexion was 'of the deepest olive'. At least, the Italians thought, West must have had the education of a savage. If so, it would be worth seeing the effect that the sight of great art would have upon him.

The next day, more than thirty of the most magnificent carriages in Rome set out for the

Vatican to show the young Quaker its masterpieces, and it was agreed that the Belvedere Apollo should be first on the list, as being the most perfect. This work was kept in a wooden case, the doors of which were flung open, and the spectators awaited West's reaction. 'My God,' he said, 'how like it is to a young Mohawk warrior!' This remark caused some initial dismay, but West was ready with a beguiling account of the Mohawks:

> He described to [the interpreter] their education; their dexterity with the bow and arrow; the admirable elasticity of their limbs; and how much their active life expands the chest, while the quick breathing of their speed in the chase dilates the nostrils with that apparent consciousness of vigour which is so nobly depicted in the Apollo. 'I have seen them often,' added he, 'standing in that very attitude, and pursuing, with an intense eye, the arrow which they had just discharged from the bow.'

This adeptness at trading on his own exotic background, and this sure-footed diplomacy, stood West in good stead both with the Italians and with the foreign community, whose days were spent in the study of classical art:

> Every recreation of the stranger in Rome was an effort of the memory, of abstraction, and of fancy. – Society, in this elevated state of enjoyment, surrounded by the greatest works of human creation, and placed amidst the monuments of the most illustrious of mankind, and that of the Quakers of Pennsylvania, employed in the mechanical industry of felling timber, and amid the sobriety of rural and commercial oeconomy, were like the extremes of a long series of events, in which, though the former is the necessary consequence of the latter, no resemblance can be traced in their respective characteristics. In America all was young, vigorous and growing, – the spring of a nation, frugal, active, and simple. In Rome all was old, infirm, and decaying, – the autumn of a people who had gathered their glory, and were sinking into sleep under the disgraceful excesses of the vintage.[6]

So when West examined the hieroglyphs on the Egyptian obelisks, he was reminded of the records of transactions made by the Indian warriors he had seen in Philadelphia, by means of red and black figures on their Wampum belts. He thought that a language of signs derived from natural objects must have something universal in its very nature.

West's training in Italy put him ahead of all American artists of his day. It also gave him an advantage over most British artists, and when he arrived in London it was his Italian training, as much as anything, that brought him to the attention of patrons and other painters. But still, his being an American must have given an extraordinary significance to the friendship that immediately grew between West and George III.

Not every American painter found a warm welcome in London. John Trumbull, a colonel from the American rebel army who was taken on by West's studio in 1780, was arrested on suspicion of espionage, and sent work to the Royal Academy exhibition of 1781 from his cell in Bridewell prison. It appears to have been turned down. It was in Bridewell that Trumbull passed his time copying West's copy of Correggio's *St Jerome*, one of the most admired paintings of the time.

Throughout the period of the American Revolution, West was at the side of the King, and this warm friendship between the monarch and an American was the cause of some controversy and unease. So we learn of a conversation between Lord Cathcart, who had fought in America against the rebels, and West, which took place in the presence of the King.

> Cathcart asked West in a loud voice whether he had heard the war news that morning. West said he had not seen the papers. Cathcart: 'Then, sir, let me inform you that His Majesty's troop in South Carolina have gained a splendid victory over the rebels, your countrymen. This, I suppose, cannot be very pleasant news to you, Mr West.' West: 'No, sir, that is not pleasant news to me, for I never can rejoice at the misfortunes of my countrymen.' The King, showing a first awareness of the conversation, to West: 'Sir, that answer does you honour.' Then the King turned to

Cathcart and said, 'Sir, let me tell *you* that, in my opinion, any man who is capable of rejoicing at the calamities of his country, can never make a good subject of any government.'[7]

After the defeat of the British forces, the King told West privately that he intended to abdicate and go to Hanover. West, as he later told Farington,

> was with the king when the Box arrived from the Minister containing the acknowledgment of *American Independence*. The King sd. He shd. Have been happy had they remained under his government, as it was otherwise he hoped they would be so [that is, be happy] in their new state.[8]

West and his fellow American painter John Singleton Copley watched the King read the speech in the House of Lords.

It was in front of one of West's paintings that the King, in 1788, displayed some of the early signs of the mental disturbance that was to plague him in later life. West had painted a landscape for the Queen, and had included a lion in it, for the sake of the young Prince Adolphus. Seeing the painting on the easel, the King began to say that the lion looked like a dog. West kept silence. 'The King then deliberately took a pencil [i.e. a paintbrush] and drew it through the figure, and then drawing a fantastic

John Singleton Copley RA (1737–1815), *The Tribute Money*, 1782. Oil on canvas, 128.3 × 153.7 cm. Royal Academy of Arts, London. Diploma Work, accepted in 1782. 03/994

Benjamin West PRA (1738–1820), *A View in Windsor Great Park*, c. 1785.
Oil on canvas, 153.1 × 215.5 cm. The Royal Collection. RCIN 406917

sketch showed it to the painter as a proper drawing of the animal.' West was supposedly the first person outside the royal household to observe the King in this state.[9]

That West should have been elected President of the Academy with only one opposing vote (it went to Cosway) is one of many indications that he was seen as having authority and pre-eminence. He had been more involved in the original foundation of the Academy than Reynolds, and was on better and more intimate terms with the King. Nevertheless the dead Reynolds remained a presence to contend with, not least when, at the end of the toasts during West's first Annual Dinner, James Boswell rose and asked permission to say a few words.

Boswell was the recently elected Secretary for Foreign Correspondence – an honorary position – and his intervention was unscheduled. His remarks somewhat incoherently and tactlessly drew attention to the nervousness felt by Reynolds's admirers at his no longer being in the chair. By implication he seemed not only to be airing doubts about West's suitability to succeed Reynolds. He also, no doubt inadvertently, seemed to be questioning the King's judgment in approving the Academy's choice. Boswell spent some time and effort rectifying this error, and composed and sang a song in West's honour at the next session of the Royal Academy Dining Club.

The area in which West has been thought to have unwisely courted comparison with Reynolds was in his delivering of discourses to the students. West's education had been that of a foreign artist in Italy, and his book learning was narrow. That said, he was among colleagues who were for the most part equally ill educated. He brought to his appreciation

of the arts a New World perspective, as we have already seen in his introduction to classical art in Rome. In his first discourse, he alludes to American pictograms as being instances of primordial art.

> In the arts of design were conveyed the original means of communicating ideas, which the discoverers of countries show us to have been seized upon, as it were involuntarily, by all the first stages of society. Although the people were rude in knowledge and in manners, yet they were possessed of the means by which they could draw figures of things, and they could make these figures speak their purposes to others as well as to themselves. The Mexicans conversed in that way when Cortes came among them; and the savages of North America still employ the same means of communicating intelligence.
>
> When, therefore, you have taken up the arts of design as your profession, you have embraced that which has not only been sanctioned by the cultivation of the earliest antiquity, but to which their [sic] is no antiquity prior, except that of the visible creation.[10]

West's sense of the history of art included early monuments still to be seen in 'the pagodas of India, in some caverns of Media, and among various ruins in Persia' – some of which he dated to 2,000 years before the classic age of Greek art. In this sense, though West had the mind of a neoclassicist, he was by no means unaware of an art beyond the European classical tradition. On the contrary, he immediately identified it, as he identified the pictograms on the Egyptian obelisks in Rome, as an art related to that of the America from which he came. And if he mentions Cimabue and Giotto only in passing, that is because he dates the progress of art in Italy as beginning with the foundation of 'the Academy of St Luke in Florence', which he dates to 150 years before Michelangelo, Raphael and Bramante.

West's way of thinking was neoclassical, but his artistic temperament also had a markedly romantic aspect. His studies for the apocalyptic *Death on a Pale Horse*, one of which is in the collection of the Royal Academy, reflect an appreciation of Rubens, and seem to anticipate Delacroix, who certainly knew West's work. His portrait of the Polish patriot Tadeusz Kosciuszko, made from memory after

Benjamin West PRA (1738–1820), Study for *Death on a Pale Horse*, 1783, retouched 1803.
Pen, pencil and wash, 57 × 112 cm. Royal Academy of Arts, London. 03/6169

a visit to Kosciuszko's room in the French hotel in Leicester Square, is a domestic representation of a romantic hero.

In one famous respect West undermined neoclassical practice, in executing a history painting, in the grand style, of *The Death of General Wolfe*, depicting his subjects in contemporary rather than classical dress. This, for history painting, was a departure, and one from which both Reynolds and the Archbishop of York sought to dissuade him. West tells us that he listened to Reynolds

> with the utmost attention in my power to give, but could perceive no principle in what he had delivered; only a strain of persuasion to induce me to comply with an existing prejudice, – a prejudice which I thought could not be too soon

removed. When he had finished his discourse, I begged him to hear what I had to state in reply, and began by remarking that the event intended to be commemorated took place on the 13th of September, 1758, in a region of the world unknown to the Greeks and Romans, and at a period of time when no such nations, nor heroes in their costume, any longer existed. The subject I have to represent is the conquest of a great province of America [Quebec] by the British troops. It is a topic that history will proudly record, and the same truth that guides the pen of the historian should govern the pencil of the artist. I consider myself as undertaking to tell this great event to the eye of the world; but if, instead of the facts of the transaction, I represent classical fiction, how shall I be understood by

Benjamin West **PRA** (1738–1820), *The Death of General Wolfe, c.* 1771. Etched and engraved by **William Woollett** (1735–1785). Royal Academy of Arts, London. 03/5279

posterity! The only reason for adopting the Greek and Roman dresses, is the picturesque forms of which their drapery is susceptible; but is this an advantage for which all truth and propriety of the subject should be sacrificed? I want to mark the date, the place, and the parties engaged in the event; and if I am not able to dispose of the circumstances in a picturesque manner, no academical distribution of Greek or Roman costume will enable me to do justice to the subject. However, without insisting upon principles to which I intend to adhere, I feel myself so profoundly impressed with the friendship of this interference, that when the picture is finished, if you do not approve of it, I will consign it to the closet, whatever may be my own opinion of the execution. They soon after took their leave, and in due time I called on the Archbishop, and fixed a day with him to come with Reynolds to see the painting. They came accordingly, and the latter without speaking, after his first cursory glance, seated himself before the picture, and examined it with deep and minute attention for about half an hour. Then he rose, and said to His Grace, Mr West has conquered. He has treated his subject as it ought to be treated. I retract my objections against the introduction of any other circumstances into historical pictures than those which are requisite and appropriate; and I foresee that this picture will not only become one of the most popular, but occasion a revolution in the art.[11]

West suffered two major setbacks in his professional and personal life. One was that he lost the support of the Academicians to the extent that he decided it was better to resign, which he did at the end of 1805, being replaced by James Wyatt. West immediately began work on a painting of the death of Nelson, which had taken place a few weeks before. His intention, he later confided to Farington, had been to show the Academy what it had done in causing him to resign and then replacing him with an architect. He added, however, that resignation had been to him a happy release, since 'He could now wake in the morning without the unpleasant consideration of having those people to meet in the evening.'[12]

Charles Rossi RA (1762–1839), *Bust of James Wyatt* PRA, after 1797. Painted plaster cast, height 55 cm. Royal Academy of Arts, London. Given by N. J. S. Wyatt, 1995. 03/1816. Wyatt served as President from 1805 to 1806

Sir Francis Chantrey RA (1781–1841), *Bust of Benjamin West* PRA, 1818. Marble, height 65 cm. Royal Academy of Arts, London. Diploma Work, accepted in 1818. 03/1690

Despite such bravado, it is clear that West really did paint *The Death of Lord Viscount Nelson* (Walker Art Gallery, Liverpool) as an act of self-justification. He made this quite plain when, instead of sending it to the Academy exhibition as he would normally have done, he mounted a rival show at home, in his own gallery. The opening was timed to coincide with the Academy. It was an outstanding success. West had borrowed two of his famous historical works from the Earl of Grosvenor (*The Death of General Wolfe* and *The Battle of La Hogue*) to show with the new painting. Large numbers came. West issued 6,500 cards of admission, but some people brought parties of eight or ten. In all, West believed that 30,000 people had been to his house to see the new canvas. Not only the admission charge but also the rights in the ensuing engraving brought in large sums.

A year later, West had the satisfaction of seeing Wyatt resign his presidency (he had been extremely unsatisfactory and a poor attender of meetings), saying, as he did so: 'The best thing the members can do will be to re-elect Mr West.'

The other great setback West suffered was his losing the favour of the King, whether through the machinations of the Queen or the Prince or Wales; or because rumours had been spread about his political sympathies; or through the innumerable intrigues of the Academy; or because the King's own mental health was impaired. At all events, West went through the experience of being ignored at court and finding his salary stopped, and his work on the Chapel of the History of Revealed Religion (an immense project which traced the history of revealed religion from the fall of the Adam to the

Benjamin West PRA (1738–1820), *The Death of Lord Viscount Nelson*, 1805. Engraved by **James Heath** ARA (1757–1834). Royal Academy of Arts, London. 03/5227

atonement of Christ) cancelled. It had been intended by West as his life's crowning achievement. Had it been completed, he wrote, 'it would have marked itself as worthy of his Majesty's protection as a Christian and a patriot King, and all Christendom would have received it with affection and piety'.[13] Its place in Windsor Castle was given over to a Waterloo Gallery. Whatever the triumphs of his return to the presidency of the Academy, the humiliations he received at Windsor stayed with him.

We get a picture of West in old age from C. R. Leslie's memoirs. In the spring of 1819, West was too ill to leave his house, but expressed the wish to see the Royal Academy exhibition before it closed. He was too feeble, he said, to go on a public day, and his only chance would be to visit it the day after closing. Then he added that, if the Prince Regent went, he, as President, would be obliged to attend – 'a ceremony for which he was too unwell'.

'But surely,' said Leslie, 'the Prince, knowing how ill you are, would excuse you from the fatigue of attendance.'

'No,' replied West, contradicting himself: 'if the Prince goes, I cannot.' And after a pause: 'Mr Leslie, it is now many years since I have had cause to know the wisdom of David's advice, "put not your trust in princes".' The slights he had received from the Prince Regent were not forgotten.[14]

On Saturday 29 January 1820, George III died at Windsor, and the servants of the Academy were put into mourning. West himself lay terminally ill, but insisted on correcting the proofs of Galt's life. West, the last of the original Academicians, was the same age as the King. George had once asked him how old he was, and when learning they had been born in the same year said: 'Ah! Then when *I* die, West, *you* will shake in your shoes.' In the event, West's son, Raphael, tried to keep the newspapers from him. West said: 'I am sure that the King is dead and that I have lost the best friend I ever had in my life.'[15]

West hung on for a while, swollen with dropsy, living on sago and custard spiked with brandy. He lay on the sofa in the front drawing room, surrounded by works of art. He had two volumes of drawings by Fra Bartolommeo placed within reach, so that he could 'conveniently turn them over and enjoy them from his pillow'.[16]

On the day after West's death, Constable called at his house. He had finally been elected to an Associate membership the year before, and he had reason to be grateful to West for encouraging his early efforts. Once, after a work had been rejected by the Academy, West said to Constable: 'Don't be disheartened, young man, we shall hear more of you again; you must have loved nature very much before you could have painted this.' Then he had taken a piece of chalk, and 'showed Constable how he might improve the chiaroscuro by some additional touches of light between the stems and branches of the trees, saying, "Always remember, sir, that light and shadow *never stand still*."'

Constable recalled this as 'the best lecture, because a practical one, on chiaroscuro he ever heard'. Another piece of advice from West was recalled by Constable for Leslie:

> Whatever object you are painting, keep in mind its prevailing character rather than its accidental appearance (unless in the subject there is some peculiar reason for the latter), and never be content until you have transferred that to the canvas. In your skies, for instance, always aim at *brightness*, although there are states of atmosphere in which the sky itself is not bright. I do not mean that you are not to paint solemn or lowering skies, but even in the darkest effects there should be brightness. Your darks should look like the darks of silver, not of lead or slate.[17]

It is interesting that among the paintings by West that Constable admired were those works painted for the sake of the landscape.

Now West's servant, Robert Brunning, remarked to Constable: 'Ah, sir! where will they go now?' He meant: with West dead, where would the younger artists now go for instruction? For, as Constable said, 'in his own room, and with a picture before him, his instructions were invaluable; but as a public lecturer, he failed.' Constable was remembering not only the individual encouragement he had received, but also the morning levées at West's studio, where all artists were welcome. 'Nor did a shabby coat or an old hat ever occasion his door to be shut in the face of the wearer,' as Leslie recalls. No one had been as accessible as West.[18]

John Constable RA (1776–1837), *Cloud Study: Horizon of Trees*, 27 September 1821.
Oil on paper laid on board, red ground, 25.8 × 30.5 cm. Royal Academy of Arts, London.
Given by Isabel Constable, 1888. 03/1994

His funeral was even more imposing than that of Reynolds. The American ambassador was among the pall-bearers, and the carriages of the aristocracy were numerous. But the decline in his reputation had already begun, and it was only when the major absurdities of the flattery that surrounded him had been long forgotten that West's paintings could be appreciated again for their historical significance.

It was during West's presidency that the Academy decided for the first time to expel one of its members. James Barry, reputedly the son of a bricklayer in Cork, was a romantic dissident whose work sometimes bears a strange resemblance to that

of Blake. He was, indeed, an exemplar to Blake, both in the images he created and in his posture as the persecuted outsider: 'Obedience to the Will of the Monopolist is call'd Virtue, and the really Industrious, Virtuous & Independent Barry is driven out to make room for a pack of Idle Sychophants with whitlows on their fingers'.[19]

To Haydon, too, Barry represented the epitome of the selfless, dedicated, high-minded artist in an age without enlightened patronage: 'Barry painted the Adelphi – for nothing!'[20] He had indeed painted the Great Room of the Society of Arts, and began the project with only sixteen shillings in his pocket.

John Constable RA (1776–1837), *Rainstorm over the Sea*, c. 1824–28.
Oil on paper laid on canvas, 23.5 × 32.6 cm. Royal Academy of Arts, London.
Given by Isabel Constable, 1888. 03/1390

The Society had agreed to pay for his supplies (canvas, paints and models), but there was no provision for any wage. There was a classical precedent for this: Polygnotus is recorded as having painted the Stoa Poikile in Athens without remuneration. But if Barry set out to emulate Polygnotus, he soon realised the difficulties he was in and tried to rectify the situation by proposing a subscription to support him to the tune of one hundred pounds a year. He expected to be done in two years, after which an exhibition could be held whose profits would pay back his wage. All this, however, was proposed after the commission had been secured, and was ignored by the Society. Barry did indeed suffer for his work, which began in 1777 and was not finished until 1784, but he had set the terms for his own suffering. He had secured complete freedom as to choice of subject and composition. The exhibitions at

the opening brought a disappointing attendance, and he earned just over £500, having gone several hundred pounds into debt, despite living on a careful fourpence a day.

This was a supreme demonstration of artistic independence, and it was not forgotten. Decades later, in 1842, Haydon went back to the Adelphi to look at Barry's pictures.

> Miss Corkings, the House-keeper, was a girl of 12 years old when Barry painted the work. She told me many anecdotes. She said his Violence was dreadful, his oaths horrid, & his temper like insanity. She said he carried Virtue to a Vice. His hatred of obligation was such he would accept nothing. Wherever he dined he left 1s. 2d. in the plate, and Gentlemen indulged him. The servants were afraid to go near him; that in Summer he

James Barry RA (1741–1806), *Self-portrait*, *c.* 1800. Brush and bistre on paper, 57.3 × 42.5 cm.
Ashmolean Museum, University of Oxford

came to work at 5, & worked till dark, when a lamp was lighted, & he went on etching till XI at night.

She said, when coaxed to talk, his conversation was sublime. She thought the want of early discipline was the cause of his defects. He began to work in 1780, and was 7 years before he concluded it. She remembered Burke & Johnson calling once, but no Artist. She really believed he would have shot anyone who would have dared. He had tea boiled in a quart pot, and a penny roll for breakfast, dined in porridge Island, & had milk for supper, which was prepared in the rooms of the House.

Porridge Island was an alley of cooks' shops near St Martin-in-the-Fields. Haydon – even Haydon – concludes:

> There is a grasp of mind there no where else to be found, as Johnson said, but no color, no surface, beauty, or correct drawing. Still, as the only work [of the kind], it is an honour to the Country.[21]

It is indeed a unique work, strange in its execution and in its conception. It traces the development of Greek civilisation from primitivism to community, to agricultural society, to *The Crowning of the Victors at Olympia*. There follows a representation of *Commerce,*

or The Triumph of the Thames, in which allegorical figures are grouped with historical and contemporary portraits, *The Distribution of the Premiums in the Society of Arts*, and finally *Elysium and Tartarus, or The State of Final Retribution*, in which it was Barry's wish 'to bring together in Elysium, those great and good men of all ages and nations, who were cultivators and benefactors of mankind; it forms a kind of apotheosis, or more properly a beatification of those useful qualities which were pursued throughout the whole work'.[22]

As if he had not enough to do, completing this taxing project during daylight and working on his etchings by night, Barry offered himself for the recently vacated post of Professor of Painting at the Royal Academy. But, according to Northcote,

'he was not over diligent in preparing for the duties of his office'. Reynolds brought the matter up. Barry, 'with his fist clenched in a menacing posture', replied with great violence: 'If I had no more to do in the composition of my lectures than to produce such poor flimsy stuff as your discourses, I should soon have done my work, and be prepared to read.'[23]

Northcote goes on to tell us that Barry's Academy lectures, when he did get going, 'very soon became mere vehicles of invective and satire against the principal Academicians, and most pointedly against Sir Joshua, who was reduced by it to so awkward a situation in his chair as an auditor, that he was obliged at last either to appear to be asleep or to absent himself from the place'.[24] This belligerence

John Bluck (fl. 1791–1831), after **Thomas Rowlandson** (1756–1827) and **A. C. Pugin** (1762–1832), *Society for the Encouragement of Arts, &c., Adelphi*. Aquatint from Ackermann's *Microcosm of London*, 1809. Private collection

was universally noted. A contemporary critic said that 'One of Barry's most prominent defects was to attempt carrying everything by *storm*.' To which Haydon replies stoutly (and much in the manner of Blake):

> This was not his defect but his excellence. His defect was not providing himself with arms to render his attempt effectual, or understanding sufficiently the strength of the fortress he wished to take, or the courage of his opponents. A wish to take things by storm is a proof of a determined nature, but the result of the attempt will shew whether the judgment that directs the attempt is equal to the courage that inspired it.[25]

Burke, who befriended and supported Barry early in his career, wrote to him in Rome in 1769 with some prophetic advice:

> Depend upon it, that you will find the same competitions, the same jealousies, the same Arts and Cabals, the same emulations of interest and of Fame, and the same Agitations and passions here that you have experienced in Italy; and if they have the same effect on your Temper, they will have just the same Effects on your Interest; and be your merit what it will, you will never be employed to paint a picture. It will be the same at London as at Rome; and the same in Paris as in London; for the world is pretty nearly alike in all its parts.[26]

But no amount of kind or good advice could counter the effects of Barry's character. For he saw persecution everywhere, and spoke out against it whenever the occasion arose. His lectures at the Academy provided a perfect occasion, over the years of his professorship (1782–99), and he supplemented these with printed attacks on his perceived enemies. When Reynolds was edged out of office by what he saw as a cabal, Barry, despite his low opinion of him, rallied to his defence. When West in due course stood as Reynolds's successor, Barry tried to persuade the Academicians to bind themselves by an oath to vote for the best man. He thought that if only they could be forced to vote according to their conscience, the shame of West's presidency could be avoided. He thought West a poor painter and too close a friend of the King for the good of the Academy's independence.[27]

Eventually he wrote and published a book-length *Letter to the Dilettanti Society* which constituted an attack on the Academy for its failure to improve public taste, and an appeal to the rival body to take its place. He accused the Academicians of having misspent funds. He went into the unfortunate involvement of West and others in the matter of the purchase of the so-called Venetian Secret.[28] He was (in sharp contrast to other leading artists of the day, Reynolds excepted) passionately in favour of the founding of a public collection of art, a national gallery, and he thought the opponents of his scheme were afraid that a public collection of great works of art would expose their mediocrity.

In due course the Academy was obliged to respond. This is the original charge sheet, as presented to the Council on 2 March 1799. It was held that during his lectures Barry was guilty of:

> Making unallowable Digressions from the Subject, on which he is bound exclusively to discourse. –
> Hinting to his Auditors, that the Academy's Money was disposed of, in a mysterious, & secret manner, in Pensions for themselves. –
> And, proclaiming to many Strangers then present, particularly to the Students, that the Academy possess'd Sixteen Thousand Pounds. – But, Alas! – Alas! He lamented, and feared, that no part thereof would ever be employed in the purchase of a few Pictures, for their advancement in the Arts. – Thus Encouraging them to Licentiousness – & to Depreciate the manifest advantages, which they have long enjoyed, & continue to receive, from the Bounty of this noble Institution. –
> These, & many other unwarrantable Expressions, were made use of, by Mr Barry at the close of his last, – & in the middle of his antecedent Lecture.[29]

Barry still had some friends and supporters at the Academy, but they were in a minority. Farington detested him. Northcote outraged Farington by talking of 'high character in Art & in letters being attacked by a Landscape painter'. Farington was indeed a landscape painter, and one of very modest

James Gillray (1757–1815), *Titianus Redivivus; or The Seven-Wise-Men Consulting the New Venetian Oracle*, 1797. Hand-coloured etching and aquatint, 54.9 × 42 cm. British Museum, London. BMC 9085

achievement, so this was a low blow. In the ensuing machinations, Barry made every effort to find out what the precise charges against him were, while the Academicians in general resisted this.

A committee was formed to review the case, and on the day it was due to report Barry behaved 'with much *Bravura* & indifference'. He called for the President to take the chair, saying the room was hot. 'Little notice was taken of what He said,' Farington observes. Then the senior member of the committee, [George] Dance, began to read the report – a report which has since, mysteriously perhaps, gone missing. Farington observed Barry with remorseless interest. Occasionally Barry would interject with a 'Bravo' or 'That's false' or (when the matter of Reynolds's funeral was raised, and Chambers's reluctance to allow a lying-in-state at Somerset House) 'That's not all'.

Then the report's full impact began to dawn on Barry. He changed colour, and listened to the remainder with his eyes closed. The whole reading took around 35 minutes, at the end of which Barry rose and demanded the charges against him, saying that they were not in Spain under inquisitorial government, but in England. He wanted to be given a copy of the charges contained in the report. 'Some sharp remarks passed between him and Dance,' as Farington puts it, after which Barry left his chair and said that many of the charges were false, and if they were refused him he would retire. He did not wish to remain a member of a Society that could act in such a manner. He put on his hat and greatcoat. He was told to take off his hat (presumably wearing it was a mark of disrespect in the presence of West, who routinely wore *his* hat during Academy business – out of respect for the office), which he did, before leaving the room.

The picture that you get from Farington is of an Academy quite certain that Barry would have to lose his professorship (his only allies on this issue were Nollekens, Opie and Northcote), but much less clear either that it was fair to Barry not to give him copies of the charges against him, or that he should be expelled from 'all functions of an Academician'. Nine members voted for suspension, only thirteen for total expulsion, and the closeness of the vote created immediate unease. But once they had triumphed, the anti-Barry group were implacable. Dance,

having read the fatal report, began to think that the Academy should at least prepare strong arguments for their having refused to give Barry the charges. When Farington completely rejected this, Dance added that he thought it might be prudent to place a constable at the door of the Academy, to prevent any outrage from Barry.

It is clear that Barry still did not quite understand that the vote had gone against him and that all avenues were blocked. He sought help, apparently, from William Godwin, who dictated a letter for him to question the finality and absoluteness of the Academy's decision. But it was too late, and the King, being presented with the Roll of Obligation, the roll of members' signatures, struck Barry's name out, writing beside it: 'I have struck out the adjoining name in consequence of the opinion entered in the minutes of the Council and the General Meeting which I fully approve. George R.'

The appalling last chapter of Barry's life began. The Irish lawyer William Henry Curran described living in London not far from Barry, and being aware of a house notorious in the neighbourhood:

> The house seemed to be uninhabited. The glass of the lower windows was broken, the shutters closed, and the door and the walls strewed with mud. Upon the first occasion of my particularly noticing the house, a group of boys and idlers had collected outside, where they were shouting, whispering, pointing to the upper windows, and going through the ordinary routine of looks and gestures and muttered execrations that precede a general assault upon an obnoxious tenant. They were in the act of commencing hostile demonstrations when they were dispersed by the parish officers. I enquired the cause of these manifestations of popular anger and was informed that the house – to the terror and scandal of the neighbourhood – was occupied by an old wizard or necromancer, for this point was unsettled. But whatever he was he lived there in solitude in order that he might devote himself unobserved to some holy mysteries.

Some Irish friends called on Curran and invited him to go with them to the house of Barry, the painter.

My friends made a full stop at the house of the old magician. It was Barry's! A loud knock was given, and was for some minutes unanswered... The area was bestrewn with skeletons of cats and dogs, marrow bones, waste paper, fragments of boy's hoops and other playthings, and with the many kind of missiles which the pious brats of the neighbourhood had hurled against the unhallowed premises. A dead cat lay upon the projecting stone of the parlour window, immediately under a sort of appeal to the public, setting forth that a dark conspiracy existed for the purpose of molesting the writer of the placard, and concluding with the offer of a reward. The rest of the framework of the window was covered up with his etchings, turned upside down, of his paintings at the Adelphi.

A second and louder knock was given. It was answered by almost as loud a growl from the second floor window. We looked up and beheld a head thrust out, surmounted by a hunting cap, whilst a voice, intensely Irish, in some hasty phrases made up of cursing and questioning, demanded our names and business. Before my companions had time to answer they were recognised. In went the head, in a few seconds the door was opened and I was introduced to the celebrated Barry. The hunting cap was still on, but at a nearer view I perceived that the velvet covering had been removed and nothing but the base and ugly skeleton remained. He wore a loose, threadbare, claret-coloured coat that reached to his heels, black waistcoat and breeches, coarse, unpolished shoes with thongs. No neckcloth, but he seemed to have a taste for fine linen, for his shirt was not only clean but genteel in point of texture. His friends smiled at his attire. It was, he said, his ordinary working dress, except the cap, which he had lately adopted to shade his eyes when he engraved at night.

Around the beginning of 1803, Barry fell ill and was three days in bed without food or help, lying under a blanket. Eventually he managed to crawl to the window and stop a passing Hackney cab. He had a piece of paper in his hand, on which he had written down his wish to be taken to the house of Sir Anthony Carlisle in Soho Square. (Carlisle, a surgeon, later became Professor of Anatomy at the Academy.) He was taken care of, recovered and seemed to have been cured, by this narrow escape, of his mental hallucinations. According to Robert Southey, Barry 'cast his slough afterwards; appeared decently dressed and in his own grey hair, and mixed in such society as he liked'.[30] But this recovery was followed by attacks by the mob on his house, attacks which continued for the remainder of his life. In February 1806 he was dining out in Wardour Street when he lost consciousness. An Irish friend came upon him by chance, and took him home, but could not gain access to the house because the front door keyhole had been filled with stones.

He was eventually taken to the home of Bonomi, the architect (whose cause Barry had supported years before, when Reynolds was at odds with the Academy), where he died two weeks later of pleuritic fever. Suddenly he was treated like a hero. His body lay in state in the Great Room that he had decorated for the Society of Arts. Among those paying their respects were two young art students: David Wilkie, who was later to show the most popular work the Academy had ever exhibited, and his friend Benjamin Robert Haydon, who was doomed to a career in some ways similar to Barry's. This time, however, the solemnity of the occasion was far from their minds. Wilkie had borrowed a black coat from Haydon, having nothing suitable himself, but the garment fitted him so ill, and caused such discomfort, that the two young men spent their time warding off the hysterics. Barry was given a grand funeral procession, and was laid to rest in St Paul's beside Sir Joshua Reynolds – to whom Barry had once been wont to refer as 'that man in Leicester Fields'.

9 The Romantic Academy: Constable, Turner, Haydon, Lawrence

When Constable died in 1837, his two brothers and a few of his friends 'followed the body to Hampstead, where some of the gentlemen residing there, who had known Constable, voluntarily joined the procession in the churchyard . . . The funeral service was read by one of those friends, the Revd J. T. Judkin, whose tears fell fast on the book as he stood by the tomb.'[1] Constable was by no means obscure as a painter, but he had not yet attained either the highest fame or the fullest acceptance of his painting.

Nobody, not even Turner, could have been more devoted to the Academy as an institution, and it was galling for Constable to find himself forced to wait for election as a Royal Academician during the decade of Sir Thomas Lawrence's presidency (1820–30). He had been made an Associate in 1819, having first thought of putting his name down, and been discouraged by Farington, in 1807. Three years later we find him angling for election again, on the grounds that his father continued to think that in following painting he was 'pursuing a shadow'. Thereafter his name recurs, but for the most part he had no support among the Academicians, until in 1819 he achieved his Associateship, beating into second place his future biographer, C. R. Leslie.

Constable's father, however, had died shortly before, as his wife was to do just before his eventual election as full Academician in 1829. Perhaps the painter was thinking of both deaths when he remarked of the honour that, much as it pleased

him, 'It has been delayed until I am solitary, and cannot impart it.' Wilkie told Leslie at this time that 'when he saw Constable's pictures in the Louvre, he could not understand why the painter of such

Charles Robert Leslie RA (1794–1859), *Portrait of John Constable* RA, c. 1830. Oil on canvas, 18.2 × 13.7 cm. Royal Academy of Arts, London. Given by Isabel Constable, 1886. 03/681

John Constable RA (1776–1837), *A Boat Passing a Lock,* 1826 (detail)

John Constable RA (1776–1837), *The Leaping Horse*, 1825. Oil on canvas, 142 × 187.3 cm.
Royal Academy of Arts, London. Given by Mrs Dawkins, 1889. 03/1391

magnificent works had not long been a full member of the Academy'.[2]

'I am still smarting under my election,' was an expression Constable used at this time in a letter, referring to the humiliation he had received from Lawrence, as Leslie relates:

> Constable called, according to custom, after the honour that had just been conferred on him, to pay his respects to Sir Thomas Lawrence, who did not conceal from his visitor that he considered him peculiarly fortunate in being chosen an Academician at a time when there were historical painters of great merit on the list of candidates. So kind-hearted a man as Lawrence could have no intention to give pain; but their tastes ran in directions so widely different, and the president, who attached great importance to subject, and

considered high art to be inseparable from historical art, had never been led to pay sufficient attention to Constable's pictures to become impressed with their real merit, and there can be no doubt but that he thought the painter of, what he considered, the humblest class of landscape was as much surprised at the honour just conferred on him, as he was himself. Constable was well aware that the opinions of Sir Thomas were the fashionable ones; he felt the pain thus unconsciously inflicted, and his reply intimated that he looked upon his election as an act of justice rather than favour.[3]

One reason for Constable's slow progress through the ranks might well have been his character. Richard Redgrave, when Leslie's *Life* was published in the 1840s, made the following note in his diary:

John Constable RA (1776–1837), *A Boat Passing a Lock*, 1826. Oil on canvas, 101.6 × 127 cm. Royal Academy of Arts, London. Diploma Work, accepted in 1829. 03/923

Leslie has just completed his life of Constable, and the world will know Constable only through Leslie's agreeable life of him. There he appears all amiability and goodness, and one cannot recognise the bland, yet intense, sarcasm of his nature: soft and amiable in speech, he yet uttered sarcasms which cut you to the bone.[4]

The phrenologist J. Atkinson said of Constable:

He possessed great vanity and conceit. He thought his own works excellent, and would speak of Turner as his one great rival. He continually dwelt with singular minuteness on all which related to himself. The organs of Self-esteem and Love of Approbation were remarkably large.[5]

One can imagine that this was indeed the case, and that Constable came across as bitter, in a world that had not yet acknowledged his merit, and which therefore could see no valid reason for 'the bland, yet intense, sarcasm of his nature'.

Turner's death in 1851, by contrast with that of Constable, was marked by the most solemn of funerals, attended by Sir Charles Eastlake, the newly elected President, and several members of the Academy: William Mulready, Daniel Maclise, William Clarkson Stanfield, David Roberts, Edwin Landseer, Charles Cockerell, Richard Redgrave and Patrick MacDowell. Applications to pay last respects had to be turned away, on the grounds that it would be impossible to find vehicles. The mourners filled eleven official coaches and eight private carriages.

'Strange', writes Redgrave in his account of the day's events, 'that one who lived so penuriously, and made so little ostentatious display in his lifetime, should desire so splendid a memorial at his death.'[6] All his life Turner had despised appearances, his 'dress and personal arrangements were of the most homely kind'. Curious that he should desire 'to leave the world and to be carried to his last rest with so much pomp'. And yet Redgrave notes that the whole affair was strongly characteristic of the man.

During his last years, Turner more or less abandoned his studio and gallery in Queen Anne Street in favour of a small cottage in Chelsea, where he lived with Sophia Booth under the name 'Mr Booth'. Meanwhile Queen Anne Street was allowed to deteriorate. Turner's housekeeper, Hannah Danby, had no knowledge of what had happened to her master, until one day, finding an address on a slip of paper in a coat pocket, she traced him to his new ménage in Chelsea.

On the morning of the funeral, Redgrave, after shaving by candlelight and crossing the park on foot

6 Davis Place, Cremorne New Road, Chelsea: the house where J. M. W. Turner lived as 'Mr Booth'

since there was no cab to be had, arrived at the house in expectation of some kind of funeral baked meats. The guests were shown into the dingy gallery, whose matting gave off a fusty smell.

> The hangings, which had once been a gay amber moreen, showed a dirty yellow here and there, where the stains from the drippings of the cracked skylight had not washed out all the colour; the coved ceiling, with the plaster broken through in many places, had been patched over the dingy whitewash with old newspapers, which, in their turn, had rotted and burst, and had been again and again patched, doubtless by the hand of the poor desolate creature [Hannah Danby] who used to keep the rooms and feed Turner's cats, if they ever were fed.

This was the colony of Manx cats remembered by visitors to Queen Anne Street.

The paintings in the gallery were 'dropping from their canvases'. Redgrave recalls seeing *The Bay at Baiae*, once shown on the Academy walls, now a wreck. 'The canvas was hanging over the frame at the bottom like a bag, and when Maclise and I pressed against it, we found that this was occasioned by the mortar from the ceiling which had fallen behind it, and was piled up between the stretcher and the canvas.' The glaze had gone from the paintings. The frames had lost first their gilding, then their ground, so that you could see the bare fir-wood beneath.

As the assembled painters surveyed the dilapidation, it became clear that all of them had left home in a hurry and were expecting to be fed, but, said Redgrave, 'it seemed as if Turner, who was never known to feast or to feed anyone in his own house when alive, was determined that no one should brag of having feasted there when he was gone'. The guests were summoned to see the coffin, which was cheap, silver-nailed and with a silver plate misstating the painter's age as seventy-nine. By ten in the morning the carriages were ready.

Redgrave went with Landseer, Cockerell and MacDowell. Turner had always loved a joke, they reasoned, and Landseer (an inveterate punster as well as a good raconteur) began telling his best stories. Soon the mourners, light-headed with

George Jones (1786–1869), *Turner's Body Lying in State*, 1851.
Oil on millboard, 14 × 23 cm. Ashmolean Museum, University of Oxford

hunger, were laughing so much that they had to sit well back and hide their faces, in order not to be seen by the crowd. It took them three hours to get from Queen Anne Street, through Cavendish Square, down Regent Street, through Trafalgar Square and along the Strand to Fleet Street and St Paul's Cathedral, 'working our way through gapers, carts and omnibuses'.

Inside the church, the choir chanted the 'Dead March' from Handel's *Saul*, while the coffin was brought into the chapel. *The Times* estimated the crowd at 500, not counting the singing boys, vicars choral, vergers, minor canons, Dean Milman, the Archdeacon, the Canon Residentiary and so forth. The ceremony ended in the crypt, where Turner was laid to rest alongside Sir Joshua Reynolds and Sir Thomas Lawrence. Then back to Queen Anne Street.

> Here we were disrobed and unsashed, and, hungry and fasting, expected to be ushered in to some funeral feast; but no, nothing came of it; until at last one of the undertaker's men entered

with a black bottle of port, and another of sherry, which, with a dozen or two of glasses, he had procured from a neighbouring public-house, together with a sixpenny bag of mixed biscuits from a baker's, and this finished the ceremony.

Turner, as one of his early biographers tells us, 'was devoted to the Academy, for all its faults. It had been quick to see his genius, and to confer on him honours'. In return, he felt for it 'the affection a child feels for its mother, for his great heart was most susceptible of gratitude'.[7]

The only speech Turner was ever known to give at the Academy was recollected by W. P. Frith in his memoirs. The account allows us to hear something of the way Turner spoke, and something – to be sure – of the way Frith liked to tell a good story. But it also perhaps tells us – really does tell us – something of what Turner valued in the Academy:

> He looked earnestly at the guests before he began, and then spoke as follows: 'Gentlemen, I see some –' (pause and another look round) 'new faces at this – table – Well – do you – do any of you – I mean

– Roman History – ' (a pause). 'There is no doubt, at least I hope not, that you are acquainted – no, unacquainted – that is to say – of course, why not? – you must know something of the – old – ancient – Romans.' (Loud applause.) 'Well, sirs, those old people – the Romans I allude to – were a warlike set of people – yes, *they were* – because they came over here, you know, and had to do a good deal of fighting before they arrived, and after too. Ah! they did; and they always fought in a phalanx – know what that is?' ('Hear, hear,' said some one.) 'Do YOU know, sir? Well, if you don't, I will tell you. They stood shoulder to shoulder, and won everything.' (Great cheering.) 'Now, then, I have done with the Romans, and I come to the man and the bundle of sticks – Aesop, ain't it? – fables, you know – all right – yes, to be sure. Well, when the old man was dying he called his sons – I forget how many there were of 'em – a good lot, seven

or eight perhaps – and he sent one of them out for a bundle of sticks. "Now," says the old man, "tie up those sticks, tight," and it was done so. Then he says, says he, "Look here, young fellows, you stick to one another like those sticks; work all together," he says, "then you are formidable. But if you separate, and go one way, and one another, you may just get broke one after another. Now mind what I say," he says – ' (a very long pause, filled by intermittent cheering). 'Now,' resumed the speaker, 'you are wondering what I am driving at' (indeed we were). 'I will tell you. Some of you young fellows will one day take our places, and become members of this Academy. Well, you are a lot of sticks' (loud laughter). 'What on earth are you all laughing at? Don't like to be called sticks? – wait a bit. Well, then, what do you say to being called Ancient Romans? What I want you to understand is just this – never mind what anybody calls you. When you become members of this institution you must fight in a phalanx – no splits – no quarrelling – one mind – one object – the good of the Arts and the Royal Academy.'[8]

In telling this story, Frith would have us believe that none of Turner's listeners could see the point he was aiming for until he reached it. Redgrave too exclaims of Turner, 'What a riddle he was both to members and students! Who ever understood his jokes? yet he chuckled over them himself until others joined him out of fellowship, not only in his laugh, but hob and nob over the "brown sherry" he so much loved. . .'

It is worth noticing, however, that, within Frith's parody of Turner's speech (evidence itself of Turner's memorability), there is a point being made which we know independently to represent Turner's strongly held views: he was passionate in defence of the Academy, whose schools he had joined in 1789, as a member of the last intake approved by Reynolds before his resignation early the next year. On that occasion, the Keeper was Carlini, and Reynolds was accompanied by Chambers, William Hodges, James

George Jones (1786–1869), *Turner's Burial in the Crypt of St Paul's*, 1851. Oil on millboard, 23 × 18 cm. Ashmolean Museum, University of Oxford

J. M. W. Turner RA (1775–1851), *Dolbadern Castle*, 1800. Oil on canvas, 119.4 × 90.2 cm. Royal Academy of Arts, London. Diploma Work, accepted in 1802. 03/1383

George Dance RA (1741–1825), *Portrait of Joseph Farington RA*, 5 May 1793. Pencil with black and pink chalks and blue and black washes on cream wove paper, 24.5 × 19.1 cm. Royal Academy of Arts, London. Purchased from the artist, 1813. 03/3272

Barry and John Opie. According to Thornbury, during the years of his membership (1799–1851), Turner failed to exhibit at the Academy only four times, in 1815, 1821, 1824 and 1851, the year of his death.

In 1846, when Benjamin Robert Haydon committed suicide, Daniel Maclise heard the news in the Athenaeum Club. Seeing Turner reading a news-paper he went up to him and said, 'I have just heard the news of Haydon's suicide. Is it not awful?' Turner, without looking up from his paper, said, 'Why did he stab his mother?' Maclise: 'Great heaven! You don't mean to say, Turner, that Haydon ever committed a crime so horrible.' 'Yes,' said Turner, 'he stabbed his mother; he stabbed his mother.' Maclise failed to get Turner to explain himself, but later, on reaching home, realised what he had meant: Haydon had been a student at the Academy Schools, but had later fallen out with the institution and attacked it publicly. This put him beyond the pale, for Turner, even after his death.[9]

Haydon's journal, which takes us from 1808 to 1846, is one of the great literary achievements of the period, in marked contrast to Farington's. Farington gives us an incomparable amount of detail, and a wealth of gossip, and is a wonderfully useful tool for the period 1793 to 1821. But one cannot sit down and read a few pages of Farington for their own sake. One can find out the seating plans of innumerable dinners, and the votes cast in innumerable meetings, and one can read between the lines. But Farington was no writer, and if he had been his personality would hardly make us want to get to know him better. He was a power-monger within the Academy, within which he never held any formal position. He seems to have had very limited purposes in life. For instance, he spent a long time getting rid of Barry from the professorship of painting, without having any idea at all as to who should replace him. The post was only open to Academicians. If Fuseli were to be persuaded to take it up, fine. If not, Farington agreed with the idea that there could be annual readings of half a dozen of Reynolds's discourses – that would suffice. (Fuseli did indeed take up the post.)

Haydon, the outsider, the passionate self-educator and self-examiner, is as far from Farington as you can get. He resembles Boswell in that he comes before us as a vulnerable human being, with many absurdities, and it is true that from time to time he tests our sympathies and patience, as he tested the sympathies of his friends. But he was not the negligible artist Aldous Huxley took him to be in the preface to his edition of the *Autobiography*. He has his place in the history of the great endeavours of the period.

There are two ways to approach Haydon's journal: there is the unfinished *Autobiography*, which derives from the diaries and is supplemented by them in Tom Taylor's 1853 edition. This, for most of the past, was what people meant by 'Haydon'. But then the American scholar Willard Bissell Pope managed to track down and buy the diaries themselves. These he published in five excellently edited volumes, between 1960 and 1963. Open these anywhere and you will find something interesting.

Here (in a passage which amused Aldous Huxley) is a glimpse of Lawrence in 1821, just after he became President of the Academy, trying to preserve decorum at one of Mrs Siddons's *soirées*:

Spent the evening at Mrs Siddons to hear her read Macbeth; was exceedingly interested; she acted Macbeth himself better than either Kemble or Kean. It is extraordinary the awe this wonderful woman inspires. After her first reading the men sallied into a room to get Tea. While we were all eating toast and tingling cups & saucers, she began again. Immediately like the effect of a mass bell at Madrid, all noise ceased, and we slunk away to our seats like boys, two or three of the most distinguished men of the day passed me to get to their seats with great bits of toast sticking out their cheeks, which they seemed afraid to bite. It was curious to look up & see Lawrence's face pass you in the bustle with his cheek swelled from his mouth being full, and then when he sat down, hearing him bite it by degrees, & then stop for fear of making too much crackle, while his eyes full of water told the torture he was in; at the same moment you heard Mrs Siddons say, 'Eye of newt, toe of frog'; then Lawrence gave a bite & pretended to be awed & listening. It was exquisite! At last I went away highly gratified, and as I was standing in the landing place to get cool, I overheard my own servant in the hall say, 'Why, is that the old lady making such a noise?' 'Yes,' said another. 'Why, she makes as much noise as ever,' said Sammons. 'Yes,' said the other, 'she tunes her pipes as well as ever she did.'[10]

From Haydon as from nobody else we get an idea of what it was like to be young and idealist, a student intent on the noblest of fame, intent on cramming every hour of the day with work and study, in the romantic Academy. Setting off in the direction of the Tower of London, because some armour he had borrowed from there is going rusty and he wants the advice of the Armourer, he feels hungry and goes into Peel's coffee house for some soup: 'It was such an idle thing in the middle of the

Sir David Wilkie RA (1785–1841), *Benjamin Robert Haydon Asleep*, 1815.
Black and white chalk on paper, 12.7 × 19.7 cm. National Portrait Gallery, London. NPG 1505

day, that I shrunk in, blushing, fearful to look up for fear of meeting the eye of Michel Angelo's spectre, crying "Haydon, Haydon, you Idle rascal, is this the way to eminence?"'[11]

From Haydon too we learn the way Fuseli talked, and how two artists in London smog experienced a sense of the sublime:

> So far from the smoke of London being offensive to me, it has always been to my imagination the sublime canopy that shrouds the City of the World. Drifted by the wind or hanging in gloomy grandeur over the vastness of our Babylon, the sight of it always filled my mind with feelings of energy such as no other spectacle could inspire.
> 'Be Gode,' said Fuseli to me one day, 'it's like de smoke of de Israelites making bricks.' 'It is grander,' said I, 'for it is the smoke of a people who would have made the Egyptians make bricks for them.' 'Well done, John Bull,' replied Fuseli.[12]

Here is Haydon taking Fuseli to see the newly arrived Elgin Marbles in Park Lane:

> I drove off to Fuseli, and fired him to such a degree that he ran upstairs, put on his coat and away we sallied. I remember that first a coal-cart with eight horses stopped us as it struggled up one of the lanes of the Strand; then a flock of sheep blocked us up; Fuseli, in a fury of haste and rage, burst into the middle of them, and they got between his legs and jostled him so much that I screamed with laughter in spite of my excitement. He swore all along the Strand like a little fury. At last we came to Park Lane. Never shall I forget his uncompromising enthusiasm. He strode about saying, 'De Greeks were godes! de Greeks were godes!' We went back to his house, where I dined with him, and we passed the evening in looking over Quintilian and Pliny. Immortal period of my sanguine life!'[13]

And here is Haydon's friend Wilkie, failing to rise to a similar occasion, because he had just had an idea for a painting:

> I recollect once when we [were] at Lord Elgin's, and I thought he was lost in admiration of those exquisite remains of Grecian art, on our coming out he said as usual, 'I have been thinking of a capital subject, a parcel of boys, with one of those things they water gardens with spouting water on some others. I would make some', says he, 'in a sort of Green house out of danger, laughing at the others; and one with his nose and lips squat flat against the glass.'[14]

And here too, at around the time the two friends went to the Adelphi to see Barry lying in state, is Haydon turning up for breakfast with Wilkie:

> I went to his room rather earlier than the hour named, and to my utter astonishment found Wilkie stark-naked on the side of his bed, drawing himself by help of the looking-glass! 'My God, Wilkie,' said I, 'where are we to breakfast?' Without any apology or attention to my important question, he replied: 'It's jest copital practice!'[15]

Haydon's character was one of blazing conviction untempered by social caution. He suffered dreadfully from humiliation, but his reaction to the setbacks he received was to return, in fighting spirit, to the fray. He would not learn caution. He was warned, exactly as Barry was warned by Burke, of the consequences of indulging in controversy. Wilkie said to him, of the Academy: 'If you want to get on, flying in their faces is not the way.'[16] And it is Haydon himself who records such warnings. He is a great autobiographer because he is so hard on himself. He says, on the page preceding Wilkie's advice: 'I mean my Life, if possible, to be a guide-book to youth, and I will never spare myself if I can serve or instruct the reader.' And indeed he does instruct us, to avoid his example if possible.

He became convinced, in the course of dissecting a lion, that 'the Negro was the link between animal and man',[17] and he expounded his theories on the intellectuality or otherwise of Negroes to Leigh Hunt. When Hunt wrote in the *Examiner* about this private conversation, Haydon decided to reply. This was his fatal introduction to the thrills of public controversy.

> I went with [the letter] to the *Examiner* office, dropped it into the letter-box myself with a sort of spasm, as I was done for in even daring to

attack such a renowned critic as Leigh Hunt. Never shall I forget that Sunday morning. In came the paper, wet and uncut; up went the breakfast knife – cut, cut, cut. Affecting not to be interested I turned the pages open to dry, and, to my certain immortality, saw, with delight not to be expressed, the first sentence of my letter. I put down the paper, walked about the room, looked at Macbeth [his current painting], made the tea, buttered the toast, put in the sugar, with that inexpressible suppressed chuckle of delight that always attends a condescending relinquishment of anticipated rapture till one is perfectly ready. Who has not felt this? Who has not done this?

But a few lines later he tells us: 'My letter was considered perfectly immature and unintelligible, and I was pitied and begged not to go on. . .'[18]

But he couldn't stop himself. He felt he should start writing when young, because Reynolds, having put off composition till late in life, was accused of not writing his own lectures. He conceived a plan to attack the Academy and its abominations. It was a sort of suicide, and he should have known it. 'But no. I was unmanageable. The idea of being a Luther or John Knox in Art got the better of my reason.' He published two articles in the *Examiner*, attacking an essay by Payne Knight about Barry, attacking the Academy and defending his friend Wilkie against their 'ungrateful, cruel and heartless treatment of him'. He got neither thanks nor support from Wilkie. Fuseli said, 'By Gode, the fellow is mad or punishable.' Lawrence told him that, while there were grounds for his severity, and in the end the Academy would benefit, he himself would be the victim.

It was 1812, and Haydon was 26. Fourteen years later, he went through a ritual of repentance, which he later referred to as 'the disgrace of my life', and which ultimately did him no good. He paid a series of visits to members of the Academy, making apologies for what had happened and essentially asking to be given a second chance. This kind of informal lobbying was bread and butter to the Academicians, although Haydon's case was unusual. Farington's diary is full of people dropping in for some special favour or request, but the conversation is never given in such detail as Haydon provides.

Benjamin Robert Haydon (1786–1846), *Wilkie*, 1816. Pencil on paper, 45.7 × 35.6 cm. National Portrait Gallery, London. NPG 2423

'Why really, Mr Haydon,' says Augustus Wall Callcott, 'I won't hurt your feelings by saying what I think of your former violence.' 'Yes, but, Mr Callcott, remember the Cause, I was so & so & so & so,' says Haydon, adding as a clincher: 'Remember I never criticised the works of any living Artists. What I did was on public grounds.' (Still today it is the code among Academicians not to make public criticisms of each other's work.) 'Well, Mr Haydon, we won't talk about the matter. If you wish to reconcile you will have *heavy work*.' 'Well,' says Haydon, 'Christian, in *Pilgrim's Progress*, shook off his load at last, and so shall I.'

Haydon tells Martin Archer Shee, soon to become President, that he had felt 'justified in suffering my personal disappointments to excite me to a general attack on the system. The personal consequences I was not aware of. I might, if I had, have hesitated; but I was heaped with calumnies, anonymous letters, had everything put on my shoulders, [was] accused of envy & hatred, called a Barry, when I have always preferred clean sheets,

Sir Martin Archer Shee PRA (1769–1850), *Self-portrait*, 1794.
Oil on canvas, 76.2 × 62.9 cm. National Portrait Gallery, London.
NPG 1093. Shee served as President from 1830 to 1850

a glass of wine, & a clean house, & am naturally happy tempered.' (We see here that being called a Barry had retained a proverbial meaning.)

The account of the meeting with Flaxman shows Haydon at his writerly best:

I said, 'Mr Flaxman, I wish to renew my acquaintance at 20 years' interval.' 'Mr Haydon,' said the 'Intelligent Deformity', 'I am happy to see you; walk in.' 'Mr Flaxman, sir, you look well.' 'Sir, I am well, thanks to the Lord. I am 72 and ready to go, when the Lord pleases.'

As he said this, there was a look of real unaffected Piety, which made me hope and believe it sincere.

[Flaxman was carving a marble group for Lord Egremont.] 'Ah, Mr Haydon, Lord Egremont is a noble creature.' 'He is, Mr Flaxman; he has behaved very nobly to *me*.' 'Ah, Mr Haydon, has he? How?' 'Why, Mr Flaxman, he has given me a handsome commission.' 'Has he, Mr Haydon? I am most happy to hear it – most happy – very

happy;' and then with an elevation of brow, & looking askance, he said, 'How is your friend Mr Wilkie?' 'Why, Mr Flaxman, he is ill – so ill, I fear he will never again have his intellects in full vigour.' 'Really, Mr Haydon, why it is miserable. I suppose it is his miniature painting has strained him, for between you and I, Mr Haydon, 'tis *but miniature painting* you know! Hem – he-e-e-m.' 'Certainly, Mr Flaxman, 'tis but miniature painting.' 'Ah, Mr Haydon, the world are easily caught.' Here he touched my knee familiarly, & leaned forward, and his old, deformed, humped shoulder protruded as he leant, and his sparkling old eye, & his apish old mouth quivered on one side, and he rattled out of his throat, that was husky with coughing, an inward sort of hesitating hemming sound, that meant Wilkie's reputation was all my eye! In comparison with *ours*!

'Poor Fuzeli', said he, 'is gone, Sir.' 'Yes, Sir.' 'Ah, Mr Haydon, he was a Man of Genius, but, I fear, of no principle.' 'Yes, Sir.' 'He has left, I understand, some drawings behind him shockingly indelicate.' 'Has he, Sir?' 'Yes, Mr Haydon. *Poor Wretch*,' said Flaxman, looking ineffably modest. 'Mr Flaxman, good morning.' 'Good morning, Mr Haydon. I am very, very happy to see you, & will call in a few days.'[19]

This diplomatic offensive bore no fruit, which is not entirely surprising since Haydon had been petitioning Parliament only a few months before to create a National Gallery (always a cause about which Academicians might feel ambivalent) and asking for an annual sum to be devoted to the purchase of historical paintings (that is, the branch of the art in which he considered himself supreme). And he had begun to find supporters in the Commons among the radical members, not only for an examination of the Academy's monopolistic position – which was viewed as 'hampering free enterprise and, by reason of its association with the Crown, belonging to the era of corruption, privilege and aristocratic rule'[20] – but also for a careful look at its accountability. The key figure in these moves, a man clearly sympathetic to Haydon's cause, was William Ewart, the MP for Liverpool. A supporter of free trade, he was behind the foundation of public

libraries in Britain. (His father was godfather to William Ewart Gladstone.) In 1834 Ewart moved, and the Commons demanded the following:

> Order'd
> That there be laid before this House a statement of the conditions, if any, on which the apartments at Somerset House were originally bestowed on the Royal Academy; and of the period for which they were granted; whether unlimited, or terminable at the pleasure of the Crown, or otherwise.
>
> Order'd
> That there be laid before this House a return of the number of Exhibitors at the Royal Academy in each of the last ten years, distinguishing the number of Exhibitors members of the Academy from the number of other Exhibitors.
>
> Order'd
> That there be laid before this House a Return of the number of Works of Art exhibited at the Royal Academy in each of the last ten years; distinguishing for each year the number of historical works, landscapes, portraits, busts, and architectural drawings, respectively, contributed by Members of the Royal Academy, from the historical works, landscapes, portraits, busts and architectural drawings by other artists.
>
> Ordered
> That there be laid before this House a Return of the number of Professors in the Royal Academy, of the number of Lectures required by the rules of the Academy to be annually delivered by each Professor, and of the number of Lectures which have been annually delivered by each Professor during the last ten years.
>
> J. H. Ley,
> Cl. Dom. Com.[21]

Sir Martin Archer Shee, the President, faced a dilemma. As Quentin Bell puts it, 'to refuse would, at that juncture, have been very unwise; on the other hand, to accept would be the first step to admitting the right of Parliament to make such inquiries, and eventually perhaps to exercise some measure of control over the Academy itself. This was an unbearable idea; the Academy had always maintained that its only connection with the State lay in its direct dependence on the Sovereign.'[22]

But Shee had the mind of a barrister, and he neatly solved the problem by seeking an interview with the King, William IV, and obtaining his permission to give Parliament the requested information. In due course, the next year, Ewart successfully proposed the setting up of a Select Committee to inquire into 'the best means of extending a knowledge of the Arts and of the Principles of Design among the people', but also, tacked on to the main theme, 'to enquire into the Constitution of the Royal Academy, and the effects produced by it'.

A distinguished first witness was Gustav Waagen, the director of the Berlin Museum, who was against the whole system of academies, finding them 'a poor substitute for the medieval workshop and the guild'.

> As in Dutch gardens, the different kinds of trees were clipped to the same forms, so it was the case in academies with the different talents of different

George Dance RA (1741–1825), *Portrait of John Flaxman RA*, 12 November 1796. Pencil with pink chalk on cream wove paper, 24.9 × 18.8 cm. Royal Academy of Arts, London. Purchased from the artist, 1813. 03/3274

pupils. Would not anyone feel a greater pleasure in the free growth of the trees in a forest?[23]

Haydon, on the morning that he was due to give evidence, wrote the following prayer in his diary:

O God, thou knowest this has been my great object, as these journals testify, for 26 years. Bless my examination! Grant it may be clear, effective, & *just*. Grant nothing may happen to render me confused, or in any way to injure the value of my evidence. Grant the result of this Committee's labours may be a final & effectual blow to the imposture of Academies all over Europe. Thou knowest the purity, the sincerity, of my heart, & that I am actuated by no selfish views or wish of personal aggrandisement. Listen to my prayer in proportion only to the virtue of my wishes. Amen. Ginocchione.[24]

Haydon went ahead with his attack on the exclusiveness and 'total injustice' of the Academy. It was, he said,

a House of Lords without King or Commons for appeal. The artists are at the mercy of a despotism whose unlimited power tends to destroy all feeling for right or justice. . . It is extraordinary how men, brought up as Englishmen, could set up such a system of government. The Holy Inquisition was controlled by the Pope, but these men are an inquisition without a Pope.[25]

By seven o'clock in the evening he was back at his prayers:

I was examined & the result was glorious. Accept my gratitude, O God. Amen.

When I think in 1804, I went to the new Church in the Strand, & on my knees prayed I might be a Reformer in the Art; that often & often I have eternally had those extraordinary inspirations of '*Go on*' supernaturally inspired; and that now I am permitted to see the beginning of the end of this imposture, I must believe myself destined for a great purpose, a great purpose. I feel it, I ever felt it, I know it.[26]

For the drama of the later days, when Shee appeared before the Committee and began by

challenging its authority, only to be slapped down by Ewart, we have only Haydon's authority. The official account of the proceedings seems to have been tidied up, and Bell, when he compared the various rival accounts, found it probable that the participants had been given the opportunity to edit the record to their own advantage. What Haydon saw in his excitement was justice, revenge being enacted on his enemies of years back. But while the eventual report did state that Haydon and John Martin (who complained of an injustice of 24 years before, when a painting of his had been poorly hung) had been unfairly treated, and that the Academy had been negligent in some of its duties, nothing was said that brought any change in the status of the organisation, or its privileges. 'As it stands,' the report found, the Academy 'is not a public institution like the French Academy, since it lives by exhibition, and takes money at the door. Yet it possesses many of the privileges of a public body, without bearing the direct burthen of public responsibility.'[27]

The great figurehead of the Romantic Academy, the society portraitist *par excellence*, Sir Thomas Lawrence, died, like Byron, from having been bled excessively by his doctors. And he died, surprisingly, poor. A couple of years later, Haydon passed Lawrence's house in Russell Square:

Nothing could be more melancholy or desolate! I knocked & was shewn in. The passages were dusty, walls torn, the parlours dark, the painting room forlorn, where so much beauty had once glittered – & the whole appearance desolate & wretched – the plate on the door was green with mildew.

I went into the parlour, which used to be instinct with life. Poor Lawrence! 'Poor Sir Thomas, – always in trouble, Sir,' said the woman who had the care of the house. 'Always something to worrit him.' 'True enough,' thought I, 'my good Soul.'

I saw his bed room, small, only a little bed, the mark of which was against the wall. Close to his

bed room was an immense room, where all his manufactury was carried on – of draperies, &c. – divided, yet open over the Division. Here his assistants worked. It must have been 5 or 6 small rooms turned into one large work shop.

The painting Room was a large back drawing room – his shew Room a large front one. He occupied a parlour & bed room; all the rest of the house was turned to *business*. Any one would think that people of fashion would visit from remembrance the house they had spent so many hours in. Not they; they shun a disagreeable sensation. They have no feeling, no poetry. It is shocking! It is dirty.

There is nothing more melancholy than to visit the house of a celebrated man who is dead.

The great weakness of Life is a disposition to give proofs of sagacity, and the leading vice a hatred of superiority.

The moment a man is unfortunate, people discover every reason for his failure, and if he be successful, every reason for his success.[28]

Here is the same painting room, as it appeared six years earlier to the great American painter of birds and animals, J. J. Audubon, when he called on Lawrence to present a letter of introduction:

The room in which Sir Thomas painted, to my utter astonishment, had a southern light. Upon his easel was a canvas (kitcat) on which was a perfect drawing in black chalk, beautifully finished, of a nobleman; and on a large easel a full-size portrait of a lady represented in the open air. On the latter he went to work. I saw that his palette was enormous, and looked as if already prepared by some one else, with the various tints wanted, and that he had an almost innumerable number of brushes and pencils of all descriptions. He now glazed one part of his picture, and then re-touched another part with fine colours, and in a deliberate way did not indicate that he was in any haste to finish it. He next laid down his palette, and, turning to the chalk drawing upon the unpainted canvas, asked how I liked his manner of proceeding. But as no complaint could be made by me to such an artist, I merely said that I thought it the very quintessence of his art.

A waiter then entered and announced that breakfast was ready. He invited me to remain and join him in his 'humble meal', which I declined while we walked downstairs together. I remarked on the very large number of unfinished portraits I saw, to which he mildly replied: 'My dear Sir, this is my only misfortune. I cannot tell if I shall ever see the day when they will all be finished.' Insisting on my remaining to breakfast I went in; it consisted of a few boiled eggs and tea and coffee. He took the first and I the last; this finished, I bid him good morning. It was ten o'clock when I left and as I passed out three carriages were waiting at the door.[29]

Whitley, in quoting this passage, tells us that the large number of brushes Audubon saw were probably only a portion of Lawrence's stock, that seventeen hundred were catalogued among the contents of his painting room at his death. Audubon, at the time of his visit, was not well known. He was yet to publish his *Birds of America*. Lawrence returned Audubon's visit, looked at his work, made not much comment but asked the prices of several pictures.

Audubon's account continues:

To my surprise he said he would bring a few purchasers that very day, if I would remain at home. This I promised, and he left me very greatly relieved. In about two hours he returned with two gentlemen to whom he did not introduce me, but who were pleased with my work. One purchased the *Otter caught in a Trap*, for which he gave me twenty pounds sterling, and the other *A Group of common Rabbits*, for fifteen sovereigns. I took the pictures to the carriage which stood at the door, and they departed, leaving me more amazed than I had been by their coming. The second visit was of much the same nature, differing, however, chiefly in the number of persons he brought with him, which was three instead of two. Each one of them purchased a picture at £7, £10 and £35, respectively, and as before, the party and the pictures left together in a splendid carriage with liveried footmen. . . Without the sale of these pictures I was a bankrupt before my work was seriously begun, and in two days more, I should have seen all my

J. M. W. Turner RA (1775–1851), *The Funeral of Sir Thomas Lawrence: A Sketch from Memory*, exhibited 1830. Watercolour and bodycolour on paper, 56.1 × 76.9 cm, Tate Britain, London. Bequeathed by the artist, 1856

hopes of publication blasted; for Mr Havell (the engraver) had already called to say that on Saturday I must pay him £60. I was then not only not worth a penny, but had actually borrowed five pounds a few days before, to purchase materials for my pictures. But these pictures which Sir Thomas sold for me enabled me to pay my borrowed money and to appear full-handed when Mr Havell called.[30]

The sense of mystery about the identities of these visitors makes one wonder whether Lawrence was himself the real purchaser. He was known to be generous, careless with money and perhaps negligent in the sending out of bills to his sitters. But he was also very well paid. George IV said in bemusement: 'I have paid him £24,000 and have not yet got my pictures. The Duke of Wellington is also £2,800 in advance to him. All the world is ready to employ him at a thousand pounds a picture, and yet I am told he never has a farthing.'[31] Undoubtedly a part of his continuous financial embarrassment would have been to do with the purchase of his incomparable collection of old master drawings. And it was claimed that he was very generous to certain (unnamed) women. But when he was buried his funeral expenses came to £1,000. The Academy paid £150 of this; the rest was due to be paid out of the painter's estate. But Lawrence when he died was insolvent, and it was only by agreement with his creditors that the funeral charges were sorted out.

10 Trafalgar Square to Piccadilly

On 20 July 1836, at the end of the Royal Academy's Exhibition, a farewell dinner was held in the Great Room of Somerset House. Among those absent was Turner, who had objected to the impending move to Trafalgar Square, which would oblige the Academy to share premises with the newly founded National Gallery. As soon as the exhibition closed Turner set out on a sketching tour in Europe. Constable, however, attended the dinner, along with Wilkie, Mulready, Etty, Maclise and others.

The oldest of those present was Sir William Beechey, aged 83, who had gained admission to the Royal Academy Schools in 1772, had exhibited two works in 1776, and had contributed to the first exhibition at Somerset House in 1780. His success as a society painter had been due to an intervention of George III. A portrait of a nobleman by Beechey had been rejected by the Hanging Committee, probably in 1793. The sitter, outraged, had sent the work to Buckingham Palace, to be viewed by the royal family, who thereupon all began to sit for Beechey.[1] He became Portrait Painter to Her Majesty the Queen, and a rival to both West and Lawrence.

Many stories were told about Beechey's fall from royal favour, which came about, according to Constable (quoting the Bishop of Salisbury), because of 'the freedoms he took which were laughed at [at] the time, but were remembered with disgust'.[2]

It was said that he had overcharged the King for some frames, that he had given the Bishop of Chester a cut rate on a copy of a portrait of the King, and that his colours were fading. Beechey, as West had tried to do during his fall from favour, had 'placed himself in the King's way' at Windsor Castle.

Sir William Beechey RA (1753–1839), *Self-portrait, c.* 1793. Oil on canvas, 75 × 62.2 cm. Royal Academy of Arts, London. 03/669

Sir William Beechey RA (1753–1839), *Portrait of the Prince of Wales (afterwards His Majesty King George IV), c.* 1798 (detail). Oil on canvas, 141.4 × 117.6 cm. Royal Academy of Arts, London. 03/1380

The King advanced on him in a passion, refused to allow him to speak, and blurted out that West was an American, and Copley was an American, and Beechey was an Englishman, and that if the Devil had them all he should not care. On leaving he was heard to say to those about him, 'He would throw himself in my way and I am glad I have given it to him.'

According to one eyewitness, Beechey stepped back into the crowd, took out his snuffbox, and said calmly, 'I have had enough to last me a lifetime.' According to another, Beechey was so overcome by this terrible denunciation that he staggered into the first apartment that was open, which happened to be that of a maid of honour, where he fell upon the sofa and fainted away. According to still another – the version West liked to tell – Beechey in his fright ran to the Queen, who also gave him such a cold reception that it caused him to faint or to have some sort of fit.[3]

Beechey's career as an exhibiting artist was remarkably long – sixty-two years – and by the end of it he was seen to be a figure from a vanished era, notable for his 'thoughtless use of unmeaning oaths'. Visiting Constable, he said, 'Why, d—n it Constable, what a d—n fine picture you are making;

Frederick William Smith
(1797–1835), *Sir Francis Chantrey* RA, 1826. Marble, height 55.9 cm. Royal Academy of Arts, London. Given by Lady Chantrey, 1870

but you look d—n ill, and have got a d—n bad cold!' He regretted the convivial, hard-drinking old days of the Academy, and remarked of one of the dinners that it was 'confoundedly slow to what was the wont in his younger days, when the company did not separate until a duke and a painter were both put under the table from the effects of the bottle'.[4]

In 1830 Beechey had stood for election as president, and had lost to Sir Martin Archer Shee, the man who at the end of this farewell dinner proposed several toasts, among them one to 'The Outsiders'. Henry Sass, who ran the drawing school several of those present had attended, replied to this. Eventually the sculptor Sir Francis Chantrey, who had been knighted by William IV the year before,

> rose, and, speaking with evident emotion, said that he was about to propose a toast with which they would all be in sympathy. To-night, he said, witnessed the close of the many exhibitions and convivial meetings held in this room. They were assembled for the last time within the walls which to many of them had been fortunate, and to all, agreeable and instructive, and however bright the prospects might be of their new quarters they could not leave without deep regret the home, as it were, of their fathers. He therefore gave as a toast – 'The Walls of the Academy', within which so much high talent had been nurtured and displayed.[5]

In fact the Life School remained in operation at Somerset House for another few months, while the new premises in Trafalgar Square were still damp and braziers were used to dry them out.

The habitués of the old rooms were sorry to leave the Life School. To William Etty it was dear 'for its space and loftiness: – the dingy background, *à la Rembrandt*, contributing to give "such glorious effect" to the Figure immediately under the gaslight'.[6] Etty's devotion to the Academy's Schools was such that he would attend whenever they were open. 'On the rare occasions when . . . he did yield to other engagements, he could not absent himself wholly: he must come in for ten minutes, sometimes dressed as for a party, leaving when the sands had run out, – not before.'

Generally on the last night of term, for a treat, Gilchrist tells us, Etty would set a complete picture, as Flaxman and others had done before him, and as Constable also liked to do. Maclise recollected:

> In my time, as a Student, I have known [Etty] set three or four models together. Now, it was a group of Graces; now, a composition of two or three Gladiators. – Sometimes, a dark man or tawny female was introduced, for picturesque contrast with a fair form of the same sex. Sometimes, a Manikin in armour contrasted with the flesh; sometimes, a child with a woman; or picturesque accessory of velvet or satin drapery, of rich texture and hue, – a deep-coloured curtain or couch.[7]

We can detect here, despite the devotion of Etty and Constable to 'the Life', an incipient impatience with the academic ideal. Maclise remembered Constable as speaking of 'certain picturesque accompaniments which he thought might always be introduced with propriety', and the word 'picturesque' seems significant. Leslie, in a footnote to this observation, tells us he often heard Constable say that he 'never could look at an object unconnected with a background or other objects'.[8] But of course it was of the very nature of the *académie* that it abstracted the body from its surroundings and associations. Leslie's footnote acknowledges that it was one of the charges brought against the Academy that different instructors had different notions on this point. But he argues that 'the Life is the highest school, in the Academy, and that in which the students may be supposed to have arrived at an age to judge in some measure for themselves'.

Gilchrist tells us of a group of Three Graces Etty once set, which included as 'accessories' an impressive list of 'pedestals, vases, flowers, fruits, rich draperies, incense burning, &c.' Constable in January 1831 had made a mock-up of the Garden of Eden. He wrote to Leslie:

> I set my first figure yesterday, and it is much liked; Etty congratulates me upon it; do, dear Leslie, come and see it. I have dressed up a bower of laurel, and I told the students they probably expected a landscape background from me. I am

William Etty RA (1787–1849), *Study of a Male Nude*, 1830–40 (?). Oil paint on thick paper, 56 × 38.5 cm. Royal Academy of Arts, London. 05/67

> quite popular in the Life; at all events I spare neither pains nor expense to become a good Academician. My garden of Eden cost me ten shillings, and my men were twice stopped coming from Hampstead with green boughs by the police, who thought (as was the case) they had robbed some gentleman's grounds . . . The fun is, my garden at the Academy was taken for a Christmas decoration, holly and mistletoe.[9]

Constable also in this period set two male figures in a pose from Michelangelo's Sistine *Last Judgment*, and a female figure he called an Amazon. Etty was enthusiastic about this type of window-dressing and Maclise describes his painting 'Constable's *Garden of Eden*':

> Etty made a beautiful study once from a female figure Constable had arranged as Eve; – with a

William Etty RA (1787–1849), *Kneeling Female Nude Viewed from the Back, c.* 1850. Oil paint over pencil and chalk on wove paper, 56.7 × 48.4 cm. Royal Academy of Arts, London. 05/162

laurel-tree behind her, from which were pendent numbers of that kind of orange called 'forbidden fruit'. The glittering polished green of the leaves, and the deep orange of the fruit, you may be sure were well and happily expressed by a hasty touch or two.[10]

'When are we going to have another *landscape*?' asked Etty one day. 'When are we going to have another Phantasmagoria?' Constable retorted.

On 26 March 1837, after the last model had sat in the old Life School, Constable, who had been Visitor, made a speech, which was reported a few days later by the *Morning Post*:

Mr Constable addressed the students in a very friendly manner on the causes of the rise, progress, and decline of the arts. He pointed out to them the true methods of study that lead to eminence, and warned them of the false principles which, though specious, terminate in disappointment and defeat. He expressed his hope that in taking their last farewell of the edifice which had been, as it were, 'the cradle of British art', they would remember with grateful feelings the advantages they had derived from the instruction received within its walls, and be emulous to show that the principles imbibed in the old School of Art were such as would do honour not only to the new

establishment in Trafalgar Square but to their native land. He then returned them his most cordial thanks for the constant attention they had paid him and the diligence with which they had attended their studies during his Visitorship. At the conclusion of the address the students rose and cheered most heartily, never suspecting that this would be Mr Constable's last address.[11]

Leslie, who was not present but heard afterwards from Constable what he had said, has an account of this speech, which emphasises its patriotism at the expense of European schools:

> . . . he made a short address to the students, pointing out to them the many advantages our Academy affords, and cautioning them not to be in too great haste to exchange these for instruction in the schools of France, Germany, or Italy. He was of the opinion that the best school of art will always exist in that country where there are the best living artists, and not merely where there are the greatest number of works of the old masters. He did not admit that the French excel the best of the English artists in drawing, a point generally conceded to them; and in support of his own opinion he quoted that of Mr Stothard, who said, 'The French are very good *mathematical* draughtsmen, but life and motion are the essence of drawing, and their figures remind us too much of statues. . .'[12]

We see here an acknowledgment that the contemporary student does indeed have several alternatives to studying in Britain (the continental academies); the appeal to patriotism, although absolutely consistent with the aims of the founding fathers of the Academy, has this new sense that there are many potential rivals out there. We also find, in the disparaging reference to countries rich in old masters, a trace of that enmity between the new native art and the old which greeted the first old master exhibitions.

The break with Somerset House was deeply felt at the time. Etty marked his last life study in the old premises, made on that occasion, with the words *Vale Domum*! (Farewell to home). He gave one of his nude studies to Constable who smacked his lips and

said, 'You might eat it' – 'a cannibal-like encomium,' remarked Gilchrist.[13]

Within a week, Constable was dead. The National Gallery acquired *The Cornfield* by subscription, Constable's friends having decided that *Salisbury from the Meadows* was 'less likely to address itself to the general taste' on account of the 'boldness of its execution'.[14] Meanwhile the painting on which Constable had been working, *Arundel Mill and Castle*, was shown at the Exhibition of 1837, the first to take place in Trafalgar Square.

The new Academy was opened on 28 April 1837 by King William IV. From the top of the steps of the National Gallery, you can see all the way down Pall Mall to St James's Palace, and the Council members stood beneath the portico watching the carriages setting forth. C. R. Leslie describes the scene:

Thomas Stothard RA (1755–1834), *Seated Female Nude*, undated. Watercolour over pencil on wove paper, 18.6 × 12.4 cm. Royal Academy of Arts, London. 05/3134

Daguerrotype after M. de St Croix showing the Royal Academy in Trafalgar Square, 1839. National Gallery, London

. . . exactly at the appointed hour, we saw the royal carriages appear in the distance. A guard of soldiers, with a band of music, were stationed in front of the building, and, behind them, an immense crowd, which extended on the left to St Martin's Church, the steps and even the roof of which were covered with people – the bells pealing a merry chime from the steeple. The scene, as the King's carriage drew up, was altogether imposing . . . The King wore neither star nor ribbon, but was dressed in a plain suit of black. The Queen was prevented from coming by illness . . . When the King entered the door, Sir Martin Shee presented him with the keys of the Academy on a silver plate. They were highly polished, and had arrived that morning from Birmingham, and, as it had been found (to the great consternation of the workman), would not fit the locks. The King, however, did not try them, but restored them to the President, saying 'he could not place them in better hands'.[15]

Because of subsequent alterations it is quite impossible today to get any sense of the disposition of the rooms the Academy occupied in Trafalgar Square. For instance, a new entrance has recently been created in the East Wing of the National Gallery. In the original structure this door and the corresponding West Entrance were open alleyways that passed beneath the building and had been left open for strategic reasons, at the request of the Duke of Wellington. To the north of the building lay a barracks, and control of Trafalgar Square was considered very important in case of street-fighting and serious riots. The idea of the twin passageways was to facilitate the movement of soldiers, at a moment's notice, into the upper part of the square. Within the east passageway, there was the students'

entrance on the left, and a door on the right leading to the Council Room and Library. The Keeper's apartment had a private entrance facing St Martin-in-the-Fields.[16]

The room that has been least altered is practically inaccessible. This is the central dome on the roof, which was known as the pepper pot; in summer, because of its good light, the drawing and life classes were held there. If you look at this cupola from Trafalgar Square, it is impossible to imagine how it might have functioned, but on the north side of the structure there are still large windows. All that is missing is the semicircular bank of seats that the students would have occupied on the south side of the room, and the model's platform on the north. These, and the stairs up which the elderly Etty would tirelessly climb when the model was sitting. Presumably there was no form of heating.

On the principal floor, the Academy's rooms ran from the main entrance to the right, but only along what is now the front of the building. The chief of them were the Antique Academy, the School of Painting and the Lecture Room. A small structure

The New Staircase to the Royal Academy, 1861. Wood engraving from the *Illustrated London News,* 18 May 1861

William Wilkins RA (1778–1839), *The Galleries and Ground Floor of the National Gallery, Trafalgar Square,* 1836. Engraved illustration, published 16 August 1836. National Gallery, London

known as the Octagon was, during the annual Exhibitions, one of the worst places to be shown. During these weeks, the students could not use the Academy's main rooms. It was a situation whose disadvantages were apparent from the start.

In 1839 the Academy admitted its youngest ever student, the ten-year-old John Everett Millais. Immediately nicknamed 'The Child', he had already spent some months at Henry Sass's drawing academy, where, at the age of nine, he had won the silver medal of the Society of Arts with a large drawing depicting the Battle of Bannockburn. The next day he was hung head downwards out of the window of the Sass academy, until he lost consciousness and was only saved by the intervention of a passer-by. An appropriate fate was reserved for his bully on this occasion, whose name has not survived: he left the school shortly afterwards, failed as an artist but 'being strong and of a good physique, he became a professional model, and, curiously, sat to [Millais]

for several of his pictures. Eventually, however, he took to drink and came to a miserable end, leaving a wife and several children absolutely destitute.'

Millais and his brother, during this period, used to play at National Galleries:

We were both of us mad upon Art, and we knew every picture in the National Gallery by heart. In our own leisure moments we resolved to start a National Gallery of our own, and we worked daily upon pictures for it. I generally undertook the landscape department, and coined no end of Hoppners, Ruysdaels, Turners, etc., whilst the Titians, Rubens, Paul Veroneses, Correggios, and Rembrandts fell to my brother's share. I made all the frames out of tinsel off crackers, and we varnished our specimens to give them the appearance of works in oil.

The pictures varied in size from a visiting-card to a large envelope. We took off the lid of a large

Mason Jackson (1820–1903), *Taking in the Pictures at the RA*, April 1866. Engraved illustration

deal box, and prepared the three sides to receive our precious works. There was a dado, a carpet, and seats, and to imitate the real Gallery a curtain ran across the opening.

What a joy it was when we thought we had done something wonderful! I remember how we gloated over our Cuyp; and Rembrandt too was my brother's masterpiece, and the use of the burnt Lucifer matches in the darker parts was most effective, and certainly original. When anyone came to see us it was our greatest pride to exhibit our National Gallery.[17]

This enthusiasm among children for the two new institutions in Trafalgar Square was perhaps widespread. It had been the policy of the National Gallery from the earliest days in Pall Mall to admit children. Lord Liverpool, as Prime Minister, had instigated this, on the perhaps surprising grounds that, if children came, their parents would be encouraged to accompany them. We are told that children sometimes played in the rooms and that it was a common thing to see orange peel thrown into the corners.[18]

Richard Doyle, who became an illustrator and *Punch* cartoonist, certainly shared this new enthusiasm of the young, as his *Journal* of 1840 shows in the entry for Friday 1 May. Doyle was fifteen when he wrote this:

Here is a state of things, no van dyke brown. I must give up painting for want of a brown. I went to see the Queen going to the Exhibition. I am so tired of seeing them that I would not have gone, only that I had a sort of melancholy pleasure in going to linger about the door of the Academy, pondering about what could be the subject of Maclise's large picture, beside there is always something pleasant about seeing the crowd and hearing the yell. The bells of St Martin's had been ringing for an hour when five state carriages drove up, emptied themselves on the pavement at the door of the National Gallery, where they were received by Sir Martin Archer Shee and forthwith carried up stairs and certainly I never envied the Queen so much as I did at this moment, and for the next hour and a half. At all events Monday wont be long coming, and then for the most glorious day of the year.

Richard Doyle (1824–1883), Illustration from *A Journal Kept by R. Doyle in 1840. Illustrated . . . by the author*, Smith Elder & Co., London, 1885

On Monday the Exhibition was opened at last to the general public:

It has come at last, and at half past ten (which was a great deal too soon) James, Henry and I set out for Trafalgar Square and arrived of course half an hour before the door was opened. There was a pretty considerable number of persons collected and they were increasing in a most rapid manner, so we stood in the door watching the clock and the different characters who came crowding up. Exactly at twelve the door burst open and in we rushed, there was a great scramble to pay first and then off we darted up the stairs. There were about fifty besides us in the first rush almost in a body, and we had a desperate race. I don't know who won it, but Henry was third and I was fourth. I rushed straight down the room till I came to Maclise's picture of Macbeth and there I stopped. At the first look it appeared the best of Maclise's large pictures for colouring, but presently I found out that the background was painted with some horrid colour like ink. Macbeth himself is very fine and perhaps Lady Macbeth is also, but I am not sure. The drapery of both are beautiful and the torch bearers, leaning forward trying to see what is frightening their master, are capitally conceived.

I wanted to see the principal pictures before the crowd got too great to move, so I turned away from this and looked all round the room. There was a beautiful Landseer of a dog and parrot in the corner to the right, which first caught my

eye from the splendid colouring of the bird's feathers, then a little farther that way Leslie's portrait of Lord Cottenham. Then I looked over to the other side and easily discovered 'Henry the 1st hearing of the shipwreck of his son' to be by Hart, from the purple and yellow glow all over, which I don't like at all. Just below it was *Nell Gwynne* by Charles Landseer. Nell Gwynne is a beautiful figure but looks too nice a person, and the Merry Monarch, the Earl of Rochester and other lords look exactly like each other. I don't think the painting is as rich as Charles Landseer generally.

The most extraordinary picture altogether is *The Slave Trade* by a French artist quite unknown. The expression and drawing it is wonderful, the painting is not quite so pleasant though there is something appropriate and fine in the red sunset which covers nearly the whole sky. What a curious thing it is to think that there should be such a good artist quite unknown in England.

Malvolio in the Garden of Olivia by Maclise is beautiful for expression, but the general tone of the picture is of that cold green which Leslie has been so fond of lately, while the *Gil Blas* by Maclise also is decidedly one of his very best for colour.

Sir Edwin Landseer RA (1802–1873), *Laying Down the Law* (*Trial by Jury*), 1840. Oil on canvas, 120.7 × 130.8 cm. Trustees of the Chatsworth Settlement

How fine is Edwin Landseer's *Laying Down the Law*. As I turned from the last picture I could see the great, great white dog over the people's heads at the other side of the room, and I don't think I ever saw anything more like nature, or perhaps as much. What an extraordinary thing it is that men can be found who deny the power of Landseer and compare such animals as Hancock to him. It seems incredible. I think it must be that Landseer being so generally admired, they want to be original, and therefore always find out some shabby little dogs or other quadrupeds that they say are superior to anything that Landseer could do.

There is a rather peculiar picture by W. Etty of ten virgins running about in front of a door (which is beautifully painted). The subject is taken from Scripture but the treatment is decidedly queer. The sculpture for this year is I think less interesting than any exhibition I can remember.

This child's account is most informative, and confirms the judgment of Maclise's biographer O'Driscoll that *The Banquet Scene from 'Macbeth'* attracted more attention than any other in the exhibition. Doyle does not seem to have noticed (or been able to see for the crowd) Maclise's other entry, his portrait of Dickens. Maclise's picture of Malvolio in the garden of Olivia completely eclipsed a painting of the same subject by W. P. Frith, who was exhibiting for the first time at the Academy that year. Frith himself, venturing into the exhibition with beating heart, couldn't find his own work, until the porter, Williamson, took him into the architecture room, where his canvas had been skyed. Frith remembers thinking:

> Could that dirty-looking thing, that seemed as if ink had been rubbed all over it, be my bright picture? There was no mistake about that, but how changed! To the uninitiated it would be impossible to conceive the change that appears to come over a picture when surrounded by others in a public exhibition, and subject to the glare of unaccustomed lights and the glitter of gold frames, with the ruinous reflections from all sides.[19]

Daniel Maclise RA (1806–1870), *The Banquet Scene from 'Macbeth'*, 1840.
Oil on canvas, 182.9 × 304.8 cm. Guildhall Art Gallery, London

Daniel Maclise RA (1806–1870), *Scene from 'Twelfth Night'* (*'Malvolio and the Countess'*), exhibited 1840.
Oil on canvas, 73.7 × 124.5 cm. Tate Britain, London. Presented by Robert Vernon, 1847. N00423

The painting *Slaves on the West Coast of Africa*, which so impressed Doyle, was by François-Auguste Biard. It was presented to one of the abolitionists and now hangs in Wilberforce House Museum, Hull. It is interesting that the boy does not mention Turner's *Slavers Throwing Overboard the Dead and Dying*, which was in the same show.

On the death of Shee in 1850, the presidency passed to Charles Lock Eastlake. As a young Devonian fresh to London at the age of fifteen, Eastlake had gone to train with Haydon. Many years later he told how he and Haydon had been at the theatre when the 'O. P. riots', the Old Price riots, a protest against a sharp rise in ticket prices, broke out:

Haydon had said, 'My boy, we will go to the theatre.' And to the theatre they accordingly went; to the boxes, of course, for Haydon loved everything of the best. When they came to the door, Haydon said, 'You'll pay for me, my boy, and we'll settle it when we settle the other little matters.' When they got into the box, they found the place in an uproar, and both of them entered fully into the spirit of it. On coming away, Haydon said, 'My boy, we must see this out. This is glorious!' So they went the next night, when there was the same demand, 'Now my boy, you'll pay.' And thirteen nights did this continue, 'much to my horror,' said Eastlake, 'as I was but a student with a very limited allowance, and this made a great hole in it. It was a strange way of

François-Auguste Biard (1798–1882), *Slaves on the West Coast of Africa*, c. 1833.
Oil on canvas, 64 × 90 cm. Wilberforce House Museum, Hull City Museums and Art Gallery

taking care of me, and, after all, the "O. P." tired us out.' 'Did you ever get paid?' 'Oh no! Paid? No! but I got advice, which was worth much to me. Soon after this, he said to me, "Well, my boy, we'll go to Hampton Court." And so we went, and this was added to other little matters for future settlement. Another day he came to ask me to join him in a visit to the Tower. He had borrowed some armour, and was about to return it. So it was put into the hackney coach, and we started with it. Of course I paid the coach, and as we passed through the armoury, he said, "I may have to borrow again, we must be liberal to the servants, have you any half-crowns?" These were also placed with the little account between us, which never got settled.'[20]

It was Haydon's fate to watch Eastlake rise to every position of power he could have aspired to. He became Keeper of the National Gallery, and first Secretary of the Fine Arts Commission, in which capacity he had to write to Haydon to inform him that his cartoons had not been chosen for the decoration of the Houses of Parliament. That was one of the worst disappointments of Haydon's life. Eastlake was also one of the Commissioners of the Great Exhibition of 1851. In addition to his painting, he was a remarkable art historian who travelled in Italy assiduously, looking for works for the National Gallery. He had a formidable wife who, as will be seen in the next chapter, crossed swords (albeit anonymously) with Ruskin in print.

J. M. W. Turner RA (1775–1851), *Slavers Throwing Overboard the Dead and Dying*, 1840. Oil on canvas, 90.8 × 122.6 cm. Henry Lillie Pierce Fund, Museum of Fine Arts, Boston

Eastlake himself, in 1859, was once in a row with George Jones, the former Keeper, over whether the Turner bequest should be referred to as a fund or as a gift. At a certain point, Jones – rather late in British history for this kind of behaviour – issued a challenge:

'Then', said the ex-Keeper, 'you have given me the lie, and I shall expect you to meet me, to answer for this.' The Council were aghast at such folly in these days, when the practice of supporting one's opinions by powder and bullet is altogether scouted. But Eastlake, after a minute's consideration, said, 'Certainly, Mr Jones, however ridiculous such a settlement may be, I will meet you since you demand it.'

Unknown photographer, *Sir Charles Lock Eastlake* PRA, undated. Albumen print mounted on card with printed name, 8.8 × 5.5 cm. Royal Academy of Arts, London. Given by Mrs Booth, 1957. 04/631. Eastlake served as President from 1850 to 1865

The Council, in horror, stepped in to avert a fight. (This Mr Jones was said to bear so strong a resemblance to the Duke of Wellington that he was often mistaken for him. He told the Duke this, who replied that this was odd, since nobody had ever mistaken *him* for Mr Jones.)

Redgrave gives us a glimpse of the home life of the Eastlakes, and their conception of fun in mixed company:

When assembled in the drawing-room after coffee, Sir Charles proposed to us to play at the 'new game' of 'Post', and seated us in a circle, ladies and men together. We each took the name of some town, and Rome, Florence, Constantinople and London were soon put in urgent movement at the game of 'Post'.

Our President, with his precise white tie, volunteered to be blindfolded, and blindfolded he was, and then the game began. He was placed standing in the centre, and Lady Eastlake called out the names of two towns, such as London to Sebastopol, and these had immediately to change places without going out of the ring, while the blindfolded member of the party was, if possible, to catch one or other in the transit. The fun soon grew fast and furious, from the variety of character displayed in the endeavour to escape.[21]

Redgrave's memoirs include a night scene that must, in those days, have been not infrequent in Trafalgar Square. In February 1851, Redgrave's name was up for election as an Academician, and he made an arrangement with a friend, the painter John Rogers Herbert, that he would come out of the General Assembly at a quarter to ten in the evening to tell him the result of the election. Redgrave was working at the time in the School of Design, which had taken over the Academy's old premises in Somerset House. He sat impatiently at a meeting until he heard the quarter to ten strike.

I was on tenter-hooks, and finally saying, 'I neither can nor will hear a word more,' I rushed down-stairs, ran at full speed along the Strand, knocking this passenger off the pavement, and

Unknown photographer, *Richard Redgrave RA*, c. 1856–75.
Albumen print mounted on card with printed name, 8.8 × 5.9 cm.
Royal Academy of Arts, London. 05/2691

Unknown photographer, *Sir Edwin Landseer RA*, c. 1857–76.
Albumen print mounted on card with printed name, 8.4 × 5.3 cm.
Royal Academy of Arts, London. Given by Mrs Booth, 1957. 04/652

thrusting another against a shop, receiving many opprobrious epithets for my hurry, until I found myself in Trafalgar Square. The place of meeting was to be under the Nelson Column, in the bay (formed by the bases for the lions) which looks towards the Royal Academy. The moon was at the full, throwing a deep shadow, dark and obscure, behind the Column. Into this I rushed and paused. I looked round and saw only the solitary figure of a policeman in the bright light near the fountains. The next moment came Herbert, slithering along in the strange way he sometimes runs. I had certainly not been half a minute in the place, and had hardly got back my breath after my run, when he rushed at once into my arms. 'All right, my dear fellow, all right! God give you health long to enjoy it!' I believe, in the hurried hug I gave him, I kissed his cheek. I know it was a moment of intense excitement to me. The policeman, who had drawn a little nearer,

stared; perhaps he thought it a rendezvous of Socialists. No more was said between us.[22]

In 1865, on Christmas Eve, Eastlake died in Italy, and Sir Edwin Landseer was elected one month later in his place. However, he pleaded bad health and declined the appointment. He was prone to depressions, and was probably wise to decline the offer. On the second time round, Landseer's friend Francis Grant was decisively elected. Among his several opponents, Millais, putting down a marker, received one vote.

Queen Victoria was not pleased, writing to Lord Russell:

The Queen will knight Mr Grant when she is at Windsor. She cannot say she thinks his selection is a good one for Art. He boasts of having never been to Italy or studied the old masters. He has decidedly much talent, but it is the talent of an amateur.[23]

In this matter of not having studied the old masters, it appears from Catherine Wills's researches that the Queen was quite wrong. She had sat for Grant on several occasions, and perhaps decided to misinterpret some piece of modesty on his part as philistinism. Grant had not only studied, he had collected old master paintings. He was said to have made a vow in his youth (he was born in Edinburgh in 1803) that he would first spend his inheritance, about £10,000, and then make his fortune again in the practice of law. He collected mainly seventeenth-century Italian, Dutch and Flemish works, and he catalogued the collection of a friend. By the time his money ran out, and he had to sell his collection, he had found also that he detested law, and only wanted to paint instead.

Something of this story was known to Queen Victoria, who on meeting Grant in 1838 summed him up thus: 'a very good-looking man, was a gentleman, spent all his fortune, and now paints for money.' The case of Grant, in other words, was the opposite of that of most artists hitherto discussed, who typically came from humble backgrounds, and, through their work and other merits, acquired wealth and the status of gentlemen. Grant moved in the highest aristocratic circles, made a base in London and one in Melton Mowbray, where he pursued his passion for hunting. And all this, after a profligate youth, he financed by his own work.

He painted the Queen on several occasions. He painted her on horseback, and for this purpose he had a studio, at 12 Park Village West, Regents Park, capable of accommodating animals. An equestrian portrait of Victoria is inspired by one of the paintings he had studied in Scotland, the *Count-Duke of Olivarez*

Mary Grant (1831–1908), *Bust of Sir Francis Grant PRA*, 1866. Marble, height 66 cm. Royal Academy of Arts, London. Given by the artist, 1876. 03/2433. Grant served as President from 1866 to 1878

Sir Francis Grant PRA (1803–1878), *Queen Victoria on Horseback*, 1846. Oil on canvas, 34.8 × 30.8 cm. The Royal Collection. RCIN 400589

Franz Xaver Winterhalter (1805–1873), *The Royal Family*, 1846.
Oil on canvas, 250.5 × 317.3 cm. The Royal Collection

by Velázquez (now in the Metropolitan Museum of Art, New York). In due course, however, the Queen grew tired of Grant (and of English artists in general, it seems, finding their prices 'outrageously high'); she and Prince Albert favoured the German Franz Xaver Winterhalter. This fall from grace appears to have affected Grant permanently, for we find many years later, in 1869, that Landseer was advising him on how to deal with his jealousy of Winterhalter's success. According to Wills, 'When Grant failed to put Winterhalter on a list of candidates for honorary membership of the Royal Academy, Landseer wrote to him pointing out that he was failing to recognise Winterhalter's worth and was being unfair. In addition, Winterhalter's exclusion would annoy Queen Victoria.'[24]

Another whose merit Grant had failed to recognise was his own eventual successor to the presidency, Leighton.

Here is what Redgrave noted in his diary for 5 May 1866:

Today our new President, Sir Francis Grant, took the chair at our annual dinner, for the first time. On Thursday last, while showing the Prince of Wales round the rooms, the Prince asked him if he felt at all nervous at the prospect of his duties at the dinner. Grant replied, 'Not at all.' 'But then,' he added, 'I am perhaps in the same condition as the captain who went up in a balloon and was to descend by a parachute. When he had taken his place in the parachute, after quitting

the car in the air, his fellow voyager called out just before he cut him loose, "All right down below? do you feel at all nervous?" "Not at all," replied the captain, "cast off;" and', said Grant, 'down he came, and the next moment was smashed up. Now that may be the case with me.' The Prince laughed heartily at the story. But tonight, the result was quite the reverse, for the President was a great success. He had four princes at his table to grace his *début*, and he did all his speechifying extremely well, even after Eastlake. For what it lost in calm impressiveness it gained in geniality. The fox-hunter came out, and made one or two good hits.[25]

At the time of Eastlake's death, discussions were already in progress over the acceptance of new premises for the Academy.[26] The National Gallery had grown fast and had been very popular from the outset. In 1842, Eastlake had written an open letter to Sir Robert Peel, who was an active Trustee of the Gallery, complaining that William Wilkins's building was badly planned and unable to cope with a large number of visitors, that its ground floor rooms were too poorly lit to be used as galleries, that there was lack of space for cleaning and restoration, and that the heating and ventilation did not work. Eastlake had been in favour of the separation of the two institutions as early as 1845. Lord Russell, the Prime Minister, had given notice in 1850 that the 'apartments now occupied by the Royal Academy would be required for the purposes of the National Gallery'.[27] In 1860–61, a new room was constructed at the back of the vestibule, but this did not solve the National Gallery's problems.

Grant's contribution to the history of the Royal Academy was to resist pressure from Queen Victoria and Lord Derby for the Academy to move to Kensington Gore to be part of 'Albertopolis' (Prince Albert had died in 1861, and the Queen was keen to make this part of town his memorial). He was afraid of the expense of building a new Academy from scratch, and apprehensive that Kensington was too far out of what was then conceived as London. The dependence of the Academy on incomes from the annual Exhibitions made the Academicians nervous of such a radical move. Here is a letter from Grant to the Hon. William Cowper, First Commissioner of Works, illustrating his firm but tactful approach:

> If the R.A. has to build a new building from scratch, it will inevitably exhaust the available funds of the Academy, leaving us unable to meet the expenses of our pension list and charitable donations, or to carry on the important and national object of the Institution in the teaching of our schools. I beg to remind you that we have the written guarantee of the Chancellor of the Exchequer that in the event of our being required to vacate our present building in Trafalgar Square, he under-takes to provide an equivalent elsewhere. Now, in the transactions of ordinary life, if you were to turn a man out of his comfortable and well-furnished house, it could hardly be considered an equivalent to offer him another piece of ground on which he was to build a house and furnish it at his own cost.[28]

Wills tells us that at the time he wrote this letter, Grant had the idea that the National Galley could be induced to leave Trafalgar Square and move to

Sir Godfrey Kneller (1646–1723), *Richard Boyle, 3rd Earl of Burlington, as a Boy, with His Sisters Elizabeth, Juliana and Jane, c.* 1700. Oil on canvas, 193.7 × 178.4 cm. Trustees of the Chatsworth Settlement

Burlington Houfe in Pickadilly Belonging to the Rt Honble Charles Boyle & Bandon, Vircount Kynalmeaky & Dungarvan, Earle of Corke in the King County of the City of Corke, Lord high Treasurer of Ireland, Lord high Steward

Baron Clifforde of Londesburgh, and Earle of Burlington Baron of Youghall of Ireland, Chief Governour of the County of Corke, and of the City, and the Royalty of Knaresburgh in the County of Yorke, some of the Gentlemen of his Mats Bedchamber

Johannes Kip (1653–1722), after **Leonard Knyff** (1650–1721), *Burlington House in Pickadilly*, from *Britannia Illustrata*, London, 1707, plate 29. Etching, 32.5 × 47.8 cm. Royal Academy of Arts, London. 05/3704

Burlington House, but that a change of government made him see that this hope was futile. He therefore approached Sydney Smirke, the Academy's recently elected Professor of Architecture, to draw up a plan for the use of Burlington House. The house itself would, under this scheme, be a home for the administration, while to the north, on the site of the garden, would be built the new galleries and the Schools.

The beauty of this scheme, according to those who proposed it, was that it would reduce building costs. The old building (with an extra floor added) would form the façade of the Academy as a whole. What was constructed behind would need no visible façade. It was an example of what would now be called infilling: a central London site would be created by means of an adaptation and extension of an existing structure. Several familiar buildings have an odd and complicated history of this kind:

the National Gallery itself was eventually extended to the north, so that the present interior in no way resembles the original simple enfilade of rooms designed by Wilkins on his limited budget. And the Ashmolean Museum in Oxford has the same shallow original façade backed by a later development.

But neither is quite as odd in its history as the Academy's Burlington House, which began life in the seventeenth century under Charles II's Surveyor of the Office of Works, Sir John Denham, the poet, author of 'Cooper's Hill', and whose first inhabitant was Richard Boyle, 1st Earl of Burlington and 2nd Earl of Cork. That house can be seen in an engraving of 1707 by Johannes Kip: the thoroughfare of Portugal Street, now Piccadilly, runs in front, and the grounds are protected from the street by a high wall. There is a courtyard where the modern courtyard lies, but the house itself is more or less

Andrea Palladio (1508–1580), *Palazzo Porto, Vicenza: Half Elevation of the Façade and Section of the Courtyard*, c. 1572. Pen and iron gall ink over incised construction lines on two sheets joined vertically, 28.8 × 18.4 cm. RIBA Library Drawings Collection, London. SC 227/XVII/3

Madejski Fine Rooms has, however, survived under the paintwork.

Although Burlington lost interest in his London house as he became more involved with his villa and gardens at Chiswick, his Piccadilly establishment remained intact for a long time – the house as remodelled by Campbell, the flanking buildings (office block and stables) that formed the front courtyard as designed by Gibbs. An imposing gate onto Piccadilly was designed by Campbell: as we

free-standing, of eleven bays and built of brick with stone quoins. Its architect was Hugh May.

The famous 3rd Earl of Burlington, to whom Pope dedicated an epistle, inherited this house in 1704 at the age of ten, and by the time he was eighteen he had started remodelling it, probably according to designs by James Gibbs. In 1714–15 he was in Italy making the Grand Tour, returning to London in time to celebrate his coming of age and to appoint Colen Campbell in Gibbs's place, and set him to remodel the façade.

The resulting Palladian design, based on the Palazzo di Iseppo da Porto in Vicenza, is what you see if you stand in today's Annenberg Courtyard, facing the Academy, and use your hand to eliminate the uppermost storey with its statues in niches. After a further Italian trip, Burlington returned to London with William Kent, whom he set to work on the interior decoration of the house. Burlington's notion was that Kent was to be the leading history painter of his day, but it turned out that his talents lay instead in the direction of architecture. Kent's decoration of what are now known as the John

ABOVE RIGHT: **Office of Sir John Soane RA** (1753–1837), *Perspective of the Courtyard, Looking North towards Burlington House*, c. 1817. Pencil, pen, watercolour and bodywash on paper, 59.4 × 123.6 cm. Sir John Soane's Museum, London. 17/4/8

RIGHT: **George Meredith** (1762–1831), *Gate of Burlington House: Elevation of the Inner Front*, 1782. Pen and ink and watercolour, 45.4 × 46.5 cm. Royal Academy of Arts, London. 05/472

saw earlier, it appears in a satirical print by Hogarth entitled *Masquerades and Operas*.

The gate was linked to the house by a famously beautiful pair of colonnades, possibly designed by Gibbs. Horace Walpole describes visiting Burlington House: 'passed the evening at a ball, at daybreak, looking out of a window to see the sun rise, I was surprised with the vision of the Colonnades that fronted me: it seemed one of those edifices in fairy tales, that are raised by genii in a night's time.'[29]

By the early nineteenth century this interesting ensemble had fallen from favour, and in 1809 Sir John Soane, for one of his architectural lectures to the Royal Academy (he was Professor of Architecture from 1806 to 1837), had illustrations made of it: he believed it doomed to destruction, and to a large extent he was right. The view shown in the *Illustrated London News* on 15 September 1866 allows us a last look at it before the Victorian improvements which provided accommodation

Elevated View of Burlington House, Piccadilly, 1866 (detail).
Wood engraving from the *Illustrated London News*, 15 September 1866

for the learned societies around the courtyard, and the construction of the upper storey, creating the elevated façade of the Academy as we know it today.

Architecture's loss was the Academy's gain. Grant secured the Burlington House site for an annual rent of £1 for 999 years. The learned societies were not so lucky, and have suffered for it recently. There can be no doubt at all that without this peppercorn rental agreement the Academy would have found it very hard indeed to survive.

In November 1868, work on the new premises was sufficiently advanced for the Academy to hold its first meeting there, while the first Exhibition and annual dinner in the building were held the following year. That was the year in which the Academy yielded up its coveted rooms on the principal floor at Trafalgar Square to the National Gallery. Two years later, they vacated the Cast Room on the ground floor, then the officers' and servants' rooms (which were considered a fire hazard), and finally the Library in 1874.

Sydney Smirke RA (1798/99–1877), *Burlington House, Piccadilly: Elevation Showing Proposed Alteration of the South Front*, March 1867 (detail). Pencil and wash, 39 × 45.5 cm.
Royal Academy of Arts, London. 05/2111

Here is an extract from Redgrave's diary for 31 December 1873:

I finished the old year at the Royal Academy, dining with the old and the incoming Council, as our usual practice is. This dinner, however, was so far unusual in that we this day took living possession of Burlington House, and dined in one of the suites of rooms in which the Royal Society gave their *soirées*, and where, before them, the noble proprietor and architect [Burlington] used to hold his pomp and state. It is hard to tell how the rest of the household lived, especially where the servants 'pigged in', unless it was under the table of the servants' hall, or the pantry.

After dinner, the President's (Sir F. Grant's) health was proposed, and in replying he told us a curious fact. 'In this very room,' said he, 'forty-two years ago, I commenced my professional practice as a London portrait painter. The old Lady Burlington desired me to paint her grand-daughter (or niece), Lady Elizabeth Cavendish, and while my easel was placed in yonder window, she sat, as early as possible, where I now sit as your chairman. I had painted one portrait before in Edinburgh, but this was my first in London. It was less than life, head and bust, and I had thirty-five guineas for the work. Little chance seemed there then that I should take my place as your President at the first dinner of the Academy Council in this same chamber!'[30]

Sydney Smirke RA (1798/99–1877), *Burlington House, Piccadilly: Perspective of Proposed Design of Interior of Gallery III*, 1866–67 (detail). Pencil, pen and ink, and watercolour, 29 × 32.5 cm. Royal Academy of Arts, London. 05/2123

11 Ruskin as Arbiter of Taste

Between 1855 and 1859, the critic and polemicist John Ruskin published an annual set of *Notes* on those pictures in the Academy Exhibitions that most interested him 'either in their good qualities, or their failure'. He was a bold and astringent critic, asserting in the preface to the first of these *Academy Notes* that 'Twenty years of severe labour, devoted exclusively to the study of the principles of Art, have given me the right to speak on the subject with a measure of confidence. . .' Indeed, painters must have been in something of a quandary as to whether to welcome his attentions or hope he ignored them. Visitors to the Exhibition could buy Ruskin's pamphlets outside the Academy (but not inside).

His notice of *The Wrestling Scene in 'As You Like It'* by Daniel Maclise, in 1855, begins:

> Very bad pictures may be divided into two principal classes – those which are weakly or passively bad, and which are to be pitied and passed by; and those which are energetically or actively bad, and which demand severe reprobation, as wilful transgressions of the laws of all good art. The picture before us is of the last class.

And, sure enough, the severe reprobation is administered. Maclise was nervous about criticisms of his pictures, and is said to have exhibited nothing at all in the 1853 exhibition for that reason. Queen Victoria, an admirer, remarked: 'How strange that he should care for such things; I'm surprised he should think anything of newspaper criticisms.'[1] How the painter responded to Ruskin's ferocity on this occasion I have not found.

Sir John Everett Millais Bt PRA (1829–1896), *Ruskin in a Frock Coat*, 1854. Oil on canvas, 78.7 × 68 cm. Private collection

David Wilkie Wynfield (1837–1887), *Sir John Everett Millais Bt PRA*, c. 1860. Albumen print on card, 16.7 × 21.6 cm. Royal Academy of Arts, London. Given by William Frederick Yeames RA, 1911. 03/4255. Millais served as President in 1896

Daniel Maclise RA (1806–1870), *The Wrestling Scene in 'As You Like It'*, 1854.
Oil on canvas, 128.9 × 177.2 cm. Harris Museum and Art Gallery, Preston

Ruskin is no respecter of position, so the President of the Academy gets treated in exactly the same manner as any other exhibitor:

120. *Beatrice* (C. L. Eastlake, P.R.A.)
An imitation of the Venetians, on the supposition that the essence of Venetian painting consisted in method: Issuing, as trusts in Method instead of Fact always must issue, – in mere negation. Sir Charles Eastlake has power of rendering expression, if he would watch it in human beings – and power of drawing form, if he would only look at the form to be drawn. But when, because Giorgione and Titian drew broadly, and sometimes make their colours look broken, he supposes that all he has to do is to get a broken breadth; he ends, as all his imitators must end, in a rich inheritance of the errors of his original, without its virtues.

Titian and Giorgione have a slight tendency to flatness; but Giorgione's G Flat has accompaniments, Sir Charles's C Flat stands alone.

The real source of the error may be sufficiently seen in the distance; Titian paints his distances in pure colour – but at least indicates what is grass, and what is stone. The distant ground, here, with its white spot for a castle, is a mere space of dim brownish-green paint, which can by no possibility stand for grass, or moss, or any other natural thing. It seems to me however, that there are some points in the execution of the picture, considered as an example of certain textures, which are instructive. The whole is careful, and the draperies well cast. But who is the lady? Dante's Beatrice or Benedict's? She can hardly be either: her face indicates little piety, and less wit.

This judgment made Lady Eastlake furious, and she attacked Ruskin, anonymously, in print: 'Mr Ruskin's intellectual powers are of the most brilliant description; but there is, we deliberately aver, not one single great moral quality in their application.' His writings have 'all the qualities of premature old age – its coldness, callousness and contradiction'. About *Academy Notes*: 'Nothing can be more degradingly low, both as regards art and manners, than the whole tone of this pamphlet, calculated only to mislead those who are as conceited as they are ignorant.'[2]

The comparison with the Venetian painters would have been galling anyway to Eastlake and his wife, but particularly so when it came in the same pamphlet in which Ruskin hailed the début of Frederic Leighton, who had sent an enormous history painting from Rome. The work, depicting the procession carrying Cimabue's altarpiece through the streets of Florence, had been highly praised in expatriate circles in Italy: Browning and Thackeray had admired it, and the German painter Peter Cornelius, who had suggested a radical alteration to the design (which involved the

John Watkins (fl. 1857–1876), *Frederick Leighton Esqr.*, 1862. Photograph, 9.3 × 5.3 cm. Maas Gallery, London

last-minute repainting of a dozen figures in order to have the procession turn a corner, to give variety), had prophesied that Leighton would become an important figure for Britain. He had, indeed, already been recognised, by Thackeray in a jocular remark to Millais, as a possible future president of the Academy: 'Johnny, my boy, we always settled that you should have the Presidentship of the Royal Academy, but I've met in Rome a versatile young dog called Leighton, who will one of these days run you hard for it.'[3]

On 3 May 1855, Eastlake had written to Leighton to inform him that the Queen had expressed her intention to purchase the picture, and that Eastlake, following Leighton's instructions, had named a price of 600 guineas. A week later, Dante Gabriel Rossetti wrote to William Allingham:

There is a big picture of Cimabue, one of his works in procession, by a new man, living abroad, named Leighton – a huge thing, which the Queen has bought; which everyone talks of. The R.A.s have been gasping for years for some one to back against Hunt and Millais, and here they have him, a fact that makes some people do the picture injustice in return. It was very interesting to me at first sight; but on looking more at it, I think there

Lord Leighton PRA (1830–1896), *Cimabue's Madonna Carried in Procession through the Streets of Florence*, 1853–55. Oil on canvas, 222 × 521 cm. National Gallery, London, on loan from Her Majesty The Queen

is great richness of arrangement, a quality which, when really existing, as it does in the best old masters, and perhaps hitherto in no living man – at any rate English – ranks among the great qualities.[4]

Here is Ruskin's notice:

569. *Cimabue's Madonna Carried in Procession through the Streets of Florence* (F. Leighton)

This is a very important and very beautiful picture. It has both sincerity and grace, and is painted on the purest principles of Venetian art – that is to say, on the calm acceptance of the whole of nature, small and great, as in its place, deserving of faithful rendering. The great secret of the Venetians was their simplicity. They were great colourists, not because they had peculiar secrets about oil and colour, but because when they saw a thing red, they painted it red; and when they saw it blue, they painted it blue; and when they saw it distinctly, they painted it distinctly. In all Paul Veronese's pictures, the lace borders of the table cloths or fringes of the dresses are painted with just as much care as the faces of the principal figures; and the reader may rest assured that in all great art it is so. Everything in it is done as well as it *can* be done. Thus, in the picture before us, in the background is the Church of San Miniato, strictly accurate in every detail; on the top of the wall are oleanders and pinks, as carefully painted as the church; the architecture of the shrine on the wall is well studied from thirteenth-century Gothic, and painted with as much care as the pinks; the dresses of the figures, very beautifully designed, are painted with as much care as the architecture; and the face with as much care as the dresses: that is to say, all things throughout, with as much care as the painter could bestow. It necessarily follows, that what is most difficult (i.e. the faces) should be comparatively the worst done. But if they are done as well as the painter could do them, it is all we have to ask; and modern artists are under a wonderful mistake in thinking that when they have painted faces ill, they make their picture more valuable by painting the dresses worse.

The painting before us has been objected to, because it seems broken up into bits. Precisely the same objection would hold, and in very nearly the same degree, against the best works of the Venetians. All faithful colourists' work, in figure painting, has a look of sharp separation between part and part. I will not detain the reader by explaining *why* this is so, but he may convince himself of the fact by one walk through the Louvre, comparing the Venetian pictures in this respect with those of other schools. Although, however, in common with all other works of its class, it is marked by these sharp divisions, there is no confusion in its arrangement. The principal figure is nobly principal, not by extraordinary light, but by its own pure whiteness; and both the master and the young Giotto attract full regard by distinction of form and face. The features of the boy are carefully studied, and are indeed what, from the existing portraits of him, we know those of Giotto must have been in his youth. The head of the young girl who wears the garland of blue flowers is also very sweetly conceived.

Such are the chief merits of the picture. Its defect is, that the equal care given to the whole of it, is not yet *care enough*. I am aware of no instance of a young painter, who was to be really great, who did not in his youth paint with intense effort and delicacy of finish. The handling here is much too broad; and the faces are, in many instances, out of drawing, and very opaque and feeble in colour. Nor have they, in general, the dignity of the countenance of the thirteenth century. The Dante especially is ill conceived – far too haughty, and in no wise noble or thoughtful. It seems to me probable that Mr Leighton has greatness in him, but there is no absolute proof of it in this picture; and if he does not, in succeeding years, paint far better, he will soon lose his power of painting so well.

In the following year, Ruskin paid especial attention to Holman Hunt, whose *The Scapegoat* was proving controversial. In 1854, Hunt had been in Jerusalem, hoping to find Jewish models for *The Finding of the Saviour in the Temple*. Suspicion had been aroused among European Jews, one of whom,

a Mr Cohen, laid a curse on any Jews who mingled with Christians. Despite his protestations that he had no interest in the conversion of the Jews, Hunt was unable to placate Cohen, and he therefore had difficulty in finding sitters for as long as Cohen remained in the city.[5]

Around this time Hunt decided to paint a religious work in which, as it happened, no human being featured at all. The scapegoat, the animal which traditionally bore the sins of the Israelites, was to stand as the prefigurement of Christ, and Hunt went to immense lengths to paint the background on the shores of the Dead Sea, working in the remote desert day after day to catch the effects of sunset. One goat died on him, while its replacement had to be painted in the courtyard of his Jerusalem lodgings, among specimens of salt and mud.[6]

On the frame of the painting, quotations were inscribed from Isaiah and Leviticus, pointing the viewer towards the parallel with Christ. In the exhibition catalogue itself, there was an explanatory note by Hunt, as follows:

> The scene was painted at Oosdoom, on the margin of the salt-encrusted shallows of the Dead Sea. The mountains beyond are those of Edom.
>
> While the ceremonies of the day of atonement were in progress in the Temple, after the lots had been cast which had devoted one of the two goats for the Lord, and while it was being sacrificed as a burnt offering, the congregation present manifested their impatience by calling upon the priest to hasten the departure of the scapegoat, and afterwards by following the beast as he was led away by the man appointed, to a cliff about ten miles from Jerusalem; tormenting it by the way, and shouting, 'Hasten, carry away our sins.' It is recorded that, on many occasions, the poor beast sprang over the precipice, and there perished; but that oft-times it turned aside, to be hooted and driven away by every 'Israelite who met with it, until it had reached a land not inhabited'. A fillet of scarlet was bound about its horns, in the belief that, if the propitiation were accepted, the scarlet would become white (in accordance with the promise in Isaiah: 'Though your sins be as scarlet, they shall be as white as snow: though they be red like crimson, they shall be as wool'). In order to ascertain the change of colour, in case the scapegoat could not be traced, a portion of the scarlet wool was preserved on a stone, and carefully watched by the priests in the Temple. – See the Talmud.

Notwithstanding this considerable amount of annotation and explanation, there was a degree of bafflement and resistance among the critics, one of whom 'found it difficult to divine the nature of the subject'. Here is Ruskin's notice:

398. *The Scapegoat* (W. H. Hunt)
This singular picture, though in many respects faultful, and in some wholly a failure, is yet on the whole the one, of all in the gallery, which should furnish us with most food for thought. First, consider it simply as an indication of the temper and aim of the rising artists of England. Until of late years, young painters have been mostly divided into two groups; one poor, hard-working, and suffering, compelled more or less, for immediate bread, to obey whatever call might be made upon them by patron or publisher; the other, of perhaps more manifest cleverness or power, able in some degree to command the market, and apt to make the pursuit of art somewhat complementary to that of pleasure; so that a successful artist's studio has not been in general a place where idle and gay people would have found themselves ill at ease, or at a loss for amusement. But here is a young painter, the slave neither of poverty nor pleasure, – emancipated from the garret, despising the green room, and selecting for his studio a place where he is liable certainly to no agreeable forms of interruption. He travels, not merely to fill his portfolio with pretty sketches, but in as determined a temper as ever mediaeval pilgrim, to do a certain work in the Holy Land. Arrived there, with the cloud of Eastern War gathered to the north of him, and involving, for most men, according to their adventurous or timid temper, either an interest which would at once have attracted them to its immediate field, or a terror which would have driven them from work in its threatening neighbourhood, he pursues calmly his original

William Holman Hunt (1827–1910), *The Scapegoat*, 1854. Oil on canvas, 87 × 139.8 cm.
Lady Lever Art Gallery, Port Sunlight

purpose; and while the hills of the Crimea were white with tents of war, and the fiercest passions of the nations of Europe burned in high funeral flames over their innumerable dead, one peaceful English tent was pitched beside a shipless sea; and the whole strength of an English heart spent in painting a weary goat, dying upon its salt sand.

And utmost strength of heart it needed. Though the tradition that a bird cannot fly over this sea is an exaggeration, the air in its neighbourhood is stagnant and pestiferous, polluted by the decaying vegetation brought down by the Jordan in its floods; the bones of the beasts of burden that have died by the 'way of the sea' lie like wrecks upon its edge, bared by the vultures, and bleached by the salt ooze, which, though tideless, rises and falls irregularly, swoln or wasted. Swarms of flies, fed on the carcases, darken an atmosphere heavy at once with the

poison of the marsh, and the fever of the desert; and the Arabs themselves will not encamp for a night amidst the exhalations of the volcanic chasm.

This place of study the young English painter chooses. He encamps a little way above it; sets his easel upon its actual shore; pursues his work with patience through months of solitude; and paints, crag by crag, the purple mountains of Moab, and grain by grain, the pale ashes of Gomorrah.

And I think his object was one worthy of such an effort. Of all the scenes in the Holy Land, there are none whose present aspect tends so distinctly to confirm the statements of Scripture, as this condemned shore. It is therefore exactly the scene of which it might seem most desirable to give a perfect idea to those who cannot see it for themselves; it is that also which fewest travellers are able to see; and which, I suppose, no one but Mr Hunt himself would ever have

William Holman Hunt (1827–1910),
The Light of the World, c. 1851–53.
Oil on canvas, 125.5 × 59.7 cm.
Keble College, Oxford

dreamed of making the subject of a close pictorial study. The work was therefore worth his effort, and he has connected it in a simple, but most touching way, with other subjects of reflection, by the figure of the animal upon its shore. This is, indeed, one of the instances in which the subject of a picture is wholly incapable of explaining itself; but, as we are too apt – somewhat too hastily – to accept at once a subject as intelligible and rightly painted, if we happen to know enough of the story to interest us in it, so we are apt, somewhat unkindly, to refuse a painter the little patience of inquiry or remembrance, which, once granted, would enable him to interest us all the more deeply, because the thoughts suggested were not entirely familiar. It is necessary, in this present instance, only to remember that the view taken by the Jews of the appointed sending forth of the scapegoat into the Wilderness was that it represented the carrying away of their sin into a place uninhabited and forgotten; and that the animal on whose head the sin was laid, became accursed; so that 'though not commanded by the law, they used to maltreat the goat Azazel – to spit upon him, and to pluck off his hair'. The goat, thus tormented, and with a scarlet fillet bound about its brow, was driven by the multitude wildly out of the camp: and pursued into the Wilderness. The painter supposes it to have fled towards the Dead Sea, and to be just about to fall exhausted at sunset – its hoofs entangled in the crust of salt upon the shore. The opposite mountains, seen in the fading light, are that chain of Abarim on which Moses died.

Now, we cannot, I think, esteem too highly, or receive too gratefully, the temper and the toil which have produced this picture for us. Consider for a little while the feelings involved in its conception, and the self-denial and resolve needed for its execution; and compare them with the modes of thought in which our former painters used to furnish us annually with their 'Cattle pieces' or 'Lake scenes', and I think we shall see cause to hold this picture as one more truly honourable to us, and more deep and sure in its promise of future greatness in our schools of painting, than all the works of 'high art' that since the foundation of the Academy have ever taxed the wonder, or weariness, of the English public. But, at the same time, this picture indicates a danger to our students of a kind hitherto unknown in any school; the danger of a too great intensity of feeling, making them forget the requirements of painting as an *art*. This picture, regarded merely as a landscape, or as a composition, is a total failure. The mind of the painter has been so excited by the circumstances of the scene, that, like a youth expressing his earnest feeling by feeble verse (which seems to him good, because he *means* so much by it). Mr Hunt has been blinded by his intense sentiment to the real weakness of the pictorial expression; and in his earnest desire to paint the Scapegoat, has forgotten to ask himself first, whether he could paint a goat at all.

I am not surprised that he should fail in painting the distant mountains; for the forms of large distant landscape are a quite new study to the Pre-Raphaelites, and they cannot be expected to conquer them at first: but it is a great disappointment to me to observe, even in the painting of the goat itself, and of the fillet on its brow, a nearly total want of all that effective manipulation which Mr Hunt displayed in his earlier pictures. I do not say that there is absolute want of skill – there may be difficulties encountered which I do not perceive; but the difficulties, whatever they may have been, are not conquered: this may be very faithful and very wonderful painting – but it is not *good* painting; and much as I esteem feeling and thought in all works of art, still I repeat, again and again, a painter's business is first to *paint*. No one could sympathize more than I with the general feeling displayed in the *Light of the World*; but unless it had been accompanied with perfectly good nettle-painting, and ivy painting, and jewel painting, I should never have praised it; and though I acknowledge the good purpose of this picture, yet, inasmuch as there is no good hair-painting, nor hoof-painting in it, I hold it to be good only as an omen, not as an achievement; and I have hardly ever seen a composition, left apparently almost to chance, come so unluckily: the insertion of the animal in the exact centre

William Powell Frith R A (1819–1909), *The Derby Day*, 1856–58.
Oil on canvas, 101.6 × 223.5 cm. Tate Britain, London. Bequeathed
by Jacob Bell, 1859. N00615

of the canvas, making it look as if it were painted
for a sign. I can only, therefore, in thanking Mr
Hunt heartily for his work, pray him, for practice
sake, not to paint a few pictures with less feeling
in them; and more handling.

In 1858, the sensation of the Exhibition was
W. P. Frith's *The Derby Day*. According to Frith, the
exhibition of this work brought such crowds that
a barrier had to be put up in front of it, and a police-
man placed on guard. The only precedent for such
measures had been in 1822, when Wilkie exhibited
*The Chelsea Pensioners Reading the Gazette of the Battle of
Waterloo*. After its exhibition at Trafalgar Square,
Frith's picture toured the world – the Antipodes,

America, Austria and France. The Queen was an early enthusiast. Ruskin's notice acknowledges a popular success without either condoning or attacking it.

218. *The Derby Day* (W. P. Frith, R.A.)
I am not sure how much power is involved in the production of such a picture as this; great ability there is assuredly – long and careful study – considerable humour – untiring industry, – all of

them qualities entitled to high praise, which I doubt not they will receive from the delighted public. It is also quite proper and desirable that this English carnival should be painted: and of the entirely popular manner of painting, which, however, we must remember, is necessarily, because popular, stooping and restricted, I have never seen an abler example. The drawing of the distant figures seems to me especially dexterous

and admirable; but it is very difficult to characterize the picture in accurate general terms. It is a kind of cross between John Leech and Wilkie, with a dash of daguerreotype here and there, and some pretty seasoning with Dickens' sentiment.

Whether Ruskin was always as high-minded as his tone usually implies may be questioned. The Eastlakes (who had, as we have seen, a grievance) sometimes doubted Ruskin's motives, but they may have had good reason. Ruskin's treatment of Millais in *Academy Notes* passes hectically from adulation to condemnation. That Millais had, a short while before the *Notes* begin, run off with Ruskin's wife Effie (a confidante, incidentally, of Lady Eastlake) can hardly be thought irrelevant. But the first notice of Millais is in adulatory mode. Ruskin writes in 1855 of *The Rescue*:

Sir John Everett Millais Bt PRA (1829–1896), *Cartoon for 'The Rescue'*, *c.* 1855. Pencil and red chalk on paper, 38 × 28 cm. Birmingham Museums and Art Gallery

It is the only *great* picture exhibited this year; but this is *very* great. The immortal element is in it to the full.

But the rest of this short notice is devoted to 'various small cavils'. In 1856 the adulation is maintained:

200. *Peace Concluded*, 1856 (J. E. Millais, A.) I thought, some time ago, that this painter was likely to be headed by others of the school; but Titian himself could hardly head him now. This picture is as brilliant in invention as consummate in executive power; both this and *Autumn Leaves*, 448, will rank in future among the world's best masterpieces; and I see no limit to what the painter may hope in future to achieve. I am not sure whether he may not be destined to surpass all that has yet been done in figure-painting, as Turner did all past landscape.

The following year, Ruskin hurtfully withdraws all this praise. 'The Pre-Raphaelite cause', he tells us in his preface, 'has been doubly betrayed, by the mistimed deliberation of one of its leaders, and the inefficient haste of another; and we have to regret at once that the pictures of Holman Hunt were too late for the Exhibition, and that those of Everett Millais were in time for it.' A sadistic touch is his indication, in the sarcastic notice of *News from Home*, that there is worse to come:

50. *News from Home* (J. E. Millais, A.) We will pass this for the present; merely asking, as we pass, whether Mr Millais supposes this to be the generally bright aspect of a Highlander on a campaign? or whether he imagines that Highlanders at the Crimea had dress portmanteaus as well as knapsacks, and always put on new uniforms to read letters from home in?

'We will pass this for the present,' but when Ruskin reaches Millais's *A Dream of the Past* he unburdens himself of such hateful feelings as, we cannot help but feel, he has been storing up during the years in which he praised him. Now the adulation of the previous year is, as far as possible, withdrawn, for we learn that 'as it is possible to stoop to victory, it is also possible to climb to defeat'. Ruskin sees with

Sir John Everett Millais Bt PRA (1829–1896), *Peace Concluded*, 1856. Oil on canvas, 117.5 × 91.4 cm. Minneapolis Institute of Arts, Michigan

Sir John Everett Millais Bt PRA (1829–1896), *News from Home*, 1856–57. Oil on panel, 35.5 × 25 cm. Walters Art Museum, Baltimore

consternation that 'it was not the Parnassian rock which Mr Millais was ascending, but the Tarpeian' – that is, a rock to be thrown off.

> The change in his manner, from the years of *Ophelia* and *Mariana* to 1857, is not merely a Fall – it is a Catastrophe; not merely a loss of power, but a reversal of principle: his excellence has been effaced, 'as a man wipeth a dish – wiping it, and turning it upside down.' There may still be in him power of repentance, but I cannot tell: for those who have never known the right way, its narrow wicket-gate stands always on the latch; but for him who, having known it, has wandered thus insolently, the by-ways to the prison-house are short, and the voices of recall are few.

This religious tone, this threat of what amounts to little short of eternal damnation, is maintained in the final passage of the notice:

For Mr Millais there is no hope, but in a return to the quiet perfectness of work. I cannot bring myself to believe that powers were given to him only to be wasted, which are so great, even in their aberration, that no pictures in the Academy are so interesting as these, or can be for a moment compared with them for occasional excellence and marvellousness of execution. Yet it seems to be within the purpose of Providence sometimes to bestow great powers only that we may be humiliated by their failure, or appalled by their annihilation; and sometimes to strengthen the hills with iron, only that they may attract the thunderbolt. A time is probably fixed in every man's career, when his own choice determines the relation of his endowment with his destiny; and the time has come when this painter must choose, and choose finally, whether the eminence he cannot abdicate is to make him conspicuous in honour, or in ruin.

Sir John Everett Millais Bt PRA (1829–1896), *A Dream of the Past: Sir Isumbras at the Ford*, 1857.
Oil on canvas, 125.5 × 171.5 cm. Lady Lever Art Gallery, Port Sunlight

Millais could be expected to resent this bitterly, and to notice, for his part, some of Ruskin's shortcomings. He predicts, for the Academy of 1859, that Ruskin would be disgusted

> for all the rubbish he has been praising *before being sent into the Royal Academy* has now bad places. There is a wretched work like a photograph of some place in Switzerland, evidently painted under his guidance, for he seems to have lauded it up sky-high; and that is *just where it is* in the miniature room! He does not understand my work, which is now too broad for him to appreciate, and I think his eye is fit only to judge the portraits of insects. But then, I think he has lost all real influence as a critic.[7]

Whether it was true that Ruskin could have written up the kind of run-of-the-mill painting Millais seems to be talking about before it was sent to the Academy is hard to say. It seems improbable. That he had lost his influence as a critic was certainly not true, nor did Millais really believe it. He was anticipating an attack. But this year, the last (apart from one more in 1875) in which Ruskin published his *Notes*, Millais showed an extraordinary picture of

nuns digging a grave, which Ruskin, as ever giving with one hand while taking with the other, was prepared, ambiguously, to defend.

15. *The Vale of Rest* (J. E. Millais, A.)
I have no doubt the beholder is considerably offended at first sight of this picture – justifiably so, considering what might once have been hoped for from its painter; but unjustifiably, if the offence taken prevents his staying by it; for it deserves his study. 'We are offended by it.' Granted. Perhaps the painter did not mean us to be pleased. It may be that he supposed we should have been offended if we had seen the real nun digging her real grave; that she and it might have appeared to us not altogether pathetic, romantic, or sublime; but only strange, or horrible; and that he chooses to fasten this sensation upon us rather than any other.

It is a temper into which many a good painter has fallen before now. You would not find it a pleasant thing to be left at twilight in the church of the Madonna of the Garden at Venice, with the last light falling on the skeletons – half alive,

Sir John Everett Millais Bt PRA (1829–1896), *The Vale of Rest*, 1858–59.
Oil on canvas, 102.9 × 172.7 cm. Tate Britain, London, Presented by Sir Henry Tate, 1894. N01507

dreamy, stammering skeletons – shaking the dust off their ribs, in Tintoret's *Last Judgment*. Perhaps even you might not be at your ease before one or two pale crucifixes which I remember of Giotto's and other not mean men, where the dark red runlets twine and trickle from the feet down to the skull at the root of the cross. Many an ugly spectre and ghastly face has been painted by the gloomier German workmen before now, and been in some sort approved by us; nay, there is more horror by far, of a certain kind, in modern French works – Vernet's *Eylau* and *Plague*, and such like – which we do not hear any one declaim against – (nay, which seem to meet a large division of public taste) than in this picture which so many people call 'frightful'.

Why *so* frightful? Is it not because it is so nearly beautiful? – Because the dark green field, and windless trees, and purple sky might be so lovely to persons unconcerned about their graves?

Or is it that the faces are so ugly? You would have liked them better to be fair faces, such as would grace a drawing-room, and the grave to

be dug in prettier ground – under a rose-bush or willow, and in turf set with violets – nothing like a bone visible as one threw the mould out. So, it would have been a sweet piece of convent sentiment.

I am afraid that it is a good deal more like real convent sentiment as it is. Death, confessed for king before his time, asserts, so far as I have seen, some authority over such places; either unperceived, and then the worst, in drowsy unquickening of the soul; or felt and terrible, pouring out his white ashes upon the heart – ashes that burn with cold. If you think what the kind of persons who have strength of conviction enough to give up the world, might have done for the world had they *not* given it up: and how the King of Terror must rejoice when he wins for himself another soul that might have gone forth to calm the earth; and folds his wide, white wings over it for ever: He also gathering his children together; and how those white sarcophagi, towered and belfried, each with his companies of living dead, gleam still so multitudinous among

the mountain pyramids of the fairest countries of the earth: places of silence for their sweet voices places of binding for their faithfullest hands; places of fading for their mightiest intelligences: you may, perhaps, feel also, that so great wrong cannot be lovely in the near aspect of it; and that if this very day, at evening, we were allowed to see what the last clouds of twilight glow upon in some convent garden of the Apennines, we might leave the place with some such horror as this picture will leave upon us; not all of it noble horror, but in some sort repulsive and ignoble.

It is, for these reasons, to me, a great work: nevertheless, part of its power is not to the painter's praise. The crude painting is here in a kind of harmony with the expression of discord which was needed. But it is crude – not in momentary compliance with the mood which prompted this wild design; but in apparent

consistency of decline from the artist's earlier ways of labour. Pass to his other picture, the [*Apple Blossoms,*] *Spring*, and we find the colour not less abrupt, though more vivid.

And when we look at this fierce and rigid orchard – this angry blooming – petals, as it were, of japanned brass; and remember the lovely wild roses and flowers scattered on the stream in the *Ophelia*; there is, I regret to say, no ground for any diminution of the doubt which I expressed two years since, respecting the future career of a painter who can fall thus strangely beneath himself.

The power has not yet left him. With all its faults, and they are grievous, this is still mighty painting: nothing else is as strong, or approximately as strong, within these walls. But it is a phenomenon, so far as I know, unparalleled hitherto in art-history, that any workman capable of so much should rest content with so little.

Sir John Everett Millais Bt PRA (1829–1896), *Apple Blossoms, Spring*, 1856–59. Oil on canvas, 113 × 176.3 cm. Lady Lever Art Gallery, Port Sunlight

Sir John Everett Millais Bt PRA (1829–1896), *Ophelia*, 1851–52. Oil on canvas, 76.2 × 111.8 cm.
Tate Britain, London. Presented by Sir Henry Tate, 1894. N01506

All former art, by men of any intellect, has been wrought, under whatever limitations of time, as well as the painter could do it; evidently with an effort to reach something beyond what was actually done: if a sketch, the sketch showed a straining towards completion; if a picture, it showed a straining to a higher perfection; but here, we have a careless and insolent indication of things that might be – not the splendid promise of a grand impatience, but the scrabbled remnant of a scornfully abandoned aim.

And this wildness of execution is strangely associated with the distortion of feature which more or less has been sought for by this painter from his earliest youth; just as it was by Martin Schongauer and Mantegna. In the first picture (from Keats's *Isabella*) which attracted public attention, the figure in the foreground writhed in violence of constrained rage: in the picture of the *Holy Family at Nazareth*, the Virgin's features were contorted in sorrow over a wounded hand; violent ugliness of feature spoiled a beautiful arrangement of colour in the *Return of the Dove*, and disturbed a powerful piece of dramatic effect in the *Escape from the Inquisition*. And in this present picture, the unsightliness of some of the faces, and the preternatural grimness of others, with the fierce colour and angular masses of the flowers above, force upon me a strange impression, which I cannot shake off – that this is an illustration of the song of some modern Dante, who at the first entrance of an inferno for English society, had found, carpeted with ghostly grass, a field of penance for young ladies; where girl-blossoms, who had been vainly gay, or treacherously amiable, were condemned to recline in reprobation under red-hot apple blossom, and sip scalding milk out of a poisoned porringer.

12 The High Victorians at Home

We have seen that from the earliest of days, when a pre-eminent artist was in a position to do so, he tended to live and work in the greatest of splendour. Van Dyck, Lely and Kneller had set the trend, following no doubt the precedent set by Rubens. Reynolds had his great coach, Cosway his romantic interior, West his gallery.

But no one ever, before or since, had a studio to match that of George Dawe when he worked in St Petersburg at the Winter Palace, where he painted 329 half-length portraits of Russian generals in the aftermath of the Napoleonic Wars. It was engraved by his brother-in-law Thomas Wright, an unbelievably stately space, with a view out down a great colonnade. Here Dawe would work with a bold and swift brush. He seemed to throw the paint at the canvas, as well he might, having so many generals awaiting their turn.

Dawe was an unpopular figure with his English colleagues. We are told that

> His anxiety to accumulate was such, that he had recourse to several even most unprofessional means to increase a fortune already becoming large from his full avocations: thus at the death of Princess Charlotte he had his portrait of her engraved, and himself employed persons to hawk it about the town, at the coach-stands and other places, by which means he realised a considerable sum.[1]

Dawe was another painter who, like Northcote, turned his hand to biography: he wrote a quite remarkably frank and judicious life of George Morland.[2]

During the prosperous period of the Leighton presidency, G. D. Leslie informs us that:

> Thinking that the good times had come to stay, numbers of successful painters who could afford it, and, sad to say, very many other artists who could not, bought houses with gardens attached to them, in St John's Wood, Kensington, Hampstead, and other suburban districts, where they built themselves large and luxuriously fitted studios; in these on 'Show Sundays' they were visited by crowds of fashionable people, but on working days such artists at their easels, with their models, always seemed to me to be sadly out of scale with their spacious and magnificent surroundings. I can well remember, for example, John Pettie appearing to me as quite lost in his large studio. I suspect he must have felt something of this sort himself, for he had divided the place in half by a huge velvet curtain, hanging from ceiling to floor.[3]

One might expect such a development to be noticed by Leslie, for his father, Constable's friend and biographer, had made do with a studio so small

Thomas Wright (1792–1849), *Tsar Alexander I Visiting George Dawe's Studio in St Petersburg*, 1820s.
Etching and aquatint on paper, 25.1 × 40.7 cm. Royal Academy of Arts, London. 05/4562

'that it was difficult to make one's way on a floor strewn with materials at hand for the purpose. There was little or no space to retire from his work to enable him to see the effect.'[4]

To the High Victorians, such cramped conditions might have been all very well for struggling youth, but, as soon as circumstances permitted, a grand studio became a priority. The Show Sundays mentioned by G. D. Leslie were open days at the artist's home which took place before the Academy Exhibitions. Visitors were reportedly as keen to see the artist and the manner in which he lived as they were to look at the paintings. An imposing home gave reassurance to clients of the high standing of the painter.

Millais, who had had such a splendid start to his artistic life, spent some years on the edge of respectability when, in 1855, he married Ruskin's former wife Effie. By 1861 however it was possible for the couple to live in London together and they took

a house off the Cromwell Road, 7 Cromwell Place, whose studio still exists and is now the meeting room of the National Art Collections Fund. Comfortable and large, it was hung with Flemish tapestries, which Jeremy Musson tells us had become 'almost the *sine qua non* of respectable studio-house interior decoration'.[5]

From here, a decade and a half later, Millais moved to a house which had been specially designed for his needs and status, at 2 Palace Gate, Kensington Gore. Again, this building still exists, and is today occupied by the Zambian High Commission. It was designed by the Royal Academician Philip Charles Hardwick in a style that reminded contemporaries of a Genoese palazzo. A marble hall, with a marble staircase and dado, led the patron and the sitter upstairs in appropriate style, past a marble fountain on the landing. There were back stairs for servants, and a dressing room on the ground floor seems to have been intended for the

Joseph Parkin Mayall (1839–1906), *Sir John Everett Millais in His Studio*, 1884.
Photo engraving on copper plate. Royal Academy of Arts, London

Frederic George Kitton
(1856–1904), *View of 2 Palace
Gate, Kensington*, 1885.
Pencil on paper, 15 × 21 cm.
Guildhall Library, London

use of the models, who had their own staircase from there to the studio.

These first-floor studios, typically in the period, were conceived both as atelier and as reception room, and Millais would regularly have friends visiting his studio on Sunday mornings. The parquet floor was of course practical, but it also put visitors immediately in mind of a ballroom, which is what the studio resembled in its dimensions. Millais's 1877 remark that 'my new home shall be a Palace such as the Italian painters commonly used', is seen by Musson as evidence that Millais regarded himself as successor to the great Italian artists.[6]

The remark also suggests the influence of Vasari, or of Jacob Burckhardt's *The Architecture of the Italian Renaissance*, which noted that: 'A delightful completion to the cosmopolitan lives led by such (busy) architects was often afforded by the houses they built for themselves in their later years in their home-land. It would be well worthwhile to collect all that remains or has been recorded of artists' houses in Italy.'[7] It is hard, however, to think of many artists' houses in Italy that could compare with those of Millais or Leighton. Raphael, Giulio Romano, Mantegna and Leone Leoni all had palatial dwellings, but Vasari's house in Arezzo is modesty itself by comparison.

Musson quotes two versions of the story of Thomas Carlyle's visit to Millais at Palace Gate, for his portrait to be painted. In the first, Carlyle asks, 'Has paint done all this Mr Millais?' Millais: 'Sir, it has.' Carlyle: 'I had not thought there were so many fools in the world.' In the second version it is Carlyle's niece who asks: 'Has a paint pot done all this?' Either seems to reflect the question that the architecture was designed to elicit.

Perhaps it is true that the rivalry between Millais and Leighton was reflected in the splendour of their houses. Leighton's, at 2 Holland Park Road, differed from Millais's in one extraordinary respect: Millais made a home for himself and his large family, and as a grand bourgeois family home his house differed very little from those of his neighbours. Leighton, a bachelor all his life, designed himself a dwelling (with the help of his architect George Aitchison) without accommodation for anyone other than himself and his servants. His bedroom was simple.

His public rooms were memorably elaborate, and included his large studio, which also served, as it still does today, as a music room. But there was no accommodation for a spouse, or for guests.

Nobody seems to have gossiped much about Leighton's personal arrangements, or lack of them. Henry James based one of his supernatural stories, 'The Private Life', on the characters of Browning and Leighton. The Browning character was conceived as having a double: the rather disappointing character one met in public, and the writer of genius who stayed behind at his desk, working away. The Leighton character was the opposite of this: his public persona was all there was; left on his own, he ceased to exist. Here is how the Leighton character, Lord Mellifont, is introduced:

> It was a peculiarity of this nobleman that there could be no conversation about him that didn't instantly take the form of anecdote, and a still further distinction that there could apparently be no anecdote that was not on the whole to his honour. If he had come into a room at any moment, people might have said frankly: 'Of course we were telling stories about you!' As consciences go, in London, the general conscience would have been good. Moreover it would have been impossible to imagine his taking such a tribute otherwise than amiably, for he was always as unperturbed as an actor with the right cue. He had never in his life needed the prompter – his very embarrassments had been rehearsed. For myself, when he was talked about I always had the odd impression that we were speaking of the dead – it was with that peculiar accumulation of relish. His reputation was a kind of gilded obelisk, as if he had been buried beneath it; the body of legend and reminiscence of which he was to be the subject had crystallised in advance.[8]

This sounds very like Leighton. The kinds of anecdote that attached itself to him included stories of his level-headedness and capability: how he had helped put out a fire in the Baptistery in Florence; how, on a farm in the Campagna, when a donkey had kicked over a beehive and was being attacked by a swarm, he had tied a handkerchief over his face

Joseph Parkin Mayall (1839–1906), *Lord Leighton in His Studio*, 1884. Photo engraving on copper plate. Royal Academy of Arts, London

and managed to free the donkey from its hobble. Leighton's friendships were well known: at the age of twenty-two he had formed a strong attachment to an older woman, the singer Adelaide Sartoris, then possibly thirty-eight, and had frequented her salon. At the time of the donkey incident he had formed a lifelong friendship with an Italian painter, Giovanni Costa, with whom he regularly spent summers in Italy.

That he lived alone in London and spent much of the year travelling alone in Europe and North Africa suggests that he might perhaps have put his social and his sexual life into separate compartments, which in turn might lead one to wonder whether he was homosexual. But Caroline Dakers, in her study of the artists who gravitated to Holland Park, finds rather convincing evidence that Leighton supported

one of his models, a married woman, and her child, and that, in the family of this offspring, the understanding was that Leighton was the father.[9]

What is clear is that Leighton presented his life, through the design of his house, as thoroughly aestheticised. One never visited him except by appointment or invitation. Of the spaces in which one might be received, the most extraordinary was and remains the Arab Hall, which Aitchison designed as a space to display the notable groups of Islamic tiles which Leighton had acquired from Damascus though the good offices of the explorer Sir Richard Burton, and through Sir Caspar Purdom Clarke, who was collecting at the time for the South Kensington Museum.

One of Leighton's achievements was to have promoted new talents in sculpture and to have

brought them into the orbit of the Academy. Hamo Thornycroft was one of these; another was Alfred Gilbert. In the summer of 1882 Leighton, while visiting Giovanni Costa at his house near Perugia, as was his custom, made the effort to look up Alfred Gilbert, the young sculptor who had caused interest that year by exhibiting a striking marble group, *The Kiss of Victory*, at the Royal Academy, and by following this up with a bronze of *Perseus Arming*, at the Grosvenor Gallery.

Gilbert had studied at the Royal Academy Schools, beginning in 1873, while working during the day in the studio of Joseph Edgar Boehm. He had earned his place at the Academy 'on the strength of a model I made of a statuette, a cast in plaster from the original bronze in the British Museum of a figure, commonly known to all students at that time as "the squinting Hercules"'. The Academy training in those days was in itself utterly inadequate, but Richard Dorment, in his monograph on Gilbert, points out that it had this advantage, that by offering evening hours it gave the student the opportunity to combine practical atelier work with his academic studies. Very little was offered by the Academy specifically for the student of sculpture. Gilbert, Dorment tells us, 'visualised the Academy as an Olympus, the Academicians as remote gods, among them Frederic Leighton, revered as an artist whose ideals in art all Gilbert's contemporaries wished to emulate. In his imagination, his fellow students lived in an underworld, untouched by "the mighty Forty, and their satellites, who were Gods . . . over our heads".'

Here is Gilbert mythologising the dark basement at Burlington House in those days:

> I am back again, within the precincts of the Royal Academy Schools, awaiting with a number of other youths and maidens, at the student entrance . . . The door suddenly opened inwards into a dimly lit vaulted cavernous cellar, a sort of compromise between an underground railway station, and the entrance to a Mummy Chamber.

The Arab Hall at Leighton House, 2 Holland Park Road. Leighton House Museum and Art Gallery, London

The porter, Farren, leads them through the vaulted cellars, 'with an expression halfway between the callous gravedigger, and the . . . manipulator of the Charnel house'. He was a 'janitor of the nether regions of Olympus above', who led them

> through dark passages, to a long corridor, dimly lighted by high windows on one side, whose only purpose was to transmit a borrowed light from the room itself to illuminate very dimly the plaster casts of dead Emperors, posing Venuses, fighting and defying Heroes, and mawkish cupids. Here and there was a death mask.[10]

The experience may have been awesome, but the education was 'non-existent': Gilbert wrote later, 'Personally I owe nothing whatever to the Academy training.'

Three years later, having made his cousin pregnant, Gilbert eloped to Paris and continued his studies at the Ecole des Beaux-Arts, proceeding from

Sir Alfred Gilbert RA (1854–1934), *The Kiss of Victory*, 1878–81. Marble, height 227.3 cm. The John R. Van Derlip Fund. Minneapolis Institute of Arts

Lord Leighton P R A (1830–1896), *An Athlete Wrestling with a Python*, c. 1874–77. Original plaster statuette, height 24.8 cm. Royal Academy of Arts, London. 04/1427

Sir Hamo Thornycroft R A (1850–1925), *Teucer*, 1881. Bronze, height 44 cm. Royal Academy of Arts, London. Given by Elfrida Manning, 1987. 03/2432

there to Rome in order to carve his first major work. So when this imposing marble was shown, with the elegant bronze *Perseus* as a follow-up, Gilbert had been away from Britain for over five years. Although he had been thought a promising student, it is unlikely that anyone much remembered this promise. Now, out of the blue, Leighton arrived at Gilbert's farmhouse, offering a commission for a bronze statue, the subject and handling to be decided by the artist.

Dorment sees this as both a generous act by an 'infinitely thoughtful and discerning' patron, and as a temptation from an unwitting Mephistopheles.

Leighton himself had not long before taken up sculpture with great success, producing his *Athlete Wrestling with a Python*, one of the key and characteristic works of the movement that become known in the 1880s as the New Sculpture. In 1879 this had been sold for £2,000 – a handsome sum. Leighton's instincts were generous, and it was natural for him to wish to draw talent into his orbit and arrange for it to thrive.

Gilbert responded with a statue of *Icarus* that contained its own tribute to a painting by Leighton, *Daedalus and Icarus*. It was a fitting response to an important commission, and it found its way directly

Sir Alfred Gilbert R A (1854–1934),
Perseus Arming, 1881–83. Bronze,
height 36.8 cm. Tate Britain, London.
Bequeathed by Frederick Harrison, 1936.
NO4828

to a key position in Leighton's house. There was no better way for an English artist to launch his career. Nevertheless, if Gilbert was frightened, it was because worldly success in London represented a temptation for him. If Leighton launched Gilbert, it fell to one of his successors as President of the Royal Academy, Edward Poynter, to do his best to pick up the pieces.

Over the years Gilbert proved incapable of satisfying all his commissions and his creditors. In 1901, faced with bankruptcy proceedings, he left England for Bruges, having first smashed most of the plaster models in his studio. In Belgium his financial problems continued, but for a while he was able to juggle his finances, until he fell foul of a very determined widow, Julia Frankau. In 1905, Mrs Frankau commissioned a monument to her late husband, a Jewish tobacco merchant. The contract stipulated that £150 was to be paid on signature, and thereafter £50 a month for six months, on receipt of a written certificate from the artist that work was going according to schedule. The balance of the total 600 guineas would be paid on delivery, but for every day of delay beyond the six months Gilbert was to forfeit one pound.

The moment Mrs Frankau realised that there was a delay, she sent out her solicitor, who discovered that the monument had not proceeded beyond the clay model stage. She not only demanded her money back, but also threatened to expose Gilbert in the scandalous pages of the magazine *Truth*, for which her sister worked as a gossip columnist, 'in order to prevent other widows being similarly robbed by him'.[11] Begging her forgiveness and understanding, Gilbert warned Mrs Frankau that if she pursued her threats, he would be honour-bound to resign from the Academy. This had the opposite of the expected deterrent effect. As Dorment tells us, she placed an advertisement in several newspapers, including Gilbert's local, the *Journal de Bruges*:

MR. ALFRED GILBERT R.A.
ANYONE WHO HAS GIVEN COMMISSIONS
TO Mr. ALFRED GILBERT DURING THE LAST
FIFTEEN YEARS IS INVITED TO COMMUNICATE
WITH MRS. FRANKAU, 11 CLARGES STREET,
PICCADILLY, W.

She also wrote to Poynter, setting out her complaint, and receiving the reply from him that 'the Royal Academy has no authority to interfere in the private affairs of its members, or to force them to fulfil their engagements'.[12]

Poynter was in a narrow sense right: the Academy did not possess the authority to force an artist member to honour a contract, nor had it tried to do so in cases well known. We have seen that Lawrence's commissions were regularly unfulfilled, and that he received far larger sums of money from far grander figures than Mrs Frankau. But Mrs Frankau was something new. She was middle class and implacable. Her contract, with its penalty clause ticking away, was less than a year old, and a mere five months overdue, when she went public with her grievance. But she had the law on her side, she was a widow and she understood publicity. When her case was taken up by *Truth*, Gilbert was roundly accused of obtaining money by deliberately lying, using humbug to defend his position as a delinquent artist, taking advantage of his position on the Continent, out of reach of English law, and of utilising 'his status as a Royal Academician to obtain large sums of money on account for execution of commissions without executing them'.

An appeal made on Gilbert's behalf to George Bernard Shaw by Countess Feodora Gleichen backfired in the most spectacular manner. The Countess, as Dorment tells us, was the daughter of Queen Victoria's nephew, the sculptor Count Edward Gleichen, and was herself a sculptor. She asked Shaw 'whether a sculptor should be treated like a commercial mechanic', and drew the following riposte:

My Dear Countess,
I do not think a sculptor should be treated like a commercial mechanic. A commercial mechanic can be sent to Holloway on a judgment summons, or be refused his discharge in bankruptcy when he cannot meet his engagements. But a dishonest sculptor should be shot. For Gilbert, if Mrs Frankau's story be true, shooting is too honourable a death. He should be drowned in the fountain with which he disfigured Piccadilly Circus.

Pray do not suppose that I deny an artist's right to be judged by a different standard to other people. I grant that – in fact I insist on it – and as an artist's standard is more exacting and higher than the tradesman's standard I know that it not only binds the artist to accept obligations that are too severe for the tradesman, but also relieves him from obligations not the tradesman's. He accepts a tradesman's job for a monument; takes the money for it; and then – well, would *you* do what he did? You are artist enough to know that they are lies – that the picture of the great sculptor striving vainly to do justice to the memory of Mrs Frankau's husband, and shattering his work in despair, is an ignoble, ridiculous fiction – don't

you? It dishonours us all, you, me, everyone whose work is fine art. It encourages the public to believe that artists are people who claim the privilege of being worse than other people instead of the honour of being better than they.

In the course of my life I have had to support myself for many years by journalistic work which was not the highest work in my power. What would you have thought of me if I had taken the money for it and not done it instead of doing it as well as I could? I could at this moment get a considerable sum from any London manager by promising him a popular play to be ready by next October. Suppose I took it, and then said I really could not control my genius and harness it to the

Lord Leighton PRA (1830–1896), *Daedalus and Icarus*, 1839–96. Oil on canvas, 138.2 × 104.6 cm. The Faringdon Collection Trust, Buscot Park, Oxfordshire, inv. 80

Sir Alfred Gilbert RA (1854–1934), *Icarus*, 1882–84. Bronze, height 49.5 cm. Tate Britain, London. Bequeathed by Frederick Harrison, 1936. NO4827

Sir Alfred Gilbert's unfinished Frankau Memorial, 1906.
Clay, height 274.3 cm (destroyed)

took it and denied her the agreed consideration. What do you call that? I call it Christian roguery. There!

 Yours faithfully,
 G. Bernard Shaw

Shaw's letter, of course, was not published at the time. The Academy failed publicly to call Gilbert to account, although both Poynter and Hamo Thornycroft wrote to him privately. It was not until 1908, when another scandal involving Gilbert's failure to complete the Leicester War Memorial, to the exasperation of the Duke of Rutland, hit the press, that the pressure began to mount. Gilbert was perfectly aware that expulsion from the Academy would, in the last resort, be a matter for the King (as it had been in the case of Barry), and he did not scruple to involve his mother in his telegraphed pleas to the monarch.

YOUR MAJESTY PLEASE STAY EXECUTION / ALFRED GILBERT WILL FINISH HIS WORK NOW AND THAT QUICKLY / HIS SONS IN THE ROYAL NAVY / HIS MOTHER

And on the same day, 18 November 1908:

I PRAY YOUR MAJESTY GRANT AUDIENCE TO MY SON LIEUTENANT FRANCIS GILBERT R.N. LEAVING ME SPECIALLY TONIGHT WITH FACTS AND FULL EXPLANATIONS TO AWAIT YOUR MAJESTY'S PLEASURE AT ADMIRALTY / ALFRED GILBERT

The response from Windsor Castle was to the point:

YOUR REQUEST IS QUITE IMPOSSIBLE / THE KING CANNOT SEE YOUR SON / YOU HAD BETTER THEREFORE RECALL HIM / PROBYN

Only in the nick of time, with one day to go, did Gilbert get his letter to the Council, 'begging to be allowed to offer & asking the President & Council to accept his resignation as a member of the Royal Academy'.[13] He was not to be reinstated until the presidency of William Llewellyn, in 1932.

box office of fashionable theatres! Would you not say, 'then why did you take the money?'

 The love of titles and dignities you mention seems to me quite of a piece with his other characteristics. The duty of an R.A. is quite plain in the matter; and Poynter's apparent want of perception seems to me to justify that attitude of the British Philistine toward artists of which you complain.

 If I were you I would make a statue of Mrs Frankau for nothing, to commemorate her very proper and public-spirited action. It is the best virtue of the Jew that when he (or she) makes an agreement he (or she) means it. She paid her money honestly. That was not mean. Gilbert

Ralph Winwood Robinson (1862–1942), *Sir Alfred Gilbert in His Studio*, 1889. Photograph from *Members and Associates of the Royal Academy*, Chiswick Press, 1892. Royal Academy of Arts, London. PC 96/2/004

13 From Millais to Munnings

The man who carried the splendid wreath of the Royal Academy, and placed it on Leighton's coffin as soon as it had been lowered into the crypt of St Paul's, was John Everett Millais, Leighton's natural successor as president. Unfortunately Millais was suffering from a tumour of the throat, and was noticeably ill even at the time when he accepted the candidacy. He was elected with only one opposing vote – his own.

Holman Hunt, in a letter of congratulations, asked him, 'Did you ever hear of [Edward] Lear's pun? . . . It was – that the *Millais-nium* of Art had come. You have gone a letter higher – from P.-R.B. to P.R.A.' That is, from Pre-Raphaelite Brotherhood to President of the Royal Academy. Victorian painters were exceedingly fond of such elaborate puns. When, in the same year, Solomon Solomon was made Associate, someone remarked that 'Even Solomon in all his glory was not A.R.A.-ed like one of these.'

Here is a description of Millais in his last days, published posthumously in the *Daily News*:

There was something very pathetic in the way Millais lingered round the galleries of the Academy during the last days before it opened for the first time under his presidentship. He was in the rooms on the Saturday before the private view (the last of the members' varnishing days) shaking hands with old friends, and saying, in a hoarse

whisper, which told its tale tragically enough, that he was better. He came again on Monday – that was the outsiders' varnishing day. The galleries were full of painters young and old, hard at their work – much to do and little time to do it in – when someone said, 'Millais is in the next room.' Young men and old, they all looked in, mournfully realising it might be their last chance to see the greatest of their brethren. There he was, leaning on the Secretary, and slowly going his round. One young painter, perched upon a ladder, varnishing his canvas,

Lord Leighton PRA (1830–1896) lying in state at Burlington House, 1896

Motor-cars and carriages parked in the forecourt of Burlington House for a private view at the Royal Academy, 29 April 1910

248

felt his leg touched, but was too busy to turn round. Again he was interrupted. It was the President, who, in a scarcely audible whisper, wished to congratulate him on his work. That was on Monday. He came again on Tuesday. There was discussion amongst a few of the members about a picture that in the hanging had not got so good a chance as it deserved. 'Take one of my places,' he said; and he meant it. It was not the first time he had offered to make way, giving up his own position to an outsider.[1]

Millais had been elected in February and died in August, following Leighton to St Paul's on 20 August 1896, to be buried like him by his fellow Academicians in Painter's Corner, with, as his son puts it, 'his illustrious predecessors Sir Joshua Reynolds, Sir Christopher Wren, Sir Thomas Lawrence, Benjamin West, Opie, Fuseli, and Sir Edgar Boehm'.

A couple of years earlier, George Du Maurier had caused a sensation with his novel *Trilby*. One of the incidental characters in this tale of Bohemian Paris in the 1850s is based on Edward Poynter, who now succeeded Millais. This is how Du Maurier, in his acid way, evokes the character of Poynter as a young man:

Then there was Lorrimer, the industrious apprentice, who is now also well pinnacled on high; himself a pillar of the Royal Academy – probably, if he lives long enough, its future president – the duly knighted or baroneted Lord Mayor of 'all the plastic arts' (except one or two perhaps, here and there, that are not altogether without some importance).

May this not be for many, many years! Lorrimer himself would be the first to say so!

Tall, thin, red-haired and well-favoured, he was a most eager, earnest and painstaking young enthusiast, of precocious culture, who read improving books, and did not share in the amusements of the Quartier Latin, but spent his evenings at home with Handel, Michael Angelo, and Dante, on the respectable side of the river. Also, he went into good society sometimes, with a dress-coat on, and a white tie, and his hair parted in the middle!

. . . Enthusiast as he was, he could only worship one god at a time. It was either Michael Angelo, Phidias, Paul Veronese, Tintoret, Raphael or Titian – never a modern – moderns didn't exist! And so thorough-going was he in his worship, and so persistent in voicing it, that he made those immortals quite unpopular in the Place St Anatole des Arts. We grew to dread their very names. Each of them would last him a couple of months or so; then he would give us a month's holiday, and take up another.[2]

Poynter was indeed a great holder of high office, as this faintly unpleasant sketch makes clear. In 1871 he had been appointed the first Slade Professor of Fine Art at University College, London. In South Kensington, four years later, he had been made Director of Art at the Museum (now the Victoria and Albert) and Principal of the National Art Training School (which became the Royal College of Art). In 1894, he took on the directorship of the National Gallery, and when in 1896 he became President of the Royal Academy, like Eastlake, he ran the two places in tandem for several years. This did not stop him painting every day. His works were popular all around the world, and when he died in 1919 there was not a single unsold picture in his studio.[3]

Although, as we have seen, there were two women among the original Academicians, for a century they had no successors. In 1879, the Council delivered itself of the opinion that, strictly speaking, the original Instrument of Foundation did not allow for women members. However it was moved by a request from the General Assembly to pass a resolution making women eligible for membership but restricting their privileges.

In 1913, a demonstration was made by some suffragettes, who attempted to start a fire in the ladies' lavatory, as a prelude to a public meeting in the galleries. Later, as Alfred Munnings recalled:

I was with Laura Knight and other artists looking at one of her paintings when suddenly we heard

Ralph Winwood Robinson (1862–1942), *Sir Edward Poynter Bt PRA*, *c.* 1891. Photograph from *Members and Associates of the Royal Academy*, Chiswick Press, 1892. Royal Academy of Arts, London. BW 53. Poynter served as President from 1896 to 1918

CRIMINAL RECORD OFFICE,

NEW SCOTLAND YARD, S.W.

16th May, 1914.

In continuation of the Memorandum of 24th April, 1914, special attention is also drawn to the undermentioned SUFFRAGETTES who have committed damage to public art treasures or public offices, and who may at any time again endeavour to perpetrate similar outrages.

MARY ALDHAM.

ETHEL COX.

crashing blows and the falling of splintered glass
– then sounds of hurrying feet in the next room.
Rushing through with the crowd, we were in
time to see a frail woman with a small hatchet or
chopper, striking viciously at the already slashed
portrait of Henry James by Sargent. She was
seized and surrounded. By then the room was
crowded to overflowing. Whilst the commotion
was at its height again there came the crashing
and breaking of glass.

A general stampede followed, and in the
adjoining room there was another determined
woman hacking away at a painting of a beautiful
nude by George Clausen called 'Primavera'. There
were shouts of rage and disgust at this vicious
act. I can see the great slashes in it now as
I recall that remarkable scene.

It took many men, it seemed, to restrain the
energies of these women suffragettes.

Henry James's gashed face looking out of
the picture was a comic sight had it not been
so serious. In much less time than one would
believe, the pictures which had appeared to
be damaged beyond repair were restored and
again hung, and it was interesting to try to
trace where the holes had been. There was not
a sign of them.

Munnings, who was famously obsessed by horses
and never missed an important race, goes on to
describe how little impact the famous death of
Emily Davison made on the crowd at the Derby:

That same year, a few weeks later, a suffragette
threw herself in front of the horses at Tattenham
Corner and was killed. I remember being some-
where on the rails near the finish. This tragic
event at the moment, amongst that great
concourse of people on the Downs, was a minor
disturbance excepting only to witnesses on the
spot where horses were brought down and the
woman killed.

All we heard was that the favourite had fallen.
The excitement of the finish being over, the news

Dame Laura Knight RA (1877–1970) showing fellow
Academicians her *Lamorna Birch and His Daughters*
on Members' Varnishing Day, April 1934

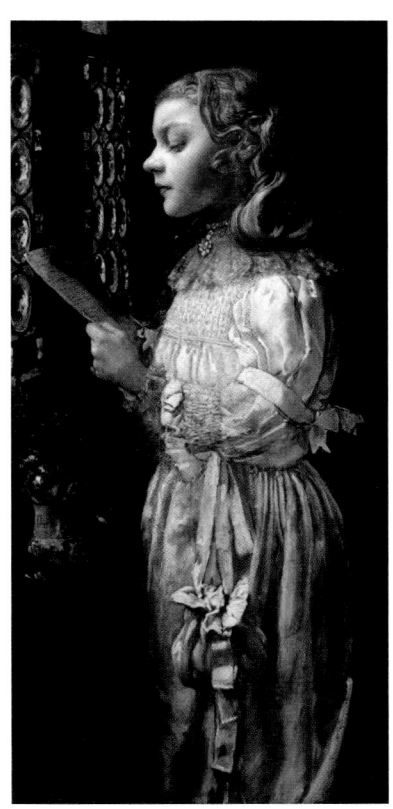

A poster was produced by the police after the
suffragette attacks and displayed on the railings
outside Burlington House

Annie Swynnerton ARA (1844–1933), *The Letter*, undated.
Oil on canvas, 101.6 × 48.2 cm. Royal Academy of Arts,
London. Purchased by the Stott Fund, 1934. 03/882

of what had happened spread through the crowd, already intent on the runners for the next race and caring little about votes for women.

The sight of the horses and jockeys leaving the paddock for the next race dispelled all such ideas to the winds.[4]

In 1922, the painter Annie Swynnerton was elected Associate, and was followed five years later by Laura Knight, who went on to full membership in 1936.

Sir Aston Webb, who succeeded Poynter in 1919, was (with the exception of James Wyatt, who took over from West briefly in 1805) the first architect to become President of the Academy. Webb's work had an important impact on London, for he designed Imperial College and the Victoria and Albert Museum, and redesigned the east façade of Buckingham Palace for George V, adapting the Mall and creating Admiralty Arch as a memorial to Queen Victoria, thereby completing the ceremonial ensemble still familiar today.

A vision of the first annual Exhibition of Webb's presidency is provided by Virginia Woolf, in an essay first published in the *Athenaeum* on 22 August 1919.[5] After describing the rich arriving in their motor-cars in the courtyard, and making their way up the stairs, Woolf conjures up the effect of the paintings. 'The point of a good Academy picture', she tells us, 'is that you can search the canvas for ten minutes or so and still be doubtful whether you have extracted the whole meaning.'

The example she chooses is no. 248, *Cocaine*, by Alfred Priest. On sale at £472. 10s, it found no takers.

A young man in evening dress lies, drugged, with his head upon the pink satin of a woman's knee. The ornamental clock assures us that it is exactly eleven minutes to five. The burning lamp proves that it is dawn. He, then, has come home to find her waiting? She has interrupted his debauch? For my part, I prefer to imagine what in painters' language (a tongue well worth separate study) would be called a 'dreary vigil'. There she has sat since eight-thirty, alone, in pink satin. Once she rose and pressed the photograph in the silver frame to her lips. She might have married that man (unless it is her father, of which one cannot

Sir William Llewellyn PRA (1858–1941), *Portrait of Sir Aston Webb* PRA, *c*. 1921. Oil on canvas, 74.2 × 62.2 cm. Royal Academy of Arts, London. 03/661. Webb served as President from 1919 to 1924

be sure). She was a thoughtless girl, and he left her to meet his death on the field of battle. Through her tears she gazes at the next photo-graph – presumably that of a baby (again the painter has been content with a suggestion). As she looks a hand fumbles at the door. 'Thank God!' she cries as her husband staggers in and falls helpless across her knees, 'thank God our Teddy died!' So there she sits, staring disillusion-ment in the eyes, and whether she gives way to temptation, or breathes a vow to the photo-graphs, or gets him to bed before the maid comes down, or sits there forever, must be left to the imagination of the onlooker.

But the queer thing is that one wants to be her. For a moment one pretends that one sits alone, disillusioned, in pink satin. And then people in the little group of gazers begin to boast that they have known sadder cases themselves. Friends of theirs took cocaine. 'I myself as a boy for a joke – ' 'No, George – but how fearfully rash!' Everyone wished to cap that story with a better, save for one lady who, from her expression, was

acting the part of consoler, had got the poor thing to bed, undressed her, soothed her, and even spoken with considerable sharpness to that unworthy brute, unfit to be a husband, before she moved on in a pleasant glow of self-satisfaction. Every picture before which one of these little groups had gathered seemed to radiate the strange power to make the beholder more heroic and more romantic; memories of childhood, visions of possibilities, illusions of all kinds poured down upon us from the walls. In a cooler mood one might accuse the painters of some exaggeration. There must be well over ten thousand delphiniums in the Royal Academy, and not one is other than a perfect specimen.

The condition of the turf is beyond praise. The sun is exquisitely adapted to the needs of sundials. The yew hedges are irreproachable; the manor house a miracle of time-worn dignity; and as for the old man with a scythe, the girl at the well, the village donkey, the widow lady, the gipsies' caravan, the boy with a rod, each is not only the saddest, sweetest, quaintest, most picturesque, tenderest, jolliest of its kind, but has a symbolical meaning much to the credit of England. The geese are English geese, and even the polar bears, though they have not that advantage, seem, such is the persuasion of the atmosphere, to be turning to carriage rugs as we look at them.

Alfred Priest (1874–1929), *Cocaine, c.* 1919. Oil on canvas (?), 137 × 112 cm. Plate 17 from *Royal Academy Illustrated*, 1919

John Singer Sargent RA (1856–1925), *Gassed*, 1919. Oil on canvas, 231 × 611.1 cm.
Imperial War Museum, London

In the end, the sight of a war painting by Sargent, *Gassed*, making what she considers a crass bid for sympathy, drives Woolf crazy:

> . . . one had been jabbed and stabbed, slashed and sliced for close on two hours . . . From first to last each canvas had rubbed in some emotion, and what the paint failed to say the catalogue enforced in words. But Mr Sargent was the last straw. Suddenly the great rooms rang like a parrot-house with the intolerable vociferations of gaudy and brainless birds. How they shrieked and gibbered! How they danced and sidled! Honour, patriotism, chastity, wealth, success, importance, position, patronage, power – their cries rang and echoed from all quarters. 'Anywhere, anywhere, out of this world!' was the only exclamation with which one could stave off the brazen din as one fled downstairs, out of doors, round the motor-cars, beneath the disdain of the horse and its rider, and so out into the comparative sobriety of Piccadilly.

Webb should by rights, as Sidney Hutchison intimates, have been succeeded by Sir Reginald Blomfield, an interesting writer, but unfortunately an architect. The membership was against having two architects in succession, and turned instead to the painter Frank Dicksee, who was duly knighted. A painter of chivalric subjects (*The Passing of Arthur*, *The Redemption of Tannhäuser*), Dicksee was something of a Pre-Raphaelite in manner, but, as his obituary in *The Times* put it, 'without the queerness of the original group'.

Dicksee was a model for some of his notorious successors in his after-dinner denunciations of modern art. He also had to cope with what Sidney Hutchison calls 'a very ticklish problem'. Charles Sims had painted, and exhibited in 1924, a portrait of George V. The King disliked the work, and told Dicksee as much. An agreement was sought whereby Sims was paid 250 guineas and the portrait was to be destroyed, but instead Sims took the money, exhibited the painting in New York, and made arrangements for it to be shown in Canada. Hutchison tells us:

> This put the President and the Academy in a very embarrassing position and, on payment of a further 750 guineas, they took possession of it 'unreservedly'. The official records are silent as to its ultimate fate but rumour has it that the head was cut from the rest of the canvas and retained for a short while though both pieces were eventually burned to ashes in the boiler-house at the Academy under the supervision of the Treasurer and the Secretary.[6]

A curious fact about Sir William Llewellyn (1858–1941), who succeeded Dicksee in 1928, is that he must have lied about his age, and by doing so was able to retain the presidency five years beyond

the age limit. Llewellyn's term, during which the catastrophic split between the Academy and the avant-garde became manifest, was nevertheless remarkable for its major winter exhibitions, including one of the most extraordinary of such shows ever mounted.

The invention of the Old Master Exhibition proper, giving the public a chance to see masterpieces which were normally kept inaccessible in private homes, goes back to 1815 in London, the year in which the British Institution, at its rooms in Pall Mall, mounted a display of 'Pictures by Rubens, Rembrandt, Van Dyke and other artists of the Flemish and Dutch schools'. Haydon describes the reaction of the painters to this innovation:

> . . . nothing showed so much the want of noble feeling on the part of the Academy as the way in which its members received the resolution. Lawrence was looking at the Gevartius when

I was there, and as he turned round, to my wonder, his face was boiling with rage as he grated out between his teeth, 'I suppose they think we want teaching.' I met Stothard in my rounds, who said, 'this will destroy us.' 'No,' I replied, 'it will certainly rouse me.' 'Why,' said he, 'perhaps that is the right way to take it.' On the minds of the people the effect was prodigious. All classes were benefited, and so was the fame of the old masters themselves, for now their finest works were brought forth to the world from odd corners and rooms where they had never perfectly been seen.[7]

In previous years, the British Institution had put on old master shows exclusively for the use of artists, and they were well aware of the controversial nature even of their mounting a retrospective of Sir Joshua Reynolds's work in 1813. The Academicians thought 'the plan of exhibiting a collection of pictures by Sir J. Reynolds at the British Institution

Joseph Parkin Mayall (1839–1906), *Sir Frank Dicksee in His Studio,* c. 1883. Photo engraving on copper plate. Royal Academy of Arts, London. BW 14. Dicksee served as President from 1924 to 1928

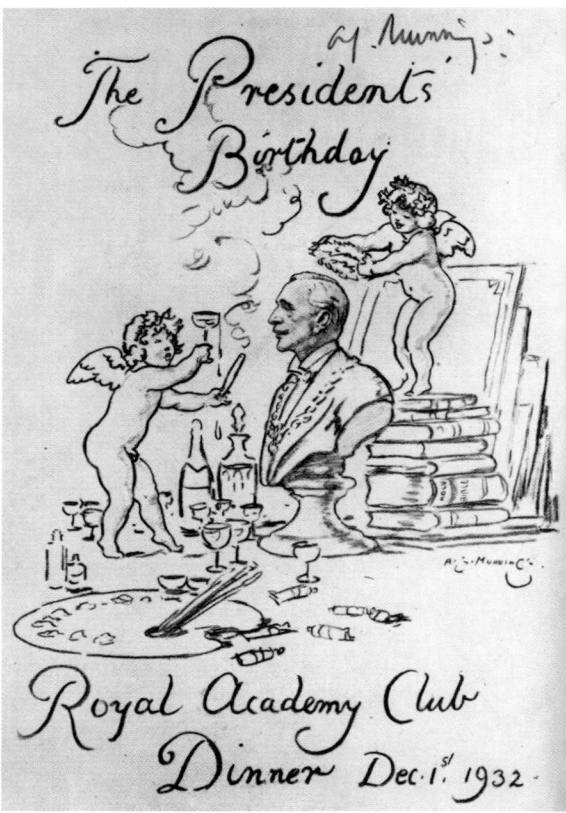

Sir Alfred Munnings PRA (1878–1959), Royal Academy Dining Club menu with sketch of Sir William Llewellyn PRA, 1932. Charcoal and pen on paper, 50.8 × 31.5 cm. Sir Alfred Munnings Art Museum, Dedham. Llewellyn served as President from 1928 to 1938

during the Exhibition of the Royal Academy invidious towards artists of the present day', and were refusing to lend any works to the show, until Lawrence persuaded them to relent.[8]

The suspicions of the Academicians were allayed over the years. In 1867 the lease on the British Institution's rooms in Pall Mall expired, and the premises were turned over to the Marlborough Club, the Prince of Wales (so Francis Haskell informs us) wanting to smoke there without the restrictions that had been imposed at White's. By now the Academicians were convinced that the old master exhibitions had been 'of so high importance to Artists, students and Amateurs, that the discontinuance of them would be most injurious to the best interests of the Arts and Artists of the day'.[9]

It was therefore decided that the new galleries at Burlington House should be host to winter exhibitions of the kind that had been mounted at the Institution over the years, but with this novelty: that the paintings in question should be chosen, not by their mainly aristocratic owners, but by a small committee of Academicians. So, in 1869, the first requests for loans went out, six weeks before the exhibition was due to open, on 2 January 1870. Receipts in the first year from tickets and catalogues were £3,000, as opposed to the £17,000 for that year's annual Exhibition, but the show was a success and established an annual precedent.

Here is Henry James, a regular visitor, opening his review of the 1877 show:

American travellers who, during the last few years, have passed through London during the midwinter months, will remember having lost a sense of gloom which at that period characterizes the British metropolis, during the hour or two that they may have spent in the rooms of the Royal Academy. This institution eight years ago established the practice of collecting during the dull season such privately-owned specimens of the great schools of painting as their possessors were willing for a time to part with. The result has been, year by year, an extraordinary testimony to the art-wealth of Great Britain, as well as to the liberality of those persons in whose hands it resides, to say nothing of the opportunity (just mentioned) for the fog-smitten wanderer to pass out of the January darkness of Piccadilly into the radiant present of Titian and Rubens. As the successive exhibitions have unfolded themselves, however, it had been remarked that there is an end to everything, even to the picture-list of English castles and Mayfair mansions, and that before very long all the Titians and Rubenses, all the Van Dycks and Gainsboroughs, will have taken their turn. The fund upon which the Royal Academy can draw is not inexhaustible.[10]

James reverts to this theme, that shows could not go on in this way, in his review of the next year's exhibition when he says that 'the stock is doubtless not nearly exhausted, but the milk-pan, if I may be allowed in such a connection so vulgar an expression, has been pretty well skimmed'.

The installation of the Exhibition of Italian Art, 1930

James supposed that, if the Academy did indeed run out of old master paintings to exhibit, they could always begin again, working their way back down the list. And to a certain extent this did happen, and the winter exhibitions continued until 1914. When they were revived in 1920, they included foreign loans; the exhibition of Spanish paintings brought masterpieces from museums in Valencia and Seville (although not from the Prado) and from Spanish private collections. The idiom of this exhibition would horrify today's audience, for it included not only loans of old masters, but also large numbers of indifferent modern Spanish paintings, many of which were for sale.

For the subsequent international loan exhibitions, arrangements were made by special committees, such as the Anglo-Swedish Society, the Anglo-Belgian Union, and a Dutch exhibition put on by the Anglo-Batavian Society. The shows were considered good publicity for the countries in question, and governments were involved in one way or another.

The most spectacular of these was the Italian Exhibition, which was promoted by Lady Chamberlain, wife of the Conservative foreign minister, Sir Austen Chamberlain. This was a highly political event, seen both by Lady Chamberlain and by Mussolini as a means of furthering the cause of Italy and Fascism. Everything arrived by one ship, the *Leonardo da Vinci*, which docked in December 1929 at the Port of London. Haskell does not exaggerate when he says that it discharged 'perhaps the most remarkable cargo ever to be brought into England'. There were about 1,000 exhibits, and no punches were pulled: Botticelli's *Birth of Venus*, Giorgione's *La Tempesta*, Piero della Francesca's *Duke and Duchess of Urbino*, Raphael's *La Donna Velata*, Donatello's *David*... The list goes on and on.

Kenneth Clark describes the Academicians of the day, rather like their forebears in 1815, as 'hostile to what were known as Old Masters, rightly supposing that if the public took a fancy to that kind of painting their own degraded realism would be at a discount'.

He describes his old friend Sir David Murray (then in his eighties) 'leading round a group of colleagues and saying about the Titians, "They're really no sae bad. Ye can learn a lot from these old fellies!" His friends grunted in disapproval.' Sir William Llewellyn is seen to look for a minute at Giorgione's *Tempesta* before saying – sincerely, Clark insists – 'We would have rejected that if it had come up before our hanging committee.'[11]

By any standards, the attendance of 600,000 was enormous. Sidney Hutchison tells us that the Academy received 17.5 per cent of the profits, over £6,000.

In 1935, a scandal broke which underlined the rift between the Academy and the avant-garde, and which is behind many of the later refusals of artists to have any dealings with the establishment at Burlington House. The Epstein affair had begun long before Llewellyn's presidency, in 1907, when the young Jacob Epstein was commissioned to provide figures to be incorporated in Charles Holden's British Medical Association building in the Strand (now Zimbabwe House on the corner of Agar Street). The Association had suggested that these figures might be famous medical men, but Epstein produced nude men and women 'in their various stages from birth to old age'.

As the scaffolding was removed, protests began, and the *Evening Standard* started a campaign, alerting the police to the question of obscenity. This was potentially a very serious matter. Notable figures came to Epstein's support: Charles Holmes, then Slade Professor of Fine Art at Oxford (and later Director of the National Gallery), the artists and Academicians Charles Ricketts and Charles Shannon, the poet Laurence Binyon, and, speaking in his private capacity, the Director of the National Gallery, Charles Holroyd. The British Medical Association itself decided to allow the work to go ahead, and the statues remained in place for more than a quarter of a century – the subject of many a joke and music-hall song, but unharmed nevertheless.

The situation changed at once in 1935 when the Southern Rhodesian Government took over the building and announced in the press that the statues would be removed because the new occupants found them undesirable. Epstein protested at such an act of philistinism, and was answered by a member of the firm of the Academician Sir Herbert Baker (the man who vandalised Soane's Bank of England). Baker was now architect to Southern Rhodesia House. His subordinate wrote:

> The position has been misunderstood. What we feel is that the figures, which were all very well, and indeed very appropriate, round the British Medical Association building, are quite out of place as decoration to a Government Office. Anatomy for the British Medical Association, yes. But do these figures indicate the produce of Southern Rhodesia? No. It is a question of what is appropriate.[12]

Few on either side of the argument would have been convinced by this display of mock innocence. Once again the great and the good wrote to the press to display their support for Epstein: Sir Eric Maclagan, Director of the Victoria and Albert Museum, the

Charles Holden's British Medical Association building in the Strand, showing sculpted figures by Sir Jacob Epstein (1880–1959)

Detail of the façade of the British Medical Association building, showing Epstein's *Maternity, Man* and *New-Born* in Portland stone, 1908

painter Sickert, Kenneth Clark, the Earl of Crawford (who later campaigned to save the Leonardo Cartoon) and several others. But the *Evening Standard* put out a story that the President of the Royal Academy had been approached by Maclagan and had refused to sign a joint letter.

It was this refusal that prompted Sickert's resignation from the Academy, and the letter quoted in the introduction to this book. Llewellyn's line was that he had been asked to sign in a personal capacity 'but felt unable to do so without seeming to commit the Academy as a whole to its support'. Again, no one would have been taken in by this disingenuousness. If the Director of the National Gallery had been able to write to the press in his personal capacity, what could have held back Llewellyn? Anyway, Sickert answered the point at the time in the *Daily Telegraph*:

> The Academy ought to have summoned an emergency meeting, and sent a request asking to be allowed to make a representation to the King on the subject. But they did not do so. It is not the President's fault. He sticks to his ship and does what he has got to do. But I am not an official. I am very fond of him and all my colleagues, who have been most extraordinarily kind to me, but sloppy sentimentality does not enter into it.

They are in a sense Public Trustees, as a dignified representative body of art, and as such should have taken up the matter.

And a lethal letter appeared in *The Times*, from the President of the Royal Institute of British Architects, H. S. Goodhart-Rendel, attacking Llewellyn:

> I cannot imagine that Sir William was requested to sign the letter on behalf of the Royal Academy, any more than Mr Clark was requested to sign it on behalf of the Trustees of the National Gallery, or Professor [W. G.] Constable on behalf of Cambridge University, or Lord Crawford on behalf of the House of Lords. Much, however, as the signatories of that letter may regret that Sir William's name could not appear with ours, his delicacy throws into relief an inaction on the part of the Royal Academy that it would be discourteous not to consider surprising. The proposal against which protest is being made is not that of taking loose statues out of niches, but of cutting away integral sculpture from an architectural design by one whom many of us consider to be the first English architect of our day. Against such needless mutilation of fine architecture the Royal Academy, which includes architects in its membership, might reasonably be expected to make some public appeal.[13]

David Low (1891–1963), 'Epstein Sensation', 1935. First published in the *Evening Standard*, 25 May 1935. Centre for the Study of Cartoons and Caricature, University of Kent

David Low (1891–1963), 'Falling Epsteins in the Strand', 1937. First published in the *Evening Standard*, 10 July 1937. Centre for the Study of Cartoons and Caricature, University of Kent

It was the failure of the Academy, over an extended period, to exercise its influence, that led to the widespread disgust among artists of the period, rather than merely Llewellyn's interpretation of the proprieties of signing a letter. For the whole affair took place over three decades, and not a finger was lifted by the Academicians.

In 1937, after the coronation of George VI, when the decorations along the Strand were being taken down, a head of one of the figures was said to have fallen and hit or narrowly missed a woman. Epstein was not allowed to examine the state of his sculptures. Instead, they were chiselled back to their present mutilated condition, and rendered inoffensive to the taste of the Southern Rhodesian authorities. Among the letters to the press was this from Edwin Lutyens:

> . . . Nothing is more distressing to an artist than that his work should collapse, even though he may be in no way responsible for the obvious cause of failure.
>
> In the case of a living artist the loss is not irreparable; and in that he is still alive and in the full vigour of work and imagination, and with the faith he has in himself, he surely knows that

within his wider powers he can yet achieve better than he did years ago. Real tragedy occurs when the work of a dead genius perishes and the spark that created it is no longer existent. Such loss is irreparable. . .[14]

The note of regret was entirely hypocritical. Lutyens had no high opinion of Epstein's vigour and powers, and he never offered him a single commission. Indeed, after signing an especially large tax bill in 1924, he quipped, 'I felt as though I had been modelled by Epstein.' A year after penning this casuistry, Lutyens was elected President of the Royal Academy.

An architect much valued and remembered today for his country houses and his collaborations with the garden designer Gertrude Jekyll, Lutyens came late to the presidency – and indeed to the Academy itself. His father, Charles Lutyens, had been an obsessive believer in the Venetian Secret, about which he had written a novel. The theory propounded in the novel was that the secret consisted of a mathematical formula, which Titian had discovered from the Greeks, and which Reynolds had once known. Using this formula, the hero of the novel produces 'a brilliant portrait in only a few

Sir Alfred Munnings PRA (1878–1959), *Dinner to Sir Edwin Lutyens* PRA. The Arts Club, 30 January 1939. Royal Academy of Arts, London. 04/791. Lutyens served as President from 1938 to 1944

and sometime enemy, Sir Herbert Baker. Lutyens was no longer well, and relied heavily for guidance on the Secretary, Walter Lamb: 'The Lamb is my shepherd, I shall not want,' he would say. But he did something to mend the rift that had appeared under Llewellyn between artists and the Academy. He got Augustus John to reapply for election, and, when Llewellyn objected that re-election was against the rules, Lutyens secretly enlisted the support of the King, George VI, quoting the precedent of George III's intervention over the re-election of Reynolds. Lutyens records that this made Llewellyn 'perfectly jibbery furious'.[16]

Unfortunately the main project of Lutyens's wartime presidency, greeted with dismay in its day, was the Royal Academy Planning Committee's Interim Report, printed by *Country Life* under the title *London Replanned*. The idea was to profit from the opportunity provided by the recent German air-raids to rebuild the centre of London. In a way, the presentation of this project makes it look more even more terrifying than it really was. For instance, in the drawing of 'Piccadilly Circus as it might be', the architecture of all the streets shown is based (for purposes of illustration only) on that of commercial Regent Street. Nevertheless one cannot help noticing that, in the interest of traffic flow around Eros, Shaftesbury Avenue and the whole of Soho seem to have been destroyed.

brush strokes' but none of the critics, and no one at the Royal Academy, believes him, and his painting is 'condemned as too dark, like the old paintings in the National Gallery'.[15]

Fact and fiction became intertwined when Charles Lutyens did indeed, according to Jane Ridley, offer the Royal Academy his secret, and had it rejected. The bitterness caused by this episode (no doubt long forgotten at the Academy itself) was apparently thought by some to have delayed his son's election. Edwin himself believed, by contrast, that he could never have been made a member while Poynter was President. It was Webb who eventually sponsored him as an Associate in 1913. Full membership followed in 1920.

In 1938, at the age of 69, Lutyens was elected President, by the crucial vote of his old colleague

Zhuang Shangyan with Sir Walter Lamb (1882–1961), Secretary of the Royal Academy from 1913 to 1951, taking delivery of loans for the Chinese Exhibition at Burlington House, 1935. Black and white silver gelatin print, 19.3 × 24.6 cm. Royal Academy of Arts, London. 05/3614

Drawn by J. D. M. Harvey.

COVENT GARDEN REPLANNED AS A MUSIC AND DRAMATIC CENTRE

Drawn by J. D. M. Harvey.

APPROACH TO THE BRITISH MUSEUM FROM THE SOUTH, SHOWING ST. GEORGE'S CHURCH

— 11 —

'Covent Garden Replanned as a Music and Dramatic Centre' and 'Approach to the British Museum from the South, Showing St George's Church', from *London Replanned*, Country Life, 1942. Royal Academy of Arts, London

A zippy road bridge leaps across the Thames, obliterating Charing Cross Station and bringing traffic up to a vast roundabout behind St Martin-in-the-Fields, where underground garages, entered through archways, provide 'an architectural feature'. 'Covent Garden Replanned as a Music and Dramatic Centre' knocks down the existing opera house as well as almost everything else, to replace it with something resembling a reconstruction of Rome as it might have looked under Caracalla. On the same page, a tremendous vista tells us that everything south of the British Museum, apart from St George's Bloomsbury, has been flattened, as has everything south of the Victoria and Albert Museum (Thurloe Square, for instance, is a thing of the past). In compensation there are some surreal reduplications at Hyde Park Corner – two Apsley Houses and two Ionic Screens.[17] Osbert Lancaster wrote in the *Observer* that under this scheme London 'will not be unlike what the new Nuremberg might have been had the Führer enjoyed the inestimable advantage of the advice and guidance of the late Sir Aston Webb'. And this was putting it politely.

As Lutyens's health began to fade in late 1943, a move was made to persuade Alfred Munnings to stand as President. He deliberated the matter, on horseback on Exmoor, along the following lines:

> I thought of Sir Francis Grant, P.R.A. He hunted for the Melton in the Shires with famous packs, and painted Queen Victoria in her carriage at a meet of the Buckhounds, famous sportsmen like Assheton Smith, Mr Villeboi and many more. He painted large full-lengths of dukes, duchesses, earls and countesses in England, Scotland and Ireland, and yet had time for Presidential duties. His was a major case; mine was a minor.[18]

Munnings decided that, if Grant had been able to combine hunting and painting with the presidency, then so should he.

Lutyens died on New Year's Day 1944. Augustus John had also been approached for the presidency. He and Munnings were exact contemporaries (both were born in 1878). John wrote to Philip Connard, a fellow Academician:

> I would of course like to do my best for the R.A., and would be fully conscious of the honour of such a position but am only doubtful of my ability to cope with the duties, official and social, it would entail. Here's the snag. Apart from this, as P.R.A. is only an extension of R.A. I would have no logical reason to refuse.[19]

This kind of reluctance would easily have been communicated to the members, and would naturally have told against him. But still, for an outsider and sometime critic of the Academy, he had a strong following. In the first ballot that ensued, Munnings led with 17 votes to eight for John. On the second, he beat John by 24 to 17. And so began a truly disastrous presidency.

Mythology has it that Munnings was simply a worthless artist who used his position to wage a war against modern painting. But Munnings had talent, and one can see from the illustrations to the first volume of his autobiography just where that talent lay. He was, as a young man, a gifted commercial artist, a designer of posters and advertising material – an illustrator, drawing heavily on William Nicholson and Randolph Caldecott. He had been apprenticed to a lithographic firm in Norwich at the age of fourteen, and attended evening classes at the Norwich School of Art. His advertisements for Caley's Crackers and Waverley Cycles are good fun, though indistinguishable from the rest of the commercial art of the period.[20] His drawings show that he had it in him to be an admirable book illustrator, within the conventions of the day, or a *Punch* cartoonist, when such cartoons required elaborate draughtsmanship.

His paintings reveal that success came rather easily to him, rather early, and was then swiftly eroded with repetition. At no point, not even after time spent as a war artist in France in 1918, does he seem to undergo the *crise de nerfs* that might be a prelude to something truly individual and interesting. Instead, he hits on a formula which happily combines his obsessive interest in horses with his slightly less obsessive desire to be an artist. That the formula has proved a resounding commercial success, decades after his death in 1959, shows what

Munnings's advertisement for Waverley Cycles. Sir Alfred Munnings Art Museum, Dedham. The design won three guineas in a competition set by *The Cyclist*, 1895. Munnings served as President from 1944 to 1949

Sir Alfred Munnings PRA (1878–1959), *Kilkenny Horse Fair*, 1922. Oil on canvas, 64.3 × 76.9 cm. Royal Academy of Arts, London. Diploma Work, accepted in 1925. 03/273

outstanding commercial foresight Munnings had, and what professionalism. But it says nothing one way or the other about the quality of his art. As we have seen in the extract from his autobiography above, he had settled for a position as a minor version of Sir Francis Grant.

Knighted at once and admitted to the Athenaeum Club (where the President of the Royal Academy was an *ex-officio* member of the Committee), Munnings was in his element. His happiest hours, he wrote, were spent surrounded by guests and friends, at dinner in the Academy's General Assembly Room.

This room, with its painted ceiling, its pictures – one of which is a large Constable landscape, insured for forty thousand pounds – is an ideal place for a dinner-party. I always preferred to sit on the side of the table away from the fire and facing the mantelpiece. Behind me was a choice specimen of the Sheraton period – a large, unblemished sideboard of the peerless age of furniture design. Each of us sat in a mahogany armchair – a pattern known as Nelson chairs. My delight was to go in before the guests arrived and see that Hubbocks had put the pink or crimson tulips in nice tight bunches in the silver bowls; to look at and admire the Georgian silver, the candlesticks, the salt-cellars, and all the objects that go to make a dinner-table look as it should. Since the days of Reynolds, each man on becoming a member has presented to the Academy a piece of silver with his name and the date engraved upon it. There is a large set of silver dessert plates, all in the same pattern, with members' names engraved upon them, and when the dessert was served, and the port went round, it was a pleasant diversion for us to look at our plates and to see who had given it . . . One could take up a tall Georgian candlestick and see the long-dead donor's name engraved on the base. I am sure that members who sat at such dinners, gazing on a piece of silver, have indulged for a moment in retrospective thought of what the man who gave it was like. Their pictures were known, but they were not. And so, with the port going round, the night passed on.[21]

Round and round and round went the port –
at the Academy, at the Athenaeum, at the Other
Club, which met at the Savoy and where Munnings
would have made the acquaintance of Sir Winston
Churchill (he was never, we are told by Churchill's
daughter, Mary Soames, an intimate friend). We get
a glimpse of the Other Club in October 1939 in one
of Munnings's letters to his wife:

> Dined at the Other Club – good dinner. All as
> usual. Everyone there. Winston was clapped
> when he arrived. Lord Gort was given a terrific
> send-off to France. H. G. Wells having a go at
> the politicians, telling them they didn't think
> ahead and so on; he foresees great upheavals and
> Bolshevism in Germany if Hitler is done with.
> Anyhow, it was a great evening.[22]

In 1947 Munnings persuaded Churchill to
submit some paintings to the Academy Exhibition.

Churchill asked Sir Edward Marsh to help him
choose two (one of which had already won an
amateur competition in 1925, when the judges had
been Sir Joseph Duveen, Kenneth Clark and the
portrait painter Oswald Birley).[23] The paintings were
submitted under the name of David Winter, but
Munnings was in on the secret. When they were
approved by the Selection Committee, Munnings
'could hardly contain himself, waved his arms and
exploded, "Good job you passed them – they're
Churchill's."'[24]

Churchill was elected Honorary Academician
Extraordinary the next year, and from then on
exhibited every year until his death in 1965. One can
see that to Munnings such an association between
the Academy and the greatest British man of his
century would have represented an extraordinary
triumph, and this was anyway one of innumerable
public honours (including the Nobel Prize for

A silver sauceboat made by
Parker & Wakelin, 1764–65.
Royal Academy of Arts, London.
Presented by Nathaniel Dance RA.
03/5251

Sir Alfred Munnings PRA (1878–1959), *Sketch of Sir Winston Churchill at Dinner*, c. 1949. Sir Alfred Munnings Art Museum, Dedham

band to play after the toast of 'The Forces of the Crown', that time-honoured song 'The Boys of the Old Brigade', and it happened as I arranged – all of us standing with glasses filled, many of us singing with the band:

> Steadily, shoulder to shoulder,
> Steadily, blade by blade,
> Ready and strong,
> Marching along,
> Like the Boys of the Old Brigade.

I am sure that Lord Montgomery appreciated that turn before rising to his feet to respond.

Shaking hands with the guests as they arrived, and joining them in sherry, and with enough champagne at dinner, I threw off all cares and responsibilities as to what I was going to say, trusting to a few notes and items which I had memorised.

Munnings was drunk – not just mellow, or tiddly, but unmistakably, rip-roaringly drunk. And not just drunk but both bitter and demob-happy. What became famous as his attack on modern art – on Picasso and Matisse in particular – was also an attack on elements within the Academy itself, some of whom noisily interrupted the speech as it progressed.

Literature) received by Churchill in the aftermath of the war. There was also, of course, the long tradition of ceremonial associated with the Royal Academy's Annual Dinners, in which politicians, the military and the Church were all represented. Nevertheless the association between Churchill and Munnings came to look like a parody of all that, to Churchill's evident annoyance and embarrassment.

According to Munnings, it was Churchill who, in 1947, said, 'You must start those famous dinners again. They mean so much to the Academy.' 'All right,' said Munnings: 'If you come and make a speech, we'll have the dinner.' 'Of course,' said Churchill, 'Let's have a rag.'

> Those magic words were enough. A rag – and a good party – that was the thing! Not a heavy, solemn affair; that was why I arranged before-hand with the Bandmaster of the Royal Artillery

Sir Winston Churchill HON. RA EXTRAORDINARY (1874–1965), *Cap d'Ail, Alpes Maritimes, from La Capponcina*, September 1952. Oil on canvas, 63.6 × 76.5 cm. Royal Academy of Arts, London. Inv. C489. Diploma Work, accepted in 1960

Munnings was demob-happy because he had already decided to resign from the presidency. Why he was bitter is more of a matter for speculation. According to his own story, he had no reason for bitterness, for he had achieved all that he professedly wanted. But he had not even begun to secure the highest critical approbation, and this infects his tone – the accusatory, defensive tone that, for far too long, was to characterise the Academy itself in its dealings with the art world of the day.

Munnings clearly knew he was mocked within the Academy and the Schools, and this was to provide his point of departure. 'I find myself', he says to the dinner guests,

> a President of a body of men who are what I call shilly-shallying. They feel that there is something in this so-called modern art. You will say, I am getting right away into the subject. Well, I myself would rather have – excuse me, my Lord Archbishop – a damned bad failure, a bad, muddy old picture where somebody has tried to do something, to set down what they have seen, than all this affected juggling, this following of what – shall we call it of the school of Paris? (I trust the French Ambassador is not here tonight.) Not so long ago I spoke in this room to the students, and in my poor discourse I said to these boys and girls: they are not boys and girls – more than half of them are grown up, and they are receiving all sorts of gratuities from the Government – for what? To learn Art and become what? Not artists . . . I said to those students, 'If you paint a tree – for God's sake try and make it look like a tree, and if you paint a sky, try and make it look like a sky. . .'

Now Munnings's mind begins to wander. He tells the audience of his recent motor trips from Dedham to Newmarket and back. 'What skies there were! . . . And still, in spite of all those men who have painted skies in the past, we should be painting skies still *better*.' He attacks the foolish young men writing in the Press. He is right! he assures us. He has the Lord Mayor on his side, and *all* the Aldermen and *all* the City Companies. 'There is the Master of a City Company here to-night, the Master of the Mercers' Company – Lord Selbourne – and I am sure he is with me; and on my left I have the famous newly elected extraordinary member of the Academy – Winston Churchill. He too is with me because. . .'

At this point, Munnings, in his memoirs, refrains from repeating the rest of his sentence, although 'it caused the loudest "hear, hears" and the most prolonged laughter of the evening'. What he said was that he had been walking down the street with Churchill when Churchill had said to him:

'Alfred if you met Picasso coming down the street would you join with me in kicking his [here Munnings hesitates comically on the word 'arse' before continuing] something something something. I said, "Yes, sir! I would!"' But this was all untrue – or so Churchill wrote to Munnings in a latter dated 8 May 1949:

> I . . . heard with surprise your statement that we were walking up the street together when I spoke to you about kicking Picasso if we met him. I do not think we have ever walked up a street together, and anyhow this is not the sort of statement that should be attributed to me.

> I know you speak on the impulse of the moment, but I protest none-the-less against these utterances.[25]

Mary Soames tartly comments that 'Winston minded very much that such statements should be attributed to him – they would have been quite out of character, for he was both modest about his own work and respectful of that of others, whether famous or obscure, and whether he admired it or not'.

But in Munnings's inebriated fancy, it would be enough to get the Lord Mayor and the Aldermen of London, with Churchill and if possible the Archbishop of Canterbury, on his side to bring about the defeat of the highbrows (including Anthony

The Royal Academy's Annual Dinner, 1949

Blunt, who was in the audience, and was attacked for allegedly praising Picasso at the expense of Reynolds), the London County Council (guilty of exhibiting modern sculpture in Battersea Park), the Tate (for showing Matisse) and anyone else he could think of. As he says in his memoirs, 'If a suave, oily voice heard on the B.B.C. denotes culture, then I do not want to be reckoned as cultured.'[26]

As it happened, although Munnings claimed this had slipped his mind, the speeches were being broadcast live by the BBC (a recording survives). The next day, cables poured in from all around the world, and then began 'a vast, never-ending flow of letters which, if printed, would fill a volume. At my wish a canvas bagful was carried up to the Council Room, and there, alone in my glory, I sat for hours reading them until I was late – almost too late – for dinner at the Athenaeum'.

Only four of the letters (according to Munnings himself) attacked the speech: 'You were drunk, and disgustingly so, and made a complete fool of yourself.' The rest apparently were supportive: he reproduces almost twenty pages of them, including one from Newmarket Urban District Council. Typical of the tone of the shorter ones is this: 'Bravo! For sheer, trenchant, eighteenth-century speaking your effort tonight was magnificent. You must have pained the lily-white B.B.C. boys considerably.'

The notion that there was something healthily eighteenth-century about such postprandial ravings is very typical of the age, and of the crustier Academicians' self-image. They would not have compared themselves to Victorians, for there was still a strong enough sense of the uprightness and Olympian self-confidence of the Victorians. One cannot imagine a Leighton, or a Poynter, writing an autobiography which proudly reproduced (as Munnings did) letters accusing them of being drunk. One can hardly imagine them giving the slightest grounds for the accusation in the first place. But if you go right back to Hogarth's day, to the Rosa-Coronians and their great punchbowls, to *A Midnight Modern Conversation* (see p. 51), to Francis Hayman prostrate in the kennel – then you can indeed see what Munnings and his admirers might have had in mind for mentors. They would have

Sir Alfred Munnings PRA (1878–1959), 'The Punchbowl. The Origin of the Recipe Used at the Swan Hotel, Harleston', 1934. Pencil on paper, 15.2 × 12.7 cm. Sir Alfred Munnings Art Museum, Dedham

been happy to revert to academic prehistory, and that was what they were setting about – turning the Academy back into a club.

Something about this kind of sneering at high culture reminds us also that the Academy in its mid-twentieth-century nadir was dominated by people of rather modest educational attainments. Throughout this story, it would be hard to find a single artist who had been to university. Indeed, nothing on offer in the universities of the time had any direct bearing on the education of artists.

Nevertheless there were many highly educated artists, whether they had pursued their studies in Europe, or had sat up over their books at night (like poor Haydon with his Greek texts), or had simply listened to educated conversation: they valued learning. Neither in the eighteenth nor in the nineteenth century does one catch what comes across unmistakably from the Academicians of this period: a sense of educational inferiority, a hostility to learning elevated to a form of minor crusade.

14 Giants Who Didn't Come Off: Kelly, Richardson, Wheeler

Kenneth Clark tells us how, in the first years of the Second World War, he helped to start a scheme to finance war artists. He had been inspired, he tells us, by seeing the Canadian War Artists' exhibition at the Royal Academy in 1917, which had introduced him to Vorticism.[1] Now, with the help of a resourceful civil servant, he was able to channel money in the direction of some artists. His undisclosed aim was to keep them at work on any pretext, and, as far as possible, to prevent them from being killed.

> As this was the first time the government had patronised modern artists on a large scale (incredible as it now seems, the Tate Gallery had no purchase grant of its own), it was important to form a committee that would be more or less acceptable to conservatives and yet be in sympathy with the left. In Royal Academy circles I was then considered a dangerous revolutionary, and Gerald Kelly had been deputed to call on me at the National Gallery to ask me if I would stop buying the work of young artists. I pointed out to him that two of my young friends had recently calculated that if they shared a studio they could live on £85 a year. His own income in the preceding year was nearer £80,000, and his only problem was whether to lay down Château Lafitte or buy Château Batailly that was ready for drinking.

Leonardo da Vinci (1452–1519), *The Virgin and Child with St Anne and St John the Baptist, c.* 1499–1500 (detail)

To tell the truth, I lost my temper, which I have done only three times in my life. But he forgave me, and we became friends.[2]

There seems something peculiarly obnoxious in the Academy sending an emissary to try to cut out young artists from the patronage offered by the war artists' scheme. Clark had no particular reason to lie about this. He liked Kelly, and liked his work well enough to have secured for him the commission for

Sir Kenneth Clark (1903–1983), Director of the National Gallery, inspects Cranach's *Adam and Eve* (The Royal Collection) for bomb damage, 20 October 1942

the state portraits of the King and Queen on which Kelly was working at Windsor at the time.

Clark liked Kelly, among other reasons, because 'it was really thrilling to talk to someone who had not only known Rodin and Monet (even I could have done that) but who had penetrated into the studio of Degas and been treated cordially. He must have been a charming young man.'[3]

Late in life, as President of the Royal Academy, Kelly attracted the attention of the new medium of cultural television. He rose briefly to the status of national celebrity, for he was 'naughty' – he used what was considered salty language when put before the camera. He said in front of a Rembrandt self-portrait, 'My dear fellow, that's a bloody work of genius.' And again, in front of *Man in Armour*: 'I just go all goo-goo when I stand in front of it. It's one of the finest pictures in the world. In fact, it's a bloody marvel.' And, after looking at a tulip in

another Dutch painting, 'Look at that confounded drop of water. Looks as if it might fall off any moment. That's sheer damned skill.'[4] It was, for 1953, utterly daring and unconventional, and there was a queue at the 'Dutch Pictures' exhibition the next day.

Having found such a star, the BBC went on to record some of Kelly's reminiscences of the great artists he had known. He had gone as a young man to study in Paris in 1901, and he seems to have been always aware of his luck. Given a chance by Paul Durand-Ruel to visit Monet at Giverny, he spent days reading up about gardening, to help him through a conversation with the artist. However, one look at Giverny was enough to convince him that

> The joke really was on me. It wasn't a garden that required any scholarship or knowledge. It was nice and large and covered with rambling crimson

The state portraits of King George VI and Queen Elizabeth by **Sir Gerald Kelly PRA** (1879–1972) in the Summer Exhibition, 1945. Kelly served as President from 1949 to 1954

roses which, you know, you get practically speaking in any suburban garden all over England. And there was a little piece of water where there were some common or garden water lilies, and there were some iris, and all my carefully acquired erudition was worth exactly nothing.

Monet said something very true to Kelly, which is that a grey day is perfect for looking at flowers: 'The sun is the ruination of flowers, they look so bright you can't see them, but on a nice grey day like this you can really enjoy the flowers, so come along.' So then, says Kelly, 'I started praying to Almighty God, and I said, "Send the sun, let the sun come out", and do you know, in a very short time it did, and Monet said, "Here's the sun, let's go back to the studio."' There Kelly 'was very happy and he showed me a lot of pictures. Gosh, some of them were beauty! A great many of them I didn't awfully like. It was when he was in one of those periods, well never mind, it doesn't matter.'[5]

It was one of those periods, we surmise, when Monet was painting his common or garden water lilies.

Kelly's reminiscences of Degas proved disappointing to the television team. Kelly had visited Degas in Paris, at his house in the Rue Victor-Massé, he said, two or three times a year for several years, but couldn't remember one visit from another. On the first occasion,

> Degas pulled out one of his portfolios at random, and it contained about forty drawings of a woman scratching her armpit. 'They were always frightfully interesting,' said Kelly loyally, 'because you *saw* the scratching . . . I didn't think that meeting Degas would be just one long conversation all about a woman scratching her armpit . . . But that is what it really turned out to be.'[6]

Kelly came to think of Degas as 'a nice little man'.

Cézanne, too, turned out to be 'a little man', and subtly disappointing in the way the other painters were:

> He gave the awful impression he was frightened, he thought we had come to tar and feather him, or something like that. And anyway he took us into the studio, and had I known then how

Joseph Lee (1901–1975), 'London Laughs. Char's Commentary: "...and as I 'eard Sir Gerald say the other day, one can only be lost in wonder at the ruddy blush so skilfully depicted on the maiden's modest cheek"'. First published in the *Evening News*, 16 January 1953. Centre for the Study of Cartoons and Caricature, University of Kent

valuable the pictures were going to prove . . . and had I known what an important figure Cézanne was going to make in the world's history, I should have listened with more attention than I did. . . He showed us what I thought was a perfectly beastly picture . . . a huge thing . . . women rather like trees, and the trees rather like women. Very large, very miserable, and sold for a fabulous sum of money.

. . .Well, they went on talking, and obviously the old man didn't want us at all, and I went away into the corner, and saw a little picture which I took up into my hands . . . it represented about three apples, it was so thickly painted that

Sir Gerald Kelly PRA (1879–1972), *Jane XXX*, 1930. Oil on canvas, 75 × 63.5 cm. Royal Academy of Arts, London. Diploma Work, accepted in 1930. 03/253

it was like putty. I mean, absolutely loaded with paint, and in the middle of each apple there was a little hole, and round each apple there was a line traced with compasses. He had obviously dug one end of the compasses into the middle of the apple and winkled it round each a bit, and so there was a kind of little ditch in each... The apples were very red on one side, and one was a beautiful green. It was a lovely little picture. Oh, what a fool I was! I think he would probably have let me have it. Anyhow, he came up to me and said quite quietly, 'You like that?' He spoke with a very strong accent, he smelt very strongly of garlic. I don't think he was very clean in his person. But of course, I was young

and I didn't care a damn about that, and I said, 'Yes, master, I like that.' And then he did say – and this I know he said – 'It is very difficult to make apples round' ... I began to say a long complicated sentence of how the English apples were round, the French apples were very inferior, were polyhedral. I got as far as 'polyhedral' and that started the dear old man off about spheres – he talked about cones and spheres, and I was rather bored, and I went on looking at the picture and he sort of faded away ... What a wonderful story I could tell if he had expressed himself in a most amazing manner, and I could have quoted him...

And Kelly sums it all up in a memorable phrase: 'He was a giant, and for me, alas, he was a giant who didn't come off...'

Kelly was a society portraitist. His old friend Somerset Maugham sat for him eighteen times (an astonishing fifteen of the resultant portraits are at the University of Texas), and posed with top hat and cane in front of a Chinese screen for an amusing study entitled *The Jester*, in which Maugham looks as if he is about to get up and embark on a tap-dance routine in the manner of Jack Buchanan. Like Maugham, Kelly had been something of an intelligence agent during the First World War, and Maugham's *Ashenden* stories, dedicated to Kelly, are supposedly based in part on Kelly's experiences. ('Do you remember the story of "The Hairless Mexican"? That happened to me.'[7]) He is Lawson in *Of Human Bondage*, and his intervention in *The Moon and Sixpence* was to inform Maugham helpfully that the painter Stroeve could not possibly slash a canvas with a palette knife (it wouldn't cut), but that he could do so with a scraper. Kelly's Diploma Work, *Jane xxx*, is one of his many portraits of his wife (the xxx referring to 1930, the year of its first exhibition at the Academy).

Munnings apparently became rapidly disillusioned with Kelly as his successor as president. According to Hudson, he accepted that Kelly would do everything he could to keep Augustus John happy. What he found difficult to bear was the reinstatement in 1950 of Stanley Spencer. In 1935, the same year as the Epstein scandal, the Hanging Committee had rejected two of Spencer's submissions, *The Dustman, or The Lovers* (Laing Art Gallery, Newcastle-upon-Tyne) and *St Francis and the Birds* (Tate). The latter was thought by Academicians to be an assault on the reputation of St Francis. Spencer, who had become an Associate in 1932, resigned, telling a reporter, 'I never wanted to become an Associate. I do not approve of the Academy, but I thought the best way to change it was to join it.'[8] Munnings had opposed Spencer in 1935. In 1950 he did so again. Kelly answered Munnings's protest: 'I don't think Spencer will do the Academy any harm. He is almost uncannily skilful and a lovely craftsman.' Munnings objected to the Chantrey Bequest's purchase of one of

Spencer's paintings, calling the figures 'barrel-like human beings, stark, pseudo-comic; hands like bunches of bananas'.

Then Munnings did something extraordinary even by his standards. In the autumn of 1950, while Kelly was in America, Munnings, according to Maurice Collis,

> noticed in some dealer's gallery a painting by Spencer which he considered obscene. He inquired how the dealer had come by it and traced it back to Zwemmer who had bought it about the time when ... he also bought a lot of Spencer's drawings. Sir Alfred's next move was to get the painting and some of the more improper drawings on approval. When they were delivered to him, he had them photographed, showed the photographs to the police, and urged prosecution under the obscenity laws.[9]

According to Hudson's version, Munnings showed his photographs to the Dean of Westminster and to the police inspector at Newmarket. Collis tells us that the police began inquiries and that the Director of Public Prosecutions was asked to sanction a prosecution. The story broke in the press. At this point Kelly returned from America, went to see the DPP and convinced him that the case should be dropped. It would have been unlikely to succeed, says Collis, since there was no evidence that the works had been exhibited. Nevertheless, the Academy was shocked, and on 31 October, to its credit, recorded the following stiff minute:

> The President read extracts from newspapers dated between 1st and 21st October showing that Sir Alfred Munnings had sought to defame the character and art of Mr Stanley Spencer by showing certain unexhibited paintings to members of a London club and the police. It was agreed that it was highly reprehensible that a Member of the Academy should attack another in this way, and that the President would personally assure Mr Spencer of the Council's regret for the occurrence and their readiness to assist him if further attacks of the kind were made on him.[10]

Spencer was grateful to Kelly for the efforts made on his behalf, and by the end of 1950 was able to tell

him that he had received 'no material damage'. However, Collis tells us that

> Munnings's attack was such a shock that his papers contain no mention of it, a most unusual course for a man so prone to complain about people. He had had a fright and withdrew quietly into himself. It was from this date that he took the precaution to keep a painting of Hilda and himself called *Toasting* under the bed in the spare room and removed from the First Scrapbook two lavatory compositions. Dangerous people were evidently prowling about.[11]

Kelly had his own campaigns, as we have seen. He led a group of artists in a letter to *The Times* (30 October 1946) protesting against the cleaning of paintings returned to the National Gallery, recently reopened after the war, including Rubens's *Chapeau de Paille* and the Velázquez portrait of Philip IV. Clark told Hudson that he was on Kelly's side in this matter:

> I remember well Kelly's intervention on the cleaning of the Rubens *Chapeau de Paille* and *Philip IV when Old* and in fact I was on his side. I think that both pictures have now settled down, but the Philip has never quite recovered its old mystery.[12]

Kelly's successor, voted into the presidency at the age of 74, and granted by royal permission a year's extension of his office, was the architect Albert Richardson. Known for his tendency to dress in knee breeches and a cocked hat, for churchwarden-smoking parties, for eschewing gas and electricity in favour of candlelight and the odd oil-lamp, Richardson, a former Professor of Architecture, would always be good for a quote. Skyscrapers?

> *Maggotries!* Towers of Babel, packed with maggots, packed with millions of disconsolate typists . . . Hypothetical designs of men with insect minds on the pavements and the ambitions of giants in the sky.

Modern architecture?

> *Match-boxes!* That's what they give us. Match-boxes standing up on their ends! . . . *Pseudo-engineers* they are, strip-teasing architecture, stripping it naked, right down to the skeleton. Is it the skeleton you want? Or is it the flesh?

Planners? A race, 'maddened by the statistical virus', who deserve to be dumped in the sea.[13]

Here he is described by his successor as president:

Sir Stanley Spencer RA (1891–1959), *The Resurrection: Port Glasgow*, 1947–50. Oil on canvas, 214.6 × 665.5 cm. Tate Britain, London. Presented by the Trustees of the Chantrey Bequest, 1950. N05961

when hearing that the General Assembly for Elections was to take place,

> would gather on the steps of Burlington House for the first member to appear outside with the news of who was 'in'. They would then rush away to the fortunate man's studio to acquaint him and to receive the customary guinea. The first to arrive received the *pourboire*, but somehow, I suspect, by arrangement – for they were a true fraternity – several appeared on my doorstep one fine March evening. They were invited in and we all drank something standing looking rather stupid in the middle of the drawing-room till they, having gotten their grateful guineas, took their grinning

Just as Munnings dug his feet in about painting Richardson did likewise about architecture and he was just as indiscreetly outspoken, but he had a clever wit. Architecture at the time was altering just as violently as were the other arts, but A. R. kept an even course. He stood firmly on the classical shore, letting the mighty waves of revolutionary ideas beat about him. He would only shake his brine-soaked head and look defiant. One of his great hates was the concrete lamp-post, for his architectural light burnt atop an eighteenth-century silver candelabrum with an eighteenth-century clarity and grace. He surrounded himself – nay, hemmed himself in rather – with things of beauty. His Georgian house at Ampthill was loaded with pictures, period furniture and *objets d'art*. At public dinners I have seen him bring out from his white waistcoat pocket a small silver paint box, dip a sable brush in his glass and make a wine-colour drawing of the scene about him, then present it to the Lord Mayor.[14]

Charles Wheeler, the author of this pen-sketch, is one source for an interesting Academy tradition that disappeared before the Second World War. The Italian models who used to sit for the Academy,

Sir Stanley Spencer RA (1891–1959), *Toasting*, 1937–38. Oil on canvas, 30 × 20 cm. Private collection

Sir Albert Richardson PRA (1880–1964), President from 1954 to 1956

Sir Charles Wheeler PRA (1892–1974), President from 1956 to 1966

leave while I was left smiling, I suppose, in smug complacency.

He had been elected Associate. Wheeler continues:

There is no company of Italian models nowadays to run a marathon from Piccadilly to Chelsea or St John's Wood with the good news. It is all done on the 'phone. They have gone, to my regret, for they were a colourful piece in the studio tapestry up to 1939. They could be relied upon to turn up for sittings. To sit well was professional craftsmanship in which they took great pride. Their bodies were mostly well made, golden coloured, with a stolid Latin cast of anatomy. Where now are the Mancinis Domenico, G[i]ulio, Antonio and the rest? Grandfather, sons and grandsons all of whom served so well the artists of the nineties and the first forty years of this century. They lived frugally and saved every penny, sold hot potatoes on winter evenings when they had no sittings and, in the summer, ice cream in Hammersmith and Shepherd's Bush. It was not uncommon, I am told, for them to return with their savings

after many years of hard work, to their native villages and become mayor of the place.[15]

Wheeler, who has already been mentioned in the introduction, is responsible for some enduring architectural sculpture of insipid character, such as the telamons on the Bank of England, which he provided when Herbert Baker transformed that Soane building (in an act that caused, according to Nikolaus Pevsner, 'the worst individual loss suffered by London architecture in the first half of the twentieth century'[16]) and the massive reclining figures of *Earth* and *Water* outside the government offices in Whitehall. He was the first sculptor to be elected to the presidency, which he took over from Richardson in 1956.

He therefore inherited, in Humphrey Brooke, a Secretary who had served under two of his predecessors, and who, having arrived in 1952, was already well ensconced in his job. Brooke had, at the time of his application to the Academy, an acknowledged history of past nervous problems at the Tate Gallery, where he had been briefly Deputy Keeper before moving to the Ministry for Town and Country Planning. He was a formidable character, who had

not yet been diagnosed as a manic depressive, but who was already known to have reduced Sir Gerald Kelly to tears.

A friendly obituarist tells us that

> When Humphrey Brooke came into a room, it was an occasion of exuberance and danger. His huge frame, his powerful eyes enlarged by his spectacles, brought to mind an aged eagle, Lear dispossessed, Samson at the mill with slaves. Sweetness and wrath changed places as he belaboured or praised, not from spite or sentimentality, but from principles founded on his experience of history.[17]

Brooke himself, long after his painful removal from the Academy, described his symptoms in an article for the *Observer*:

> Manic depressives tend to arouse strong feelings one way or another. We are opinionated, egotistical and verbose. We chain-smoke, which is socially unacceptable today (though doctors have advised me that there is no anti-depressant on the market, certainly not one that is safe, as effective as cigarettes). We make superhuman demands on our spouses, who need to be exceptionally intelligent and sympathetic. We send long, hand-written letters to all our friends. The word manic is often confused with maniac, a cross we have to bear.[18]

Brooke did one thing uncommonly well: he is remembered in gardening literature as a superb and original-minded cultivator of roses. At his home, Lime Kiln, Claydon, Suffolk, where he lived with his wife, the Countess Nathalie Benckendorff, he performed the unusual feat of growing old roses on chalk, according to a method of his own devising which was the opposite of the traditional way. Instead of placing manure around the roses, Brooke left them to fend for themselves in the matter of food and water. He believed that they would only prosper in the long run if they were encouraged from an early stage to put down deep roots and sort out their own nutritional needs. By all accounts, this approach – tough love for roses on chalk – worked extremely well.

Many of the Academy luminaries of this period divided their time between office and club. Brooke was unusual in sometimes going from the office to electro-convulsive shock therapy, and *then* on to the club. Towards the end of his career at the Academy, he wrote a letter to the press, on Academy paper, demanding that a Henry Moore statue that had been installed on a lawn during the Aldeburgh Festival should be removed, because it was spoiling the view. Of course, it was none of the Academy's business what happened at Aldeburgh, and of course one sees in retrospect that Brooke was going through a manic phase. Yet, as we have seen, this kind of interfering behaviour, as far as the general public was concerned, was what was expected of the Academy.

Throughout the affair of the Leonardo Cartoon, the Academy pleaded desperately with the public to see things from its point of view, and to understand that a great act of altruism was being performed on the nation's behalf. But Brooke's notion of public relations during this period was to threaten all his critics, down to the most benighted vicar who might have written to the press, with lawyers' letters. Wheeler whinged. Brooke bullied. It was not an attractive combination.

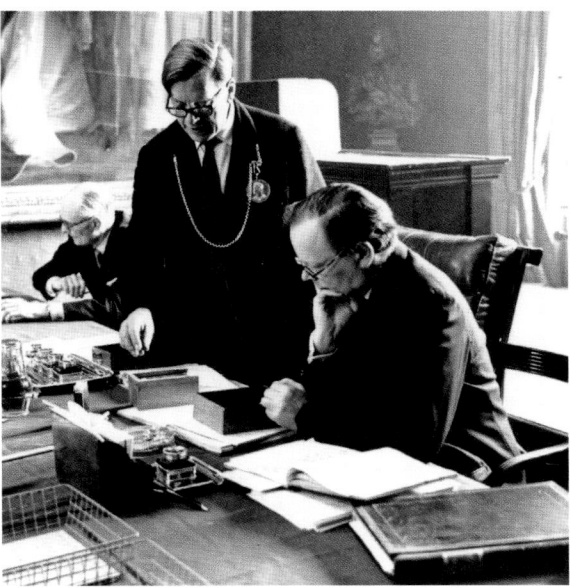

Marshall Sisson RA (1897–1978), Sir Thomas Monnington PRA (1902–1976) and Humphrey Brooke (1914–1988), Secretary of the Royal Academy from 1952 to 1968

Leonardo da Vinci (1452–1519), *The Virgin and Child with St Anne and St John the Baptist, c.* 1499–1500. Black chalk and touches of white chalk on brownish paper mounted on canvas, black and white chalk on tinted paper, 141.5 × 104.6 cm. The National Gallery, London, NG 6337. Purchased with a special grant and contributions from the National Art Collections Fund, the Pilgrim Trust, and through a public appeal organised by the National Art Collections Fund, 1962

Wheeler tells us:

I shall never forget the day in January, 1962 (after a bad start to the 'Primitives to Picasso' exhibition) when I had an earnest private talk with Humphrey Brooke, the Academy Secretary, about our budget. Things looked black; we had clearly reached an impasse. How were we to go forward? There were two ways only. One was to beg for help, the other was to help ourselves. The former would mean a degree of loss of independence. The other would lead to a continuance of unimpaired independence. At what level of importance did we place the independence we had kept from our foundation? It was surely at the highest. Freedom from outside interference is essential to an artist. To the Academy, in these days particularly, its freedom from obligations to anyone but itself is

an asset to be preserved above all else . . . In this conviction Humphrey and I were instantly and jointly certain and almost together we said: 'We must sell the Leonardo Cartoon.'. . . I recall the hollow silence that followed during which we realised what a dreadful thing we had said. It was like a great betrayal.

Perhaps it sounded like a great betrayal because that was what it was. For everything about Wheeler's reasoning, upon closer examination, falls to pieces. What was the independence of the Academy? As we have seen, it was not a quality which any observer from the eighteenth or nineteenth centuries would have recognised, because the Academy had put itself in the hands of the monarch. Nor had it at any stage broken free: the vaunted independence had never been asserted.

The financial independence that Wheeler so cherished had depended, since 1868, on a peppercorn rent of Burlington House from the government: £1 a year for 999 years. Political independence, whatever that might have meant, had never been remotely an issue. The symbolism of the Annual Dinners, as it had become codified over the years, involved devoted recognition of the Monarchy, the Government of the day, the Armed Forces and the Established Church. Munnings's mad attempt to have Spencer handed over *either* to the clergy of Westminster *or* to the Newmarket police had its own symbolism too: one might well think of the Academy as a coercive rather than a freedom-loving body – and, as we have seen, that is indeed the line many artists took.

If the sudden discovery of artistic freedom is a mystery, even harder to fathom is the nature of the *emergency* that had befallen the Academy. It had, as was explained to the General Assembly of 20 February, at which Wheeler announced that the Leonardo had to be sold, an annual expenditure of £50,000, a fixed income from investments of £20,000, and an average income from exhibitions over the previous ten years of £22,000. So there was an average shortfall of around £8,000 (in the previous year it had risen to £18,000) and, in addition, an overdraft of £45,000. It was on the basis of this information that the Assembly

splendidly backed up the decision we had made and with only one dissentient we now had authority to sell one of the two High Renaissance treasures we possessed and one of the greatest works of art in the world. It was the unanimous wish of our members that when sold it should remain in this country. My own opinion was not adamant on this point.[19]

All the figures given to the Academicians were much more alarming at the time than they appear today. Nevertheless, the modern director of such an institution would be bound to ask, what had been done to raise money hitherto? What had been done to attract sponsorship? What fund-raising activities were in hand? Had the Friends been asked to help out? And so forth. But all these activities lay in the future for the Academy. There was no Friends scheme. There was no fund-raiser. There was no sponsorship.

Then again, the question would have to be put: is there something wrong with the current financial priorities? What about, for instance, this provision of free education? Is this not by now a little out of date? Other students receive government grants – why should ours not do the same? But this would indeed have felt like a surrender of principle, and might have created anxiety about opening the Schools to the scrutiny of the Ministry of Education. And that surrender was a few years off.

From the word go, the Academicians understood that the Leonardo, if sold, would fetch a sum in the upper six figures, if not a million pounds. They were told in secret on 8 March that Sotheby's had made a very conservative estimate of a *reserve price* of £800,000. And so the selling of the Leonardo was never merely a question of clearing the overdraft. Wealth was expected, the sums involved were huge, and indeed voices were raised in concern that the Academy might become *too* rich. Too much wealth, said Thomas Monnington, would create an unfortunate impression; the Academy needed goodwill as well as finance. Wheeler replied to this that the paramount necessity was to create an ample endowment fund. If this was too large for the Academy's immediate needs, it might be used to promote the arts of design in other ways.

During this second discussion, the Academy was informed that the Prime Minister had regretted that money was not available from public funds for the purchase of the Cartoon, but that the Chief Secretary to the Treasury, Henry Brooke, had given an assurance that the government recognised the Academy's right to sell at auction, and would undertake 'not to be nasty to the Academy or to put artificial barriers in the export machinery'. Sir Edward Boyle, the Financial Secretary, had told them that 'a factor in the minds of many M.P.s was the need to keep an open market for art in London and one that worked both ways. The Country was relatively rich in Renaissance works, but less rich in other periods.'[20] In other words, Wheeler and Brooke could anticipate a clean, swift sale, and a large pot of money at the end.

The alternative, which they had already debated at the previous session, was to go to the City to raise money. Basil Spence, the architect of Coventry Cathedral, had told the Council that the City was unlikely to come up with a large amount of money. But the General Assembly had still toyed with this idea. Perhaps the City would give money – maybe as much as a million pounds – but it would come with 'conditions'. Perhaps the City would give something as an outright gift, but then surely it would be better to sell the cartoon than accept such an outright gift. Perhaps the City itself might be persuaded to buy the cartoon as a gift for the nation.

What is clear so far is that Wheeler and Brooke, having together decided that the Leonardo had to be sold, put this to the Council and the General Assembly without offering any seriously assessed alternative. The talk of raising money from the City was no more than a dream: no one had a clear idea on what terms it would be raised. The option of selling the Michelangelo tondo was not apparently taken seriously, for the good reason that it was known exactly when and by whom this was donated to the Academy, while the source of the Leonardo remained, conveniently, a mystery. In the first Council meeting, John Ward is reported as saying that the cartoon did not represent 'the essential Academy', but was 'only an ornament'. This view prevailed.

But one key issue was being fudged, and Wheeler appears to have recognised this. The Academicians wanted the cartoon sold, but wanted it to remain in Britain. Put another way, they wanted it saved for the nation. And yet, as I mentioned in the introduction, perceived from another point of view, and one they had never discouraged, they were indeed the nation. Or if they were not a national institution, what were they, and were they at all worth taking seriously? Monnington had been right to argue from the start, with Spence, that the cartoon should remain in the country, and he was right that the Academy needed goodwill as well as finance. But how could the Academy sell the cartoon for a good price, ensure it remained in the country, and retain or acquire goodwill with the public?

Wheeler, after the first meeting, offered the cartoon, confidentially, to Downing Street, for £675,000, a discount on the average of the estimates they had received, which was £750,000. But Macmillan turned this offer down. So the second General Assembly meeting voted 17 to 2 'that the Leonardo Cartoon be sold at auction by Messrs. Sotheby's on a date to be agreed with them', the reserve price to be settled on the advice of the auction house. An announcement was made.

The Academy had received three expert opinions on the value of the cartoon. These documents still exist, and they make interesting reading today, since they set out clearly the reasoning for each prediction as to the expected price. At the time, the top price paid for an old master painting, by a very long way, was the recent £821,000 for Rembrandt's *Aristotle Contemplating the Bust of Homer*. Before that sale, Peter Wilson of Sotheby's assured the Academy, 'it seems that $2,000,000 (£714,000) was a generally accepted maximum price, a kind of sound barrier which only two bidders were prepared or able to break'. But for the Rembrandt there had been no less than six bidders prepared to go to such a price. Wilson estimated that the cartoon would not fetch less than £850,000, and might fetch well over a million.

James Byam Shaw, on behalf on Colnaghi's, suggested £700,000 as a reasonable valuation on the open market. His reasoning was comparable to Wilson's, and included a rumour that £1,000,000 had been offered for the *Portrait of a Lady* by Leonardo then in the Liechtenstein collection (now in the National Gallery of Art, Washington DC). Finally Geoffrey Agnew advised the Academy that 'a fair value between the Royal Academy and the nation would be between £500,000 and £600,000. I would certainly advise the Royal Academy not to sell at less than those figures. I would certainly advise the nation to buy at somewhere between those figures.' But it might be possible to sell it at a higher price.

At a meeting on 22 March, Macmillan's letter was read to the Academicians, asking them to delay the sale of the cartoon until the autumn, and to fix a price for purchase by national appeal. But on the same day, Wilson and his colleague Carmen Gronau let Brooke know by post that if the cartoon came up for sale in June it would fetch over one million pounds.

> We know for certain that two of the most important museums on the eastern seaboard of America are seriously interested. It is probable that Cleveland, with I believe eleven million dollars at their disposal, will be interested, and apart from this we have definite assurance that a fourth museum in the United States with immense funds at their disposal is anxious to buy the cartoon and will be seriously represented at the sale. We personally think, however, that if the sale does take place now or in October the picture may well be bought by an English buyer and in fact will not go to America. This has happened with the two most expensive of master paintings we have ever sold, and we have an indication from one particular quarter that there will be very serious competition from this country, which I believe will be successful.

Whether or not this letter had yet arrived by the time of that day's General Assembly meeting, its contents were known and it was already clear that the price of the cartoon was going to go up. Legal advice had been taken from several parties, including the Charity Commissioners. The asset had to be disposed of to the 'best advantage' of the Academy – that is, the Trustees had to get a good price for it.

Press cuttings concerning the sale of the Leonardo Cartoon, from a scrapbook compiled by the Royal Academy

Evening Standard - 10.3.62.

That da Vinci drawing is taken away in the night from its place at the Royal Academy

£1m TREASURE GOES TO SECRET VAULT

'Shall we sell?' Storm is growing

Evening Standard Reporter

Resting today in a secret, heavily guarded vault is the Leonardo da Vinci drawing which the Royal Academy wants to sell to preserve its independence.

It was moved last night. Not even council members of the Academy know where it is.

And as a veil of silence surrounded the charcoal drawing of the Virgin and Child which is expected to

A detail from the drawing,

fetch more than £1,000,000 at Sotheby's in June, art-loving MPs decided to act.

They don't want the masterpiece to leave Britain. They fear an American buyer may snatch it.

So watchdog groups on both sides of the House considered approaching the Chancellor to discuss the matter.

The Academy council says it must raise money by selling the picture if it is to remain independent.

Whose idea was it to sell? No one can say. The possibility has been considered more than 10 years.

Some opposition

Said secretary Mr. Humphrey Brooke: "Ever since I have been a member of the Royal Academy —at least 10 years—the question of realising out this enormous asset has been borne in mind.

"The possible sale of the picture has been considered recently at four meetings."

The decision to sell was nearly unanimous.

The strictest precautions will be taken until the picture is sold.

"It was taken away last night from the place where it used to hang in the council room," said Mr. Brooke.

"I can't tell you where it is, or whether it is likely to be moved again. Neither can I tell you how it is being guarded."

It is only six months since the Goya portrait of the Duke of Wellington vanished from the National Gallery — and that made the whole art world extra security-conscious.

The Goya was not insured.

How much is the Leonardo insurance? Mr. Brooke said: "I can't answer that. But you must not assume that it is insured."

Mr. James Gunn, a portrait painter, of Hampstead, who opposed the sale at a meeting of the council, said: "It would cost a tremendous sum to insure the Leonardo."

He added that he thought the Academy could get out of its financial troubles without selling the Leonardo.

'A way will be found'

"The academy has a tremendous amount of good will," he explained.

"If Britain wants the drawing a way will be found to prevent it leaving the country."

Sir Gerald Kelly, a former president of the Academy, said : "I am entirely on the side of Sir Charles Wheeler, the present president.

"We have got a job to do. With our resources, we must do what is necessary to go on."

Daily Express - 10.3.62

£1,000,000 art treasure for sale

Detail from the drawing

'KEEP IT HERE' MOVE

By JOHN RYDON

THE Royal Academy is to sell one of Britain's major art treasures—a Leonardo da Vinci drawing which could bring up to £1,000,000 at Sotheby's in June.

It is the black chalk drawing for "The Virgin and Child with St. John the Baptist and St. Anne."

The drawing, owned by the Academy since 1779, is being sold "to meet increasing costs." News of the sale brought widespread protests.

It is the first time a Leonardo has ever been offered at a public auction. It could produce the highest-ever price for a single picture.

Big row if . . .

If the drawing were bought by a foreign gallery, there would be an outcry against it leaving the country. Almost certainly an export licence would be refused.

The 54-by-39-inch drawing (more than twice the size of this page) hangs in the council room at Burlington House headquarters of the Academy in Piccadilly. The painting for which the drawing was made is in the Louvre.

Sir Charles Wheeler, 72-year-old president of the Royal Academy, said last night : "The decision to part with the Leonardo was not easy."

It was decided by the 40-strong general assembly of Academicians last Thursday.

The Academy, said Sir Charles, was determined to stay financially independent.

With the rates and upkeep of Burlington House costing £20,000 a year and the Academy schools a further £9,000, more income had to be found. The Leonardo sale would provide an endowment fund.

Reaction was swift. Mr. Norman Wilkinson, President of the Institute of Painters in Water Colour, said : " If money can be found, the Leonardo should be prevented from leaving the country.

"It is conceivable that one of the big American galleries will be prepared to pay £1,000,000 to get it."

Fantastic

Professor Sir Anthony Blunt, surveyor of the Queen's pictures, said: "This is fantastic. Every possible effort must be taken to keep the Leonardo here."

The drawing, completed by Leonardo just before 1500, is believed to have been given to the Academy by English painter Sir Joshua Reynolds in the 1770's.

HIGHEST price ever paid for a picture was £821,000 for a Rembrandt's "Portrait of Aristotle Contemplating the Bust of Homer," sold in New York last November.

Rubens's "Adoration of the Magi" brought £275,000 at Sotheby's in 1959.

THE SUNDAY EXPRESS LONDON MARCH 11 1962

CURRENT EVENTS
John Gordon

TO buttress its finances the Royal Academy proposes to sell one of its finest treasures and hopes to make a million pounds.

As usual the cry goes up—we must save this for the nation. Which means that public money should buy it. Well, I'll suggest a better way.

The country is overflowing with clever new multi-millionaires all waiting for coronets and ermine. Why not a dukedom to anyone who produces the million ? Or earldoms for any four who cough up a quarter of a million each ? Honours have been earned less worthily.

Evening Standard. 12.3.62

I DISCOVERED today that the Royal Academy offered its Leonardo cartoon to the Government before putting it on the open market. And that the Government decided to take no action to acquire it for the nation.

Sir Charles Wheeler, President of the Royal Academy, said this morning : "Yes, we were in negotiation with the Government for the last two weeks, before we put it on the market."

Sir Charles invited me to draw my own conclusions from this. My conclusion is that the Government missed an opportunity to get the drawing for much less than it is certain to fetch at Sotheby's.

RA independence

When I asked Sir Charles whether accepting payment from the Government would not have been much the same as accepting a grant (which he feels would compromise the independence of the RA), he said: "No, it would have been realising an asset, which is quite different."

Meanwhile Sotheby's can pride themselves on having around £2,500,000 worth of paintings for sale in spring and early summer.

In April there are the Maugham and other Impressionist paintings — together likely to fetch at least £750,000. In May there is the Rubens in Madrid— another £300,000 at least. Then in June the Korda collection, and now the Leonardo, which some think will reach £1,000,000.

Sketch. 13.3.62

A MILLIONAIRE whose name is a household word will probably buy the Leonardo da Vinci drawing which the Royal Academy is putting up for sale.

He will then give it to the nation. And he will not allow his identity to be disclosed.

Preliminary moves are likely this week.

Daily Herald - 12.3.62

" I don't see why the Royal Academy should keep the Leonardo—after all he's no Annigoni."

But 'best advantage' could take into account three factors: the need for a substantial endowment fund, the retention of the cartoon in this country and, significantly, public goodwill. Although it is often thought that trustees in general when selling some asset are obliged to get the highest price they can, the Trustees of the Academy were assured that since, under the terms of the Academy's foundation, its purpose was to promote the arts of design, retaining the cartoon at the National Gallery might still count as 'promoting the arts of design'. It would be proper to offer the cartoon to the nation at £800,000 – giving a concession of 20 per cent of the lowest price it might be expected to fetch at auction. The appeal fund, run by the National Art Collections Fund, should be allowed four months to reach that target.

Monnington, who also sat on the board of the National Art Collections Fund, once again tried to intervene in the cause of the promotion of goodwill, asking the Academy not to increase its price, and asking them to minute this view of his. Wheeler told him he had been reluctant to accept a figure as low as £800,000, but had had to give way to the views of his fellow officers.

The upshot was that, in a short time, news got out that there had been an earlier, lower price, which Macmillan had turned down. To the world at large, it looked as if the Academy were being greedy. To the harder-nosed members of the Academy, it would have become gradually clear that they had made a mistake: they had offered the cartoon at the wrong price. One such member was Kelly, the former President who, late in the ensuing campaign, attended a meeting of the General Assembly, as he put it, 'only as an old man on the shelf'.

> At recent assemblies, in his absence, the Members had allowed too much sentiment to weigh with them. In effect the Academy had handed over more than £200,000 as a bribe to the general public. He deplored this. He had never heard a good word about the Academy from people who lay down the law about art in this country, and their opinions would not be changed as a result of this sacrifice. He would have preferred a straightforward sale and no further bargaining.[21]

Afterwards Kelly wrote to Wheeler:

> You made an excellent speech (you do make excellent speeches), and then you repeated it all over again – but perhaps you have to do that with members of the Royal Academy. I cannot myself see how you could have said all those wise and just things about our being Trustees of the Academy's property, and then casually offer the cartoon to the Government for so small a sum! And then you propose to contribute £200,000 towards an appeal!! For your sake I hope that the appeal is a failure, and that the sale at Sotheby's goes through.[22]

The appeal had been first plotted at a meeting in the Travellers Club on 16 March, attended by, among others, Lord Crawford of the NACF, Kenneth Clark, Anthony Blunt, and Martin Davies from the National Gallery; Davies took the minutes. At the time, it was not known if the Academy would be persuaded to withdraw the cartoon from auction, and one of the questions which had to be resolved was: where, if saved for the nation, would the cartoon go? Theoretically, it should have been destined, as a drawing, for the British Museum, but Frank Francis (the museum's representative) argued that 'at present there was nowhere suitable in the printroom for its exhibition. A plan for re-organising the Print Room was due to be put into operation and would be completed in perhaps ten years.' Perhaps, he said, a special exhibition room could be made for large drawings such as the Leonardo and the Michelangelo cartoon the British Museum already had.

It was Kenneth Clark who made the decisive intervention, whose result is the happy anomaly whereby the cartoon was treated as a painting instead of a drawing, and was acquired by the National Gallery. One of the points he made was that the National Gallery would stand a better chance of encouraging contributions for the appeal than would the British Museum, and it was this argument, together with the museum's professed inability to house the cartoon properly for another ten years, that seems to have won the day. After all, it was not so anomalous that the cartoon, which was going to cost far more than any old master drawing

had hitherto fetched, should be treated as an honorary painting.

The National Gallery put up, out of its own budget, the first funds for the appeal, and thereby consolidated its position. It also provided the offices for the campaign that Lord Crawford ran and that was said to have brought about his death soon after. At the outset, public opinion smiled to an extent both on the Academy and on the appeal. But as the appeal began to get into difficulties, the acrimony against the Academy began to grow.

As usual in this story, the Academy had only itself to blame. In this case, the President made a speech at the Annual Dinner, keen as ever to stress the point the world was too obtuse to concede, that the Academy was being very generous to the nation in forgoing what must be at least a quarter of a million pounds – perhaps more, for rumours had reached Wheeler that there were those who valued the 'treasure' at two and a half million pounds.

> It would seem that for such a prize 'the sky's the limit'. Strange, isn't it? But then, how can such a work of art as this be equated with pounds – or dollars? It could perhaps be equated with a chapter in the New Testament, with one of Shakespeare's greatest plays, or with Beethoven's Violin Concerto – for it belongs to that highest order of things created since the first six days of the world. Suppose the chapter, the play, the concerto were to disappear, which of course they cannot, and let us suppose that the Leonardo were to be destroyed which, alas, is not impossible, how much poorer mankind would be.
>
> Many a fortune of a million pounds has been lost and another made, and when one flower dies a second may be picked, but if this picture were lost it could never be replaced because no one will ever draw again with da Vinci's hand and that hand never drew more divinely than here. It is a unique flower of human genius which belongs to the world. We do not sell it, how *could* we sell it?

The diners must here have wondered whether Wheeler had suddenly decided to call the whole thing off, but he went on:

> What we sell is the privilege we have enjoyed for nearly two hundred years of being allowed to take care of it. The new custody will be, we hope, in the hands of Britain.

And now, in full rhetorical flood, he began to blame the country for the situation he and Brooke had brought about:

> I say 'We hope'. The slow progress of the appeal so efficiently and enthusiastically undertaken by our splendid National Art Collections Fund, to which we should all be grateful, does not render bright the hope. An affluent society in a welfare state, a society which can find ten million pounds to gamble on the Grand National, should have responded more immediately to their cause. The question is prompted: 'Does Britain deserve to retain the cartoon?' If it does, its people will not hold back any longer. If it does not, then let it go to America or where you will, if there is a livelier care for beauty or a less unpolished pride in things of the mind.[23]

Anyone awake by the end of this purple rhetoric, of which there was still more to come, might well have reflected that it was fundamentally disingenuous to raise the question of the country not deserving to retain the cartoon, when the Academy by now had a financial interest in the failure of the appeal. Kelly was not the only one who wanted the appeal to fail. Wheeler was carefully preparing the moral ground for just this eventuality.

Nor was there any love lost between the Academy and the National Art Collections Fund. Lord Crawford had been trying to get the Academy to revert to its original price, and his every disparaging remark was reported back to Humphrey Brooke. The bush telegraph had one unique facility: Academicians were engaged in painting portraits of key establishment figures, who blabbed.

> July 2nd. Lionel Fraser to HB (at Tate party): 'Of course David Crawford is *very hostile* to the Academy.'
>
> July 3. T. Mullaly told HB that the change in attitude of the *Sunday Telegraph* has been influenced by material supplied to Machlachlan by Lord C.

July 6. Mrs Gronau on Lord C telling everyone that RA had fixed an impossible target and too little time.

July 10. P. Greenham reported that during sitting that morning the Duke of E told him Lord C had complained to the Queen about RA not giving him warning. 'PRA's lack of tact.'

July 11. J. Gunn confirmed from 2 hour sitting given by PM that PM had been briefed by Crawford with complaints about the price + the time factor...

Master sleuth that he was, Brooke kept track of every slight. The battle by Lord Crawford was continued up to the very last moment, and the Academy went so far as to prepare two press releases, to cover either outcome. In the end, though, Macmillan came up with the shortfall, and Crawford was able to send a letter to Wheeler agreeing to buy the cartoon for £800,000, half by a cheque which was enclosed with the letter, and the balance within seven days. The cartoon was to become absolute property of the National Art Collections Fund on their receiving Wheeler's confirmation of these arrangements, but the Royal Academy 'will maintain your insurance cover at your expense for a further 24 hours from now to enable us to effect the gift we are making of the Cartoon to the National Gallery'. The preciseness of the conditions seems a kind of hostility in itself.

Crawford was too ill to give a press conference. He went from Burlington House straight into hospital that evening for an operation.

Wheeler for his part tells us that he went back to his studio and wept like a child. As well he might.

Press cuttings concerning the sale of the Leonardo Cartoon, from a scrapbook compiled by the Royal Academy

Sunday Telegraph · 6·5·62

Leonardo's Not for Them

By MICHAEL WOLFF

OVER at the Royal Academy Private View someone was saying: "I do hope the nation will buy the Leonardo . . . well, no, I haven't actually contributed anything yet. I wonder when the Government will step in: after all, it's part of our heritage."

Me, I'm tired of being lectured about giving away this priceless heritage. To whom was this heritage entrusted in the first place? The Royal Academy. How dare they even contemplate selling it off—and then blame us for it!

"Anyway, it was looted from Italy in the first place," an art student pointed out. He does not understand the hysteria with which the suggestion that it might go to America is greeted. He detects some political motive. "When a Picasso is bought in London for a Frenchman there is some profound artistic purpose behind it; when an American buys, it's highway robbery and an affront to European culture."

IS IT REALLY . . ?

Actually, many people are still genuinely puzzled as to the motives behind the Royal Academy's appeal. What do they want the money for—what do they do? Can £800,000 or even more really be necessary to keep going their art school, or to ensure an annual summer exhibition on whose merits the art world is invariably divided?

Too often, alas, the proceedings of the Royal Academy are associated in the minds of the public with pompousness and social snobbery. "All they do is give themselves a whacking good dinner once a year," a

nearby tobacconist remarked—enviously, I thought.

"It's nothing but a fashion parade," said an elderly artist of the Private View. "If they were charged a pound admission, as they are on the second day of the Chelsea Flower Show, there would be some sense in it. But no—they let these silly young girls in for free!

Even the Royal Academy's desire to remain independent of the State is regarded in some quarters as an attempt to maintain a unique social position. "What they mean," says a teacher at an art school, "is remain independent and aloof from British art in general."

Those who have clamoured long and loud for more State contributions to the arts regard the Royal Academy's appeal as something of a betrayal. And there are fears that it will have an adverse effect on support for art in general and art galleries in particular. "People will get the idea that if the galleries are really desperate they can always sell an old master . . ."

The Establishment atmosphere that seems to surround the Royal Academy is also detected—and resented—in the manner in which their appeal was launched—the prissy, admonitory leader in the *Times* followed, in due time, by the traditional letter to that newspaper —asking for money. "An Establishment gang-up to stick-up the public."

Philanthropists dislike strong-arm methods. The proposal to publish a list of subscribers to the Fund is being viewed with some misgiving. Usually such a list is published as a mark of acknowledgement and gratitude. Now, says a West End finan-

Leonardo on view: whose money goes in the box?

cier, "it looks as if they are trying to put the bite on those of us whose names do not appear."

There are wealthy men who have not given anything, but who might have if they had been properly approached in the first place and had the financial situation of the Academy explained to them. "I think fifty of us might have raised £10,000 each." That was how Churchill College was founded.

BARGAIN BASEMENT

As it is, there are many in the City and elsewhere who believe that the Royal Academy is merely cashing in on a seller's art market—"and good luck to them" is the inevitable comment.

City men are frankly contemptuous of the idea that anybody in possession of such valuable property in Piccadilly cannot raise enough "ready" to keep going for a long time.

There is, moreover, some distaste for what are regarded as bargain basement tactics. First the Royal Academy said they needed a huge but unspecified sum. Then they said they

could get a million for the Leonardo, but would let the nation have it at the unrepeatable cut-price offer of £800,000. Now the President of the Royal Academy talks in terms of £2¼ million.

"The price," commented a broker, "seems to go up to persuade the public that they are being offered an even better bargain than they thought. But it is being neither realistic nor businesslike."

In commercial circles and among rich businessmen there is an inclination to despise the "namby-pamby" attitude of the Royal Academy. They would rather see an honest public appeal for funds for the Academy than have the picture go for less than its full market price.

"If they have any sense," said one shrewd operator, "they ought to make sure that the appeal will fail so that they can then get twice the price on the open market."

Come to think of it, perhaps they are doing just that. It would explain a lot.

CLAUD COCKBURN will be back next week

Daily Telegraph · 5·5·62

The Queen looking at the Leonardo da Vinci cartoon during her visit yesterday to the National Gallery. She was accompanied by Prince Philip.

QUEEN VISITS LEONARDO FUND WORKERS

TARGET ACHIEVEMENT HOPE

DAILY TELEGRAPH REPORTER

THE Queen and Prince Philip went to the National Gallery yesterday to see the Leonardo da Vinci cartoon for which the public appeal for £800,000 has been launched. The present response to the appeal stands at about £230,000.

They were shown the cartoon by the Earl of Crawford and Balcarres, chairman of the National Art Collections Fund which is launching the appeal, and Mr. John Witt, chairman of the trustees of the Gallery.

The Queen said: "I do so hope that the total will be reached. Leonardo was a wonderful craftsman and this is a most beautiful example."

When Mr. Witt thanked the Queen for her personal contribution to the appeal she replied with a smile, "I was so glad to do it."

The Queen and Prince Philip went to the basement to watch those engaged in recording the contributions from the public appeal. They spoke to many of the workers who are giving their time until the appeal closes at the end of July.

"CITIZEN JAMES"

Subject sees portrait

Citizen James went to the Royal Academy's private view day yesterday to see "Citizen James," the Ruskin Spear portrait of Sidney James, the comedian, as he appears on television. As Mr. James looked sardonically at his sardonic image, he said: "The Mona Lisa is definitely prettier."

Gallery three, where Augustus John's "The Blue Lake" has pride of place, was the centre of interest for the crowds which thronged the exhibition throughout the day. Sir Mortimer Wheeler, Mr. Paul Getty and Lady Lawson, a former Lady Mayoress of London, were among the early arrivals.

205 Works bring £17,067

Yesterday 205 works were sold for a total of £17,067 compared with 209 works for £15,272 on the corresponding day last year. The exhibition, which opens today, continues till Aug. 26.

Financial Times · 9·5·62

LEONARDO APPEAL

Sir Charles Wheeler, president of the Royal Academy has asked that contributions to the Leonardo appeal be addressed to the Leonardo Fund, the National Gallery, Trafalgar Square, London. Many letters, he said, were being sent to the Royal Academy. "The Royal Academy is not making the appeal and to deal with the present flood of letters is almost beyond the resources of our small staff."

The Fund's total is now £235,14s.

Sunday Times. 13·5·62

Over 30,000 Buy Copies of the Leonardo

Up to yesterday more than 30,000 copies of The Sunday Times reproduction of the Leonardo da Vinci cartoon had been applied for by readers. This tremendous response has meant that a further large printing has had to be put in hand, and all indications are that the demand will continue strongly.

Profits go to the National Art Collections Fund, which is appealing for £800,000 to enable this supreme masterpiece of art to be kept in the country.

Here are comments by leading authorities on THE SUNDAY TIMES reproduction:

The Earl of Crawford and Balcarres, chairman of the Fund: "It is quite first-class and extraordinarily good value for money. Everyone will be delighted to possess it. I am sure it will induce people to feel that the Leonardo must belong to this country."

Sir Charles Wheeler, President of the Royal Academy: "It is quite the best art reproduction of its type I have ever seen—an incredible five-shillings' worth."

Impetus to Fund

Sir John Rothenstein, Director of the Tate Gallery: "An admirable reproduction, and its sale should certainly give impetus to the Fund."

Sir Gerald Kelly, P.P.R.A.: "A very good reproduction indeed."

Mr Leonard Rosoman, A.R.A., one of Britain's best-known younger painters: "Because of its subtlety, the reproduction catches the mysterious beauty of the original."

Many readers have generously made donations to the Appeal in addition to the money they sent for the reproductions.

Reproductions of the cartoon, in two-colour lithography are available to readers, price five shillings each, sent post free, in cardboard tubes, ready for framing. Applications to "The Leonardo Cartoon," THE SUNDAY TIMES, 196, Gray's Inn Road, London, W.C.1.

LONDONER'S DIARY

A DEPUTATION IS CALLING ON THE CHANCELLOR TO ASK HIM FOR AID TO SAVE THE FAMOUS LEONARDO CARTOON FOR THE NATION.

VICKY

"Harold, fancy asking ME for a million quid to save a CARTOON . . ."

15 'Why do you desire so much to be in the Academy?'

Writing in the *Observer* in 1959, at the end of the Summer Exhibition (which had attracted nearly 100,000 visitors and sold £43,000 worth of works of art), Sir Hugh Casson asked why the Royal Academy should feel uneasy. It fulfilled, he conceded, the principal aim of its founders, which was, he said 'to raise the status of the profession'. 'To its gruesome success in this a century ago,' wrote the architect, 'the stout red-faced mansions of Melbury Road still stand melancholy witness.' The Academy taught 100 artists for free, sold their work without commission, honoured some of them with membership, and assisted them financially when they were old and indigent. It regularly presented magnificent exhibitions of the art of other times. 'As a machine,' he concluded, 'it runs smoothly . . . solid bearings, a precise and regular rhythm, a calculated and not too advanced spark, polished and obliging governors to set the pace, needing only the occasional touch of oil or wipe over with a rag to keep going.'

But, he asked, to what purpose? Here Casson took five claims usually made on behalf of the Academy, and tested them. First: 'It upholds tradition.' False, said Casson. 'Tradition is not a corpse to be propped up. If it has value and strength it will survive unaided.' Second: 'It is Academic.' This Casson found to be half-true, since Academic means concentrating on teaching and discussion. 'These', he said, 'are only minor activities as far as the R.A. is concerned

and contact with other learned societies is vestigial.' 'It preserves Standards,' was the third claim, which Casson found not proven, for the only standard worth preserving was that of quality, and 'So far as the Summer Exhibition is concerned this cannot be claimed.'

The fourth claim was that 'It represents "the Other Point of View".' True, said Casson, but this was only of negative importance:

> The wish to please is no more despicable than the wish to shock. There is nothing immoral about a policy of providing space and support for art that is unfashionable or lacking in novelty. Indeed it may be valuable in that it helps to prevent the unhealthy domination of the art world by a single clique . . . Yet this gulf between 'traditional' and 'modern' is never to be bridged by emphasising its depth and shaking fists across it. In the long run art will be the loser.

Finally Casson came to the point that the Academy 'has Prestige Value'. He was already a knight but still three years short of becoming an Associate. Here is what he wrote on the subject:

> It depends what you mean by prestige. Social prestige is irrelevant, financial prestige meaningless. The R.A. winter exhibitions rightly have international prestige and to be an academician

Sir Hugh Casson PRA (1910–1999), President from 1976 to 1984.
Photograph by Snowdon, 1984

'Philosofia XXVIII' and 'Musicha XXVI', two tarot cards from a set probably printed by Johann Ladenspelder (1510/11–c. 1580). Copper engravings thought to be by **Andrea Mantegna** (1430/31–1506), 17.5 × 9.9 cm and 17.7 × 10 cm. Private collection

is an honour, though it comes unadventurously late as a rule, considering that the age of consent is twenty-five. Yet many artists of international reputation, among them the most distinguished, deliberately refrain from showing there. (Even so academic a painter as Sir William Nicholson used gleefully to cherish a letter addressed to him at Burlington House and returned to the G.P.O. marked 'Unknown Here'.) Why indeed should they bother to appear in such uneven and crowded company when they can take any time a more glamorous ride on the international circuit of Venice, Paris, Pittsburgh and Rio? There may be international traffic and prestige of a sort in, say, Tachisme or for that matter quaffing cardinals. There is virtually none in those items which in summer overcrowd the R.A. galleries.

And he went on to call the Summer Exhibition 'a provincial show of no interest to anybody but ourselves'. It was ridiculous to parade it, he said, 'when London is full of international visitors and when nothing but the best of anything should be on show'. The Winter Exhibition should be held in the peak summer months while the Summer Exhibition, severely truncated, should be held in

October: 'Once clear of the Ascot-Wimbledon-Season circus, it would be taken more seriously and could become more serious.' And the galleries – dingy as they were – should be redecorated and re-lit.[1]

Casson, who had been knighted in the 1952 New Year's Honours List for his work on the Festival of Britain, and who had designed the decorations for Queen Elizabeth II's coronation the next year, was head of a newly created Department of Interior Design at the Royal College of Art. Diplomatic enough in their expression, his criticisms of the Academy were by implication devastating. In particular, the assertion that the Summer Exhibitions were provincial and of purely local interest, and his proposal that there be a change of priorities, so that winter and summer swapped places, completely undermined the pretensions of the Burlington House establishment.

What Casson is saying here is that if the strength of the Academy lies in its role as an exhibiting society, then it should place emphasis on the kind of exhibitions it does well. What he does not address is the loss of meaning this would imply for the Academy as an association of artists. The founding purpose of the association had been to present, and sell, contemporary artists' work; it was not to take the

work of a previous era, or a different country, and promote that instead. Again, Casson was right that the Academy had no significant academic contacts, and little by way of a teaching programme. This had been a continual weak spot, in different ways and at different periods, and one that the enemies of the Academy were always keen to seize upon. And Casson, of course, was writing this from the position of a professorship at the Royal College of Art, by then a rival of the Academy.

The weakness of the scholarship at Burlington House during this period may be seen at the back of the affair mentioned in the introduction, the sale in 1967 of the Cumberland collection of Italian prints. These had been rediscovered two years earlier, bound in nine volumes, having been lost sight of since the war, when some separately mounted works were turned out of the Keeper's studio on the retirement of Sir Henry Rushbury. The collection was valued by Messrs Colnaghi, who found that it could be divided into two parts. There was a set of tarot cards, dating from fifteenth-century Italy, one of only nine complete sets recorded. These Colnaghi's proposed to sell on commission, for £20,000. The rest of the collection they would buy for £11,700.

In a 'strictly confidential' note of 7 June 1967, recommending the private sale through Colnaghi's, Humphrey Brooke informed the Academy that 'The Cumberland Collection has lost its original purpose as material for consultation by students, but has greatly increased in market worth and is now standing at its highest value.' The President, Monnington, and the Council (with two dissentients) had already voted in favour of this. And in a letter dated 10 June, Raymond Cowern, principal of Brighton College of Art, added his support, while suggesting that the Academy might wish to keep a few of the prints, including a magnificent Barocci etching 'which for me would be one of the treasures of the R.A. if we could retain it; equally the Mantegna'.

Cowern's letter goes on to say that the Academy

should record the collection, at least in a representative way, as this could be of great value for future art-historical reference. I wonder if we still have the full catalogue which is referred to

on each mount? If so I think we should retain it and the slides could be referenced to it. I imagine at most 6 boxes of 36 slides each which I think would cost £8 in material.

What is pathetic about this, and the request that comes with it for copies of these slides to be made for Brighton and for the University of Sussex, is that Cowern clearly did not know, nor did anybody tell him, that George Cumberland's catalogue not only existed – it had been published in 1827, with Cumberland's annotations.

Cowern could see that there was historical interest in an early nineteenth-century collection of renaissance prints. What would he have said if he had been able to read Cumberland's introduction to his catalogue, in which he justifies the study of prints by reference to the tastes of his friends in the Academy?

As to prints, they not only aid the young without pretensions, but improve and delight the older

School of Andrea Mantegna, (1430/31–1506) or **Giovanni Battista Cima da Conegliano** (c. 1459–c. 1517), *The Virgin Kneeling Adoring the Infant Christ*, 1460 (?). Engraving identified in Cumberland's 1827 catalogue, page 89. An old inscription on the mount attributes the work to Maso Finiguerra (1426–1464)

Artists, and to the last hour of life are a solid amusement, as I have often witnessed *Mr Bankes*, *Mr Nollekens*, and *Mr Cosway*, whose collections and enthusiasm in collecting will never be rivalled. *Sir Joshua Reynolds*, and my friend *Barry* also knew the value of those things perfectly; and I doubt not that numbers, whom I have not had the pleasure of knowing, are equally rich in, and equally benefited by them. It is not to steal the ideas of the old masters that we study them, but rather to amalgamate them with those of each other and our own: new ideas of beauty and grandeur can alone rise from happy combinations, and as he that has read attentively the best authors is likely to acquire the best style, so he that is conversant with the works of all the good Artists, it is most likely, will be successful in his own.[2]

Cumberland might have added another friend of his, William Blake, to the list. He tells us in a footnote that when writing his introduction he had little imagined that the Royal Academy 'would propose the acquisition of my collection for [the use of students] – or that it even knew of my collecting – and it has been doubly grateful to me, that what once I amassed for the improvement of my own taste, should *ultimately be placed where I most wished to see it*, and yet not out of the reach of my own inspection'.[3]

There are some marvellous passages in Cumberland's introduction, pregnant phrases such as 'the *Hesiod*-like simplicity of *Mantegna*' or when, after a completely surprising digression on Persian miniatures and on Indian paintings (which, because they were frequently copied, he considers to have been 'a sort of favourite print in India'), he refers to Persian miniatures as 'these Persian Peruginos'. There are instructions on how to choose the best impression of a print, advice against washing stained prints with weak acids, and there is a notable expression of a low opinion of Dürer's artistry. Cumberland considered the set of 50 tarot cards to be the work of Maso Finiguerra, whom Vasari held to be the first to have engraved on metal in Italy. That they were of great interest and rarity was well known to him, and he placed them at the head of his catalogue, with many details as to their provenance, and a note that 'Such a work ought to

have gone direct to the British Museum, but this at the Academy will secure it to the country, and the author of this work is gratified to have been the means of placing his copy there.'[4]

It is bad enough that such a collection was sold and dispersed – for the prints were sold piecemeal by Colnaghi's over the years, and thereby lost their significance as an ensemble. Worse was the fact that nobody at the Academy was informed as to the significance of what was being dispersed – a scrupulously catalogued and annotated collection. Monnington, the Council minutes inform us, 'favoured turning the collection into cash as it was something that could not easily be shown'. (A shameful sophistry.) The Treasurer, Marshall Sisson, 'stressed that a sale would represent a switch of investment. The Academy badly needed a new fund to help with special expenses such as the bi-centenary' – a good example of a 'need' conjured out of thin air.

Ten years later, the floggers-off were still at it, and there survives a list of 'Books from the Library proposed for sale' – fifteen items including the works of Piranesi, three volumes of Goya and Stubbs's *The Anatomy of the Horse*. By now Casson was president, having succeeded Monnington in 1976. And Casson had inspired Rykwert's letter of January 1977, which I print in the introduction to this book. Still, the pressure to sell off possessions was there, and in October 1977 Hutchison presented to the Special Financial Advisory Committee a document explaining why. Between 1971 and 1977 the net overdraft had risen from £55,134 to £482,800, while the investments of the Academy stood at £780,000. A single year's deficit – the last audited, for 1975–76 – had been £260,000.

But the accounts given contained new features. There was £100,000 from the newly founded Friends. Commissions on sales from the Summer Exhibition, at 15 per cent, had brought in £30,000. A small commission on sales had been a Casson proposal in 1959, finally implemented. The Friends had been established at the beginning of the year, with an annual fee of £10. Eight thousand members had been enrolled in the first few months (this had risen to 80,000 by the summer of 1999). And the introduction of fees in the Schools was expected

George Stubbs ARA (1724–1806), *Finished Study for 'The Tenth Anatomical Table of the Muscles ... of the Horse'*, 1756–58. Pencil on paper, 35.5 × 19.5 cm. Royal Academy of Arts, London. Bequeathed by Charles Landseer RA, 1879. 03/5717

George Stubbs ARA (1724–1806), *Finished Study for 'The Fourteenth Anatomical Table of the Muscles ... of the Horse'*, 1756–58. Pencil on paper, 36.8 × 18.4 cm. Royal Academy of Arts, London. Bequeathed by Charles Landseer RA, 1879. 03/5711

to bring in around £40,000 in the current year. Although it made little difference at the time to the students, whose fees were met by the Department of Education and Science, this move marked the end of an era, or the pretence of an era, for it would no longer be possible to argue the separation of the Academy from the State.

One writer who had noted the significance of these three moves was Norman Rosenthal, in a *Spectator* article dated 1 January 1977. He was prepared to go further. The Academy should be given, he said,

secure financial backing. Even if it sold more of its treasures, it could no more be expected to operate without public funding than the Royal Opera or the National Theatre. The annual Summer Exhibition should not only be improved upon: it should be supplemented by 'a carefully planned programme of contemporary art, both from this country and from abroad'. Aggressively enough, Rosenthal argued that 'The Institute of Contemporary Art is now utterly defunct and should be closed down once and for all. However startling the proposal, there is

Norman Rosenthal (b. 1944), the Royal Academy's Exhibitions Secretary from 1977

Sidney C. Hutchison (1912–2000), Secretary of the Royal Academy from 1968 to 1982

no reason why the RA should not take upon itself that programmatic role and become the major forum for new art again, as it was in its first hundred years.'

This was, to say the least, a change from the run-of-the-mill line about the Academy, and Casson was quick to circulate the Council with copies of the article, and to write to thank its author, for whom he later that year created the post of Exhibitions Secretary. In every respect, what Rosenthal said about the Academy coincided with, or developed from, what Casson had written almost two decades earlier. But to many Academicians it was icono-clastic in one respect – it made clear that the future for the Academy lay in public funding.

A great deal of misplaced pride had been invested in opposing such moves, in the name of independence. Sidney Hutchison described Casson at his first Council meeting as president, in 1976. 'Hugh said very little for a while. He just listened to the requests from various members of the Council that independence should be maintained at all costs. Then eventually he said, "You know there is no independence in bankruptcy."'[5]

This habit of stressing the independence of the Academy, forgetting or (perhaps worse) taking for granted its relation to the monarchy, belonged it would seem to the twentieth century. In 1863, in response to questions from the Fine Arts Commission, Eastlake had not used the term independence:

> 191. (Lord Elcho.) Do you consider the Royal Academy a public, or a private institution? – I consider it a public institution.

> 192. Do you consider it a thoroughly national institution at present? – It is impossible that it can be within its limited means of accommo-dating students in the school and exhibitors in the exhibition.

The Academy is seen as unequivocally public, but limited in its role as a national institution by the modesty of its means. In other words, there is a qualification, but one that arises out of the resources of the Academy, not one that stems from its constitution.

The Hanging Committee of the 1983 Summer Exhibition: seated from left, Allen Jones RA (b. 1937), Rodrigo Moynihan RA (1910–1990), Sir Roger de Grey PRA (1918–1995), William Bowyer RA (b. 1926), H. Andrew Freeth RA (1912–1986) and Sir Peter Blake RA (b. 1932)

Around this crucial year of 1977, one major option was closed to the Academy: that of selling off its greatest single remaining treasure, the Michelangelo tondo. Wheeler had made it a matter of pride that, if it proved necessary to do this, he would be prepared to, in order to preserve the Academy's independence. By now, however, the Schools were receiving fees from the Department of Education and Science and applications were being made for Arts Council grants. If the Academy put up the tondo for sale, there would be no defence this time against the hostile arguments that had been raised by the Leonardo sale: that the Academy was holding the nation to ransom, or that one national institution was forcing another to bale it out. A national institution could not put up for sale what would, inevitably, be considered a national treasure.

Casson and Rosenthal won so many of the arguments in their respective manifestos that it is worth looking at the ones they did not win. Casson (1959) had been in favour of the shifting and disciplining of the Summer Exhibition, but this has never yet proved possible. Secondly, both Casson as president and Rosenthal in his manifesto were in favour of seeking state subsidy, but memories of the old defiant Academy were still too fresh for that. Nor did Rosenthal manage to close down the ICA, or indeed to make the Hayward Gallery redundant. The Academy was not handed a subsidy nor with it the brief to look after the interests of contemporary art in Britain – which was the eventual logic of Rosenthal's 1977 piece.

What happened instead was that the Academy took the alternative routes available to it, which had not yet been tried. It took its own initiatives in finding sponsorship, both from business and from individuals. It founded a Friends scheme, and the American Associates of the Royal Academy Trust (AARAT). It developed a shop and a mail-order list, and set about developing its publications. And above all it concentrated effort on its exhibitions policy, so that this could become a source of income rather than the drain on resources that it was becoming in the 1970s.

The Jillian and Arthur M. Sackler Wing of Galleries, designed by Foster Associates, 1991

Some government money was made available to help with the repair of the building, but it was private sponsorship that made the Jillian and Arthur M. Sackler Wing of Galleries possible. Opened in 1991 and designed by Norman Foster, this development made clever use of the space between the old Burlington House and Smirke's nineteenth-century galleries in order to provide a lift and staircase to take visitors up to what used to be the Diploma Galleries, the extra floor put onto old Burlington House when the Academy first moved in. These Diploma Galleries had once been so little visited that they had become known as 'a trysting place for lovers'. Now they provided a smaller exhibition space, modern in feel, enabling the Academy to run two substantial exhibitions at any one time.

Immediately as you leave the glass lift, a door leads into the new premises of the Library, and here too the smallest-scale exhibitions can be and

are mounted, within the Librarian's office. The Library itself, a compact and ingenious structure designed in 1986 by H. T. Cadbury-Brown, leads from this office, and there is a further Muniment Room where documents are kept under climatically controlled conditions. This suite of rooms, designed for the preservation of the library, the archive and the collection of prints and drawings, is evidence that the days of piecemeal disposal of assets are well in the past. But anyone who has worked in these spaces will know that space is at a premium and that on any day of the week it might be that the Library gets used as a meeting-room, just as the Librarian's office gets used as a gallery.

Beyond Foster's glass staircase (a feature which has given pause to many a sufferer from akrophobia), and well behind a sheet of thick protective glass, is the Michelangelo tondo, the only work in marble by the artist in Britain. The placing of this major work is

an act of perverseness which will no doubt eventually be rectified.

Coming down the glass staircase we are able to glance in on the Academy's offices, in one of which Casson, a short man, used to work with his rather taller young secretary. 'He would hold her hand against his face', his biographer tells us, 'as he gave her instructions, put one hand on her knee as he worked, rest his head on her shoulder when faced with a problematic assignment, saying "Do I have to?"' He was entering his seventies, and she would keep him going with doses of weak whisky.[6]

On the ground floor, behind the foot of the main staircase, but not open to the public, is the entrance to the basement and to the Schools. While I was working on this book I received a letter from an acquaintance who was working as a model, and had just posed at the Academy. Here is the way this quintessential academic activity struck her in 2004:

I was supposed to meet the tutor at 5 pm but wanted to get there early enough to absorb the atmosphere of the place. I hadn't been alone in Burlington Gardens before, so when I saw the series of philosophers that line the walls of the Schools [she is approaching the newly acquired Burlington Gardens building] I was thrilled I'd come early. As I looked in awe at the wonderful stones, I began to feel nervous about modelling in such a renowned place, so I quickly moved on down to the industrial-looking entrance to the Schools. It's a great behind-the-scenes contrast to the grandiose entrance on Piccadilly.

I then opened the double doors to the long arched corridor and watched as young students carrying wooden frames and rolls of paper rushed over the shadows of the Greek and Roman gods that lined and leaned over them in the corridor. The massive struggling sculpture of Laocoön sent a tension through my head and memories of Garland's depiction of Blair [in a cartoon] as that Trojan priest entangled by the hosepipes of the fire-fighters on strike. I sat down with Athene on my left, a discobolus on my right and the weight of history running through me.

I then went into the office and met the secretary, Sue Ford, who was wonderfully official and friendly. She handed me an RA employee form and rather than worry about how much I was going to be taxed (most colleges pay cash in hand) I filled out my name in bold lettering remembering all those unnamed female life models banished from the records by the incredible condescension of history.

I then met the tutor, who said that I wouldn't be modelling for students but the Academicians and some patrons. This made me a lot more nervous. He went on to explain that he wanted three or four poses which I could choose but that must rotate around a pivotal point. We then walked into the room I'd spent last year dreaming about.

Light was streaming in through the high windows and I felt my heart race as I looked across at the back wall that shelved about 14 busts which included Achilles, possibly Plato, a slave and others I couldn't decipher. To the left of the wall was a cast of Venus, another discus-thrower, a huge horse I liked to think was Trojan and an encased body cast of a smuggler called Smugglerius! There was also a cast of a man who had been hanged for murdering his brother. His skin had been flayed and stretched onto a cross. I then went into the only purpose-built model's room I've ever seen. It had a mirror, coat-hangers and an old chair for all my things.

I began modelling with my head facing towards the Gods. I couldn't believe I was getting paid to stare and scrutinise incredible works of art for the entire length of a pose. I felt my eyes well up until a pearl of sweat ran down the side of my arms as if to replace a tear. The tutor noted the wonders of natural light to create the perfect shadowing. We stayed in natural light even as dusk descended.[7]

The woman admiring these sculptures of athletes had, herself, trained in the pentathlon, and would therefore have been looking at the discus-thrower from a discus-thrower's point of view.

OVERLEAF
A life class in the Royal Academy Schools, c. 2000

At the end of 2004, the President of the Royal Academy, Professor Phillip King, resigned on grounds of ill health, and an election was held. King had succeeded Sir Philip Dowson (1993–99), who in turn had succeeded Sir Roger de Grey (1984–93), Casson's successor. The major achievement under King's presidency had been the purchase of 6 Burlington Gardens. There had also been great tensions, and a notable Secretary, David Gordon, had resigned after a long-running series of disputes with the President. Now Gordon's successor as Secretary, Lawton Fitt, had herself decided to resign on the grounds that the governance structure of the Academy did not give clear authority and accountability to anyone and did not reflect the requirements of the modern world. She said that her reported disagreements with the Exhibitions Secretary, Norman Rosenthal, had been 'a manifestation of that larger problem', but that they were symptoms rather than the disease itself.

In addition to these tensions, a financial scandal had recently broken. The Keeper, Professor Brendan Neiland, had been discovered to be running a bank account in the name of the 'Royal Academy Schools Trust', into which income of and donations to the Schools had been placed. No such trust existed. Receipts had not been kept. Expenditure was not accounted for. When the Secretary and Treasurer of the Academy tried to examine the bank account of the 'Trust' they were refused access by the bank, on the grounds that they were not signatories. Neiland's explanation for his running this *sub rosa* fund was that the needs of the Schools were always being overlooked, and that money raised on their behalf had in the past been diverted for the general needs of the Academy. However, it was clear that the Royal Academy, as a registered charity, could not be running secret bank accounts, and Professor Neiland resigned the Keepership, although not his position as an Academician.

So it was that, on the evening when Professor King's successor was to be chosen, there were present a Secretary who had handed in her notice and was serving out her term, and a Keeper who had resigned under a cloud but insisted on remaining

an Academician. The Exhibitions Secretary had himself raised some eyebrows by appearing at a fancy-dress party dressed as a newt, but on the evening in question he was out of town.

In the Friends' Room, where Academy staff awaited the outcome of the meeting, the Roll of Obligation was laid out and we were able to examine Barry's signature, and the words with which George III had confirmed his removal from the Academy. The Archivist indicated that if Professor Neiland were expelled, the Queen would be asked to strike out his name in the same way.

The Academicians were expected to elect Allen Jones, but turned instead to the architect Sir Nicholas Grimshaw, who seems to have won support with a statement setting out the issues facing the Academy, and his proposed approach to them. It is perhaps natural that in a time of crisis, a large organisation, such as the Academy has now become, would be inclined to turn to an architect who had experience of running an international practice, rather than an artist. Grimshaw had certainly made a point of this. 'I think', he wrote,

> my experience of running a large architectural practice for 25 years with an average of 100 employees and a turnover of around £8m will greatly help me with the understanding of the Academy and all its operations. In view of recent traumatic financial events I would now propose a detailed and forensic financial audit every six months, for the next few years. Furthermore I feel an audit on personnel procedures needs to take place. All members of staff should have their employment contracts checked and regular appraisals must take place.

There had to be an end, this passage strongly implies, to the situation whereby, from time to time, large sums of money were found to have been diverted, in one instance to the private bank account of a member of staff, and in this latest case to what purported to be a *sub rosa* fund for the use of the Schools.

Transparency was the watchword. There could be no question of raising money from donors who were not entirely clear about where their money was going. Transparency also meant, however, that when the Neiland case was discussed by the Academicians,

which it was within a few minutes of Grimshaw's election, it was considered right that a report should be drawn up, detailing precisely what the charges against the former Keeper were. This had been the request of Barry, at the time of his still unique expulsion – that he know the charges against him – and it had been refused. A decision on Neiland was delayed until Sir Alan Moses, a judge acting in a private capacity, produced his report. It is a very clear document, and, although it drew protests from Neiland, the report notes that the former Keeper did not deny that he had benefited in cash from money belonging to the Academy, that he had deliberately evaded the Academy's financial controls and that his decision to divert funds had damaged the Academy. In May 2005 the General Assembly decided to expel him, and the Queen at once confirmed this decision, commanding the Acting Secretary, MaryAnne Stevens, in a later letter to strike out Neiland's name on her behalf.

After electing Grimshaw and postponing a decision on Neiland, the Academicians proceeded to a session of their informal Dining Club, the club that has met on such occasions throughout most of the Academy's history. It was an evening whose general

Sir Philip Dowson PPRA (b. 1924), President from 1993 to 1999, in the galleries during the hanging of the 1995 the Summer Exhibition. Behind him stand Jeffery Camp RA (b. 1923) and Ralph Brown RA (b. 1928)

joviality was spotted by areas of local discomfort. The microphone was handed round, and speeches were made in tribute to the outgoing President, and in acknowledgment of the merits of his successor. The Professor of Anatomy spoke in praise of Professor King's anatomy. Allen Jones, who had come second in the poll, made a speech pointing out his own resemblance to Cassius – which was indeed startling. To the outsider it was hard to be certain that there might not be some massacre in store before the end of the celebrations.

Grimshaw, when he rose to speak, was careful to strike a note of optimism, and to speak of recent difficulties as if they were minor irritants to be brushed away, so that the positive qualities, the exciting prospects, could be appreciated. It was a speech such as the occasion demanded, and as he made it I thought that perhaps the architects would always be at an advantage over the other artists on such occasions, since making presentations is so much a part of their job.

But later, I began to think that this business of working with large numbers of other people, which had seemed so much a distinction between architects and others, was less crucial than I had imagined. After all, many of the painters and sculptors in this story were heads of studios, and indeed, even if they were bachelors like Reynolds, they might have been masters of demanding households, which had to be governed in some sense.

Sir Roger de Grey PRA (1918–1995), President from 1984 to 1993

20 Redgrave, pp. 254–55.
21 Redgrave, pp. 114–15.
22 Redgrave, pp. 72–73.
23 Wills, p. 71.
24 Wills, p. 76.
25 Redgrave, pp. 285–86.
26 See Redgrave, p. 281.
27 Wills, p. 71, citing minutes of
 Royal Academy General Assembly,
 27 March 1850.
28 Wills, p. 94.
29 Harris Burlington, p. 54.
30 Redgrave, p. 330.

ELEVEN · RUSKIN AS ARBITER OF TASTE,
PAGES 212–31

1 Redgrave, F. M., p. 106.
2 Her article was published in the *Quarterly
 Review*, March 1856. The quotations given
 come from Hilton 1985, pp. 230–31.
3 Gaunt, p. 44.
4 Barrington, vol. 1, p. 187.
5 Hunt and Tupper, pp. 45–46.
6 Hunt, pp. 42–44.
7 Millais, p. 174.

TWELVE · THE HIGH VICTORIANS AT HOME,
PAGES 232–45

1 *Arnold's Library of the Fine Arts; or repository of
 painting, sculpture, architecture and engraving*,
 vol. 1, February 1831, p. 14.
2 George Dawe, *The Life of George Morland,
 with Remarks on His Works*, Vernor, Hood
 and Sharp, London, 1807.
3 Leslie, G. D., p. 131.
4 Musson, p. 97.
5 Musson, p. 100.
6 Musson, p. 115.
7 Campbell, pp. 267–68.
8 James Stories, vol. 2, p. 9.

9 Dakers, pp. 201–05.
10 Dorment 1985, p. 15.
11 Dorment 1985, p. 242.
12 Dorment 1985, p. 243, citing *Truth*.
13 Dorment 1985, pp. 262–63.

THIRTEEN · FROM MILLAIS TO MUNNINGS,
PAGES 246–69

1 Millais, pp. 353–54.
2 Trilby, p. 88.
3 Gaunt, pp. 167–70.
4 Munnings 1952, pp. 100–01.
5 Woolf, pp. 206–11.
6 Hutchison, p. 149.
7 Haydon Autobiography, p. 205.
8 Haskell, p. 51.
9 Haskell, p. 74.
10 James, p. 194.
11 Clark 1974, p. 182.
12 Epstein, p. 31.
13 Epstein, p. 33.
14 Epstein, p. 40.
15 Ridley, p. 31.
16 Ridley, pp. 405–06.
17 London Replanned, *passim*.
18 Munnings 1952, p. 77.
19 Holroyd 2, p. 107.
20 See illustrations in Munnings 1950.
21 Munnings 1952, p. 96.
22 Munnings 1952, pp. 64–65.
23 Soames, p. 156.
24 Hutchison, p. 170.
25 Soames, p. 157.
26 Munnings 1952, p. 144.

FOURTEEN · GIANTS WHO DIDN'T COME
OFF: KELLY, RICHARDSON, WHEELER,
PAGES 270–87

1 Clark 1974, p. 77.
2 Clark 1977, p. 23.

3 Hudson, p. 47.
4 Hudson, p. 114.
5 Hudson, pp. 13–14.
6 Hudson, p. 15.
7 Hudson, p. 38, quoting the diary of
 Dr Frederick Whiley Hilles.
8 Robinson, p. 69.
9 Collis, p. 215.
10 Collis, p. 216.
11 Collis, p. 216.
12 Hudson, p. 81.
13 Lord Kinross in *Punch*, 27 April 1955.
14 Wheeler, pp. 70–71.
15 Wheeler, pp. 64–65.
16 Pevsner Buildings, pp. 164–65.
17 Peter Greenham RA in *The Independent*,
 30 December 1988.
18 'Extremes of Mind', Humphrey Brooke
 describes the state of manic depression,
 Observer, 11 April 1982.
19 Wheeler, p. 84.
20 Note of a meeting at the Treasury,
 6 March 1961, RA Archives.
21 General Assembly Minutes, 10 July 1962.
22 Letter dated 11 July 1962.
23 Typescript in RA Archives.

FIFTEEN · 'WHY DO YOU DESIRE SO
MUCH TO BE IN THE ACADEMY?',
PAGES 288–303

1 Sir Hugh Casson, 'Our Royal Academy',
 Observer, 16 August 1959.
2 Cumberland, p. 15.
3 Cumberland, p. 12.
4 Cumberland, p. 74.
5 Manser, p. 239.
6 Manser, p. 250.
7 Letter from Lucy Capes, 4 May 2004.
8 Ward, p. 162.

Bibliography

ALBERTS
Robert C. Alberts, *Benjamin West: A Biography*, Houghton Mifflin, Boston, 1978

ALLEN
Brian Allen, *Francis Hayman*, published in association with English Heritage (Iveagh Bequest, Kenwood) and the Yale Centre for British Art by Yale University Press, New Haven and London, 1987

BAROCCHI
Paola Barocchi (ed.), *Il Giardino di San Marco: Maestri e Compagni del Giovane Michelangelo*, Silvana Editoriale, Florence, 1992

BARRINGTON
Mrs Russell Barrington, *The Life, Letters and Work of Frederic Leighton*, 2 vols, George Allen, London, 1906

BARZMAN
Karen-Edis Barzman, *The Florentine Academy and the Early Modern State: The Discipline of 'Disegno'*, Cambridge University Press, Cambridge, 2000

BELL
Quentin Bell, 'Haydon Versus Shee', *Journal of the Warburg and Courtauld Institutes*, vol. 22, 1959, pp. 347–58

BENTLEY
G. E. Bentley Jr, *The Stranger from Paradise: A Biography of William Blake*, published for the Paul Mellon Centre for Studies in British Art by Yale University Press, New Haven and London, 2001

BIGNAMINI
Ilaria Bignamini, 'Art Institutions in London, 1689–1768: A Study of Clubs and Academies', *Walpole Society Journal*, vol. 55, 1988, pp. 1–148

BIGNAMINI AND POSTLE
Ilaria Bignamini and Martin Postle, *The Artist's Model: Its Role in British Art from Lely to Etty*, exh. cat., University Art Gallery, Nottingham; The Iveagh Bequest, Kenwood, 1991

BINDMAN 1977
David Bindman, *Blake as an Artist*, Phaidon, Oxford, 1977

BINDMAN 1981
David Bindman, *Hogarth*, Thames and Hudson, London, 1981

BLAKE, COLLECTED
Geoffrey Keynes (ed.), *The Complete Writings of William Blake, with Variant Readings*, Oxford University Press, London, 1966

BRITISH DRAWINGS
Edward Croft-Murray and Paul Hulton, *Catalogue of British Drawings, Volume One: XVI and XVII Centuries*, The Trustees of the British Museum, London, 1960

CAMPBELL
Louise Campbell, 'Decoration, Display, Disguise: Leighton House Reconsidered', in *Frederic Leighton: Antiquity, Renaissance, Modernity*, Tim Barringer and Elizabeth Prettejohn (eds), Studies in British Art 5, published for the Paul Mellon Centre for Studies in British Art by Yale University Press, New Haven and London, 1999, pp. 267–93

CASSON 1946
Hugh Casson, *Homes by the Million: An Account of the Housing Achievement in the USA, 1940–1945*, Penguin, Harmondsworth, 1946

CASSON 1981
Hugh Casson, *Diary*, Macmillan, London, 1981

CLARK 1974
Kenneth Clark, *Another Part of the Wood: A Self-portrait*, John Murray, London, 1974

CLARK 1977
Kenneth Clark, *The Other Half: A Self-portrait*, John Murray, London, 1977

COLLIS
Maurice Collis, *Stanley Spencer: A Biography*, Harvill Press, London, 1962

COLVIN
Howard Colvin, *A Biographical Dictionary of British Architects, 1600–1840*, third edition published for the Paul Mellon Centre for Studies in British Art by Yale University Press, New Haven and London, 1995

CONDIVI
Ascanio Condivi, *The Life of Michelangelo* [1553], Hellmut Wohl and Alice Sedgwick Wohl (eds), Penn State University Press, University Park, 1999

CUGOANO
Quobna Ottabah Cugoano, *Thoughts and Sentiments on the Evils of Slavery* [1787], Vincent Carretta (ed.), Penguin, New York, 1999

CUMBERLAND
George Cumberland, *An Essay on the Utility of Collecting the Best Work of the Ancient Engravers of the Italian School, Accompanied by a Critical Catalogue*, London, 1827

DAKERS
Caroline Dakers, *The Holland Park Circle: Artists and Victorian Society*, Yale University Press, New Haven and London, 1999

DIVINE MICHELANGELO
The Divine Michelangelo: The Florentine Academy's Homage on His Death in 1564, a facsimile edition of *Esequie del Divino Michelagnolo Buonarotti*, Florence, 1564, introduced, translated and annotated by Rudolf and Margot Wittkower, Phaidon, London, 1964

DORMENT 1985
Richard Dorment, *Alfred Gilbert*, Yale University Press, New Haven and London, 1985

DORMENT 1986
Richard Dorment et al., *Alfred Gilbert, Sculptor and Goldsmith*, exh. cat., Royal Academy of Arts, London, 1986

EDWARDS
Edward Edwards, *Anecdotes of Painters Who Have Resided or Been Born in England; with Critical Remarks on Their Productions*, Leigh and Sotheby, London, 1808

EPSTEIN
Sir Jacob Epstein, *An Autobiography*, Hulton Press, London, 1955; first published as *Let There Be Sculpture*, Michael Joseph, London, 1940

EVERY LOOK SPEAKS
Every Look Speaks: Portraits of David Garrick, with an essay by Desmond Shawe-Taylor, exh. cat., Holburne Museum of Art, Bath, 2003

FARINGTON
The Diary of Joseph Farington, vols 1–6, Kenneth Garlick and Angus Macintyre (eds), Yale University Press, New Haven and London, 1978–79; vols 7–16, Kathryn Cave (ed.), Yale University Press, New Haven and London, 1982–84; index volume by Evelyn Newby, Paul Mellon Center for British Art in association with Yale University Press, New Haven and London, 1998

FLEMING
John Fleming, *Robert Adam and His Circle*, John Murray, London 1978 (first edition, 1962)

FRITH
W. P. Frith, *My Autobiography and Reminiscences*, 2 vols, Richard Bentley and Son, London, 1887

GALT
John Galt, *The Life, Studies and Works of Benjamin West, Esq., President of the Royal Academy of London*, 2 vols, T. Cadell and W. Davies, London and Edinburgh, 1820

GAUNT
William Gaunt, *Victorian Olympus*, Jonathan Cape, London, 1952

GILCHRIST BLAKE
Alexander Gilchrist, *The Life of William Blake*, edited with an introduction by W. Graham Robertson, John Lane, The Bodley Head, second edition n.d. [1906] (first edition, 1863)

GILCHRIST ETTY
Alexander Gilchrist, *Life of William Etty RA*, 2 vols, David Bogue, London, 1855

GOODDEN
Angelica Goodden, *Miss Angel: The Art and World of Angelica Kauffman*, Pimlico, London, 2005

GUNNIS
Rupert Gunnis, *Dictionary of British Sculptors, 1660–1851*, new revised edition, The Abbey Library, London n.d. [1968]

HARRIS BURLINGTON
John Harris, *The Palladian Revival: Lord Burlington, His Villa and Garden at Chiswick*, exh. cat., Royal Academy of Arts, London, 1994

HARRIS CHAMBERS
John Harris, *Sir William Chambers, Knight of the Polar Star*, with contributions by J. Mordaunt Crook and Eileen Harris, A. Zwemmer Ltd, London, 1970

HARRIS AND SNODIN
John Harris and Michael Snodin (eds), *Sir William Chambers, Architect to George III*, Yale University Press in association with the Courtauld Gallery, Courtauld Institute of Art, London, 1966

HASKELL
Francis Haskell, *The Ephemeral Museum: Old Master Painting and the Rise of the Art Exhibition*, Yale University Press, New Haven and London, 2000

HASKELL AND PENNY
Francis Haskell and Nicholas Penny, *Taste and the Antique: The Lure of Classical Sculpture, 1500–1900*, Yale University Press, New Haven and London, second printing (with corrections), 1982 (first edition, 1981)

HAYDON AUTOBIOGRAPHY
The Autobiography and Memoirs of Benjamin Robert Haydon, edited from his journals by Tom Taylor with an introduction by Aldous Huxley, 2 vols, Peter Davies, London, 1926

HAYDON DIARY
The Diary of Benjamin Robert Haydon, Willard Bissell Pope (ed.), 5 vols, Harvard University Press, Cambridge, Mass., 1960–63

HAYES
The Letters of Thomas Gainsborough, John Hayes (ed.), Yale University Press, New Haven and London, 2001

HAZLITT
William Hazlitt, *Conversations of James Northcote, Esq., RA*, Henry Colburn and Richard Bentley, London, 1830

HELMSTUTTLER
Kelley Helmstuttler di Dio, 'Leone Leoni's Collection in the Casa degli Omenoni, Milan: The Inventory of 1609', *Burlington Magazine*, August 2003, pp. 572–78

HILTON 1985
Tim Hilton, *John Ruskin: The Early Years, 1819–1859*, Yale University Press, New Haven and London, 1985

HILTON 2000
Tim Hilton, *John Ruskin: The Later Years*, Yale University Press, New Haven and London, 2000

HIRST AND DUNKERTON
Michael Hirst and Jill Dunkerton, *The Young Michelangelo: The Artist in Rome, 1496–1501*, National Gallery Publications, London, 1994

HOGARTH
William Hogarth, *The Analysis of Beauty*, Ronald Paulson (ed.), Yale University Press, New Haven and London, 1997

HOLROYD 1
Michael Holroyd, *Augustus John, Volume 1: The Years of Innocence*, Heinemann, London, 1974

HOLROYD 2
Michael Holroyd, *Augustus John, Volume 2: The Years of Experience*, Heinemann, London, 1975

HOOCK
Holger Hoock, 'The King's Artists: The Royal Academy of Arts as a "National Institution", *c.* 1768–1820', D.Phil thesis, Oxford, 2000; subsequently published as *The King's Artists: The Royal Academy of Arts and the Politics of British Culture, 1760–1840* by Oxford University Press, 2003

HUDSON
Derek Hudson, *For the Love of Painting: The Life of Sir Gerald Kelly KCVO PRA*, Peter Davies, London, 1975

HUNT
William Holman Hunt, exh. cat. Walker Art Gallery, Liverpool; Victoria and Albert Museum, London, 1969

HUNT AND TUPPER
A Pre-Raphaelite Friendship: The Correspondence of William Holman Hunt and John Lucas Tupper, James H. Coombs et al. (eds), UMI Research Press, Ann Arbor, Michigan, 1986

HUTCHISON
Sidney C. Hutchison, *The History of the Royal Academy, 1768–1986*, second edition, Robert Royce Ltd, London, 1986 (first edition, Chapman & Hall, London, 1968)

JAMES
Henry James, *Essays on Art and Drama*, Peter Rawlings (ed.), Scolar Press, Aldershot, 1996

JAMES STORIES
Henry James, *Collected Stories*, 2 vols, Everyman, London, 1999

JOHNSON
The Letters of Samuel Johnson, Bruce Redford (ed.), 5 vols, Oxford, 1992–94

KEMP
Dr William Hunter at the Royal Academy of Arts, Martin Kemp (ed.), University of Glasgow Press, Glasgow, 1975

KIDSON ESSAYS
Those Delightful Regions of Imagination: Essays on George Romney, Alex Kidson (ed.), Studies in British Art 9, published for the Paul Mellon Centre for Studies in British Art by Yale University Press, New Haven and London, 2002

KIDSON ROMNEY
Alex Kidson, *George Romney, 1734–1802*, exh. cat., National Portrait Gallery, London; Walker Art Gallery, Liverpool; Huntington Library, San Marino, 2002

KING
James King, *William Blake, His Life*, Weidenfeld and Nicolson, London, 1991

KITSON
'Hogarth's "Apology for Painters"', Michael Kitson (ed.), *Walpole Society Journal*, vol. 41, 1968, pp. 46–111

LAMB
Sir Walter R. M. Lamb, *The Royal Academy: A Short History of Its Foundation and Development*, revised and enlarged edition, G. Bell & Sons, London, 1951 (first edition, 1935)

LESLIE AUTOBIOGRAPHY
C. R. Leslie, *Autobiographical Recollections*, Tom Taylor (ed.), London, 1860, reprinted 1978

LESLIE CONSTABLE
C. R. Leslie, *Memoirs of the Life of John Constable, Composed Chiefly of His Letters*, Phaidon, London, 1951 (text of second edition, 1845)

LESLIE HANDBOOK
C. R. Leslie, *A Handbook for Young Painters*, John Murray, London, 1855

LESLIE, G. D.
G. D. Leslie, *The Inner Life of the Royal Academy*, John Murray, London, 1914

LESLIE AND TAYLOR
Charles Robert Leslie and Tom Taylor, *The Life and Times of Sir Joshua Reynolds, with Notices of Some of His Contemporaries*, 2 vols, John Murray, London, 1865

LLOYD
Stephen Lloyd, *Richard and Maria Cosway, Regency Artists of Taste and Fashion*, exh. cat., Scottish National Portrait Gallery, Edinburgh, 1995

LONDON REPLANNED
London Replanned, The Royal Academy Planning Committee's Interim Report, foreword by Sir Edwin Lutyens, introduction by Sir Charles Bressey, Country Life Ltd, London, October 1942

MCINTYRE
Ian McIntyre, *Sir Joshua Reynolds: The Life and Times of the First President of the Royal Academy*, Penguin, London, 2003

MANNERS
Lady Victoria Manners and Dr G. G. Williamson, *Johan Zoffany RA: His Life and Works*, John Lane, The Bodley Head, London and New York, 1920

MANSER
José Manser, *Hugh Casson: A Biography*, Penguin, London, 2000

MILLAIS
John Guille Millais, *The Life and Letters of Sir John Everett Millais*, Methuen, London, 1905

MILLAR
Oliver Millar, *The Later Georgian Pictures in the Collection of Her Majesty The Queen*, Phaidon, London, 1969

MUNNINGS 1950
Sir Alfred Munnings, *An Artist's Life*, Museum Press, London, 1950

MUNNINGS 1951
Sir Alfred Munnings, *The Second Burst*, Museum Press, London, 1951

MUNNINGS 1952
Sir Alfred Munnings, *The Finish*, Museum Press, London, 1952

MUSSON
Jeremy Musson, 'Has a Paint Pot Done All This?: The Studio-House of Sir John Everett Millais, Bt', in *John Everett Millais: Beyond the Pre-Raphaelite Brotherhood*, Debra N. Mancoff (ed.), Studies in British Art 7, published for the Paul Mellon Centre for Studies in British Art by Yale University Press, New Haven and London, 2001, pp. 95–118

NEOCLASSICISM
The Age of Neo-Classicism, exh. cat., Royal Academy of Arts, Victoria and Albert Museum, Arts Council of Great Britain, London, 1972

NORTHCOTE
James Northcote, *The Life of Sir Joshua Reynolds*, second edition revised and augmented in two volumes, 1819

PAULSON
Ronald Paulson, *Hogarth*, 3 vols, Rutgers University Press, New Brunswick and London, 1991, 1992, 1993

PENNY
Reynolds, Nicholas Penny (ed.), exh. cat., Royal Academy of Arts, London, 1980

PEVSNER ACADEMIES
Nikolaus Pevsner, *Academies of Art, Past and Present*, Cambridge University Press, Cambridge, 1940

PEVSNER BUILDINGS
Nikolaus Pevsner, *The Buildings of England: London, vol. 1, The Cities of London and Westminster*, Penguin, Harmondsworth, 1957

PIPER
David Piper, 'A Chinese Artist in England', *Country Life*, 18 July 1952, pp. 198–99

PLASTER ICONS
Plaster Icons: The History and Conservation of the Royal Academy Cast Collection, exhibition handlist, Royal Academy of Arts, London, 2002

POSTLE
Martin Postle, 'The St Martin's Lane Academy, True and False Records', *Apollo*, July 1991, pp. 33–38

POSTLE AND VAUGHAN
Martin Postle and William Vaughan, *The Artist's Model: From Etty to Spencer*, exh. cat., Merrell Holberton Publishers Ltd, London, for York City Art Gallery; The Iveagh Bequest, Kenwood; Djanogly Art Gallery, University of Nottingham, 1999

PRESSLY
William L. Pressly, *The Life and Art of James Barry*, Yale University Press, New Haven and London, 1981

REDGRAVE
Richard and Samuel Redgrave, *A Century of British Painters*, Phaidon, Oxford, 1947 (first edition, 1866)

REDGRAVE, F. M.
F. M. Redgrave, *Richard Redgrave CBE RA: A Memoir Compiled from His Diary*, Cassell, London, 1891

REYNOLDS APOLOGIA
In Frederick Whiley Hilles, *The Literary Career of Sir Joshua Reynolds*, Cambridge University Press, Cambridge, 1936, pp. 249–76

REYNOLDS DISCOURSES
Sir Joshua Reynolds, *Discourses on Art*, Robert R. Wark (ed.), Yale University Press, New Haven and London, 1997 (first edition, 1959)

RIDLEY
Jane Ridley, *Edwin Lutyens: His Life, His Wife, His Work*, Pimlico, London, 2003 (paperback edition; hardback 2002)

RIGAUD
Stephen Francis Dutilh Rigaud, 'Facts and Recollections of the XVIIIth Century in a Memoir of John Francis Rigaud Esq., RA', abridged and edited with an introduction and notes by William L. Pressly, *Walpole Society Journal*, vol. 50, 1984, pp. 1–165

ROBERTS
W. Roberts, *Sir William Beechey RA*, Duckworth, London, 1907

ROBINSON
Duncan Robinson, *Stanley Spencer*, Phaidon, London, 1990

RUSKIN
John Ruskin, *Pre-Raphaelitism and Notes on the Principal Pictures in the Royal Academy, The Society of Painters in Water Colours, etc.*, George Routledge & Sons, London, n.d.

SANDBY
William Sandby, *The History of the Royal Academy of Arts, from Its Foundation in 1768 to the Present Time, with Biographical Notices of All the Members*, 2 vols, Longman, London, 1862

SHYLLON
Folarin Shyllon, *Black People in Britain, 1555–1833*, published for The Institute of Race Relations, London, by Oxford University Press, 1977

SMITH
J. T. Smith, *Nollekens and His Times*, 2 vols, second edition, Henry Colburn, London, 1829

SOAMES
Mary Soames, *Winston Churchill: His Life as a Painter*, Collins, London, 1990

SOCIETY OF ARTISTS
'The Papers of the Society of Artists of Great Britain', *Walpole Society Journal*, vol. 6, 1917–18, pp. 113–30

SOLKIN 1982
David H. Solkin, *Richard Wilson: The Landscape of Reaction*, exh. cat., Tate Gallery, London, 1982

SOLKIN 2001
David H. Solkin (ed.), *Art on the Line: The Royal Academy Exhibitions at Somerset House, 1780–1836*, exh. cat., published for the Paul Mellon Centre for Studies in British Art and the Courtauld Institute Gallery by Yale University Press, New Haven and London, 2001

STAINTON AND WHITE
Lindsay Stainton and Christopher White, *Drawing in England from Hilliard to Hogarth*, exh. cat., British Museum, London, 1987

SUMMERSON
John Summerson, *Architecture in Britain, 1530 to 1830*, Penguin, London, 1953

THORNBURY
Walter Thornbury, *The Life and Correspondence of J. M. W. Turner*, Ward Lock, London, second edition 1877, reprinted 1970

TRILBY
George Du Maurier, *Trilby*, with introduction and notes by Daniel Pick, first published 1894; Penguin, London, 1994

TURNER
Richard Turner, *Inventing Leonardo: The Anatomy of a Legend*, Papermac, London, 1995 (first edition, Knopf, New York, 1993)

VERTUE 1
George Vertue, Autobiography (BM Add. MSS. 23070; 23091) and Notebooks A.j. and A.b (Add. MSS. 21111; 23069), *Walpole Society Journal*, vol. 18, 1929–30

VERTUE 2
George Vertue, Notebooks A.g. and A.c. (BM Add. MSS. 23070; 23075), *Walpole Society Journal*, vol. 20, 1931–32

VERTUE 3
George Vertue, Notebooks A.f., B.4 and another (BM Add. MSS. 23076; 23079; 23074), *Walpole Society Journal*, vol. 22, 1933–34

VERTUE 4
George Vertue, Notebooks A.q. and A.x. (BM Add. MSS. 23071; 23072), *Walpole Society Journal*, vol. 24, 1935–36

VERTUE 5
George Vertue, Notebooks A.y.y., A.w., B.3 and D.1 (BM Add. MSS. 23073; 22042; 23087; 23089), *Walpole Society Journal*, vol. 26, 1937–38

VERTUE INDEX
Index to Vertue 1–5, *Walpole Society Journal*, vol. 29, 1940–42

VERTUE 6
George Vertue, Miscellaneous notebooks and notes, with independent index, *Walpole Society Journal*, vol. 30, 1948–50

WALES
HRH The Prince of Wales, *The Old Man of Lochnagar*, with illustrations by Sir Hugh Casson KCVO, Hamish Hamilton, London, 1980

WALPOLE
Horace Walpole, *Anecdotes of Painting in England*, 4 vols, Strawberry Hill Press, London, 1762–71

WARD
Conversations of James Northcote RA with James Ward on Art and Artists, Ernest Fletcher (ed.), Methuen, London, 1901

WEDD
Kit Wedd, with Lucy Peltz and Cathy Ross, *Creative Quarters: The Art World in London from 1700 to 2000*, exh. cat., Merrell, London, for the Museum of London, 2001

WHEELER
Sir Charles Wheeler, *High Relief: The Autobiography of Sir Charles Wheeler, Sculptor*, Country Life Books, London, 1969

WHITLEY 1
William T. Whitley, *Artists and Their Friends in England, 1700–1799*, 2 vols, The Medici Society, London and Boston, 1928

WHITLEY 2
William T. Whitley, *Art in England, 1800–1820*, Cambridge University Press, Cambridge, 1928

WHITLEY 3
William T. Whitley, *Art in England, 1821–1837*, Cambridge University Press, Cambridge, 1930

WILLS
Catherine Wills, *High Society: The Life and Art of Sir Francis Grant, 1803–1878*, exh. cat., National Galleries of Scotland, Edinburgh 2003

WOODALL
The Letters of Thomas Gainsborough, Mary Woodall (ed.), The Cupid Press, Ipswich, 1963

WOOLF
Virginia Woolf, *Collected Essays*, vol. 4, Harcourt Brace, New York, 1967

WRIGHT
Edward Wright, *Some Observations made in travelling through France, Italy, etc., in the Years 1720, 1721 and 1722*, Ward and Wickstead, London, 1730

YATES
Frances A. Yates, *The French Academies of the Sixteenth Century*, Routledge, London and New York, 1988 (first edition, 1947)

Photographic Acknowledgments

Art Archive, London: 254. Clive Boursell: 302 (left). Bridgeman Art Library, London: 85 (left), 93, 102, 116, 142, 149, 164, 165, 175, 176, 199 (top), 200, 201, 221, 222, 226, 227 (both), 228, 230, 239. Copyright © British Museum: 49 (detail), 54, 94, 108, 110, 116–17, 134 (left), 167. Bill Burlington: 303 (right). Camera Press, London: 288. Courtesy of Sir Hugh Casson/Penguin Books: 29. Christie's Images, London: 76, 214. Copyright © The Churchill Heritage Ltd: 266 (bottom). Colnaghi Ltd, London: 291. Copyright © The Trustees of the Faringdon Collection 1999. All rights reserved: 243 (left). © Felix Rosenstiel's Widow & Son Ltd, London: 256, 261, 264, 266 (both), 269. © Foto Scala, Florence 36, 40. Getty Images: 196, 246, 258, 259, 268, 271. Dennis Gilbert/VIEW: 34, 35, 296. Guildhall Library, City of London: 235. Reproduced by kind permission of the Earl and Countess of Harewood and the Trustees of Harewood House Trust: 82. James Hunkin: 303 (left). Estate of Gerald Kelly. Licensed by CARCC: 274. Marcus Leith 33 (bottom). Copyright Maas Gallery: 215. Muzeum Uniwersytetu Jagiellonskiego © Grzegorz Zygier: 43. National Gallery of Ireland © Roy Hewson: 135. National Magazine Company © Chris Taylor: 294 (top). National Portrait Gallery, London: jacket, 50, 53, 61, 72, 73 (left), 85 (right), 179, 181, 182; also Private Collection, courtesy of National Portrait Gallery, London: 213. NTPL © Brian Tremain: 134 (right). Photo Studios: 295. Press Features: 26. RIBA Library Drawings Collection: 208. RMN Photo – © Michèle Bellot: 42 (top); © Droits réservés: 42 (bottom). Leonard Rosoman: 28. Royal Academy of Arts, Stockholm © Magnus Persson 1993: 97. Royal Borough of Kensington and Chelsea: 174. Royal Collection © 2005 Her Majesty Queen Elizabeth II: 66 (detail), 70–71, 156, 204 (left), 205, 216–17. Samuel Courtauld Trust, Courtauld Institute of Art Gallery, London: 119. Phil Sayer: 14–15, 30–31. Solo Syndication/Associated Newspapers: 260 (both), 267, 273. Soprintendenza Speciale per il Polo Museale Fiorentino: 39. Estate of Stanley Spencer. All Rights Reserved, DACS 2006: 276–77, 277. © Tate, London 2006: 133, 187, 199 (bottom), 224–25, 229, 231, 241, 243 (right). © Paul Tozer: 2–3, 12–13. © V&A Images: 140.

Index

Numerals in *italic* type indicate pages with illustrations